ACC. No. 75/0138l 7 CLASS No. 759·06

**MID CHESHIRE COLLEGE OF FURTHER
EDUCATION, HARTFORD, CHESHIRE**

BK04949

KT-237-691

BK04949

ABSTRACTION·GEOMETRY·PAINTING

ABSTRACTION

Organized and with an essay by MICHAEL AUPING

GEOMETRY·PAINTING

Selected Geometric Abstract Painting in America Since 1945

HARRY N. ABRAMS, INC.·PUBLISHERS·NEW YORK

in association with

ALBRIGHT-KNOX ART GALLERY

Project Director: Margaret L. Kaplan
Editors: Karen Lee Spaulding (Albright-Knox)
and Beverly Fazio (Abrams)
Designer: Judith Michael

Library of Congress Cataloging-in-Publication Data
ABSTRACTION ▪ GEOMETRY ▪ PAINTING:
Selected geometric abstract painting in America since 1945/organized by
Michael Auping.; with an essay by Michael Auping.
p. cm.
Bibliography: p.
Includes index
ISBN 0-8109-1027-6. —ISBN 0-914782-70-3 (Albright-Knox Art
Gallery: soft)
1. Painting, Abstract—United States—Exhibitions. 2. Painting,
Modern—20th century—United States—Exhibitions. I. Auping,
Michael. II. Albright-Knox Art Gallery.
ND212.G46 1989
759.13'074'014797—dc19 88-39709
CIP

Copyright © 1989 The Buffalo Fine Arts Academy
Letter from Barnett Newman to John Gordon, page 16, copyright © 1989 The Barnett
Newman Foundation
Published in 1989 by Harry N. Abrams, Incorporated, New York,
in association with the Albright-Knox Art Gallery, Buffalo,
New York. All rights reserved. No part of the contents of this book may
be reproduced without the written consent of the publishers

A TIMES MIRROR COMPANY

Printed and bound in Japan

This book was published on the occasion of the exhibition
ABSTRACTION ▪ GEOMETRY ▪ PAINTING:
Selected Geometric Abstract Painting in America Since 1945

Albright-Knox Art Gallery September 17–November 5, 1989
Buffalo, New York

Center for the Fine Arts December 15, 1989–February 25, 1990
Miami, Florida

Milwaukee Art Museum April 1–June 1, 1990
Milwaukee, Wisconsin

Yale University Art Gallery July 1–August 30, 1990
New Haven, Connecticut

The exhibition and publication were made possible, in part, by public funds from the National Endowment for the Arts and by a generous grant from the New York State Council on the Arts.

LENDERS
TO THE EXHIBITION

Anne and Martin Z. Margulies

Estate of John McLaughlin,
Courtesy of André Emmerich Gallery, New York

John M. Miller

David Novros

Leon Polk Smith

Emily Leland Todd, Houston

Mike and Penny Winton

Albright-Knox Art Gallery, Buffalo

Allen Memorial Art Museum, Oberlin, Ohio

The Carnegie Museum of Art, Pittsburgh

The Solomon R. Guggenheim Museum,
New York

High Museum of Art, Atlanta

Milwaukee Art Museum, Wisconsin

The Museum of Contemporary Art, Los Angeles

San Francisco Museum of Modern Art

Yale University Art Gallery,
New Haven, Connecticut

CONTENTS

FOREWORD

In 1987, the Albright-Knox Art Gallery presented *Abstract Expressionism: The Critical Developments* as the highlight of its year-long celebration of the 125th anniversary of the founding of The Buffalo Fine Arts Academy. Organized by the Gallery's Chief Curator, Michael Auping, the exhibition paid homage to a movement considered to be America's most vital contribution to the history of art. Due in large part to the generosity of Seymour H. Knox and his early, farsighted support of this movement, Abstract Expressionist works are a cornerstone of the Gallery's modern art collection. A perfect complement to this set of works is yet another remarkable group—works in the geometric abstract tradition—largely brought together as well by Seymour H. Knox.

The role of Geometric Abstraction in postwar America involves a vast range of philosophical, painterly, and conceptual approaches to the classical components of the geometric image. *Abstraction • Geometry • Painting: Selected Geometric Abstract Painting in America Since 1945* covers this wide range, with works by such diverse artists as Josef Albers, Ilya Bolotowsky, and Burgoyne Diller to Ad Reinhardt, Ellsworth Kelly, John McLaughlin, Agnes Martin, Jo Baer, Peter Halley, and John M. Miller, among others.

It has been our good fortune to have had the involvement and cooperation of the Yale University Art Gallery during the course of planning this exhibition. Their substantial loan of nine works has infinitely broadened the scope of the exhibition; as well, this collaboration has brought together the two institutions which hold for Mr. Knox great meaning and importance. Both museums are indeed fortunate to be the recipients of such an honor.

Michael Auping's commitment and perseverance during the arduous period of planning this exhibition was admirable. His essay, which outlines the evolution of the movement, addresses the legacies inherited from Europe as well as from the American Abstract Artists group, and places the movement in relation to a larger twentieth-century tradition, is comprehensive and illuminating. I am grateful to him for his very hard work.

We are grateful, too, to Margaret L. Kaplan, Executive Editor and Senior Vice President at Harry N. Abrams, Inc., for making it possible for us to collaborate on this publication. It is a pleasure to be able to work together again.

Public funds from the New York State Council on the Arts and the National Endowment for the Arts, have made this exhibition possible. We are indeed grateful to our lenders for ensuring the success of this exhibition by parting with important works for such a lengthy period of time.

This exhibition will be seen in three other venues besides Buffalo: at the Milwaukee Art Museum, the Center for the Fine Arts in Miami, and the Yale University Art Gallery in New Haven. To Russell Bowman, Director of the Milwaukee Art Museum; Robert H. Frankel, Director of the Center for the Fine Arts; and Mary Gardner Neill, The Henry J. Heinz II Director of the Yale University Art Gallery, our appreciation for making it possible for audiences across the country to see this survey of geometric abstraction.

Douglas G. Schultz
Director
Albright-Knox Art Gallery

The Albright-Knox Art Gallery contains one of the richest collections of postwar American art in the world. It is thus a privilege to be able to study and work with its holdings. Not surprisingly, a substantial portion of this presentation comes from the Gallery's collection. So many of these outstanding and seminal works are the result of Seymour H. Knox's dedication to supporting the art of our time, and I must from the outset acknowledge my gratitude for having the opportunity to be associated with one of this country's great collectors of contemporary art.

The form of this exhibition and catalogue is partly the result of numerous conversations with many of the artists represented in the exhibition. They have been overwhelmingly generous and patient with my many queries. While their responses were invariably insightful, they should not be held responsible for my appropriation or transformation of their original ideas. I extend my sincere thanks to the following individuals who have been particularly helpful: Richard Anuszkiewicz, Flo Davis, Peter Halley, Al Held, Ellsworth Kelly, Robert Mangold, Agnes Martin, John M. Miller, Annalee Newman, David Novros, and Leon Polk Smith. I would also like to acknowledge Paula Cooper of the Paula Cooper Gallery, Dorsey Waxter of the André Emmerich Gallery, and Douglas Baxter of Pace Gallery for their kind assistance.

We have greatly benefited from the generosity of a number of lenders. Of critical importance was the Yale University Art Gallery; its significant collection of American geometric abstraction has added immeasurably to the selection for this exhibition. For their extraordinary support and cooperation, I owe a debt of thanks to Mary Gardner Neill, The Henry J. Heinz II Director, and Sasha Newman, Seymour H. Knox Associate Curator of European and Contemporary Art, of the Yale University Art Gallery. To the other institutions, museums, galleries, and private lenders, all of whom are listed herein, we extend our deepest appreciation for the continued cooperation they offered us throughout the long course of planning this exhibition.

This publication would not have been possible without the astute organizational skills of the Gallery's Editor of Publications, Karen Lee Spaulding. She has been the guiding force behind a very special team that included Patty Wallace Nickard, formerly Curatorial Researcher; Annette Masling, Librarian; Kathy Corcoran, Assistant Librarian; and Lucille Groth, Curatorial Secretary. Guiding us all has been Douglas G. Schultz, Director of the Albright-Knox Art Gallery, who, as always, has been extremely giving of his time and knowledge. At Harry N. Abrams, Inc., for their continued patience and the sustained care they have given this book, we are grateful to Margaret L. Kaplan, Senior Vice President and Executive Editor; Beverly Fazio, Senior Editor; and Judith Michael, Associate Art Director.

Finally, we owe much appreciation to the museums that form the tour for this exhibition and to the directors of those institutions. In addition, I would particularly like to thank Mark Ormond, Curator, Center for the Fine Arts, Miami; James Mundy, Chief Curator at the Milwaukee Art Museum; and Sasha Newman at Yale University Art Gallery, for their participation. Their help and cooperaton have been invaluable.

Michael Auping
Chief Curator
Albright-Knox Art Gallery

ABSTRACTION ▪ GEOMETRY ▪ PAINTING

FIELDS, PLANES, SYSTEMS:
GEOMETRIC ABSTRACT PAINTING
IN AMERICA SINCE 1945

MICHAEL AUPING

By "beauty of shape" I am not thinking of certain
pictures but a straight line or a circle and resultant
planes and solids produced on a lathe or with
ruler and square. . . . In my view these things are
not, as other things are, beautiful in a relative
way, but are always beautiful in themselves, and
yield their own special pleasures.

Plato, Philebus 51 c-d

INTRODUCTION

The great pioneer of geometric abstract painting, Kasimir Malevich, wrote in a lucid and pragmatic moment, "People always demand that art be comprehensible, but they never demand of themselves that they adapt their mind to comprehension."[1] From the standpoint of the serious abstract artist, Malevich's words must strike a very special cord. Indeed, abstract art remains a little understood phenomenon in our culture. It seems that over the past three-quarters of a century, its proliferation as a mode of response in painting has done relatively little to make it more accessible to a broad public. As one visitor to the museum recently put it, "I want a vision of the real world." Malevich would undoubtedly ask, "*Which* real world?" For Malevich, a white square on a white ground was a phenomenon as worthy of sustained admiration as a winter landscape.

The fact is that the development of abstraction has, from its embryonic beginnings, been a controversial issue for artists and laymen alike. Indeed, since its invention in the early part of this century, it has continuously been said to be in a crisis. Even Cézanne, often considered the father of modern art and, implicitly, abstraction, had serious reservations about straying too far from a directly observed nature, no matter how abstract some of his images might appear. Toward the end of a long and illustrious career, the artist wrote about his flirtations with abstraction and his solace in verifying one's feelings with nature seen:

Now, being old, nearly 70 years, the sensations of color, which give light, are the reason for the abstractions which prevent me from either covering my canvas or continuing the delimitation of the objects when their points of contact are fine and delicate; from which it results that my image or picture is incomplete. On the other hand, the planes are placed one on top of the other from whence Neoimpressionism emerged, which outlines the contours with a black stroke, a failing that must be fought at all costs. Well, nature when consulted gives us the means of attaining this end.[2]

Cézanne and his immediate progeny, the Cubists, resisted the risky conceptual intensities of a truly abstract art. In the end, they remained stubbornly attached to the world of natural appearances. They sought to achieve an equilibrium between the "reality" of experience and the "abstract beauty" of ideas.[3] The central issues surrounding abstraction and its relation to the world in which we live are at the very heart of what we think of as "modern," and although we have lived with abstraction for almost a century, we would be less than honest if we did not admit that it remains a relatively new language with a complex vocabulary that is still being unraveled.

In 1936, Alfred H. Barr, Jr., then Director of The Museum of Modern Art in New York and the dominant figure in shaping our understanding of the dynamics of twentieth-century art, presented his influential exhibition and catalogue *Cubism and Abstract Art*. In his inimitable manner, Barr describes the complex evolution of abstraction in unusually logical and fundamental terms. According to Barr, the two main arteries of abstract art consist of the expressionistic and the geometrical, the former deriving from the theories of Gauguin evolving into the art of Matisse, Kandinsky, and later the Surrealists. "This Tradition," Barr wrote, ". . . is intuitional and emotional rather than intellectual." The other strain, which he describes as "more important," developed from the art of Cézanne through Cubism, Constructivism, and the radical geometry associated with the abstraction of Mondrian. This strain required a considerable number of adjectives, and even then Barr admitted to a fuzzy definition. In the end, he referred to this development as "intellectual, structural, architectonic, geometrical, rectilinear and classical in its austerity and dependence upon logic and calculation. . . . Apollo, Pythagoras and Descartes watch over the Cézanne-Cubist-geometrical tradition; Dionysus (an Asiatic god), Plotinus and Rousseau over the Gauguin-Expressionist-non-geometrical line."[4]

Barr's analysis followed the earlier views of Wilhelm Worringer, whose *Abstraction and Empathy* was published in 1908. Worringer saw pure abstraction in terms of a

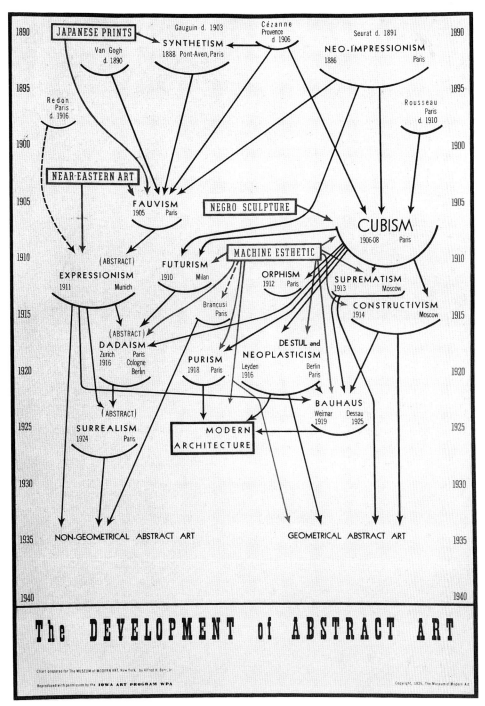

The DEVELOPMENT of ABSTRACT ART

Chart prepared for The MUSEUM of MODERN ART, New York, by Alfred H. Barr, Jr.

Reproduced with permission by the IOWA ART PROGRAM WPA

Copyright, 1936, The Museum of Modern Art

"The Development of Abstract Art." Chart prepared for The Museum of Modern Art, New York, by Alfred H. Barr, Jr., 1936. Photograph courtesy The Museum of Modern Art, New York

classical reduction of forms that establishes a rational model and give a sense of order to human experience. A separate impulse existed as "Empathy" with a direct, unedited expression of feeling. Worringer saw these as two very distinct strains of creativity.[5] Worringer's and Barr's analyses, in essence, described the right and left sides of the modernist brain.

Of these two tendencies, geometric abstraction in its acute and Platonic reduction has, ironically, had the most profound and continuing controversial effect on society-at-large. The environments we inhabit on a daily basis are virtually a collage of applied designs that appropriate the geometric side of abstraction. At the same time, the fact that we can gladly accept a room wallpapered in lines, circles, or squares and yet be hostile to a painting by Barnett Newman—indeed, be moved enough to attack it with a knife[6]—is testimony to the unique challenge of Newman's vision, as well as to the extreme reactions that geometric imagery often incites.

It is also true that the subtle and seemingly puritanical calibrations involved in geometric painting do not offer the overt sensuous pleasures of an expressionist imagery.

In contrast, geometric painting looks positively austere, if not drastic, in its self-imposed reduction. Far from being a weakness, this is, in fact, the works' essential strength. By jettisoning all aspects of recognizable subject matter and by embracing not only abstract but seemingly impersonal forms in a manner that often leaves out an overt sense of the artist's "touch" or "hand," the pioneers of geometric abstraction have restructured the character of twentieth-century aesthetics. Indeed, geometric abstraction remains one of the most striking developments in the history of art. Apollinaire went so far as to suggest that "geometry is to the plastic arts what grammar is to the art of the writer."[7]

The question that this exhibition addresses is whether we can speak of a definable geometric tradition in postwar American abstract art, undoubtedly the most important period in this country's aesthetic evolution. We take as our starting point the year 1945, perhaps the most referred-to date in American art studies. As the year that marks the end of World War II and the approximate beginning of Abstract Expressionism, it provides a decidedly convenient point of departure. In the case of this exhibition, 1945 begs another reference. Piet Mondrian, the towering presence of geometric abstract painting, died in New York in 1944. With the death of Mondrian we address a new chapter, and while the ghost of the Dutch master plays a considerable role later in this essay, we are dealing with two stories: what might be thought of as a secular version of the old and new testaments.

We begin with works by painters associated with the American Abstract Artists group, whose pioneering efforts—while not always stellar breakthroughs—allow us to speak not only of a geometric tradition in American art but also of an even more basic tradition of abstraction. The phase associated with Abstract Expressionism, while generally thought of as a gestural movement, was, in fact, critical to the development of geometric abstract painting in America. The works of Barnett Newman and Ad Reinhardt would set the stage for the next two decades of geometric investigations.

The issue of Barnett Newman's possible inclusion in this exhibition has been a particularly sticky but intriguing problem. One of the largest and most heated ideological issues that Newman addressed was his relationship to the geometric tradition. Indeed, although Newman's works often depict powerful geometric forms, the artist made numerous attempts to distinguish his intentions from those of artists whose work was based on geometry. Those who knew him were well aware of his adamant feelings about being associated with American geometric painting, including the work of his fellow Abstract Expressionist Ad Reinhardt. Newman did not simply discuss this issue in casual conversation. He made explicit pronouncements on the subject.

The artist's widow has, as well, consistently discouraged and resisted any attempts to include Newman's paintings in such presentations, as she has done in the case of this exhibition. Knowing of Newman's philosophy, other lenders were equally reluctant. In light of all of these considerations, Newman's paintings are not included in this show. According to Mrs. Newman, the artist came close to allowing his works to be exhibited in the Whitney Museum of American Art's *Geometric Abstraction in America* held in 1962. This, for the most part, was based on Newman's friendship with the curator, John Gordon. In the end, however, Newman resisted the temptation, sending Gordon the following letter (copyright 1989 The Barnett Newman Foundation):

I have given the show you contemplate doing, "Geometric Abstraction," a great deal of thought since your last telephone call. I am moved by your invitation and by your interest in my work. You are the only one at the Whitney, in the many years that I have been on the scene, who has ever offered me an invitation to show and it is not easy for me to refuse you.

I realize the point you wish to make but I honestly cannot convince myself that by amalgamating me with those who do not represent it, that you can make the point about me.

To the extent that mine is, I believe, a new *kind* of painting, devoid of plastic dogmas and totally unrelated, if not antagonistic to theirs, the inclusion of my work with those others would, it seems to me, only confuse the issues. I did not come out of the world they advocate. To make me a part of

Opposite:
Installation views, *Cubism and Abstract Art,* The Museum of Modern Art, New York, March 2–April 19, 1936. Photograph courtesy The Museum of Modern Art, New York

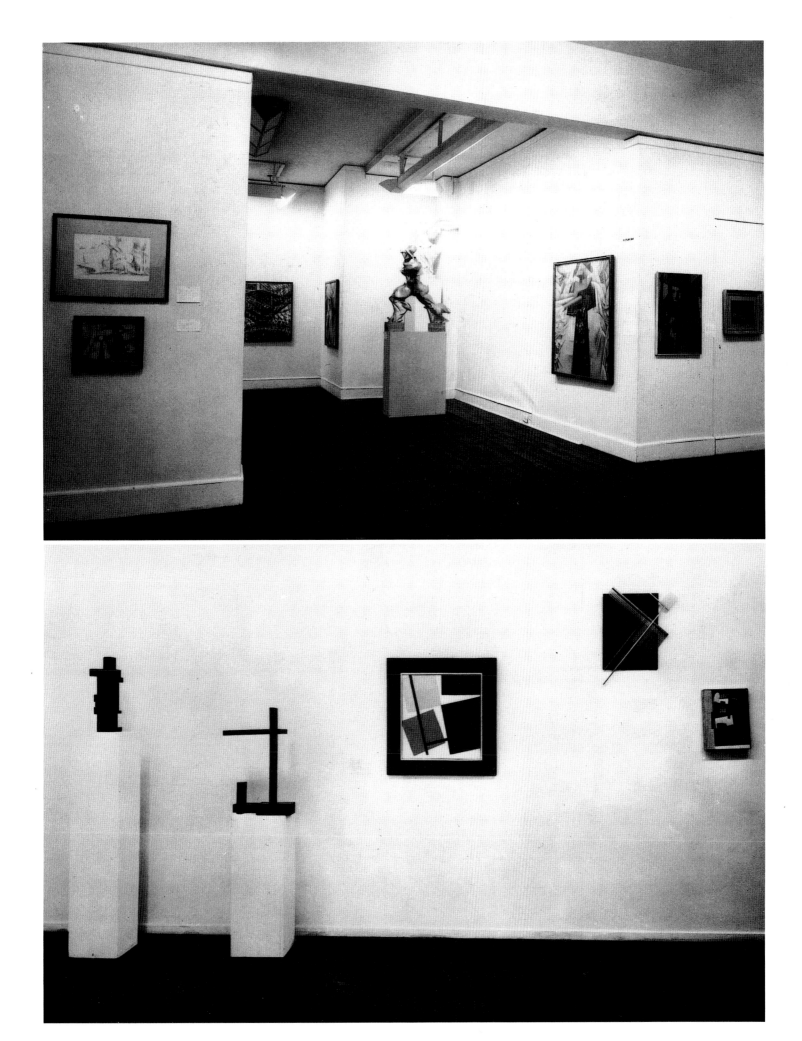

it or to present me as its culmination would only distort my work and my history. What is involved here are two separate realms. (I wish to avoid a discussion of quality.)

I am sorry, therefore, that I must decline your kind invitation. I hope that you will understand that I am acting on what are my convictions in the matter.[8]

Regardless of Newman's convictions, the number of artists represented in this exhibition who saw Newman's art as a model or inspiration is an affirmation of the importance of his work to this tradition. For that reason, Newman's art is discussed in the following pages. In different ways, Newman's and Reinhardt's presence in New York in the late 1950s and early 1960s in regard to geometric painting was essentially Socratic, with both artists questioning the very nature of geometry and abstraction.

The 1970s, seeing the emergence of highly conceptual and systemic approaches with unabashedly romantic tendencies, reflected one of the more eclectic periods in American art. The 1980s have witnessed a resurgence of geometric painting, the so-called Neo-Geo. This new breed of geometric painters understands abstraction less as a universal metaphor of a spiritual state than as an inherited cultural icon.

If, then, the forty-year period represented in this exhibition by such astute and challenging abstract painters as Ad Reinhardt, Frank Stella, Ellsworth Kelly, Robert Mangold, and, most recently, Peter Halley, among others, can be considered a tradition, then obviously the answer to our question of whether or not we have a definable geometric tradition is yes. Each of these artists employs a geometrically based imagery that represents American art at seminal points in its development. Indeed, based on the artists included in this presentation, one can say that geometric abstraction has played a critical role in virtually every avant-garde transition, from the early developments of the American Abstract Artists and the Abstract Expressionists to the Color Field painters, the Minimalists, and the "Neo-Geo" artists.

Defining this strategy in American art as a style, however, is quite another matter. As Barr noted in his seminal catalogue essay, there are significant linguistic problems in fixing on a theme or sensibility such as this.[9] As always, the most basic problem is that of description, the elusive and ponderous process of fitting pictures to words. The challenge remains to find a term that describes not only the given group of paintings, but also the collective attitude of the artists who made them. Barr was well aware of the impossibility of his task, one that would involve constant reinvention by future curators. Indeed, we continue to try to refine Barr's terms as we grapple with a body of American paintings that continues a vital tradition in twentieth-century abstraction. As Barr's earlier comments indicate, numerous words can be used to describe this tendency in modern painting; none of them is precise and many are often more contradictory than explanatory.

Not the least of the problems is the definition of the term abstraction. An unwieldy and imprecise designation, abstraction pivots in a number of directions and accommodates various types and degrees. There is an abstraction from nature based on distilling the natural world's essential elements. A more radical form of abstraction exists in what is often referred to as "nonobjective" painting, in which forms, shapes, and colors do not relate to nature but exist rather on their own as pure invention. To further confuse the issue, there is the philosophical notion that all art is abstract in the sense that there is the kind of abstraction we call "realism." Indeed, no matter how faithful a particular rendering may be, it is invariably abstracted in terms of the quantity of information, reduction of shape and color, and so on. For the purposes of this study what is important here is that the images appear abstract and self-contained, regardless of their sources. Ellsworth Kelly, for instance, has made seminal contributions to the development of geometric abstract painting, and yet many, if not all of his images come from an acute observation of nature.

As imprecise as the term abstraction is, the designation "geometric" presents similar problems. Among the terms Barr suggested—"classical," "intellectual," "structural"—"geometric" has become by far the most common adjective in referring to this strain of modern abstraction. As do most art historical labels, however, it tends to isolate something out of a larger context, setting it in relief in a way that is perhaps unnatural. Geometry is seldom, if ever, the subject of painting but rather a means to a variety of ends.

This exhibition and essay are by no means the first attempt to define this strain in American painting, and the rationales and terminologies have varied over a number of decades. Our inherited picture of the art contained here revolves around the concept and forms of "geometry," which the dictionary defines as "the mathematics . . . [of] measurement, properties and relationships of points, lines, angles, surfaces, and solids.[10] As noted earlier, Barr focused on this term to distinguish this strain of twentieth-century abstraction from the expressionist branch. The term offers a straightforward, if by no means perfect description of this imagery. Historically, however, the artists and their theorists (including Barr) have found the term ambiguous and less than provocative.

In a number of instances, the more regal and historically loaded term "classic" or "classicism" has been substituted. The notion of a classicized abstract form in the twentieth century—the heritage of Greek simplicity and essential form in totally nonobjective terms—is indeed tempting. In 1953, the Walker Art Center presented the exhibition *The Classic Tradition in Contemporary Art*. The accompanying catalogue described the presentation as an attempt to redefine "the geometric tradition," which the author, H. H. Arnason, described as "a term which has never made me very happy, so I have substituted the much older and broader term. . . . Classic, in our usage, pertains to the phase of contemporary art which is based on a sound system of structural and generally geometric drawing."[11] The focus of the Walker exhibition was surprisingly broad—it included painting and sculpture as well as abstract and representational works—and while much of the imagery did involve forms of geometry, the presentation also encompassed the biomorphic and expressionistic, including works by Miró, Marin, Tomlin, and others. In this case, it appears that the breadth and ambiguity of the term classicism hindered, rather than helped, the focus of the presentation.

In 1959, the California critic Jules Langsner used essentially the same terminology to present a more concise exhibition, but with similar theoretical fuzziness. *Four Abstract Classicists* presented the work of four California painters—Karl Benjamin, Lorser Feitelson, Frederick Hammersley, and John McLaughlin—whose imagery was decidedly geometric. Langsner admitted to the British critic Lawrence Alloway in 1958 that he intended his term to refer to all geometric abstract art, not just the four abstractionists in his exhibition, and chose "classicist" because geometry seemed too ambiguous.[12] In his essay for the accompanying catalogue, Langsner aligned the California painters with "the pictures of Malevitch and Mondrian . . . an art of flat geometric shapes that is not fixed and stabile."[13] The author's definition of classicist settled on the notion of a preoccupation with form:

The impulse to Classicism is marked by concern with the element of form in a work of art. The classicist might be described as a form-conscious artist. It is indeed true that form participates (in one degree or another) in most works of art. However, form as a primary force in esthetic experience is stressed in classical art. . . . Form in classical art is articulated in an orderly relation to every other form in the same work. That is to say, forms are structured in accordance with some unifying concept or organizational plan. Moreover the unifying concept in a classical work is not simply an invisible skeleton supporting forms that otherwise might fall apart. The relation of form to form—the construction of the work—constitutes a raison d'être in itself. Our pleasure, our satisfaction, in response to a classical work of art derives in no small degree from awareness of the work's configuration, from the clarity and coherence of its structure.[14]

In trading the problems of defining geometry for those that defined classicism, Arnason and Langsner faced an even larger challenge. Although the history of art remains dense with references to classicism, there is in fact no consensus about its definition when applied to the visual arts. [15]

Langsner's essay was perhaps most notable for introducing the rubric "hard edge" painting, a term that has become almost a staple in describing the geometric strain in American painting. Alloway appropriated Langsner's term but used it a year later for very different reasons, sidestepping its connection to earlier European painters in the geometric abstract mode as well as underplaying if not denying the sense of form that Langsner had identified. In Alloway's article "On the Edge," he used the term hard edge "to refer to the new development which combined economy of form and neatness of surface with fullness of color, without continually raising memories of earlier geometric art. It was a way of stressing the holistic properties of both the big asymmetrical shapes of [Leon Polk] Smith and [Ellsworth] Kelly and the symmetrical layouts of [Alexander] Liberman and [Agnes] Martin." [16] Alloway's article specifically addressed the new tendencies in geometric abstract art in the United States since 1945, obviously utilizing the term hard edge to drive a theoretical wedge between the new art and what he thought of as traditional geometric abstraction. He separated the two tendencies in the following way:

The "cone, cylinder, and sphere" of Cézanne-fame have persisted in much 20th century painting. Even where these forms are not purely represented, abstract artists have tended toward a compilation of separable elements. Form has been treated as discrete entities [whereas] forms are few in hard-edge and the surface immaculate. . . . The whole picture becomes the unit; forms extend the length of the painting or are restricted to two or three tones. The result of this sparseness is that the spatial effect of figures on a field is avoided. [17]

Alloway's text was important in its identification of a new generation of painters who were combining the frontal and holistic qualities of Abstract Expressionist Field painting (particularly that of Rothko, Pollock, and Newman) with the formal vocabulary of geometry. Unfortunately, the term hard edge was not necessarily appropriate for all the work he was describing. Ellsworth Kelly and Agnes Martin, two artists singled out in Alloway's article, do not see their work relating to the term. Kelly has flatly said, "I'm not interested in hard edge painting. I'm interested in form and mass." [18] Martin remarked recently, "I don't think about hard edges. I'm not sure my edges are that hard. I suppose the image is basically geometric or planar but that still doesn't get to the content." [19]

In 1962, the Whitney Museum of American Art returned to the basic notion of geometry as a common denominator. In the catalogue for the exhibition *Geometric Abstraction in America*, John Gordon proposed a bare-bones definition:

Geometric Abstraction, in our discussion here, is used to describe purely abstract painting and sculpture which is chiefly concerned with the square, the rectangle, the triangle, the circle and geometric volumes such as the cube, cone, etc. The forms do not usually relate to subject matter. They are often arranged architecturally and suggest geometry. Primary colors are frequently used. Aesthetic aims are often deeply involved with a search for ultimate reality, understanding of nature, psychic intuition, etc. [20]

In an exhibition at The Museum of Modern Art in 1975, which addressed geometric abstract art, both European and American, from the early part of the century to the date of the exhibition, the term geometric is again utilized but qualified by the phrase "Contrasts of Form." The evocative catalogue essay described this form of abstraction in a manner similar to Langsner's sense of "classical form." The catalogue states:

We have adapted the title of this publication and exhibition from that of a major group of Léger's paintings: not to give Léger himself special prominence here, but in order to stress the fact that a

Opposite:
Installation views, *Geometric Abstraction in America*, Whitney Museum of American Art, New York, March 20–May 13, 1962. Photograph by Geoffrey Clements, Staten Island, New York

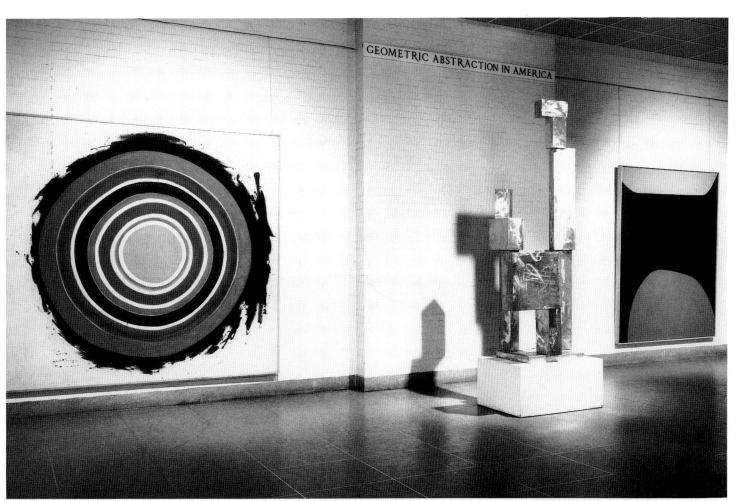

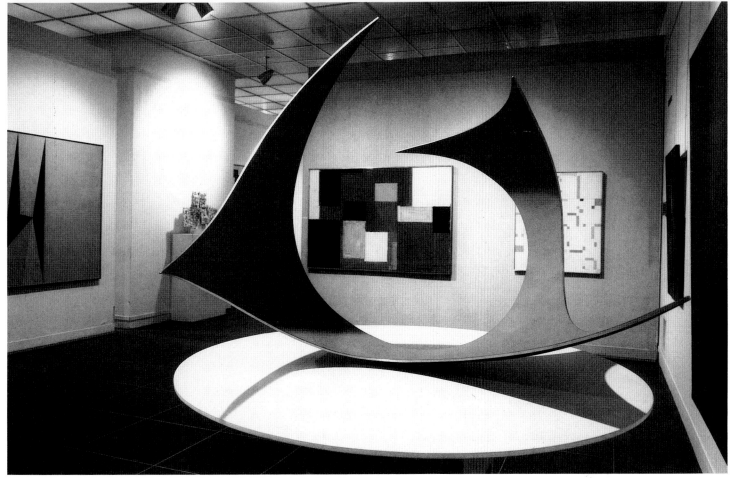

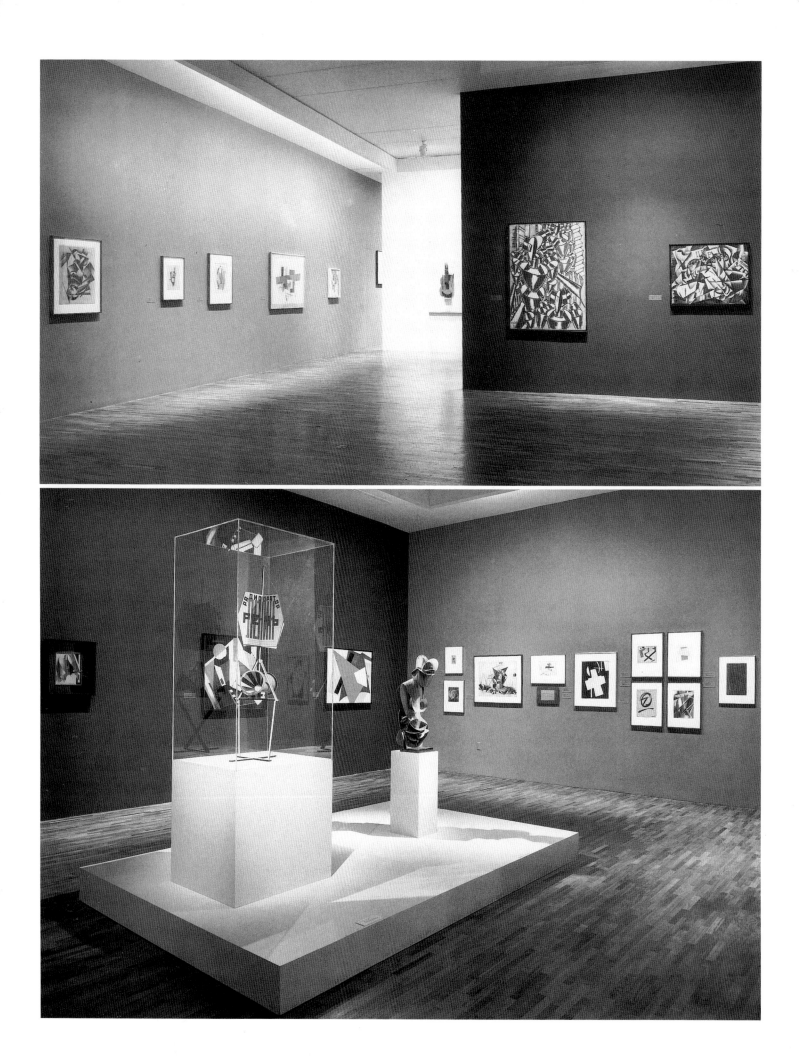

preoccupation with form, in contrasting ways, links the artists represented. This is not to suggest, however, that form, as such, is the ultimate preoccupation of every artist here (nor, of course, that a preoccupation with form is the prerogative only of abstract artists). Indeed, I venture to assume that form, as such, is not the ultimate concern of any of the artists here: "content" presumably is. But form, for almost all of them, is the means through which content is discovered. Not all of them find inspiration purely in form—for many of them, especially in the earlier periods, form was a surrogate for often very specifically definable subject-matter. But nearly all do find in the searching, inventive manipulation of geometric abstract forms a way of generating aesthetic meaning. (The exceptions are the few geometric-realist artists included, for whom representation, as well as their departure from it, fulfills that function.)[21]

And here, we offer yet numerous other turns of phrase. *Fields, Planes, Systems: Geometric Abstract Painting in America Since 1945,* like all the aforementioned labels, is what one might call an educated compromise. The title developed out of numerous discussions with many of the represented artists; from those conversations, a remarkable range of terms surfaced. The term geometry was universally disparaged as being too ambiguous and as being either too pedestrian or too scientific or mathematical in connotation. The term is retained here in the subtitle because it relates to Barr's original distinction and to this author's belief that Barr's designation—although by no means perfect—describes this strain of abstraction in a basic structural sense.

The term "field" was originally suggested by Clement Greenberg to describe the expansive character of certain Abstract Expressionist paintings.[22] Conceivably Reinhardt and Newman fit under this designation. More recent artists have reaffirmed Charmion von Wiegand's description: "The home of abstract art is in the two-dimensional surface, *the plane.*"[23] Kelly noted recently, "The problem with this type of art is not one of edge, line or geometry in a strict sense. If it can be described at all—and I think of Newman, myself, Stella, a lot of us—it's planar: large, flat, holistic planes."[24] Gene Davis has remarked, "Hard edge is too relative a term, geometry too confining. In postwar art, what you're looking at is an aggressive, symmetrical planarity. I like planarity better than Greenberg's term "field."[25]

Agnes Martin and Brice Marden, whose works project an evocative, romantic relation to nature, similarly see their work in planar terms. Martin has written, "When I draw horizontals you see this big plane and you have certain feelings."[26] Brice Marden wrote in 1973:

I paint paintings made up of one, two or three panels. I work from panel to panel. I will paint on one until I arrive at a color that holds that plane. I move to another panel and paint until something is holding that plane that also interestingly relates to the other panels. I work the third, searching for a color value that pulls the planes together into a plane that has aesthetic meaning. This process is not as simple as explained.[27]

These remarks essentially delineate the central distinguishing characteristic between early twentieth-century abstraction and postwar American painting: the consolidation of hierarchies or relational forms, in which various shapes are counter-balanced across the surface of a picture through size and color, into large nonrelational fields, the main characteristic of which is symmetry or unmodulated monochrome. These fields are, in a very direct sense, planar. Planar, derived from the Latin *planus,* essentially means flat, yet it can refer to the frontal, almost emblematic quality of much postwar American abstraction.

For Peter Halley, whose recent geometric paintings have posed new critical problems within the tradition of abstraction, we encounter planes of a kind of hyper-reality that is elegantly iconic and, in light of the artist's numerous writings, socially pointed.

Robert Mangold, David Novros, and Dorothea Rockburne have been described as "systemic" painters; each employs a system or structure that evokes a particular fascina-

Opposite:
Installation views, *Contrasts of Form: Geometric Abstract Art 1910–1980,* The Museum of Modern Art, New York, October 2, 1985–January 7, 1986. Photograph courtesy The Museum of Modern Art, New York

tion with architecture or mathematics. Mangold has said, "I realize that I use geometry, but frankly I'm not aware of it as geometry per se. For me, it's about structures or invented systems. The structural support of a painting, like architecture, is inherently geometric. I like to explore ways of complicating that structure."[28] Similarly, Novros has talked of making paintings that "relate to architectural systems" but are "not subsumed by them."[29] Rockburne's paintings derive from a system that relates to the artist's fascination with the balanced perfection of the Golden Section.

Fields, planes, systems: although as inexact as their predecessors, these terms are used here to add yet more descriptive elements to our lexicon of abstraction, and in the spirit that it will allow this aspect of abstraction room to breathe, and to expand and contract its parameters as imagery becomes re-formed with individual inventions. Perhaps, more importantly, we use them here with a healthy skepticism. Indeed, to attempt to speak with precision about beliefs and practices common to the artists in this exhibition is to invite some confusion. This becomes quickly apparent in scanning the artists' statements included herein. The generational spread of this exhibition ensures that the work derives from different sources. We have assembled these statements in the belief that artists should have the opportunity to speak for themselves, bringing the reader into closer contact with the concerns, ambiguities, and anxieties that accompany the artmaking process. At the same time, these statements should be taken only as a kind of insight into the artists' vision. In the end, what remains impressive about these paintings is their sheer visual power.

ESTABLISHING POSITION: EARLY AMERICAN ABSTRACTION

America was slow to develop a tradition of abstract art. The more esoteric qualities of pure abstraction came to us, a country of realists and pragmatists, in a tentative series of advances and retreats. An initial and well-known moment of passage occurred with the Armory show of 1913, which contrasted the coarse, urban scene realism of the American Ashcan School with the more experimental works of the Cubists, Fauvists, and a range of abstract and figurative expressionists. The Armory show touched off a prolonged debate on the state of American art, which to a small group of progressive Americans appeared dry and stilted in its incessant attraction to tangible landscapes and objects, and on the validity of a modernism rapidly evolving into radical areas of pure abstraction.

In the early part of the century, a number of American painters attempted to reconcile this native tendency toward realism and direct observation with the more searching and experimental developments into abstraction suggested by the European avant-garde. An important early result of this reconciliation was the cubistic realism of the Precisionists Charles Demuth, Charles Sheeler, and Joseph Stella, on the one hand, and the figurative expressionist works of John Marin, Marsden Hartley, Georgia O'Keeffe, and Max Weber, on the other.

The late 1920s and the 1930s, however, gave rise to the naturalistic realism and socio-political content of the American Scene painters, such as Thomas Hart Benton, John Steuart Curry, Grant Wood, Reginald Marsh, and Raphael Soyer. Such artists recoiled from what was seen as the purely intellectual proposition of abstraction that, by this time, was in an advanced state in Europe, through Picasso's and Braque's Cubism, the radical simplification of form through the inventions of Fernand Léger, Jean Arp, and Constantin Brancusi, and the potently austere abstractions of Mondrian and the de Stijl artists. These rapidly evolving events placed Paris at the theoretical hub of a developing international avant-garde, attracting a cadre of curious and impatient American artists. Patrick Henry Bruce, Charles Biederman, Burgoyne Diller, Harry Holtzman, Carl Holty, Theodore Roszak, Isamu Noguchi, Stuart Davis, John Ferren, A. E. Gallatin, and George L. K. Morris all spent time in Europe, particularly Paris, during the 1920s and 1930s. It was

through these individuals that the possibility of an American school of abstraction would eventually develop.

Early on in this development, a sensibility informed by classicism and an appreciation of elementary forms and geometric structures would play a central role. The Paris-based group Abstraction-Création, established in 1931, was a rallying point for a wide range of artists, both European and American, who were developing the more rational and classical side of abstraction through various forms of geometry. Through their publication *Abstraction, création, art non-figuratif,* the group established an important dialogue between the European avant-garde and what was essentially the first generation of American abstractionists. The young French painter Jean Hélion, who was the publication's first editor, attracted a circle of artists that included Americans Holty, Ferren, Gallatin, and Morris.

The wealthy Gallatin became one of New York's most prominent collectors of contemporary European and American art. Gallatin's collection was especially significant because of its high quality and the fact that he made it available to the public with the opening of his Gallery of Living Art at New York University in 1927. The Gallery of Living Art played a critical role in the education of American artists between the late 1920s and the early 1940s, but it was an education with a particular slant. Gallatin's collection presented a view of history that placed various forms of geometric abstraction at the apex of modernism, highlighted by major examples of Cubists, the Constructivists, and the de Stijl group. There is little doubt that Gallatin also imagined a continuing evolution of these great breakthroughs through his own geometric abstractions as well as those of his American colleagues. Even a very young Willem de Kooning, known today as one of the twentieth century's great expressionists, was enticed by Gallatin's presentations. De Kooning recalls: "I went so many times. I remember a Mondrian, and also the French artist Hélion. When I met Gorky he used to go there often. It was so easy to walk in and walk out again, no charge, it was so nice."[30] Gallatin's collection did much to focus a developing American avant-garde on the pure, elementary aspects of abstraction, affecting the early development of Charles Biederman, Ilya Bolotowsky, Byron Browne, Burgoyne Diller, Arshile Gorky, John Graham, Balcomb Greene, Gertrude Greene, Philip Guston, Carl Holty, Harry Holtzman, Alice Mason, George L. K. Morris, Ad Reinhardt, Charles Shaw, and David Smith.[31]

The opening of New York's Museum of Modern Art in 1929 established another phase of transition. For American abstract painters, however, it was an event of mixed blessings. Under the directorship of Alfred H. Barr, Jr., the museum established a highly energetic and ambitious program of exhibitions and acquisitions. A remarkable collection that surveyed early twentieth-century art with precise and dynamic examples was amassed in a relatively short period of time. Such a presentation could not help but raise the level of sophistication of artists and laymen alike. Indeed, a museum of this caliber signaled the coming of age of American modernism.

The bitter pill that a developing American avant-garde had to swallow was that American abstract art did not play a role in Barr's historical scheme. While Gallatin's Gallery of Living Art was formed to nurture the fertile future of abstract art in the United States through the continuous exposure of important examples of early twentieth-century European abstraction, Barr's approach drove a theoretical wedge between the Europeans and the Americans. In Barr's view, if one could speak of a tradition of American art at that point, it was a tradition of representational painting. As such, Barr's tendency in his exhibitions and acquisitions was to focus on this aspect of American art at the expense of the American abstractionists. Ilya Bolotowsky saw it as essentially an adversarial relationship. According to the artist, "The Modern Museum at that time was against abstraction for American art. Barr felt it was a foreign development."[32]

This attitude was clearly reflected in one of Barr's most celebrated exhibitions, *Cubism and Abstract Art.* Using Cubism as a seminal point of development, as had Gallatin, Barr

presented a concise bipolar evolution that traced developments in geometric painting through Cubism, Russian Constructivism, and Mondrian's Neoplasticism, on one hand, and on the other an expressionist strain that included Kandinsky, the German Expressionists, and the Surrealists. No contemporary American abstract painters were included. [33]

American abstract artists were caught between the proverbial rock and hard spot. They were criticized for turning their backs on the social and economic problems of the time in a depression-worn atmosphere that held the virtues of realism and the American scene far above what was seen as the esoteric vagaries of abstraction. On the other hand, the one institution that seemed to understand the importance of the development of abstraction to twentieth-century art did not acknowledge their import or even their presence. Remarks in Barr's catalogue added further salt to their wounds. While Gallatin and his American colleagues saw various forms of geometric painting as the path to the future and as an inspired extension of the tradition established by Cubism and Neoplasticism, Barr—in an apparent contradiction of his oblique dedication in the early pages of the catalogue to "the painters of circles and squares"—concluded his essay by noting that "it seems fairly clear that the geometric tradition in abstract art . . . is in the decline . . . the formal tradition of Gauguin, Fauvism, and Expressionism will probably dominate for some time to come the tradition of Cézanne and Cubism." [34] Barr's perspective was both European and current. By the late 1920s, the Paris-based Surrealists had indeed established a new figurative and literary phase for modern painting, one that would have an important impact on succeeding generations of Europeans and Americans. Thus the conclusion of Barr's essay reflected the most current changes in the dialectic between figurative expressionism and geometric abstraction.

The same year, and in apparent response to Barr's exhibition, Gallatin organized *Five Contemporary American Concretionists: Biederman, Calder, Ferren, Morris and Shaw* at the Reinhardt Galleries in New York, showcasing American abstractionists whose works were dominantly geometric. The timing and message of Gallatin's show was not lost on Barr. In the final footnote of his catalogue he wrote, "As this volume goes to press, an exhibition of five young American abstract painters opens in New York." A movement of American geometric abstraction was acknowledged but recognized only as a footnote in history.

The 1930s and 1940s, then, witnessed a lively debate about which path American art should follow. Participants in this debate included established American Scene painters, budding Surrealists whose works gravitated to the biomorphic aspects of abstraction, and American abstract artists in the geometric tradition. The most vociferous element was undoubtedly the more politically oriented Regionalist and Social Realist painters. The 1930s were marked at home by a barrage of economic and political upheavals, most significantly the stock market crash of 1929 and the resulting Great Depression, and abroad by Hitler's rise to power and the eventual outbreak of World War II. The decade saw an intense climate in which many artists felt a need either to address political issues directly or to reassure a tense populace through their art. Thomas Hart Benton, Grant Wood, and John Steuart Curry, often described as Regionalists, rejected abstraction for a narrative figuration that extolled American's agrarian past. Social Realists such as William Gropper and Ben Shahn also addressed narrative figuration, but used it to depict the condition of poor and working class people suffering under the conditions of a capitalist system gone awry.

In December 1933, President Franklin Delano Roosevelt established the Public Works of Art Project, which eventually became the Federal Art Project under the auspices of the Works Progress Administration. The WPA recognized not only the financial plight of artists but also their importance in helping to build a new vision for Americans. As one would expect of a government bureaucracy, the administration of the WPA was conservative on matters of art, leaning toward representational painting that could be easily understood by a broad public.

Within the conservative aesthetic of the WPA, however, geometric abstract painting found an ardent supporter in Burgoyne Diller, who had been appointed to supervise the Mural Division of the project. A highly respected painter who had studied with Hans Hofmann and at the Art Students League, Diller was a serious student of Constructivism and Neoplasticism. Diller is generally considered to be the first American painter to be influenced by and to promote the Neoplastic principles of Mondrian. As early as 1934, he painted a group of works entitled "Geometric Composition" that utilized the rectilinear grids and solid color planes of Mondrian. In a milieu of Regionalist and Social Realist painting, Diller's geometric abstractions remain among the earliest investigations into this radical new abstraction in America.

After 1945, Diller moved to a large studio in Atlantic Highlands, New Jersey, where he developed an extended series of works based on three themes. Diller's journals refer to the first theme as compositions formed by "Free Elements," that is, geometric forms isolated on a monochromatic ground. The second theme consisted of works based on an "element generated by a continuous line," that is, solid rectangles of color anchored into a linear grid across the surface of the canvas. The artist's third theme was an homage to Mondrian, whose famous "Boogie Woogie" paintings inspired Diller to create images based on the syncopated dynamics of numerous colored rectangles of primary colors balanced across the surface of the picture.[35]

It can be argued, however, that Diller's greatest contribution was not as a painter but in his role as head of the Mural Division in the New York City section of the WPA. Under Diller's supervision, the Mural Division became the most progressive component of the WPA Federal Art Project. Diller facilitated the creation of works by Ilya Bolotowsky, Byron Browne, Stuart Davis, Arshile Gorky, Balcomb Greene, Harry Holtzman, Willem de Kooning, Lee Krasner, Ibram Lassaw, George McNeil, Jan Mantulka, Irene Rice Pereira, Ad Reinhardt, and David Smith, among others. Certainly not all these artists were entranced by geometry—or even abstraction for that matter. Nonetheless, many of them shared Diller's vision of the progressive possibilities and strategies associated with geometric abstraction. Thus, the artists who had rallied around Gallatin's Museum of Living Art found a supportive haven for their visions of a conceptual and formal clarity through geometric painting under Diller's program. Ilya Bolotowsky would later comment:

This was the beginning of something new. And I don't think people realize that at that time Diller was instrumental in something historical. . . . He played a most important role in the development of abstract art in this country as mural project administrator even giving up his own painting for quite a while. And yet he was painting Neo-Plastic paintings as early as 1934. He was totally dedicated to promoting abstract style in murals before abstract art was accepted in the U.S. He deserves absolute credit for his work in all the future art history books.[36]

As has been recorded in numerous studies, the WPA was profoundly important in bringing the American avant-garde together for social and professional exchange. The dialogues and working relationships established in those projects set the stage for the possibility of a professional organization that would foster and support new American abstraction.

The WPA stimulated the formation of the American Abstract Artists group, which was founded in 1937. Following a year or so of heated debates, theatrical posturing on the part of prospective members, and creative speculations on the criteria for membership, an essentially tolerant and diverse group involved in various forms of abstraction— biomorphic, geometric, and cubistic—came together. One of the salient issues addressed by this group focused on the differences and values between those who based their art on observation of the natural world and then abstracted from those perceptions, and those who maintained that true abstract art could not be referential but had to be the exclusive product of invented forms. The latter was referred to as non-objective painting

and most commonly involved various forms of geometric abstraction, geometry being thought of as one of Western civilization's most profoundly abstract inventions. Like Diller, these artists explored the radical notion, pioneered by the Europeans, particularly Malevich and Mondrian, that color, form, and shape have a life or "reality" of their own, separate from objective reality.

For a number of the artists associated with the AAA, this was a highly speculative, if not suspect assumption. One of the most respected elder statesmen of the period, Stuart Davis, fully understood the importance of Cubism and, like the Precisionists, had ambitions to adapt it to his own environment. Unlike the American Scene painters, Davis was enthralled with the abstract, geometric character of the modern American landscape. The images in his paintings tended to alternate between forms he saw in his environment and those he invented. As Davis himself said:

What is abstract art? . . . Art is not and never was a mirror reflection of nature. . . . Art is an understanding and interpretation of nature in various media. Therefore in our efforts to express our understanding of nature we will always bear in mind the limitations of our medium of expression. Our pictures will be expressions which are parallel to nature and parallel lines never meet. We will never try to copy the uncopiable but will seek to establish a material tangibility in our medium which will be a permanent record of an idea or emotion inspired by nature.[37]

Although until recently little acknowledged as an influence on American painting, Davis's work was clearly a pivotal and diplomatic transition from American Scene subject matter to the future development of American abstraction from European models. One of Davis's unique contributions was in the area of color. Davis rejected the subdued tonalities of Cubism for a more experimental and excited palette, one which often involved dynamic pastels and aggressive primaries. The idiosyncratic and personal character of Davis's color would foretell the similar sense of color experimentation among younger geometric abstractionists.

Eventually, the geometric abstract faction of the AAA came to influence a number of agendas that developed. Ilya Bolotowsky, who along with Diller was a founding member of the American Abstract Artists group, developed an inventive variation on Neoplasticism that centered on the use of shaped canvases. Born in St. Petersburg, Russia, in 1907, Bolotowsky settled with his family in New York in 1923. He studied at the National Academy of Design from 1924 to 1930 and subsequently was employed by Diller on the WPA project. Indeed, Bolotowsky painted some of the most ambitious abstract murals associated with the project.

Bolotowsky's first nonrepresentational paintings, done in the mid-1930s, indicate an early appreciation of Malevich's austere planar compositions. Bolotowsky employed starkly outlined planes made of sharp diagonals, establishing a highly energized multidirectional space. This vocabulary quickly evolved into various families of abstract forms—some playful biomorphic shapes and others, the more severe geometric planes of the earlier work—on a single ground.

In the 1940s, Bolotowsky gradually eliminated the diagonal line as well as the Surrealist and biomorphic elements from his paintings; he began to address instead the Neoplastic principles of Mondrian, which renounced the diagonal line for the forty-five-degree angle. At the same time, Bolotowsky imposed a number of variations on Mondrian's strict set of principles. While both van Doesberg and Mondrian had worked with shaped canvases, Bolotowsky extended this idea to include explorations of the diamond, oval, and tondo formats. In 1947, the artist produced his first diamond format picture. Much later he recalled the formal issues involved in such a move:

A diamond format is obviously a square standing on one corner. The feeling of space, however, is much greater in a diamond area than in a square area of the same size. This is so because the

Opposite:
Ilya Bolotowsky preparing for the opening of the Mural Show at the Federal Art Gallery, 225 West 57th Street, New York, May 24, 1938.
Photographic Division, Federal Art Project W.P.A. Photograph by Mipaas. © Smithsonian Institution, Washington, D.C.

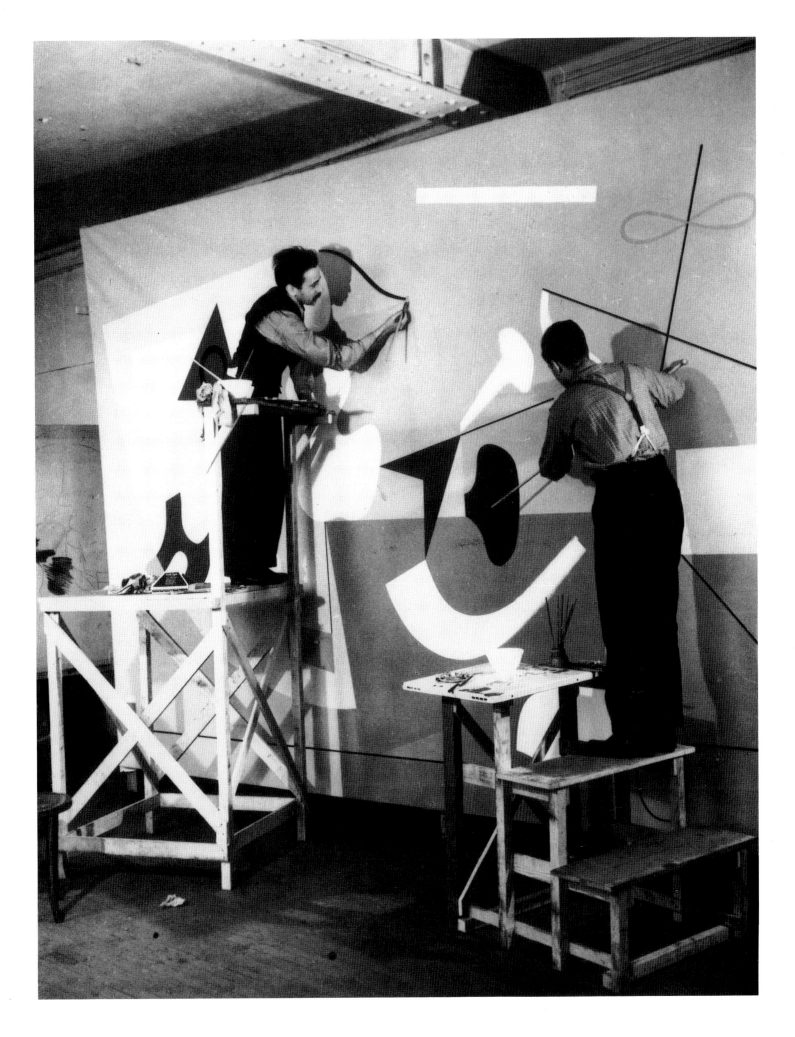

vertical and horizontal measurements of such a diamond are larger than those of the square of the same size. One may object that vertical-horizontal *Neoplastic* painting on a diamond canvas creates triangular shapes. I do not think that this objection is important. Is it because the rectilinear "tensions" are more important than the resulting triangles? For whatever reason, the viewer's eye seems to extend the triangles beyond the painting, without undermining the diamond format. The effect is still that of a rectangular relationship.[38]

In the early 1950s while teaching in Wyoming, Bolotowsky was given several wagon wheels as a gift from a nearby rancher. By removing the spokes, he used the wheels as stretchers for his first tondo. The curved shape offered the artist special visual problems and advantages in his quest to establish a personal idiom within the Neoplastic tradition:

A straight line or a straight edge of a color plane running across a tondo seems to be curving away from the edge of the tondo. As we look at the tondo with more concentration, the line appears straight again. As our eyes travel around a tondo painting, the straight edge again seems to be pushing away from the edge of the tondo. This effect may be either obvious or subtle, depending on the position of the edge or line in the tondo. I consider that this effect is useful in creating a feeling of a line or an edge under strong tension, like a bowstring. The effect in an ellipse is similar to the one in a tondo. This bowstring effect does not exist in Neoplastic paintings of a rectangular format.[39]

In his later works Bolotowsky also veered away from Mondrian's principle of adhering only to primary colors. Bolotowsky used a wide range of color for expressive effects; it has been suggested that the jewel-like color of Russian icons, which the artist experienced as a youth, influenced his interest in especially vibrant tonalities.[40]

Fritz Glarner, another member of the AAA, as well as of its precursor, the French Abstraction-Création group, also was an inspired follower of Mondrian. Having studied Mondrian's work and theories assiduously—he once remarked of the Dutch painter, "He was my friend . . . and he was my master"[41]—Glarner, as had Bolotowsky and Diller, addressed the challenge of developing a Neoplastic style particular to his own needs, which were "to bring about a purer and closer interrelationship between form and space."[42] In the early 1940s, Glarner noted that lines that do not overlap, but begin on one edge of the canvas and stop abruptly before reaching the other side, established a more dynamic integration between the foreground planes and the background space. According to Glarner, Mondrian came to see one of these early breakthrough pictures, *Peinture relative.* "He was especially interested in the stopping of the black horizontals. He felt that the dynamic relationship of these horizontals increased the sense of space of the composition."[43]

It was not until Mondrian's death in 1944, however, that Glarner came to his mature style. In the late 1940s, Glarner began the extended series he referred to as "Relational Paintings." In such works, the background and foreground merge through the dense coupling of a field of two-part rectangular forms, each form composed of a large area of color attached to a sliver-like form. The common edge of these companion forms slants at approximately a fifteen-degree angle. Like Mondrian's de Stijl colleague Théo van Doesberg, Glarner deviated from Mondrian's incessant right angle. Ironically, while breaking away from the pure space of Mondrian's geometry, Glarner's comparatively rambunctious abstractions owe a debt to the Dutch artist's late, dynamic "Boogie Woogie" works, and perhaps, as well, to Glarner's fascination with the crystalline qualities of stained glass cathedral windows.[44]

Another of Mondrian's closest admirers in the AAA was Charmion von Wiegand. Born in Chicago in 1900, von Wiegand spent her childhood in Arizona and California. Von Wiegand's father, Karl H. von Wiegand, was a correspondent on international affairs, and she spent portions of her childhood traveling in Europe. Describing her schooling as "a Humanist education, no degree,"[45] von Wiegand attended public school in San

Francisco, private schools in Europe, and Barnard College for one year before she enrolled in the Columbia University School of Journalism.[46]

Like her father, von Wiegand began her career as a writer. She first met Mondrian in 1941, when she was assigned to write about him for *The Journal of Aesthetics and Art Criticism*, the first article on Mondrian to be published in America.[47] She was curious but skeptical, and her reminiscences of that first visit have become legendary. Von Wiegand remembered the artist's studio as having no furniture: "only an easel and a drawing board . . . everything was spotless white like a laboratory."[48]

Von Wiegand maintained a friendship with Mondrian until his death in 1944. Prior to becoming closely involved with his art and theories, she had, since 1929, been painting figuratively, influenced by Derain, among other European modernists. It was through her relationship with Mondrian's work that she turned her energies to planar abstraction; however, her art did not become strictly focused on geometry and color until 1946.

Von Wiegand's early abstractions reflect the influence of Mondrian's late "Boogie Woogie" paintings, involving compositions of balanced squares of primary colors. It is mainly in the area of color, however, that von Wiegand eventually distinguished herself from Mondrian. While Mondrian adhered to primary colors, von Wiegand treated color in a far more varied and intuitive way, deriving her choices from a number of sources. An important early experience for the artist occurred in 1926, when she was undergoing psychoanalysis: "Under therapy, I got colors I had seen in Chinatown as a child in San Francisco. I remembered the confetti (pink and green) and the red dragons and firecrackers: also, our Chinese cook's advice to 'paint, no look,' when I sat in the garden to paint the apple tree."[49]

Like Mondrian, she was inspired by theosophy, and particularly by Madame Blavatsky's *The Secret Doctrine*, 1888, a text that was also read by Kandinsky and Mondrian. Not surprisingly, Blavatsky's writings explored the emotional and symbolic values of color. Von Wiegand's interests, however, widened to include Tibetan painting, Mandala imagery, and architectural floor plans of Asian temples, all of which inspired compositions. In a number of works, such as *The Wheel of the Seasons*, 1957, von Wiegand based the geometry and color on the *I Ching*; from these Chinese writings she derived a format in which color moves the viewer's eye in a circular fashion. Von Wiegand invariably used geometry and theory in an intuitive way, bringing together what the artist called "a play of opposition between Western geometric structure and Eastern color gamut."[50]

These artists all perceived the rational and classically inspired forms of geometry to be the future of American art. Indeed, as early as the late 1930s, the AAA was a bastion of geometric abstraction, a development that did not go unnoticed. In response to a 1939 exhibition of AAA artists, *New Yorker* critic Robert Coates registered his complaint at this situation:

It's the mood of the show, the tendencies it illustrates, that bothered me. With few exceptions, the trend of the group is toward the purest of "pure" abstraction, in which all recognizable symbols are abandoned in favor of strict geometric form. It seems to be a move in the wrong direction; indeed, it is precisely in the development of symbols, and the exploration of their capacity to express emotion, that the true field of abstract painting lies.[51]

Such criticism was leveled as well against the supportive presence in New York of European artists who had immigrated to the United States, artists who fully understood and defended the attraction to mechanical or geometric forms. Among them were Josef Albers, Fernand Léger, and László Moholy-Nagy. Albers was a particularly critical though subtle force in American abstraction beginning in the mid-1930s. A respected teacher and veteran of the European avant-garde, Albers offered a philosophical counterpart to the expressionist Hans Hofmann, often regarded as the patriarch of

Abstract Expressionism in the 1940s and 1950s. As both a student and an instructor at the Bauhaus from 1920 to 1933, Albers opted for an abstraction both decidedly geometric and antigestural, and of severe precision.

Albers and his wife, Anni (who achieved acclaim for her textiles and graphics), left Germany in 1933, when the Nazis forced the closing of the Bauhaus, and came to teach at Black Mountain College, North Carolina; he would hold that position until 1949. The first member of the Bauhaus faculty to teach in the United States, Albers introduced its concepts of design and painting to several generations of American students. Albers gained a reputation as an influential lecturer and teacher and committed himself to a number of lectureships and teaching posts throughout the country. Most notable were his seminars at the Graduate School of Design, Harvard University, between 1936 and 1941. In 1951, Albers was a visiting critic at the Yale University Art School; he subsequently was appointed head of the Department of Design there. Throughout the 1950s and 1960s, he also served as a visiting professor at some sixteen universities in North and South America and at Max Bill's Städtische Hochschule für Gestaltung in Ulm, West Germany. Albers was almost as prolific a writer as he was a teacher and painter, publishing in 1963 his well-known opus *Interaction of Color,* a text that has since been reissued in eight languages. By the time Albers finally stopped teaching at Yale in 1960, two years after his "retirement," he had influenced the lives and careers of generations of American artists.

Albers's role as teacher has to some extent obscured his achievements as a painter of rigorously austere, at times transcendental abstractions. Albers's art evolved toward an increasing preoccupation with the laws of color, juxtaposing various colors in simple geometric configurations and demonstrating how color could perform various illusions of hue, space, and form. Albers extended the Bauhaus ideal of reductive geometry and formal simplicity to a radical point. He sought a life and a format of working stripped of all excesses, an image pared down to the barest, purest essentials, and followed this ascetic path with almost religious conviction, spending the last twenty-six years of his life principally painting differently colored squares.

Albers initiated his well-known "Homage to the Square" series in 1949 at the age of sixty-one. In order to explore what the artist called "the discrepancy between physical fact and psychic effect" in relation to color, he drastically restricted his format to a series of three or four differently colored squares within squares. Eschewing the relational, asymmetrical composition of Mondrian for an obdurately frontal, holistic image, Albers substituted relational form for the relativity of color, creating a remarkable range of emotional and optical effects.

Because of the didactic character of much of Albers's work, in the sense of his deep understanding of the science of vision, he is sometimes relegated to the role of a "Mr. Wizard" of the art world, his color squares seen simply as exercises in color performance. From this view, Albers presents us with a hollow geometry. However, Margit Rowell has persuasively argued that Albers's art is not abstract or nonobjective in the Constructivist or Neoplastic sense, but is essentially phenomenological in character, his subject being the nonobjective character not of geometry but rather, of light. According to Rowell,

Albers' color has no direction except out, toward the viewer. Whether bold or tender, Albers' "volumes" of color-light assault us and solicit our response. The painting looks at us, says Albers. Art is looking at us. Like a window, light pours in. Like a Magritte painting of a window, where the multitude of visual connotations are telescoped into a single plane, the viewer no longer knows exactly what he is seeing nor what he is supposed to see.[52]

Rowell notes that Albers's discovery of and reaction to Edvard Munch's paintings in Berlin at the 1913 *Herbstsalon* were significant in regard to his sensitivity to sensations of light.

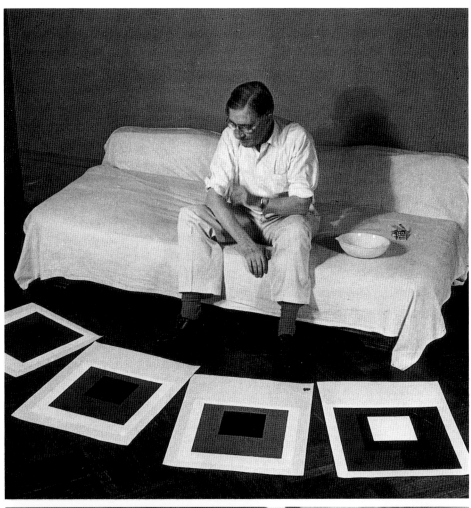

Josef Albers at Black Mountain College, Asheville, North Carolina. Photograph courtesy the University of North Carolina

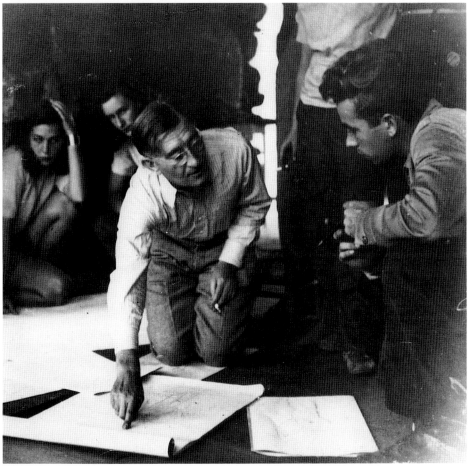

Josef Albers, c. 1955. Photograph by Rudolph Burckhardt

Of one painting in the exhibition, *The Rising of the Sun,* Albers has said, "It was a huge painting. It overwhelmed me. There was such a terrific glow that you couldn't look into that sun. It was so overwhelming that it put me on my knees. That is one of the greatest experiences I have ever had in modern painting."[53]

Albers's immense output did not sustain a high standard of quality throughout; that is only to say that every variation on a theme was not a masterwork. At the same time, his influence has been subtly pervasive, providing an uncommon clarity of vision over an exceptionally long and productive career. Indeed, Albers's influence extended well beyond the 1940s and the pioneering efforts of the American Abstract Artists with whom he was initially associated. The intense and sophisticated interplay of color, which suggests a source of interior light, and simple yet powerful forms provide an important precedent for Mark Rothko's evocative, light-filled rectangles. Moreover, Albers—along with his young friend Ad Reinhardt—must be considered a patriarchal figure for an American aesthetic that would become increasingly abstract, literal, and reductive. The stringent geometric and serial-oriented art of the Minimalists that developed in the early 1960s seem like reverent offspring.

While a myriad of influences and circumstances affected American art of the 1930s and 1940s, geometric abstraction found its early and dominating figure in the Dutch-born Piet Mondrian. For much of the avant-garde and certainly the majority of artists associated with the AAA, Mondrian's paintings represented the consummate embodiment of modernism: color, form, and space integrated into a pristine arrangement of primary colors and rectangles. It remains an image we associate with the modern city. Although Mondrian's presence in New York was brief and he had only a single one-person show in New York, his art and his philosophy—through numerous writings—had preceded him. As early as 1920, Mondrian had helped to found the magazine *De Stijl,* where a number of his most important theoretical essays were published; he had, as well, arrived at the style he called Neoplasticism—the asymmetrical division of the canvas into rectangular planes of primary color.

Mondrian's advanced thinking derived, in part, from his interest and visual interpretation of mystical literature. Like František Kupka, Kasimir Malevich, and Wassily Kandinsky, Mondrian believed in the purification of nature into abstract forms and that geometric configurations—ultimately "pure" forms—function as paradigms of spiritual enlightenment.[54] Mondrian's understanding of theosophical writings led him to the conclusion that art in its highest form resulted from the dynamic interaction of polar opposites—male and female, black and white, vertical and horizontal—which revealed a "pure" or "abstract" reality in perfect equilibrium. The strict verticals and horizontals that play such an important part in Mondrian's painting after 1914 were central to this sense of equilibrium, which he called the "universal." Mondrian defended his use of the perpendicular to such an extent that in 1924 he broke off his friendship with van Doesburg, the cofounder of de Stijl and a painter whose own compositions deviated from a strict horizontal-vertical orientation. Mondrian went on to develop his own theory of Neoplasticism. Thereafter, his universalism advanced in the form of pure primary colors and uninflected horizontal and vertical lines.

At the time Mondrian moved to New York in 1940, both his works and his philosophy of Neoplasticism were well known. His paintings had been part of a number of prominent exhibitions and collections, including Katherine Dreier's *International Exhibition of Modern Art Assembled by Société Anonyme* at The Brooklyn Museum in 1926–27, A. E. Gallatin's Museum of Living Art, and Alfred Barr's 1936 exhibition *Cubism and Abstract Art.* Indeed, in their astute recognition of Mondrian, the aforementioned Americans were in advance of their European colleagues. The Parisian abstract painter Georges Mathieu revealed that until 1945 he had never heard of Mondrian and that in their appreciation and knowledge of geometric abstraction, "a certain American public can

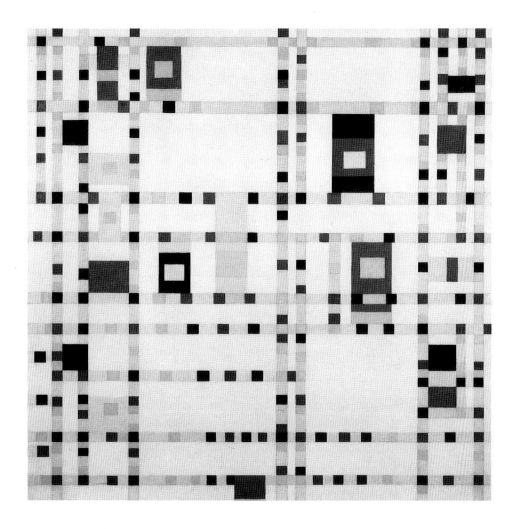

Piet Mondrian, *Broadway Boogie Woogie*, 1942–43. Oil on canvas, 50 × 50". Collection The Museum of Modern Art, New York. Given anonymously

be said . . . to have been fifteen to twenty years in advance of the corresponding French public."[55]

By no means an active joiner, the somewhat shy and reticent Mondrian accepted an invitation to become a member of the American Abstract Artists only months after arriving in the United States. Mondrian's presence in the group was for some, such as Fritz Glarner, that of a guru. For others, his presence simply indicated that the great innovator from across the Atlantic was, in fact, flesh and blood. Carl Holty remarked, "Mondrian had no effect on America during his lifetime that he didn't have before he came here."[56] Perhaps, but at the very least, the immigrant European provided a unique role model, his paintings no less than landmarks of twentieth-century art.

With Mondrian's death in 1944 there coincided a new phase of American painting, an era in which abstract painting, geometric and expressionist, would take on new meaning. Indeed, it is at this point that we can begin to speak of a truly American abstraction, one in which various geometric strategies would have a lasting effect on the course of postwar American art.

Historically, the contributions of the AAA artists have tended to be buried between the breakthrough achievements of Mondrian and the emergence of Abstract Expressionism, which we often mistakenly think of as "the beginning." These early pioneers of American abstraction inhabited a kind of aesthetic purgatory, a transitional position that involved extending the theoretical direction of Mondrian while attempting to forge a geometric approach to abstraction that was particularly American.

Indeed, their work represented an important aspect of the consolidation and rooting of nonobjective painting in American culture, as well as a subtle but important shift in sensibility. The theosophic implications of Mondrian's aesthetic did not adapt well to the American context, in which materialism played a larger role than in European culture. As

John Elderfield has pointed out, "[The] utopian philosophy wherein art, ideally at least, was meant to construct a new world, or if not that, to form a blueprint for one, did not survive the social disillusionments of the 1930s."[57] Rather, geometric painting was becoming a more formalist and, in many ways, a more complex intellectual enterprise, less spiritual in its connotations. Geometric painting in America was evolving to an art of the mind rather than the spirit. The AAA artists represented the initial stripping away of a spiritual ideal in painting, the last of a certain kind of theosophic purity. In postwar American art, this would be one of the salient aspects of geometric art, to culminate in Frank Stella's infamous and practical description of his abstract paintings, "What you see is what you see."[58] Moreover, through their early WPA murals many of these artists were instrumental in opening a new frontier in terms of the size and spatial implications of abstract painting. It would take two generations, however, to fully exploit this breakthrough.

In the meantime, American art cast its admiring gaze in another direction, toward the subconscious and the mythical possibilities of Surrealism. This would, of course, lead to the gestural beginnings of Abstract Expressionism and the first great flowering of an American art movement. This would be a transition that marked the older AAA artists as a group left behind for a new and eminently more profound vanguard, at least in American terms. At this late date it is perhaps easy to maintain a kind of ignorant bliss or even to forget that the 1930s—which Thomas Hess described as "that sad decade that was midwife to at least three decades of ideas"[59]—and early 1940s was a time and context far less conducive, indeed even hostile to the possibilities of pure, nonobjective painting. As George L. K. Morris pointed out as early as 1946:

The Barriers which faced any American painter as recently as 1936, if he wished to show abstractions, are not always recollected today . . . the changes that have overtaken painting in America during this decisive decade were at that time hardly foreseeable. Ten years ago a positive emphasis upon the internal properties of art was usually branded as foreign, and hostile to the dominant provincialism. It was not unnatural that the most militant opposition to this ephemeral illustrative tide should have been aroused among abstract painters, of whom the greater number were then working in isolation, unknown to the public or even to each other. For abstract art—at best tolerated as a legitimate expression of Europeans only, was for the most part regarded as highly unbecoming to any painter working in America; much less was it fortified as a logical contemporary approach by official recognition.[60]

Ultimately, these artists experienced the misunderstanding and neglect that faces the emergence of new and radical propositions. As Bolotowsky summarized, "The isolation in which Mondrian found himself in Paris was paralleled by the isolation of the American abstractionists in New York."[61]

GESTURE VS. GEOMETRY: THE NEW YORK SCHOOL

By the 1940s, American art and the critical discourse that it engendered began to transform itself dramatically. For one thing, the impact of the American Abstract Artists began gradually to diminish. Although such prominent Europeans as Albers and Mondrian supported the organization, many of the younger members who would act as the next generation of leaders for the group were being drafted into military service. In addition, the WPA Federal Art Project which supported many of the geometric painters and provided a sense of community was also fading out of existence. Most significantly, however, the confidence that had once existed among those practitioners of geometric abstraction was rapidly disappearing as a result of challenges from a number of quarters. The purist qualities of geometric abstraction faced a new era raked by the irrational forces of a world war that would end with a powerful nuclear explosion.

Geometric tendencies such as Cubism, Constructivism, and Neoplasticism, which had constituted an important source of inspiration for American artists during the 1930s, were being supplanted by a more subjective, expressionist aesthetic. The New York art world began looking to the color-inspired gesture of Wassily Kandinsky, which could be seen at the much talked about Museum of Non-Objective Painting that opened on East Fifty-Fourth Street in 1939. At the same time, a new generation of artists identified as Surrealists, whose strange biomorphic and figurative imagery had developed in the post-Freudian atmosphere of the 1930s, had begun to receive considerable international attention. Many of the Surrealists—prominent among them, André Breton, Max Ernst, André Masson, Matta, and Yves Tanguy—found their way during the war to New York, where their psychologically charged imagery would have a profound effect on a new generation of American artists. In 1936, Alfred Barr presented his ambitious and distinguished survey *Fantastic Art; Dada and Surrealism* at The Museum of Modern Art, and during the late 1930s and early 1940s, a number of the prominent New York galleries, Julien Levy and Pierre Matisse, in particular, were showcasing Surrealism.

Surrealism created a very different milieu, offering a new generation of Americans a less dogmatic means of expressing themselves and the particular anxieties they faced. Biomorphic and antigeometric, Surrealism established the possibility of a fluid and open pictorial structure that could be easily adapted to personal interpretation. Formally, this involved dismantling the cubist grid that had remained latent in the work of Mondrian and his American followers. It was from this transitional matrix that a powerful and new American art would emerge.

While this new movement initially looked to Surrealism and its gestural possibilities for inspiration, in key instances the Platonic qualities of geometry pioneered by Malevich and Mondrian remained nonetheless as a latent and, at times, prominent model. The decade between 1945 and 1955 constituted a profoundly experimental and eclectic period. Indeed, it is generally considered to be the most important decade in the history of American art, encompassing as it does the genesis and mature development of the aesthetic maelstrom known as Abstract Expressionism. By now, Abstract Expressionism requires little introduction to a museum-going public. Ironically, while it claims an undisputed place in the history of modern art, its true objectives and contributions are more often than not supplanted by the description of a kind of superficial group portrait of individuals living in New York whose art was essentially irrational and spontaneous. The facts, however, indicate something quite different, and certainly more complex. Abstract Expressionism was the fruit of a painstaking and often systemic endeavor to develop a style, a range of subjects, and a working process that reconciled a variety of personal identities and intellectual histories with the premises of early European modernism. As is becoming clearer and clearer with each succeeding study, Abstract Expressionism presents nothing that resembles a seamless, stylistic evolution. It was, rather, a Hydra with a myriad of aesthetic, philosophical and psychological faces.

A basic division within the movement exists between the so-called Gestural and Field painters, a distinction with some overlapping: Field painting (exemplified by the work of Still, Newman, and Rothko) and Gesture or Action painting (as in works by de Kooning, Kline, and Motherwell). Using Surrealism as its initial source of inspiration, the early development of Abstract Expressionism clearly emphasized gesture as its overriding principle. The notions of spontaneous gesture and personal "touch" were the primary characteristics for originality, and the expression of an existentially aware self.[62]

In his book *System and Dialectics,* John Graham, a friend and sometime adviser to a number of the Abstract Expressionists—Gorky, de Kooning, Gottlieb, Pollock, and Rothko, among them—promoted the technique of spontaneous gesture as a way of evoking personality in its most direct form. "Gesture, like voice, reflects different emotions. . . . The gesture of the artist is his line, it falls and rises and vibrates differently whenever it speaks of different matter. . . . The handwriting must be authentic, and not

faked . . . [not] conscientious but honest and free."[63] Through the Abstract Expressionists, automatic writing was transformed into a bold, painterly style of drawing. The most celebrated artist to utilize this raw and radical form of expression was Jackson Pollock, whose mural-sized "drip" paintings defined the outermost limits of the improvisatory mode in abstract painting.

The critic Harold Rosenberg invented the term Action painting to describe the radical nature of this method and, at the same time, to distinguish it from earlier European expressionism, which for the most part adhered to the figure or landscape and was of easel size. In characterizing this new painting, Rosenberg wrote: "At a certain moment the canvas began to appear to one American painter after another as an arena in which to act—rather than as a space in which to reproduce, redesign, analyze or "express" an object, actual or imagined. What was to go on the canvas was not a picture but an event."[64]

As the ambitions of these New York painters increased, along with the scale and size of their paintings, these "events" became monumental fields of action. In response to the mural-sized character of these works, Clement Greenberg coined the term Field painting to describe the scale (a type of modern painting that had evolved from a "window" to a "field")[65] as well as the holistic, edge-to-edge character of these works. A similar situation developed in the late 1940s in poetry, when a new literary space—William Carlos Williams's "The Poem as a Field of Action" —presented itself. Although often cranky and difficult in syntax, Williams's essay nonetheless evokes and parallels the seemingly limitless nonhierarchical space opening up in American painting.[66]

It is in the area of Field painting that geometric imagery played a distinct role in the mature development of Abstract Expressionism. Indeed, geometry came to assume a greater significance as the movement explored its options. As Morton Feldman, an avant-garde composer of the period and one very much involved with the New York painters, remarked:

The scene was not as it appeared, at least in the press. The party line was that these guys were like a fraternity of gorillas with paint-filled squirt guns. It was a lot more considered and not as "expressionist" as it might appear. Barney [Newman] wasn't flinging any paint for Christ's sake. He was tight, very considered, essentially geometric. He'd roll over in his grave if he heard me say that. He thought of himself as an expressionist, but I think for strategic reasons. The press was more interested in and could make more hay with the expressionist angle. That's just politics, right? He was an expressionist, but of a different kind. Reinhardt was different but in a different way.[67]

Regardless of the differences that their works present in relation to gestural painting, Newman and Reinhardt continue to be analyzed in relation to their Abstract Expressionist colleagues, a milieu to which they made important contributions but in which they had numerous reasons to feel uncomfortable. Indeed, in relation to their more expressionist colleagues, their position was unique. Like many of the other Abstract Expressionists, they were initially attracted to Surrealism, yet as their work matured it became gradually more planar and geometric, suggesting different sources of inspiration. A primary distinction existed in the fact that Newman and Reinhardt continued to grapple with Mondrian's achievements. One suspects that Mondrian's position may have been seen by these artists more as something to overcome than to emulate. Along with Matisse and Picasso, the Dutch-born artist offered a particularly difficult challenge.

Newman has been an especially perplexing figure in relation to Abstract Expressionism. Indeed, the work of all the emerging Abstract Expressionists was controversial, and was met with public bewilderment, if not outright hostility. Newman's work, however, generated intense and often negative reaction. Although he was included in the famous Life magazine photograph of the "Irascibles"[68]—he is the central figure in this legendary

group portrait of the movement—he, in fact, remained somewhat of an outcast for much of his career.

A number of disparate factors put Newman in this position. Unlike many of his colleagues, Newman had not been involved with the WPA. Participation in this project was almost a rite of passage to the avant-garde fraternity that developed in New York in the 1940s. As Dore Ashton put it, "Throughout the nineteen-thirties the W.P.A. was a central fact in the lives of nearly all the abstract expressionist painters. To them, the decade of the thirties represented the Project, and the Project meant the establishment of a milieu for the first time in the United States."[69] Newman readily acknowledged his isolation in this regard. "I paid a severe price for not being on the project with the other guys; in their eyes I wasn't a painter; I didn't have a label."[70]

Indeed, if Newman did not have a "label" it was because formally and conceptually his art developed relatively slowly in relation to his expressionist colleagues. Complicating the fact that he did not apprentice, as it were, on the WPA project, Newman committed himself early on to a number of nonart or semiart endeavors. During the late 1920s and the 1930s, he worked for and eventually ran his father's clothing manufacturing business. In effect, he put his art aside temporarily in order to save money and afford himself the ability to work full-time as an artist at a later date. Newman maintained during this period an involvement with art through politics, running for mayor on what he described as a "Writers-Artists Ticket." His platform involved the establishment of municipal art galleries, sidewalk cafés, city opera, and playgrounds for adults.[71]

Such endeavors gave him little time to paint and were perhaps detrimental in establishing his reputation as a serious, full-time artist. Nonetheless, Newman's status as a late bloomer, or "Ugly Duckling" as David Sylvester has described him,[72] had the effect of a double-edged sword. On one hand, it put him at a disadvantage in terms of commercial and critical success. In relation to his colleagues, Newman had relatively few exhibitions in the 1940s and 1950s. At the same time, Newman's slow gestation period allowed him a perhaps more objective view of the possibilities available to American painters. This accounts partially for the fact that Newman's mature statements appear to have emerged without a preparatory phase, fully formed and conceptualized. Newman was forty-five when he produced a barrage of mature and radical paintings. This process of considering ideas over a long period, conceptualizing his goals as well as his approach, became a prominent model for the cool and intellectual art strategies of the 1960s.

The most profound rift between Newman and some of his colleagues may have been Newman's theoretical complexities, particularly his rhetoric on subject matter in abstraction; his struggle between gesture and geometry; and his eventual attraction to the planar and classical side of abstraction. In a milieu dominated by the autographic gesture, Newman's work evolved slowly but consistently toward a more rigorous geometric image.

In his early works, Newman clearly assimilated Surrealism as a starting point toward what he sought as a new type of subject matter for painting. Rather than the literary trappings associated with French Surrealism, Newman explored the possibilities of automatic writing, creating numerous series of gestural drawings using vigorous free-form motions of his wrist, elbow, and shoulder. Thomas Hess, who spoke to Newman about these early works, noted, "He did not attempt to edit, make them more beautiful or stronger; 'how it went, that's how it was. My idea . . . was that with an automatic move you could create a world.'"[73] For Newman, automatic drawing provided a way to respond to the overly formalized and designed abstractions of the AAA. Indeed, some of the titles of Newman's early works—*Euclidean Abyss, Death of Euclid*—suggest an attack against geometric abstract art. As Newman stated quite poignantly, "It is precisely this death image, the grip of geometry that has to be confronted. In a world of

geometry, geometry itself has become our moral crisis."[74] Yet even at this expressionist stage one senses in Newman's art a struggle between gesture and geometry. Many of the early works involve a dialogue between organic expression and a rudimentary geometry. By the mid-1940s, Newman's gesture begins to coalesce into or mingle with basic shapes and forms such as lines and circles, in works like *Gea,* 1945; *Pagan Void,* 1946; *Genetic Moment,* 1947; and *Genesis—The Break,* 1946.

Newman's mature work also involves an intricate balance between gesture and geometry. In grappling with words to describe his position he often alluded to a mysterious reconciliation between the two opposites. At one point, he described his art as "not space cutting nor space building, not construction nor fauvist destruction; not the pure line, straight and narrow, nor the tortured line, distorted and humiliating; not the accurate eye, all fingers, nor the wild eye of dream, winking; but the idea-complex that makes contact with mystery—of life, of men, of nature, of the hard, black chaos that is death, or the grayer softer chaos that is tragedy."[75]

In another statement, however, Newman describes his work in less ethereal terms, as an image with a strong sense of solidity, and if not exactly geometric, then at least highly contained, not only in terms of surface but also in terms of clarity of image. In 1955, Newman objected to Clement Greenberg's statement that "like Newman, [Rothko] soaks his pigments into the canvas, getting a dyer's effect."[76] Newman responded, "This may be a description of Rothko's surface . . . but it is in error and entirely misleading as a description of my work. You know that my paint quality is heavy, solid, direct, the opposite of a stain. If you wanted to describe the sense of the single total image my pictures make, you should have made the distinction between something that is 'dyed' and something that is whole as if cut or stamped by 'dies'."[77]

As with all artists, the issue of "influences" is a complex one with Newman. From Newman's standpoint of creating a radically new vision, it was ironically crucial *not* to be European, *not* to be burdened by a sense of history. Newman wrote,

I believe that here in America, some are free from the weight of European culture . . . are creating images whose reality is self-evident and which are devoid of the props and crutches that evoke associations with outmoded images, both sublime and beautiful. We are freeing ourselves of the impediments of memory, association, nostalgia, legend, myth, or what have you, that have been the devices of Western European painting. Instead of making "cathedrals" out of Christ, man or "life," we are making it out of ourselves, out of our own feelings.[78]

At the same time, Newman clearly grasped the lessons and phases of modernism, and one of the lessons he undoubtedly found challenging was the work of an artist whose ambition for a new type of subject matter through abstraction matched his own: Mondrian. Newman referred to Mondrian on a number of occasions, most often in critical terms. One of Newman's most important theoretical essays was titled "The Plasmic Image,"[79] a title undoubtedly chosen in reference to Mondrian's "Plasticism." In his essay the artist discusses Mondrian's 1945 exhibition at The Museum of Modern Art: "There has been a great to-do lately over Mondrian's genius. In his fantastic purism, his point of view is the matrix of the abstract aesthetic. His concept, like that of his colleagues, is however founded on bad philosophy and on a faulty logic."[80]

Central to Newman's argument with Mondrian was that the latter artist's work, no matter how radical the geometric forms, still derived from nature in its strict verticals (figures) and horizontals (the horizon). Newman's goal was an even purer form of abstraction, what he referred to as "a new type of abstract thought."[81] According to Newman, "Mondrian was definitely related to the theory of nature: his horizontals and verticals moved in relation to, you might say, Platonic essences about the nature of the world."[82] Newman also took issue with Mondrian's insistence on precise right angles, and a sense of line and form so tidy that according to Newman, Mondrian's "geometry

Opposite:
Barnett Newman in front of *Who's Afraid of Red Yellow Blue III,* 1966–67. Photograph by Alexander Liberman

(perfection) swallows up his metaphysics (his exaltation)."[83] Clearly, Mondrian's "perfection" troubled Newman most. "I think," Newman said, "he had the ambition to purify all attitudes into the perfect painting, into the notion of the perfect painting."[84] For Newman, such a position was too dogmatic.

However, one might see Newman's sense of the relationship between his own work and that of Mondrian as similar to the relationship between Pollock and Picasso—an inspirational if antagonistic force that had to be overcome. With all his protests, Newman stated flatly, "I respected him [Mondrian] very highly, but I felt that I had to confront his notions."[85] Often perceived as a Mondrian antagonist and an unwilling participant in the geometric tradition, Newman might better be seen as one who reconsidered the basic tenets of geometric abstraction in an ambitious attempt to reinvest with new content what was, in American terms, in jeopardy of becoming an overly formalized tradition.

Newman continually stressed the importance of subject matter and meaning in his work. For Newman, painting was not simply a matter of finding a design format, but locating a new form of content. In 1946, Newman presented his outlook in a discussion of the art of the Kwakiutl Indians of the Northwest coast of Canada. Interestingly, Kwakiutl art is essentially geometric and figurative. What interested Newman most, however, was this people's attitude toward their imagery. As Newman wrote it, the Kwakiutl "did not concern himself with the inconsequentials . . . [of] social rivalries. Nor did he, in the name of a higher purity, renounce the living world for the meaningless materialism of design. The abstract shape he used, his entire plastic language, was directed by a ritualistic will toward metaphysical understanding."[86] In transforming his perception of the power of the Kwakiutl image into essentially geometric abstract terms, Newman sought to achieve what Harold Rosenberg would call an "inversion of the art of rectangles, circles, triangles as it had come to be in the hands of the Constructivists, de Stijl, and Mondrian."[87] For Rosenberg, the difference between what we could eventually call "Newman's geometry" and that of earlier European geometric painters was one of content. In support of this, Rosenberg quoted Newman:

To him [the painter on animal skins], a shape was a living thing, a vehicle for an abstract thought complex, a carrier of the awesome feeling he felt before the terror of the unknown. The abstract shape was therefore real, rather than a formal abstraction of the visual fact with its overtones of an already known nature. Nor was it a purist illusion, with its overload of pseudo-scientific truths.[88]

By the late 1940s, Newman had studied, executed, and digested a wide range of contemporary painting. He came to the conclusion that for him the road lay in the starkest, most astringent form of simplicity. It would be a matter of throwing everything out and starting from the most elemental position. The work would be about flatness and edge and the oscillating relationships of edge to interior space. It would be about the most minimal series of elements producing a new and aggressive totality. Newman's by now legendary breakthrough came in 1948. The artist readily acknowledges the painting *Onement I,* 1948, as the beginning of his mature career. After making the work Newman remembered that he "stopped in order to find out what I had done, and I actually lived with that painting for almost a year trying to understand it. I realized that I'd made a statement which was affecting me and that was, I suppose, the beginning of my present life."[89] *Onement I,* the first of a number of paintings with the title *Onement,* is a remarkably beautiful but modest picture, consisting of a solitary orange stripe of paint running top to bottom in the center of a two-by-three-foot canvas with a cinnamon-red ground. Although Newman had flirted with this vertical element in a number of previous pictures—*Moment,* 1946, *Untitled Drawing,* 1946, and *The Command,* 1946—this work held a special significance in terms of its rudimentary geometry, classicism, and simplicity.

Opposite:
Barnett Newman, *Onement II,* 1948.
Oil on canvas, 60 × 36". Collection Wadsworth Atheneum, Hartford. Anonymous gift.
Photograph by Joseph Szaszfai

There has been considerable controversy over the significance and intended meaning of Newman's *Onement* paintings. Rosenberg saw it as an "emblem of self . . . fused into an extraordinary unity."[90] The most popular view has been to see Newman's simple and textured line as an analogue to Alberto Giacometti's attenuated sculptured figures, which Newman saw in New York in 1948, in a show that opened ten days before he painted *Onement I*.[91]

Although a seductive theory—and indeed Newman may have been inspired by Giacometti—it does not parallel the philosophy Newman was at pains to elucidate regarding a new type of painting based on a symmetrical, nonreferential image that went beyond Mondrian. As Yves-Alain Bois has recently written, "In *Onement I*, the symmetry is the essential means used by Newman to preclude the possibility of any vestige of traditional composition—and it is certainly on this matter that Newman's enterprise departs most radically from that of Mondrian."[92] In *Onement I*, the single line is coarsely textured and has a slightly oscillating edge. In his very next painting, *Onement II*, however, also of 1948, Newman eliminated all vestiges of the painterly, making the line a uniform and clean-edged band. Newman's line or "zip" performed a highly rational and organizing element in his painting. Thomas Hess wrote of *Be I*, 1949, that the viewer would feel swallowed-up, drenched "in the chaos of red, and then feel touched by the organizing power of the vertical division."[93] Such is the rational and classical calm we attribute to the power of certain lines.

From that point on, this line or zip became Newman's emblem and preoccupation. According to what Newman told the sculptor Tony Smith, the only thing that mattered in his painting was the zip or stripe.[94] A remarkably direct and simple device, it became transformed by Newman; what in one composition might appear as a delicate line became in another, a series of assaulting planes and in yet other works, a massive, expansive field. Indeed, Newman did not envision this geometric configuration simply as a line or divider of space, but rather as a field of visual activity, specifically "a field that brings life to the other fields, just as the other fields bring life to this so-called line."[95] In Newman's paintings this expanded field, then, eliminates the multiple subdivisions of the picture plane that Mondrian inherited from Cubism. The result was a provocative continuous plane. Moreover, expansion of the painting to mural size—the fact that from normal viewing distance Newman's blanket of color essentially smothers our field of vision—established a new relationship between viewer and picture. Enveloped in broad fields of color, the viewer could not easily objectify the experience, in the sense of simply analyzing a design attached to a wall. The art had essentially become the wall, creating a powerful and animated frontal space "between my experience of place and pictorial space,"[96] in which the viewer is constantly forced in on himself as the central point of the composition.[97] At the same time, as John Elderfield has pointed out,

Mondrian's word "infinite" is wrong for Newman, but his art does seem to do optically what Mondrian's did metaphorically. This is not to say that the line between his paintings and their surroundings is blurred, but that he was able to create an expansiveness of effect within a unified object without that object appearing either indefinite or insular. Mondrian, learning his Cubism in 1912, could not help but accept the "confines" of his spaces. He had to work in terms of the frame to preserve the identity of his surfaces. Newman learned his Cubism a lot later and tempered it with the lesson of Matisse. For him, edge was an opposite problem to that of Mondrian.[98]

Indeed Matisse's breakthroughs in the area of color and space were not lost on Newman, in the sense of allowing color to act as line. Like Matisse, Newman's ambition was to give color a powerful and concrete "reality." Mondrian's system of containing small areas of color with a black grid that separated it from passages of white space created a sense of color effectively balancing and punctuating the space. In Newman's large, mature pictures color is given authority to dominate the space completely.[99]

It is after Newman made these realizations and formal breakthroughs and had time to accept them as such that he was able to acknowledge the challenge Mondrian had presented him. Among the last of Newman's paintings is a series of four works titled *Who's Afraid of Red, Yellow and Blue?* As Barbara Rose has noted, "Finally, so assured of his own conquest of the problems posed by Mondrian's paintings that he was free to use Mondrian's own palette. Newman, at the moment he was sure of his triumph, could publicly declare the challenge to Mondrian always implicit in his paintings."[100] Indeed, Newman forced color and geometry into an entirely new domain, one that even he, despite his numerous texts, was at pains to explain.[101]

Newman's art seemed far less "spontaneous" than that of his expressionistic peers, and as a result he presented us with something more troubling and far less easy to reconcile. Newman's gift was his ability to challenge in a manner that was profoundly equivocal. As Thomas Hess wrote of him in 1968, "he has been as impure as pure; as reactionary as radical, and strange as it may seem to the history-hungry critics of today, is able to keep two mutually exclusive concepts in one mind at the same time."[102] Indeed, Newman seems to have digested both sides of Barr and Worringer's division of modern art. He was, to be sure, an expressionist of considerable magnitude. Yet, Newman's passion was invariably fused with simple, highly proportioned geometric forms. His work can inspire lofty references to modernist as well as classical geometric art. David Sylvester wrote recently,

In front of *Vir Heroicus Sublimis*, Le Corbusier's words are called to mind: "Remember the clear, clean, intense, economical, violent Parthenon—that cry hurled into a landscape made of grace and terror. That monument to strength and purity." And the searing quality of the white zip frequently brings back another image of a classical temple: "And, behold, the veil of the temple was rent in twain from the top to the bottom."[103]

It was, among other things, Newman's traffic in a platonic and geometric art that distanced him from his fellow Color Field painters Rothko and Still, the latter involved in a more ethereal and turbulent expressionism. Still was likely speaking of Newman when he raved against "Bauhaus sterilities."[104] As Rosenberg has aptly pointed out:

The fundamental difficulty in grasping Newman's conception lies in distinguishing visually between a geometrical shape that functions in Cubist or post-Cubist painting as "a formal abstraction of visual fact" and the same shape in an American Indian painting where it is a "living thing." In the first instance, a rectangle is a generalized representation of a head, a torso, a building; in the second, it is a magically active "vehicle" that "carries" awesome feelings.[105]

It has not been common to deal with Newman as a "geometrical" painter. The angst and passions that often surface in Newman's own writing and that we associate with Abstract Expressionist painting initially seem antithetical to the rigid and stately forms we associate with geometry. Indeed, it was Newman's challenge to face head on what he called the "Euclidean Abyss" and reform it into something more relevant to his time. As Harold Rosenberg put it, in Newman's art "geometry changed into a language of passion."[106]

Ad Reinhardt's relationship to the Abstract Expressionist movement was equally complex and awkward, and although his attraction to classical, geometric forms parallels to some degree Newman's development, his intentions and results are quite different. A certain affinity does exist, however, in Reinhardt's attitude toward Mondrian. Reinhardt's statements, his background and the development of his art indicate a profound understanding and appreciation for the achievements of his Dutch colleague.[107]

In 1937, Reinhardt became one of the youngest members of the AAA; his early works reflected an odd amalgamation of American and European influences, especially those

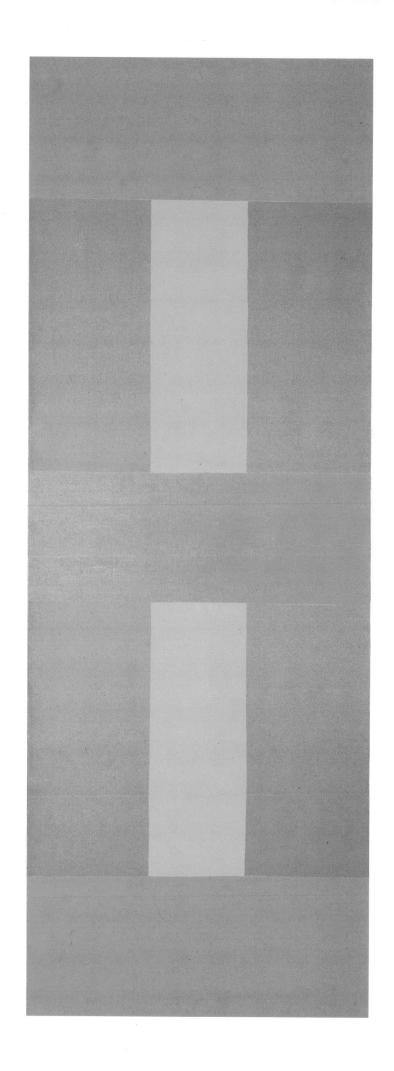

Ad Reinhardt,
Abstract Painting, 1951.
Oil on canvas, 60 × 22".
Collection Jesse Philips, Dayton, Ohio.
Photograph by Rollyn Puterbaugh

of Stuart Davis, Carl Holty, Miró, Hélion, and, most importantly, Mondrian. Like Newman, Reinhardt's early works pivoted on a dialectic between the expressive capabilities of gesture, through both drawing and brushstroke, and the seductive clarity inherent in planar fields of color. While Pollock had expanded drawing to free-form motion painting, Newman and Reinhardt would eventually consolidate it into a rigorous geometry. Reinhardt's early paintings of 1938 to 1940 incorporate contained forms, organic as well as geometric, flattened and set off against a ground of contrasting color.

During the early to mid-1940s, however, these shapes gradually dematerialized into fields of gestural calligraphy that subtly melted into their surrounding ground. As the paintings developed, Reinhardt's brushstrokes, which appear both drawn and painted, gradually formed a semigrid so that the dynamic movement suggested by the strokes was balanced with a subtle yet static structure. Reinhardt's "Persian Rug Series" of 1947 to 1949, for example, presents veils of small, gestural strokes that merge slightly with their background to form a tapestry effect. In the late 1940s, Reinhardt's calligraphy condenses into more regular geometric configurations, often simple, rectangular, architectonic surrogates for what were previously brushstrokes. Eventually the sinuous edges of these horizontal and vertical bricklike slabs of paint were eliminated altogether, replaced by solid blocks of color floating free or overlapping with each other against a similarly colored ground. Finally, Reinhardt arrived at tight, pristine, and symmetrical compositional divisions concentrating on various hues of a single primary color.

At this point, Reinhardt did not vacillate in his insistence on purging the "expressionist" element in his art. The edges of Newman's zips and planes of color often moved between a clean, uninterrupted line and that of a slight gestural or bleeding quality. The emotions which Newman's work imparted were in some instances contained in this subtle quivering of a line. Moreover, Newman at times animated his surfaces through the textural substance of his brushstroke or the combination of two different mediums contrasting on the same surface.[108] For Reinhardt, however, surface drama, including gesture and brushstroke, evoked a personal "handwriting" that was emotionally distracting. Reinhardt's mature vision embraced a shockingly rational and seemingly inert image. Toward that end, Reinhardt thinned his paints so that he could apply layers of color that in no way reflected traces of a hand or a brush. The result was a pristine, cool field of color that emitted a kind of anonymous glow. This is not the soft and insistent color atmosphere of a work by Rothko, but more the ambiguous surface of plastic or metal. In 1966, Reinhardt wrote to Sam Hunter, "Not colored light, but color that gives off light."[109]

The evolution of Reinhardt's use of color reflected his austere vision. By the time he reached his mature stages he had eliminated all color with the exception of red and blue. In the end, he finally eliminated these as well, settling on black, a noncolor. In defending his decision, Reinhardt remarked: "Someone once asked me about color and I used the occasion to mention the number of times and places in art where color was excluded— Chinese monochrome painting, analytic Cubism, Picasso's *Guernica*, etc. There is something wrong, irresponsible and mindless about color, something impossible to control. Control and rationality are part of any morality."[110] Along with his elimination of color, Reinhardt's mature format involved a "perfect" five-foot-square canvas— perfect in size because it was neither an easel that could be read as a "window" opening onto something else, nor large enough to suggest a "field" or mural indicating a kind of limitless space. The ultimate classicism that Reinhardt sought was inert and contemplative.

Reinhardt's black paintings are often initially greeted with hostility by viewers. The balanced geometric divisions, often in the shape of a cruciform, and the subtle variations in form are at first almost impossible to discern. These inert black squares have the quality of an Egyptian mirror that forces one's image back to oneself. The black paintings seem then truly to achieve Reinhardt's goal to "push painting beyond its thinkable, seeable,

feelable limits,"[111] to a highly enigmatic physical and psychological condition. Reinhardt's description of his late or "ultimate" black paintings expresses the radical point to which he had taken the geometric tradition in modern abstraction:

A square (neutral, shapeless) canvas, five feet wide, five feet high, as high as a man, as wide as a man's outstretched arms (not large, not small, sizeless), trisected (no composition), one horizontal form negative one vertical form (formless, no top, no bottom, directionless), three (more or less) dark (lightless) non-contrasting (colorless colors, brushwork brushed to remove brushwork, a matte, flat, free-hand painted surface (glossless, textureless, non-linear, no hard edge, no soft edge) which does not reflect its surroundings—a pure, abstract, non-objective, timeless, space-less, changeless, relationless, disinterested painting—an object that is self-conscious (no unconsciousness) ideal, transcendent, aware of nothing but Art (absolutely no anti-art).[112]

Reinhardt's position has attracted a broad range of evaluations. For many, Reinhardt took classicism and rationality to an ultimate, even negative point. Hilton Kramer said flatly, "Reinhardt's paintings are the most genuinely nihilistic paintings I know."[113] On the other hand, Margit Rowell has described Reinhardt's final image as "an anonymous emblem signifying the quintessence of painting."[114] She has further suggested that Reinhardt's purifying evolution from an essentially expressionist gesture to a shockingly austere geometric imagery closely parallels the problems and solutions presented in Mondrian's development. She observes,

Mondrian and Reinhardt held comparable positions in relation to their respective artistic milieu; the first reaching maturity in the age of Surrealism, the second during the reign of Abstract Expressionism. But more importantly, one might venture that these two men were cast in the same mold. From their backgrounds (Protestant) to their spiritual and philosophical affinities (in both Eastern and Western thought); in their idealism which became increasingly dogmatic; even in their pictorial evolution, these two artists travelled parallel paths.[115]

Indeed, the lessons of Mondrian's development were not lost on Reinhardt, though, like Newman, he was at pains to confess the magnitude of the challenge. On one occasion, Reinhardt was deliberately ambiguous on this point. Referring to John Berger's book *The Success and Failure of Picasso*, Reinhardt said ironically, "There could never be a book titled Success and Failure of Mondrian."[116] As Rowell has pointed out, however, there are a number of clues pointing to the artist's appreciation of the Dutch abstractionist. Referring to a Mondrian exhibition at the Valentine Galleries in the late 1940s, he wrote:

Consider the recent Mondrian exhibition. These paintings, sensuous and concrete manifestations of a certain kind of thinning and understanding which pretended to be architecture and sculpture too, and conceivably biology and engineering (biotechnics, psycho-physics, etc., demanded in their limited and concentrated area direct, first-hand experience for its appreciation . . . for if anything "looked" what it "did", here it was. The intellectual and emotional content was in precisely what the lines, colors, and spaces told, and not in anything else, (the form and content being one) . . . in a social structure which permitted the artist only an independent and selfish relation to art, this work claims to have been the most objective approach possible—the recognition of the limitations of the medium and the development of individual sensibility to lines, colors, spaces, in this instance, a preference for the horizontal and vertical line as the stronger, and for the primary colors, as the most dynamic—But the concrete result, not the philosophical pretension, does the trick. What greater challenge today (in subjective and two dimensions), to disorder and insensitivity; what greater propoganda for integration, than this emotionally intense, dramatic division of space?[117]

Reinhardt's pride in stating that he went "beyond Mondrian"[118] clearly indicates his admiration for the Dutch artist and the challenge his work presented to American abstract painters. Like Mondrian, Reinhardt's vision was a remarkably bold attempt to transcend the "self" through the purification of line and plane. Indeed, Reinhardt pushed

this rationalist abstraction to a new plateau, and in so doing presented a succeeding generation with yet a new challenge. Following Reinhardt's death in 1967, Frank Stella remarked, "If you don't know what [Reinhardt's paintings are] about, you don't know what painting is about."[119]

As with other intense periods in the development of modern art, much of the tension and theoretical posturing of Abstract Expressionism came from a dialectical struggle between geometry and expressionism. Both sides played profound roles in our perception of the movement as a whole. If it was the expressionists who opened the front door and provided an initial impetus for the first great American art movement, it was a respect for the nonobjective, geometric image that muddied the theoretical waters, affecting our perception of the cohesiveness of this movement, and perhaps most importantly, offering a back door out of an expressionist cul-de-sac. Although gesture continued to be a vehicle for a number of important artists of the late 1950s, it was in fact the next generation of gestural painters who illustrated how quickly and easily one movement's invention can become another's convention.

In different ways and from very different perspectives, Ad Reinhardt and Barnett Newman extended the possibilities of yet another revolutionary phase of American painting, one based on the cool, enigmatic qualities of geometry. Reinhardt and Newman explored an extremely rigorous pictorial economy and a daring elimination of nonessentials. Their varied developments and philosophical positions within postwar American painting offer both extensions and corrective analogues to Mondrian's position within European abstraction.

For Newman and Reinhardt, it was not simply a matter of "updating" Mondrian's forms but rather of reinventing the purpose of geometric abstraction and attempting to build a somewhat less utopian but more viable future for the geometric image. Their art and their unique approach to various geometric strategies established an attitude that permeated the art of the 1960s and early 1970s. They are, in essence, the patriarchal figures of that decade. It is a curious fact that in many ways their art, when installed in museums, seems as much at home with the work of artists two decades younger, as well as with that of their peers.

OTHER VIEWPOINTS

Newman and Reinhardt were by no means the only abstract painters to reject gestural painting during the 1950s; many others — Leon Polk Smith, John McLaughlin, and Myron Stout, for example — simply received far less critical attention. They belong to a kind of lost generation whose mature aesthetic can to some degree be identified with the American Abstract Artists group — though none of them ever joined — as well as with the holistic, nonrelational qualities of the Abstract Expressionists, though they were peripheral to that movement as well.

Smith clearly acknowledged his debt to the AAA group's guiding force, Mondrian. He identified the clarity of experience in Mondrian's work with his memory of the colorful, geometric art of the Southwest American Indian. In a statement regarding his discovery and appreciation of the Dutch artist, Smith remarks on Mondrian's color: "I grew up in the Southwest where the colors in nature were pure and rampant and where my Indian neighbors and relatives used color to vibrate and shock."[120]

Smith had seen and greatly admired the work of both Jean Arp and Mondrian in the Gallatin Collection in the late 1930s. Indeed, Smith's overall development can be understood in terms of his ambition to combine the provocative biomorphic forms of Arp with the austere color-space dynamics of Mondrian. Smith has said he would like to "release Mondrian from the rectangle" while maintaining "Mondrian's discovery of the interchangeability of form and space."[121] For Smith, the odd curve or oblique line that demarks the edge of a field of color can establish a situation in which "fields of adjacent

color lock together so there is no sense of specific form but a bold and frontal abstract space. Like the Indians I grew up around, I've never been afraid of color. I let color establish the space and the feeling. The way you approach edge or line gives color the freedom and room to express."[122]

In 1954, Smith chanced on a "way of freeing Mondrian's concept of space so that it could be expressed with the use of the curved line as well as the straight."[123] The initial inspiration came from a series of drawings of baseballs, footballs, basketballs, and tennis balls in a catalogue of sports equipment. The curvilinear seams on the different balls, when flattened out, offered a provocative set of forms or fields—part biomorphic, yet stolidly geometric—that established a dynamic but unified circular space.

Like Newman and Reinhardt, Smith's concerns evolved toward the breakdown of a figure-ground relationship, as well as of the relational character of Cubism and Mondrian. He employed the S-curve to establish an image that locked the ambiguous dynamic between flatness and curvature into a single static image which the artist has described as a "curved space which moves in every direction and when at a particular point a line changes its course you cannot tell whether it turns right or left, up or down, in or out."[124]

In a further attempt to establish a more unified, holistic image, Smith was an early pioneer in allowing the shape of a canvas to generate the interior image of the painting. As Lawrence Alloway has pointed out,

In Smith's tondos of the mid 50s, for example, the circumference frequently generates the internal image, serving as the base for entering curves and converging planes . . . the support and the surface are bound together as a whole image. In rectangular paintings, too, Smith was impressively early and resourceful in relating the real corners and the ninety-degree turned-over edges of the stretcher to the canvas plateau facing the spectator.[125]

Smith found that his large, holistic images were best served when accommodating a reduced number of colors; two colors often offered the optimum experience. This limitation functioned in two ways. First, the reduction in color parts helped to maintain a unified image that could be perceived at once. "I wanted to explore composition and division, and I wanted the viewer to see that division at once. Understanding what it actually did might take time, but I wanted it seen quickly, maybe disarmingly, not part to part."[126] Second, it allowed Smith to expand the area of a given color, to allow them room to perform. Many of Smith's configurations appear to relate to things seen—a landscape, a building, a portion of a figure. Yet these would be schematic if not for Smith's sense of color, which activates the space in these works. In Smith's work, color is the catalyst that activates the tension between an image that couples a seemingly solid form with an ethereal space. In many of his images there is a Yin and Yang quality in which strong color opposites balance each other. According to the artist, "I see color almost as 'thing,' a substance with weight. When you look at the world around you, everything has a kind of color weight. I try to translate, even complicate those equations with my color. You ask if it relates to landscape. It doesn't relate to landscape specifically, but nature. I love looking at nature, but I don't want to see it when looking at my paintings. I want you to feel it."[127]

The paintings of John McLaughlin, who resided in the small coastal town of Dana Point in southern California, reflect a similar range of generational connections, but like that of Smith his imagery did not attract a large following until the late 1950s and early 1960s. McLaughlin's art evolved slowly, building toward a complex theoretical base that resulted in remarkably austere and contemplative abstractions. McLaughlin did not begin painting seriously until rather late in life, at the age of forty-eight. He was born in 1898 in Sharon, Massachusetts, the son of a lawyer and judge, and received his education at the Roxbury Latin School and the Phillips Academy in Andover, Massachusetts. He did not study art formally, but was aware of and ultimately infected with the

enthusiasm for Japanese art in the Boston area during the early years of the twentieth century. After serving two years in the navy during World War I, he engaged in the real estate business in Boston and Chicago. During this time, McLaughlin's interest in Japanese art and language grew, and in 1935, he and his wife visited Japan, where they remained for several years. Their knowledge of Japanese art developed to the extent that upon their return to Boston, the couple began to sell Japanese prints. During World War II, McLaughlin was recruited as a language officer; after he completed his study of Japanese at the University of Hawaii, he was assigned to the Military Intelligence Language School in Minneapolis. Subsequently, he spent two years in the China-Burma-India theater. Following the war, McLaughlin and his wife settled at Dana Point, and it was not until 1946 that the artist devoted himself full-time to painting.[128]

McLaughlin's art would receive little, if any, recognition outside of a small group of southern California abstractionists for yet another decade. The artist's first substantial recognition came with his inclusion in *Four Abstract Classicists,* an exhibition organized by Jules Langsner at the Los Angeles County Museum of Art. This show traveled in a slightly different form to the Institute of Contemporary Art in London in 1959–60. The exhibition brought together Karl Benjamin, Lorser Feitelson, Frederick Hammersley, and McLaughlin, whose works, according to Langsner, constituted a new abstract classicist movement that elaborated on the ideas of Mondrian and Malevich. In his text, Langsner coined the infamous term "hard edge" to describe a new type of painting that clearly distinguished itself from the thick, paint-clotted surfaces of the American action paintings of the time. While Langsner's terms of definition were less than precise, his exhibition and catalogue were prophetic in recognizing a swing of the pendulum toward the geometric and planar in American painting.[129]

Of the group chosen by Langsner, McLaughlin's paintings have found the most lasting following and appear in retrospect to involve the most complex set of issues. McLaughlin's focus on the contemplative function of painting derived from a variety of sources. The artist prominently acknowledged the achievement of Kasimir Malevich's *White on White,* which he described as a "magnificent break-through which completely eliminates the object."[130] Upon seeing *White on White* in New York, McLaughlin perceived a parallel between the contemplative space in Malevich's art and that of Japanese painting, both of which, he felt, addressed the complex idea of "nature" in profound ways. For McLaughlin, the essence of nature was not an outside force, but a product of the mind, a form of pure contemplation. Malevich's geometry appealed to McLaughlin because it did not exist in nature but was ultimately an invention of human consciousness.[131] Like nature, he wanted his paintings to project a universal and dynamic neutrality. McLaughlin also paid homage to Mondrian. He followed the Dutch master's rejection of the diagonal line because of its overly expressive and idiosyncratic character, preferring instead more static compositions involving pure verticals and horizontals.

McLaughlin's signature form has been the rectangle, which in his hands became a shape of discrete and static neutrality. Prudence Carlson has observed that "by dissolving its own boundaries (the powerful monotony of McLaughlin's repeated, "unremarkable" rectangular shapes causes his paintings to fall away, to recede from direct observation to baffle the eye, even to elude clear memory) and by launching the work it occupies into open indeterminacy, the rectangle generates a species of actual void."[132]

McLaughlin typically executed numerous preliminary drawings and collages before applying paint to canvas. Although his images project a pristine and precise quality, McLaughlin's process was invariably intuitive. The artist did not adhere to set systems of proportion, but explored images by juxtaposing various rectangles of paper. Through this procedure, he was able initially to establish neutral symmetries based on left-right or top-bottom correspondences. Such a procedure is similar to that of Mondrian.

At the same time, McLaughlin felt that both Malevich and Mondrian suffered from "technical inadequacies" that hindered an ultimately pure sense of the contemplation of

nature and self in response to painting.[133] As did Malevich and Mondrian, McLaughlin was exploring a content that would lift his work above "influences" and superficial compositional and formalist interpretations. To achieve this transcendence, however, McLaughlin relied heavily on his love and knowledge of Asian art and philosophy. The critic Dore Ashton has convincingly argued that McLaughlin's unique conception of abstraction and its relation to nature closely parallel that of Chinese philosophers and has pointed out specific parallels, such as the "Japanese" color combinations of red and white of the 1950s.[134]

In fact, McLaughlin's color scheme is unique within postwar American abstraction. Often infused with gentle blues, whites, yellows, and olive greens, the works seem keenly reflective of the unique qualities of light and space, oft-noted characteristics of the southern California coastline. What Newman described as a new form of the sublime in his art, one finds as its analogue the "Marvelous Void,"[135] which McLaughlin sought in his works. McLaughlin has clearly stated his ambition to recover the "Marvelous Void" described by the Japanese artist Sesshu, a fifteenth-century brush-and-ink painter. Such painting, which often ingeniously balances positive/figurative or landscape forms with pure, seemingly empty spaces, finds its analogue in McLaughlin's densely colored geometric forms stilled by a corresponding light and ethereal field of color. Remarkably, McLaughlin's abstractions—though stridently rectilinear—have the natural but abstract quality of space itself. The artist's proximity to the spaciousness of the Pacific panorama is clearly not lost in McLaughlin's aesthetic. In the end, McLaughlin felt that in order to understand the meaning of the void, one needed to appreciate and empathize with nature. "Rather than announce that I have discovered a truth," McLaughlin once said, "I am much happier merely suggesting that the viewer himself look longer and deeper into nature."[136]

At the time of McLaughlin's retrospective at the Pasadena Art Museum in 1963, the critic John Coplans compared McLaughlin's art "to the same process of purging and purification which underlies and unites in an overlapping area of concern the work of Rothko, Newman and Reinhardt," in the end criticizing the artist for maintaining regressive "format-scale ideas connected more to Mondrian and Malevich."[137] James Harithas countered that such a discussion is "more academic than correct. Finding a particular scale or size for McLaughlin paintings is irrelevant, for the void which he wishes to create has, in effect, no measurable form."[138]

It is perhaps in this sense—a pure contemplation of nature—that McLaughlin's works can be most accurately distinguished from those of Newman. Though both artists clearly shared an empathy for essentially pure geometric forms, their visions come from different emotional sources: the urban intensity of New York and the open-air spaciousness of southern California. McLaughlin once remarked that Newman was essentially a "city painter," and that he (McLaughlin) was more concerned with nature.[139] While Newman's color is passionate, heroic, and rhetorical, McLaughlin's is quiet and spacious. Like the works of Newman and Reinhardt, however, McLaughlin's abstraction found its most appreciative audience in a succeeding generation. Referred to as "Painting at the Degree Zero,"[140] McLaughlin's art is now seen as a model for the Minimalist aesthetic that developed in the 1960s, particularly as it evolved in the ascetic, cool painting and sculpture of the Los Angeles area.

Operating within a related formal terrain as Smith and McLaughlin, Myron Stout established a more eccentric position in terms of both his approach and the content of his geometry. Generally described as a hermit or recluse, Stout essentially isolated himself in Provincetown, Massachusetts, between 1952 and his death in 1987, creating a strange body of frontal, curvilinear forms which the artist's friend and biographer B. H. Friedman termed "Metaphysical photographs."[141]

Stout made remarkably few paintings over a career that spanned some three decades. Given an attentiveness to detail that bordered on obsession, the artist often worked for

years refining and focusing a particular image; this sparse body of work was included in only three one-artist exhibitions between 1954 and 1980. Stout's highly considered output is all the more curious given the modest size of his works. While Stout has made works as large as three feet on a side, his images are invariably small, measuring usually twenty by twenty inches. Not surprisingly, Stout's geometry encompasses an abstract and contemplative state of mind that involves an acute sense of intimacy between painting and viewer. That Stout's paintings engage this intimacy is all the more remarkable given his strict palette of black and white.

Stout's journals, written between 1950 and 1965, include a wide range of references and acknowledgments, noting the artist's appreciation for the Greek tragedies of Sophocles and Aeschylus, Renaissance and Baroque art, Mondrian, Albers, and Barnett Newman. Of the latter two artists, Stout expressed admiration with reservation, seeing Newman's work as "over-refined" and Albers's as too "scientifically 'measured.'"[142] Stout identified more with what he saw as a mystical purism, one he associated with a previous generation that included Mondrian. Speaking of Mondrian, Stout wrote in 1960: "The earlier purists were so much more the poets and mystics in their work than any now practicing, and these are the very qualities which give their work more validity (together, of course, with a greater artistry) than that of the ones now practicing."[143]

Such statements notwithstanding, Stout also found his instincts at odds with Mondrian's dogmatic rectilinearity. Stout's mature works explore a bizarre family of images that combine an intensely crisp, though hand-painted, line with spontaneous, sensuous curves. It is an imagery that is at once obdurately flat, frontal, and emblematic in its clarity, yet mysteriously biomorphic, at times sexual in implication. Stout has readily acknowledged the anthropocentric qualities of his forms: "The source of a curve—of 'circularity'—is in one's body—not in the idea, 'circularity,' or 'curvedness,' and in my painted shapes every curve has its source in my body movements—or in my sense of them, my feeling of them."[144]

The artist has also remarked on the complex relationship between his images and those in Greek art. It is perhaps through the Greek tradition that Stout could come to terms in his own way with the mystical qualities and sense of proportion and balance he associated with Mondrian. As Sanford Schwartz has pointed out, Greek art "made him believe that his art could include a more vivid, human drama, and that this could be done without having to sacrifice those qualities of proportion and relation which had come to mean so much to him."[145]

Stout's curvilinear shapes initially surfaced as spontaneous gestures in the early 1950s. In an attempt to capture what the artist described as the "tragic poignance" he experienced while rereading the Greek poet Aeschylus, Stout found himself the author of two black-and-white paintings, each featuring a focused and iconic oval shape. Although ultimately dissatisfied with these initial pictures, Stout clearly established a powerful empathy for the austere solemnity of the curve. Throughout his career, Stout created a body of shadowy emblems pregnant with mysterious and highly personal meaning. Jed Perl noted "the oracular element in these pictures,"[146] in an attempt to bring together the sense of pictorial authority and mysterious wisdom of the artist's forms.

The density and tactility of Stout's forms, which at times border on being "overworked," provide a sense of process and history that subtly reveal his sense of surprise and doubt about the true nature of these forms. Even flatness, the overriding characteristic of twentieth-century painting, is for Stout an illusion. In his journal, Stout wrote:

I believe that flatness (as of the canvas, for instance) is something we never see, but only know. The eyes are not constructed to see flatness, and we come nearer knowing it through the sense of touch. If this is true, the basis of our apprehension of a painting has a duality of see-touch, or maybe better—touch-see, which sets up what is probably the primary, vivifying tension on the basis of which the "living"—the creative quality of a painting depends.[147]

A NEW ORDER: POST PAINTERLY ABSTRACTION

America had never experienced an artistic movement as provoking and as powerful as Abstract Expressionism. Although it took two decades for the movement's effects to settle in (c. 1945–65), there was a sense that, by 1955, American art had experienced a generation of painting that was truly profound. Indeed, Irving Sandler's classic text crowned it "The Triumph of American Painting," a title that not only celebrates the aesthetic triumph of American painting over European modernism, but also underscores the social-political competitiveness of Cold War America.[148]

The quivering anxiety and intellectual combat that resulted in Abstract Expressionism was by the late 1950s and early 1960s settling into the phenomenon of a grand style. The splashed field, dripped line, and swordsman-like stroke had come to seem more like a common emblem than an existential revelation; which is to say that what was shocking and revolutionary in Pollock or de Kooning had come to seem mannerist in the work of a second generation of Abstract Expressionists. Indeed by 1964, the concept of "gesture" could be used as a virtual cliché in Roy Lichtenstein's glib *Brushstroke, 1964*, made of mechanical Benday dots.

It was in this atmosphere that Newman's and Reinhardt's works were seen as prophetic. When the first generation of Abstract Expressionists were in the latter stages of their career, another was flowering whose attraction to pure geometric forms would verify and extend the bold accomplishments of Newman and Reinhardt. Geometric abstract art was again playing a prominent role in American painting. Just as there had been, with the influx of Surrealism, a reaction against geometric composition in the late 1930s and early 1940s, the late 1950s saw a reverse swing of the pendulum toward a cooler, more planar image.

Indeed, by 1960, the geometric image was emerging as a dominant form rather than an eccentric cousin to painterly, gestural abstraction. Clement Greenberg, who was central in signaling the development of Abstract Expressionism, also telegraphed this new change in the aesthetic climate. Greenberg's insightful writing and central role as a spokesman for Abstract Expressionism established him as a potent force in determining the direction of American art. As the sculptor John Chamberlain put it, "I don't know how many artists listened to Greenberg but a lot of people did. He was the captain of the ship at one point."[149] Chamberlain was friends with many of the emerging artists in the 1960s and his comments suggest that Greenberg's role was not simply that of observer but as an active agent in developing the direction of new art. Indeed, serious attention was given to Greenberg's assessment of the role that the post-Abstract Expressionist generation of American artists would develop. His prediction arrived in the form of what he called "Post-Painterly Abstraction." An exhibition held at the Los Angeles County Museum of Art in 1964, Greenberg's *Post-Painterly Abstraction* was an attempt to sum up the changes that were occurring in American art as it entered the decade of the 1960s. Using Heinrich Wölfflin's theory that art alternates in painterly and linear cycles, Greenberg recognized in the painting emerging in the late 1950s and early 1960s a swing toward linearity and clarity in design.

Greenberg's case stated that, "As far as style is concerned, the reaction presented here is largely against the mannered drawing and the mannered design of Painterly Abstraction, but above all against the last. By contrast with the interweaving of light and dark gradations in the typical Abstract Expressionist picture, all the artists in this show move towards a physical openess of design, or towards linear clarity, or towards both."[150] The author acknowledged that "The dividing line between the painterly and the linear is by no means a hard and fast one. There are many artists whose work combines elements of both, and painterly handling can go with linear design, and vice versa."[151] What was clearly evident in Greenberg's exhibition was that the large majority of artists used basic geometric forms to structure their imagery, a fact that indicated a new trajectory for American art. Although the rationale and quality of Greenberg's exhibi-

tion was questioned,[152] a number of the artists included in the presentation made seminal contributions over the next two decades, prominent among them Ellsworth Kelly, Kenneth Noland, Al Held, Gene Davis, and Frank Stella.

Greenberg's theory notwithstanding, many of the young artists in the exhibition came to geometry through personal and circumstantial reasons. For example, Ellsworth Kelly recalls having no direct knowledge of Greenberg or even of Newman and Reinhardt for that matter during the early 1950s when he was living in Paris.[153] Nonetheless, he was coming to similar conclusions in regard to the importance of an image that emphasized geometric clarity and composition. Following study at the Pratt Institute and the School of the Museum of Fine Arts, Boston, Ellsworth Kelly went to Paris in 1948. He attended classes at the Ecole des Beaux-Arts, and made contact with a number of the more important European abstractionists, visiting the studios of Arp, Vantongerloo, Sophie Taeuber-Arp, and Brancusi, among others. Kelly's early work in Paris was figurative in nature. He admits that though these figurative efforts were important to his development, they were essentially "a matter of admiration;"[154] in many cases, they were homages to Picasso and Matisse. Even these early efforts, however, demonstrate a keen interest in shape for its own sake, a quality that would characterize and inform all of the artist's mature, abstract work. In analyzing Kelly's figurative works, one is not so much aware of a given personality as the fact that particular shadows, patterns or background information become unusually dominant, projecting an unconscious isolation and division of the canvas into idiosyncratic shapes. As Diane Waldman would later describe these early works, "It is obvious that Kelly's fundamental interest is not in giving life to the sitter, but in restructuring or accommodating the figure to the requirements of the picture."[155] Kelly described these works recently: "I could see that certain sections seemed to take over the pictures but I wasn't quite sure why certain planar shapes just seemed more interesting to me."[156]

Eventually, Kelly's attraction to pure forms took over, and in the 1940s, the artist broke away from figurative painting and began works that were "shape and object oriented."[157] As Kelly put it, "Instead of making a picture that was an interpretation of a thing seen, or a picture of invented content, I found an object and 'presented' it as itself alone."[158] *Study for Window, Musée d'Art Moderne, Paris,* exists both as an austere and seemingly abstract geometric relief and as a replica. According to the artist, "I was fascinated by the *Window* piece because it seemed non-objective and very formal, but at the same time very real, in the sense I was not strictly inventing a shape. The source was found and existed beforehand."[159]

Kelly recently noted that when he was in Paris, "The Parisian art world seemed to feel my paintings were too American. I suppose they meant Newman and Reinhardt, though in retrospect they might have been more correct in saying Johns and Stella. Of course, when I returned to the States the Americans thought the work was somehow too Parisian, meaning Arp and Mondrian."[160] Although the association is not often made, Kelly's early Paris works affirm, if not predict, the literalist direction presented in Jasper Johns's "Flags" and later Frank Stella's shaped canvases. *Window, Musée d'Art Moderne, Paris,* 1949, also clearly predicts the artist's later method of joining separately painted canvas panels, as well as his special sensitivity to the tensions between positive and negative space.

In the early 1950s, Kelly became involved with collage, a technique that reinforced his predilection for found images and his attraction to shape as defined by unbroken areas of color. Inspired by the chance compositions of Jean Arp and Sophie Taeuber-Arp, Kelly began to cut various shapes at random and juxtapose them in an intuitive manner. Collage allowed him to bring together unrelated shapes in an expedient manner. These images reinforced his penchant for segmenting reality into simple yet precise and summary forms. He remarked recently, "At the time, whenever I would see something it seemed to come together as a collage. I was seeing images as shapes, as a collage of shapes, a system of remarkable visual facts, rather than for its practical or social

Ellsworth Kelly in his studio-room, Hotel Bourgogne, Paris, 1949. Photograph by Ralph Coburn

meaning; a church, a bank, a staircase, etc. I almost thought of it as a kind of affliction."[161]

Kelly invariably searched out forms that are generally overlooked, such as the fragmented play of shadows on a staircase, which in his *La Combe I,* 1950, becomes a highly formalized geometric abstraction in which blips of black form animate a white ground. Although Kelly refers to such works as "finding in nature what I had been doing in collage,"[162] there is, in fact, little to indicate their original source. A formal outgrowth of this approach of silhouetting significant forms is the shaped painting, an innovation Kelly would introduce into his work in the early 1950s and which became a significant aspect of his canvases in the mid-1960s.

Kelly returned to New York in 1954 and rented a studio at Coenties Slip in lower Manhattan, residing in the same neighborhood as Agnes Martin, Jack Youngerman, James Rosenquist, and Robert Indiana, all of whom shared with Kelly an interest in flat, reductive abstraction. During the early 1960s, Kelly began painting large biomorphic forms and elegant, sensuous curves, along with the more rectilinear forms related to architecture. While many of his curvilinear works of the mid-1950s have a biomorphic quality that one associates with Arp, they are like his earlier works, which were based on subtle but acute nuances of perception in nature: a hillside, the back of a leg, a wire that had fallen across a blank page.[163]

In a few instances Kelly puns the equivocal nature of his vision. In the late 1950s, the artist did a series of paintings based on letters and numbers. *New York, N.Y.,* 1957, which is based on an exaggerated rendition of the letters that form the abbreviation for the city, can be seen also as an eccentric outline of a landscape of New York City skyscrapers or as an abstract configuration. The painter James Rosenquist, a seminal participant in the Pop art movement, who saw *New York, N.Y.* in Kelly's studio at Coenties Slip, acknowledged recently that he often thought of Kelly as the first Pop artist, because of the cool, emblematic quality of Kelly's abstractions and their oblique relationship to signage.[164] Looking at this work abstractly, it becomes a kind of figure-ground riddle. One initially looks at the white sections as the figural element and the black as background, but after a moment it becomes possible to see the black as figure, or in this case landscape, and the white as the ground or sky. Eventually the juxtaposition of views becomes less the point and one experiences the images' complex unity and holistic character. Kelly said recently, "*New York, N.Y.* is somewhat the reverse of a Kline. It's primarily a white picture with a black ground. That's how I initially read it. But I often try to see things from different viewpoints, and I can imagine saying something to Jim [Rosenquist] about viewing it as a landscape."[165] Like Johns, Kelly suggested in his work of the late 1950s and early 1960s an emblematic quality that the Pop artists would fully exploit and extend in a figurative way.

Throughout the 1960s, Kelly continued to place huge, enigmatic forms on grounds that could barely contain them, until the image eventually squeezed the ground out of the picture: figure, ground, and supporting canvas became one unified entity. At the same time, he increased the size of his pictures. Like Newman, he saw that color and shape operated more effectively when given a larger area. In the late 1960s, Kelly eliminated the figure/ground relationship and began to produce works by joining panels of separate colors, juxtaposing stark combinations of squares and rectangles. Such is the case in the "Chatham" series. The inspiration for the format of the "Chatham" paintings is the profile of the *Winged Victory of Samothrace,* a work that Kelly knew from his trips to the Louvre during the early 1950s.[166] The famous Greek statue of a poised victory figure, with elegant, horizontal wings balancing the vertical thrust of the figure, is paralleled in the vertical-horizontal balance of the "Chatham" works. Kelly has transformed the original source into a pristine geometric abstraction, revealing only the formal essence of the dynamically balanced figure through the joining of a yellow and blue rectangle, the buoyancy of the supporting yellow form keeping the blue "wing" suspended in space.

Opposite:
Agnes Martin and Ellsworth Kelly in Kelly's studio, Coenties Slip, New York, 1958. Photograph © Hans Namuth 1958

Ellsworth Kelly, *Doorway to Hangar, St.
Bartholemy,* 1977. Black-and-white photograph,
8⅜ × 12⅝". Collection the artist

58

Color is often the first element of Kelly's paintings to make an impression. His economy of means intensifies the value of each hue. Rather than being subsumed by a figurative element, color instead envelops the viewer in its own presence and richness. Most artists interested in creating large areas of even color tend to use acrylic paint; Kelly works in oil because of its density and unique luminosity. Acrylic paint, though very neat when used flat, results in a dematerialized image of color; oil, on the other hand, can be built up solidly until it is more like a rich satin wall. Although Kelly insists on painstakingly applying his paint with a brush — "to achieve a grip without too much slickness" — the color is applied so evenly that the viewer's eye floats just on the surface plane of the color, neither penetrating an absorbent void nor being deflected by a hard, polished surface. This barely perceptible modulation of color allows Kelly's unique shapes to perform in concert with his color fields. Created as well is a quality of line, not drawn or brushed, but characterized by razor sharp edges which seem to incise themselves against the surface of the wall. In his exploration of mass, line, and color, Kelly has brought together the lessons of Matisse's late cut-outs and Newman's broad fields.

As with Barnett Newman, large scale has played an important role in Kelly's art. In the 1960s and 1970s, Kelly extended his sensibility for the literalness of painting into a larger, more architectural domain. He recalled succinctly, "I just replaced the painting ground with the wall. At that point, I didn't see them as strictly pictorial statements. They were very literal, dealing with the space and architecture of the room."[167] Indeed, Kelly's recent paintings activate huge expanses of wall, as his images embed themselves into the white field. Unlike many of the Abstract Expressionists, particularly Rothko and Newman, who urged viewers to look at their large paintings from relatively close up, so that the works would engulf the viewer's peripheral vision and create a more intimate experience, Kelly prefers that his images be seen from farther away. "I like to have people see my works from a distance, not much closer than twelve feet. I want you to get a sense of the edge and its dialogue with the wall."[168]

Although Kelly's work is consistently cited as an important example for Minimalist artists of the 1960s, the artist downplays the association. Indeed, his imagery is tied to nature in a way that separates it from the obdurately systematic and gridded forms of Minimalist sculpture and painting. The result of Kelly's process is a highly ascetic abstraction. The factual nature of Kelly's art, that is, the supportive evidence that his shapes exist in nature, is revealed in the photographs Kelly has been taking since the late 1940s. The collection encompasses a mélange of images and details — rooftops, odd shadows, the curve of a leg or horizon, doorways, the space between two objects — that seldom bear a direct relationship to Kelly's paintings but sustain a fascinating affinity. Kelly paints from memory, however, never photographs. Indeed, the photographs are often taken after the fact, becoming a means of verifying — for the artist as much as the viewer — his peculiar vision: "I feel a certain ambivalence toward the photographs, but in the end I find them helpful, supportive to the seeing. But supportive after the fact. I have never made a painting from a photograph, and I am sometimes concerned that when they are shown in relation to each other people might think that. I almost see them as drawings, of sorts, drawings after the event, a way of clarifying for myself what I've done."[169]

With the tenets of "Post-Painterly Abstraction," Greenberg suggested a form of modernism developed to its most radical formalist point, an art of pure opticality. For Greenberg, modernism had evolved so that visual art, in order to maintain its distinction from other arts, must focus exclusively on its inherent physical characteristics: in painting that meant surface, color, shape, and support. The metaphysical qualities and underlying symbolic or allegorical themes associated with earlier phases of expressionism were to be eliminated in a rite of ascetic purity that focused exclusively on the inherent properties of painting. While this had been an important aspect of nonobjective painting of the twentieth century, Greenberg's view of a Post-Painterly Abstraction took it to a seemingly unprecedented point. In essence, "style" became content in the sense of pure,

unadulterated pictorial invention. Greenberg's theory reaches its most systematic form with the publication of his *Modernist Painting* in 1961.[170] The criticism of Michael Fried, published in *Artforum* in the later 1960s, elaborated Greenberg's proposition.[171]

One of the most coherent and direct examples of Greenberg's theory emerged in the paintings of Kenneth Noland. The clarity of Noland's geometry and his eventual development of the stain technique for applying paint so that surface and color merged, established the balance between clarity, nonpainterliness, and flatness that Greenberg espoused. Noland studied art and music at Black Mountain College from 1946 to 1948; there he met Clement Greenberg and established not only a professional relationship but a personal friendship as well, one that has continued to the present. Indeed, Greenberg acted as a kind of tutor during Noland's early development. Noland has said that on many of his visits to New York he would see Greenberg, and that he could not think of anyone whose opinion he respected more.[172]

Noland's involvement with geometric clarity predates his involvement with Post-Painterly Abstraction. While at Black Mountain, he studied with Josef Albers and Ilya Bolotowsky, an apprenticeship that was steeped in the use of the geometric image. Albers's strict use of geometry and his emphasis on frontal balance, flatness, and color interaction find their legacy in Noland's intuitive juxtaposition of color bands and symmetrical concentric designs. Although Noland had only short periods of contact with Albers at Black Mountain, he has acknowledged his debt to the elder artist.[173] Kenworth Moffett has pointed out that "Noland familiarized himself with Albers' color theories, and, later, when teaching at Catholic University in Washington, D.C., he offered a course on the fundamentals of design patterned directly on what he had learned in Albers' class."[174]

Bolotowsky also offered Noland an insight into European geometric abstraction and particularly the work of Mondrian, which Noland very much admired. While Bolotowsky's painting evolved primarily from Mondrian and Neoplasticism, his works were distinguished by their more experimental, nonprimary colors and his involvement with a variety of shaped canvases. In a revised manner, Noland would later utilize many of these formats in his own work.

Noland lived in Washington, D.C., between 1949 and 1962, and it was there that he met his friend and "painting buddy,"[175] Morris Louis. During a visit to New York in early April of 1953, Noland introduced Louis to Greenberg, who took the two artists to Helen Frankenthaler's studio, where they saw her poured stain paintings. Noland and Louis were invigorated by Frankenthaler's art. According to Noland, "We were interested in Pollock but could gain no lead to him. He was too personal. But Frankenthaler showed us a way—a way to think about, and use color."[176] Returning to Washington, Noland and Louis worked together for a number of weeks staining color directly into raw canvas, searching for new ways to create configurations on the canvas. At times they would work together on the same canvas, first draping it over variously sized objects placed around the floor. They would then pour paint onto the surface and watch its meandering flow into the valleys and creases. Following this period of so-called jam painting, the artists began experimenting individually.[177]

Although Noland was attracted to the process of staining as an important intuitive aspect of his art, he began to search for a more stable image that would avoid the murky Surrealist space that often resulted from pouring. His work is often described in terms of the development of his simple but iconic shapes. Indeed, one of Noland's contributions is the development of a type of composition that could be grasped immediately as a single totality. By the mid-1950s Noland's imagery, though still essentially expressionistic, was becoming increasingly geometric, and by the end of the decade, he had discovered the circle motif. As with Jasper Johns's targets, the circle offered Noland an image that was immediately recognizable, on one hand, and abstract on the other. For him, it was also a perfect vehicle for experimenting with color. While Albers had used the square, Noland

exploited the centering quality of a target image as a means of aligning bands of color in sequence. The targets are paradoxical. On one hand, they are direct, emblematic, and flat: the stained colors, calibrated to establish equal intensity across the picture plane, do not float on the surface but exist as part of it. At the same time, the rotary character of the composition suggests a subtle but dynamic spinning effect.

Following the circular works, Noland experimented with a variety of motifs, among them chevrons and diamond-shaped canvases with diagonal stripes and, in the late 1960s, compositions based on long rectangular canvases with variously colored horizontal stripes. For Noland, the horizontal paintings represent his most fruitful breakthrough. In order to achieve an even more precise edge between colors in the horizontal works he employed masking tape. By this point as well Noland had begun using plastic-based paint because it allowed him to thin the paint easily. As the artist put it, "Thin it, use it in the same way as dye. Thinness reveals color."[178] In speaking of his horizontal paintings, Noland concisely summed up his ambitions as an abstract painter. "These paintings . . . are the payoff. . . . No graphs; no systems; no modules. No shaped canvases. Above all, no thingness, no objectness. The thing is to get that color down on the thinnest conceivable surface, a surface slided into the air as if by a razor. It's all color and surface, that's all."[179]

Although radically basic, Noland's imagery appears almost lyrical in relation to the paintings of Gene Davis, also included in Greenberg's Post-Painterly Abstraction. Both Greenberg and Noland saw a kindred spirit in this artist who shared their intelligence for color and flatness, and who had radically narrowed his vocabulary to fields of austere vertical stripes. Noland befriended Davis in 1950 and gave him an exhibition in 1953 at Catholic University.

Davis's use of the stripe resulted from a good deal of experimentation. Following a brief career as a political journalist, Davis, without any formal training, began painting at the age of thirty. During this period (c. 1949–50), Davis started visiting the Washington Workshop, where he became acquainted with Louis and Noland, and also with Jacob Kainen, a painter and printmaker who became an early mentor. Throughout the 1950s, Davis worked primarily in an expressionist, painterly manner, occasionally experimenting with various forms of collage. Although vertical stripes began to appear as a dominant part of his compositional format in such works as *Stripes*, 1957, the artist dated his first mature stripe paintings to 1958.[180]

Clement Greenberg and Kenneth Noland, 1982.
Photograph by Cora Kelley Ward

Davis, along with Louis, Noland, and other Washington-based painters, eventually became associated with the Washington Color School. A loosely defined group of painters, they espoused Greenberg's theories of literalness and flatness. Louis and Noland introduced Davis to the possibilities of the unprimed canvas, particularly its ability to help establish a taut, flat surface image.[181] Noland's targets may have also helped to reinforce Davis's interest in a centered, holistic image that could be perceived with immediacy and that would not distract from the performance of color.

Davis's geometry coalesced quickly. Unlike Noland, who was interested in the stripe only as a formal device, Davis was interested in the stripe as subject matter as well. In this sense, Davis's stripes relate even more poignantly to Jasper Johns's "Flags" and "Targets," in the sense that they both share a pre-Pop attitude toward the appropriation of common images in the environment, which can be seen simultaneously as familiar image and abstraction. Indeed, Davis was not afraid to compare his striped images to wallpaper. "I can see these paintings as 'wallpaper' in a positive sense. It's no different than Johns' flags in that sense. It's just using a found image—stripes are in dresses, wallpaper, awnings, etc.—and transforming it into an art context. It's really no different than using soup cans, comic strips or an American flag."[182] Davis's interest in a vernacular imagery that could be transformed into a geometric art was clearly reinforced, if not triggered by Johns's early paintings. Davis once remarked, "I remember being extremely impressed with an *Art News* cover in 1958 of Johns' target. I still have it upstairs. You know, when you've been used to looking at Milton Resnick and de Kooning and Philip Guston, and you pick up a magazine and suddenly there is a totally symmetrical cliche on the cover and it's presented as art—it's a bombshell. So I figured what the hell. I'll do some stripes. If he can do that, I can do stripes. So my stripes were not motivated exclusively by formalistic considerations."[183]

In the end, however, Davis's art falls on the side of what was becoming a powerful abstract geometric tradition in American painting. Indeed, his paintings rely finally on color, line, and plane to convey their essentially formal content. In this sense, Barnett Newman was an even more central figure for Davis, who said,

I had always admired Barnett Newman's work. I saw his first show at the Parsons Gallery in New York in 1951. It impressed me very much. Throughout the mid-fifties—a period dominated mostly by de Kooning—I thought about Newman, even though I was still painting under the influence of de Kooning. . . . All through the de Kooningesque period I was slashing away, but stripes found their way into a number of works. I don't know why. . . . Of course, Newman must have been in the back of my mind. In fact in the fifties I thought so much of Newman, I tried to buy a Newman painting. I wrote to him, telling him how moved I was by his work and asking if he would sell me a painting.[184]

The planar and coloristic assault presented by Newman's paintings seemed to Davis powerfully emotional and unitary.[185] Through Newman, Davis could see the stripe as a central means of experimenting with color. The stripe carried with it what Davis called "a built-in unity" which allowed him to take "fantastic liberties" with color.[186]

Davis achieves a sense of classic balance or dynamic equilibrium by varying a number of components. By calibrating a relationship of subtle tension between the length or height of the stripes and their width, as well as their horizontal extension across the canvas, Davis achieves a dynamic field that suggests the viewer be centered in front of the canvas. Though Davis's vertical stripes are balanced with a repetitive horizontal extension, the paintings nonetheless suggest a powerful sense of Gothic verticality and ascension. It is through this sense of a type of vertical doorway that Davis achieves the kind of space that enfolds the viewer. According to Davis,

my paintings measuring less than eight feet generally tend to work less well than those that are over eight feet. The ideal height for my work would be about ten feet. Although this is sort of impractical since very few rooms are ten feet high . . . when you get into paintings only six feet high, somehow it is no longer a world. It tends to become more of an object. And I'm really not

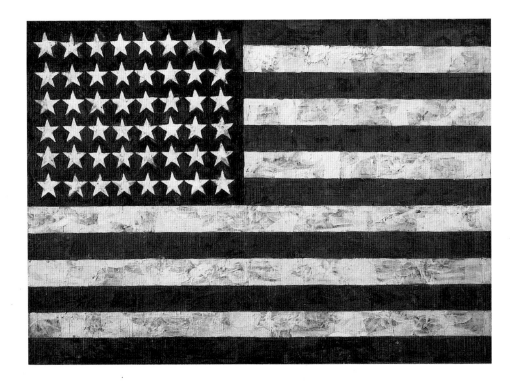

Jasper Johns, *Flag*, 1954–55. Encaustic, oil, and collage on fabric mounted on plywood, 42¼ × 60⅝". Collection The Museum of Modern Art, New York. Gift of Philip Johnson in honor of Alfred H. Barr, Jr. Photograph courtesy The Museum of Modern Art, New York

interested in making objects. I'm interested in the painting as a world into which one can enter and sort of stroll around visually.[187]

Davis has also noted his interest in intervals, comparing the distance between one colored band and another to the character of intervals in music.[188] He has referred to this exploration as

a spatial abstraction of time [explaining that] if the viewer selects individual colors and looks at them across the surface of the work, he's almost reliving the painting process, because I often do put all of one color down at one session. And then I'll come back and use another color. The viewer begins to see how this single color reacts in all its different relationships with other colors. Also, the spectator is, in a sense, entering into kind of a time experience in the same way that I did when I painted it.[189]

As with Noland's work, color rather than structure is the overriding principle in Davis's art. The essential experience is an assaultive plane of color. As an almost independent, disembodied phenomenon, the color sequence of a given Davis painting can be ominously dark, shockingly bright, or humorously generic in the sense of a storefront awning. In many cases, a single composition will incorporate all of the aforementioned.

Some have argued that the apparent radicalness of Noland and Davis is not radical at all but rather is an instance in which abstraction had for all intents and purposes become academic; an art in complicity with art criticism rather than with expressiveness, a form of "bloodless abstraction."[190] On the other hand, Davis has argued persuasively for the expressiveness of these paintings, but in terms quite different from those of a previous generation. What Davis's work expressed was a total change of aesthetic climate, a change which, as a former political journalist, he saw also reflected in the politics of the time. He was cognizant of the fact that the world had transformed its strategies; the moral passions of a "hot war" had evolved to the more intellectualized strategies of a "cold war." As Davis put it, "We made art during the Cold War. Of course, we were affected by that situation. It doesn't mean the art wasn't expressive. It required a different kind of expressiveness. I think we thought of it as approaching the sublime, but with a sense of irony and soberness."[191] Davis eventually expanded his vocabulary to include an environmental situation, expanding on the Bauhaus concept that art and architecture should achieve complementary dialogue. These were not simply large, singular canvases of color, but entire rooms or parking lots animated with the artist's exuberant stripes.

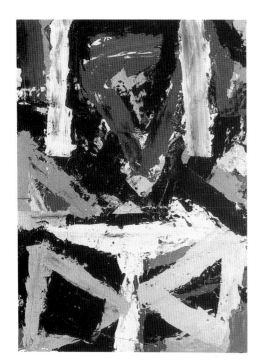

Al Held, *Untitled*, 1959. Oil on canvas, 72½ ×
54¾". Collection Albright-Knox Art Gallery,
Buffalo. Gift of Seymour H. Knox, 1986

Al Held's work in *Post-Painterly Abstraction* also focused on color as a primary formal element, yet the subsequent development of the artist's geometric imagery presented a number of other complex issues. Indeed, not all of Held's solutions fit Greenberg's strict view of modernism's development. Prior to his inclusion in Greenberg's presentation, Held had lived in Paris painting in a manner that attempted to splice the expressionism of Pollock with the structured clarity of Mondrian's geometry, an attempt, in Held's words, to combine the "subjective and personal handwriting of Pollock with the incredible clarity of Mondrian."[192] In a recent interview, Held reflected on those ambitions:

That was twenty years ago! I said it facetiously . . . I was really recounting my youth. How naive I was to think that I could simply take this and this and put it together . . . it's not that easy. At the time of that quote I was about 22 in Paris. I was dripping paint and putting it into geometric pigeon-holes. I figured that if I took the geometry and the dripped paint and put them together in a simplistic way I would get a universal.[193]

In his first mature works of the late 1950s—now called the "pigment paintings"—Held in fact achieved a unique and successful integration of gestural paint application and geometric order. In exchange for the lateral, circular explosiveness of Pollock, Held focused on a kind of existential layering of virtually pounds of pigment that congealed into networks of turgid, interlocking shapes that could be read either as immense strokes of paint or dense bricklike planes of color, creating a dynamic tapestry-like effect.

At this point (Held essentially launched his career with the pigment paintings at his first solo show at the Poindexter Gallery in 1959) the artist's development was in an accelerated state, evolving more toward architectonic clarity than gesture. Following the pigment paintings, Held immediately began to feel uneasy with what he increasingly saw as the "schmaltziness, the mushiness, the ambiguous quality"[194] of a gestural approach.

By the early 1960s, the artist had radically redefined these planar gestures into more precise geometric shapes, establishing immense puzzle-like configurations in which each section seemed to pressure its neighbors out toward the containing edges of the canvas. It was in these works—referred to by Irving Sandler as "concrete expressionism"[195]—that Held successfully brought Mondrian's clarity to mural-sized fields of color. Held continually refined this vision through an almost obsessive drawing. "In those days I would draw and redraw that edge. I would try and slow it up, till it would get a form and a presence, almost to transform a shape into a form. It came from a desire to believe in something. I just couldn't believe in a general concept like flatness, or floor, or ground, or whatever else was around."[196]

Held continued to grapple with the problem of reaching a personal subject through a very specific and idiosyncratic type of geometry; his ambition led him to subjectify geometry in a new and vigorous way. Rather than using Newman as a model (a likely reference in this regard), Held was attracted to the ragged forms of Still as well as to the ethereal bands of color in Rothko's works. As he remembers it, his attraction hinged not on particular forms, but the "presence of the form, not in terms of divisions, but in terms of presence."[197] Held utilized geometry to explore his own kind of "specificness," forms that would illustrate a sensation but would have a highly personal sense of recognizability and factualness for the artist. As Held put it, "It wasn't any circle, but that particular circle. I tried to hook up to something that was real."[198]

Held's images of this period became increasingly iconic, eventually congealing into monumental letter forms. *The Big N*, 1956, depicts an immense field of white that is punctuated at top and bottom with small colored triangles, which alternated visually between an immense abstraction and a huge figure N. Like the refreshing forthrightness of Davis's stripes, Held's images of this period evoke the scale, punchy color, and exuberant clarity of American advertising and its fine art progeny, Pop art, yet in ironically abstract terms.

In 1967, Held shifted his attention from single, iconic shapes to more complex

networks of geometric forms. He also restricted his palette to black and white in order to emphasize complex structural and spatial relationships, drawing even more heavily on Gestalt psychology and the mental process in which the mind perceives a single image in different ways, depending on which formal elements of an image it focuses on. Beginning in the late 1960s, Held painted vast networks of geometric configurations—rings, cubes, triangles—that when interconnected across the surface of the picture plane, suggested a variety of perspectival vantage points. The result was a dense and energetic multiple-focus image that bewildered viewers. This new development in which illusionism played an important role also broke with Greenberg's dictum that in order to achieve ultimate honesty, abstract painting had to convey the quality of flatness. In describing these new works, Held has said,

As contrasted with the work of the sixties when I wanted to make everything highly specific, now I'm involved with structures, how they go together and come apart. What I try to avoid continually is an eccentric shape or eccentric situations. I don't want you to focus in on a particular point and say, 'what is this? what is this really? is it an odd thing that I have to figure out?' I want the eye and the mind to relate to it in terms of equations. I'd like to think of these paintings as algebraic—as circle is to square is to triangle. So the quotations are abstracted insofar as I want you to deal with the algebraic configurations rather than the uniqueness or oddity of each individual form. What this depends on is some kind of gestalt completion. A lot of these things are fragmented, and I count on your completing them. I can play all kinds of games.[199]

Held transforms his oblique and intense sense of drawing into a surprising form of linear geometric fields. Of a number of contributions and breakthroughs Held has made within the American geometric tradition, one of the most profound is his unique integration of drawing to create an ambiguous space that appears to expand and fill the image in geometric progression. "It's not as though I think of drawing all that consciously, but I sometimes reflect on it as drawing or diagramming a space."[200] Held's exclusion of color for austere black-and-white contrasts not only helped to set his ambiguous structures in illusionistic relief but also functioned to facilitate a strong sense of light in these pictures. Although elaborately diagrammed, Held's abstractions evoke an ethereal light-emitting quality. In recent years Held has returned to the use of color, adding yet another element to complicate further the multidirectional qualities of light and space which the artist has been exploring for over two decades.

A number of the artists included in Greenberg's *Post-Painterly Abstraction* exhibition were also featured in The Museum of Modern Art's presentation of the following year, *The Responsive Eye*. This exhibition launched the popular movement known as Op art. Few movements have suffered more from the fickle fortunes of taste than Op painting, which reflected the intense sense of scientific idealism of the 1960s.

Based primarily on the ability of various color combinations to fool the eye, creating the vibrant illusion of depth or volume from simple, flat strips of color, Op art at its most basic level appeared as an art of rudimentary visual science and gamesmanship. As a movement, it was embraced by the museum-going public with swiftness and a keen appreciation for novelty. Although it launched the careers of a number of important practitioners, it is still viewed by some as the art world equivalent of the Hoola Hoop. As one artist prominent during the period put it, "It is the only movement I can remember in Postwar art that was thought of as 'fun'." With its "cool" geometric structure and vibrant use of color, Op could also be easily, if only temporarily, applied to various fashion design strategies of the period.

Seen somewhat more objectively, however, Op art and its various interpretations were a logical extension of American painting in the 1960s. In the paintings of Albers and Reinhardt, color is explored in perceptual rather than symbolic terms. Their work, along with the proliferation of popular texts on perceptual psychology in the late 1950s,

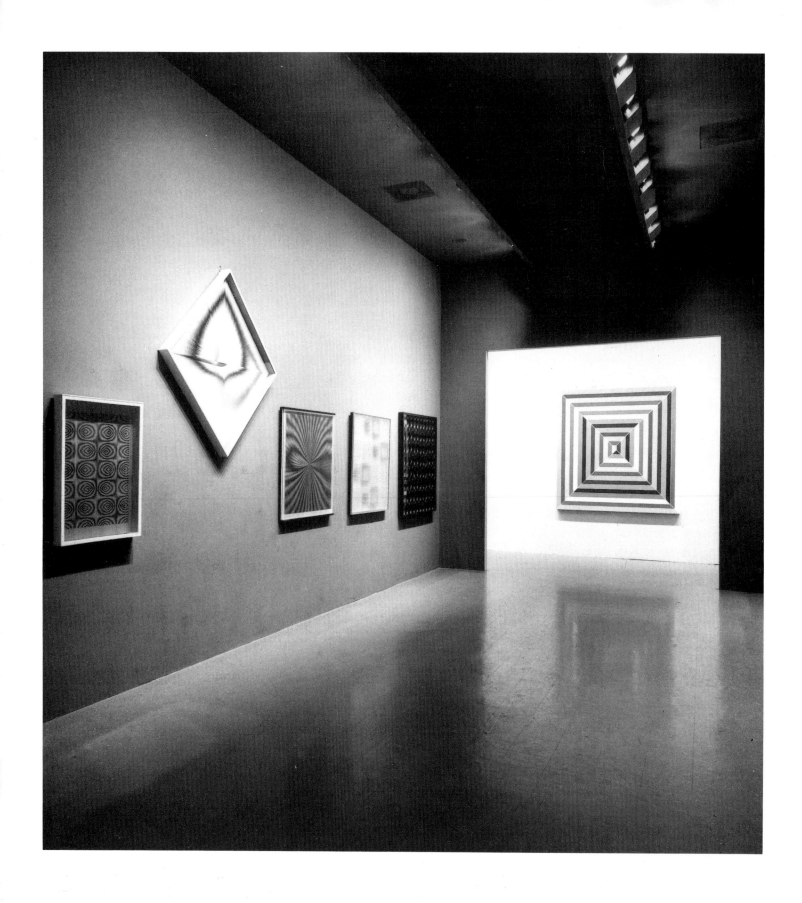

Installation view, *The Responsive Eye*, The Museum
of Modern Art, New York, February 25–April 25,
1965. Photograph by George Cserna; courtesy
The Museum of Modern Art, New York

Opposite:
Richard Anuszkiewicz painting an Op art coat,
1963. Photograph courtesy Richard Anuszkiewicz

provided the impetus for numerous followers who became involved with simple geometric compositions and the use of high-contrast, high-intensity color.

Albers's penetrating research into how given colors change and influence each other was particularly influential, providing the basis for the paintings of one of his most celebrated students, Richard Anuszkiewicz. While in graduate school at Yale, Anuszkiewicz gradually turned away from realist painting as a direct result of being exposed to Albers's empirical teaching methods and emphasis on color relativity. By the late 1950s, representation had been completely eliminated from Anuszkiewicz's paintings in favor of complex networks of abstract geometric shapes carrying a range of complementary colors that created confounding figure-ground relationships, offering contrasts between recessive and projective space.

Although Anuszkiewicz's works were initially subsumed under the rubric Op, the subject of his work has never been optical illusion, per se, but the visual function of color. In Anuszkiewicz's paintings, optical illusion functions to structure the interaction of colors. Anuszkiewicz uses essentially three types of compositions to activate his colors: repeated, concentric geometric shapes, which the artist calls "periodic structures"; a series of variously arranged or abbreviated periodic structures, which he calls "interrupted systems"; and the use of rectilinear forms juxtaposing intensely contrasting colors, creating a powerful luminous effect which the artist calls "irradiation."

The optical buzz created by Anuszkiewicz's thin divisions of color differs from the "push and pull" effect in Albers's concentric squares, yet both painters demonstrate a strong interest in light. In Albers's work, the light has an almost pastoral quality. In Anuszkiewicz's paintings, the light is more aggressive, more like electric light. Anuszkiewicz has said that he has always felt as sensitive to indoor light as to that produced in nature.[201] For him, light is an exceedingly complex phenomenon that is as emotional as it is "scientific." Indeed, the artist does not see his paintings as purely optical. He has said, "I'm interested in making something romantic out of a very, very mechanistic geometry. Geometry and color represent to me an idealized, classical place that's very clear, and pure. In a way, I always try to infuse my paintings with that."[202]

Ludwig Sander's contribution to Greenberg's exhibition was comparable to that of Noland and Davis, but with stronger ties to the European tradition of geometric abstraction, particularly in relation to Mondrian. One of the elder statesman of Post-Painterly Abstraction, Sander studied with Hofmann in Munich in the 1930s and later befriended a number of the American Abstract Artists (Carl Holty and Burgoyne Diller, for example), sharing with them a profound respect for Mondrian's paintings. As it was to his colleagues, the question of where to take Mondrian's geometry and strict sense of color remained a central concern.

In his early paintings, Sander worked through Mondrian's elemental Neoplastic formula of vertical and horizontal lines defining asymmetrical grids of primary-colored rectangles. His early works explored the equivocal manner in which Mondrian's colored planes maintain their places yet break subtly in and out of their formations to create a sense of vibration. At the same time, Sander experienced the post-Neoplastic breakthroughs of Abstract Expressionism. Based on the artist's assimilation of Abstract Expressionism's idiosyncratic gesture and a heroic enlargement of the picture to fieldlike planes, Sander's work redefined many of Mondrian's basic tenets. His manipulation of Neoplasticism came primarily in the form of deviations in color and line.

In his mature works, Sander's color schemes diverge radically from Mondrian's. In contrast to Mondrian's strict use of primaries, Sander arrived at his colors intuitively, often mixing color to achieve a spacious pastoral quality. Sander's large-scale works, characterized by a limited number of "impure" blues, yellows, and greens spread over a large surface, allowed his images to be perceived as a single field in which the color achieved a striking richness and sense of body, rather than as accents carefully distributed across a picture plane.

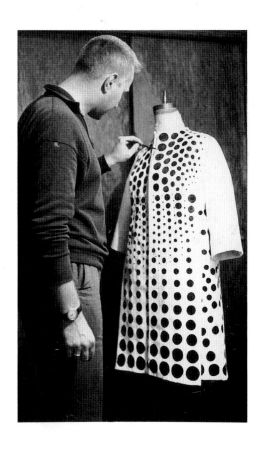

The work also evidences a subtle painterliness in the linear divisions of his colors that deviate from the almost strict, machine-like horizontal and vertical divisions of Mondrian. Although Sander's divisions are invariably geometric, they gravitate away from horizontals and verticals toward the more subtle diagonal. Moreover, Sander's line has a more natural, spindly quality, as if the color spaces were squeezing the lines into a gray neutrality, that of a distant horizon line. Irving Sandler has implied that Sander's expansive planes of color suggest the space of landscape,[203] a suggestion that has also been related to the Abstract Expressionists.[204]

As with the Abstract Expressionists, Sander's approach grew out of a highly intuitive sense of expressionism rather than from the rationalist sensibility that drove Mondrian. Like Newman and Reinhardt, Sander employed geometric form to achieve a highly personal sense of color space. At the same time, he explored an aesthetic niche that in a sense split the difference between Mondrian and the Abstract Expressionists. Rather than the hard and crisp primaries of Mondrian or the passionate and fiery, or at times provocatively somber, colors of the Abstract Expressionists, Sander's colors and images are characteristically vibrant yet diaphanous, with an exceptionally light and airy quality.

Without question, of all the artists included in Greenberg's *Post-Painterly Abstraction*, Frank Stella, by means of his imagery of the late 1950s and early 1960s, emerged as the most shocking and controversial. If by the late 1950s Abstract Expressionism was beginning to seem like art from an older, more romantic period, the stark, seemingly brutal, and conceptual nature of Stella's early paintings accelerated that feeling by light years. What appeared in Abstract Expressionist painting as heroic bravura, must have seemed in Stella's art a kind of ruined grandeur.

In 1958, Frank Stella began a series of works that would become known generically as "The Black Paintings." By early 1960, he had completed twenty-three paintings in the series. In 1959, "The Black Paintings" were exhibited in Dorothy Miller's *16 Americans* exhibition at The Museum of Modern Art. As Irving Sandler later recalled, these paintings "stunned the New York art world and, in retrospect, would seem to mark the end of Abstract Expressionism as the avant-garde."[205]

These large, seemingly demonic paintings, executed with commercial enamel paint on raw canvas, are principally concerned with symmetry and the removal of any sense of three-dimensional space from the picture. They consisted of approximately 2½-inch black bands separated by narrow strips of unpainted canvas, no line more dominant than another, and continuing right up to the framing edge of the painting. Their presence was that of a bold unified design. In the wake of Abstract Expressionism, these works were shockingly rationalistic. "The Black Paintings" constitute two types of designs: rectilinear patterns in which the linear bands run parallel to the edge of the canvas, reinforcing the rectangular shape of the painting and uniting it with the image; and diamond-shaped patterns in which the linear elements of the diamond meet the edge of the canvas at an angle, again bringing attention to the rectangular support of the picture while establishing a dynamic tension between that shape and the internal design. Stella was not focusing his attention on lofty metaphysical ideals but on the practical issues of adapting a design to an object.

In relation to even the most austere forms of abstraction, these paintings are shockingly puritanical, eliciting at the time of their emergence a variety of nervous responses from critics and curators. Visiting Stella's studio around 1960, Alan Solomon felt a sense of confusion and bewilderment upon seeing them.[206] Museum director Abram Lerner wrote, "I recall that of all the 'difficult' work that appeared in the late fifties, these lined Stellas were the most difficult to accept."[207] Later, referring to the new art for which Stella's "Black Paintings" would become a model, Lucy Lippard wrote, "Existentialist art has been replaced by an anticlimactic art founded on the same principles of opposition to the easy, but expressed in noncommittal, nonevangelical

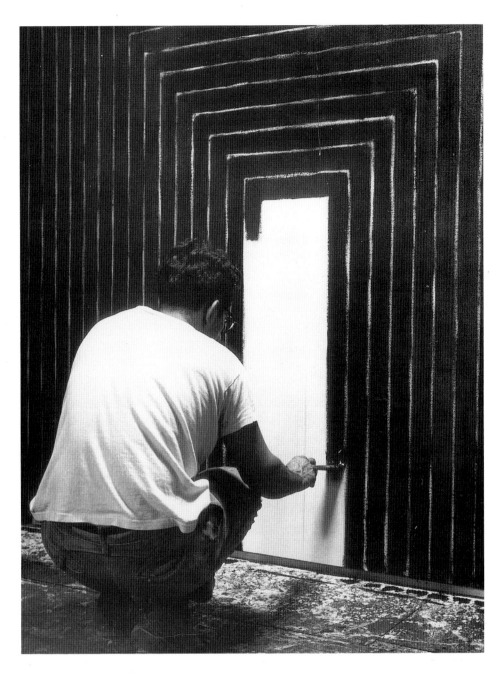

terms."[208] William Rubin summed up the feelings of many, writing that "When Stella's Black Paintings first appeared, they seemed to many to have come virtually from nowhere, to have no stylistic heritage, and to represent a rejection of everything that painting seemed to be."[209]

With current hindsight and the convenience of experiencing the development of Stella's art over three decades, we see in Stella's strategy a cunning re-evaluation of the state of abstraction not only during his own time but in previous approaches as well. The issue being addressed in Stella's early work can be summarized as falling very definitely on the literalist side of a dialectic in painting between the image as literal object and as painted illusion. This issue had been raised in Mondrian's late abstractions, in which flat planes of color wrapped around the edges of the stretcher, more like an insistent "thing" than a deep, penetrable space. Subsequently, Abstract Expressionism was able to get more mileage from an ambiguous, unlocatable type of space, somewhere between infinity and tactility. Stella, however, returned to the rigorous geometric plane of Neoplasticism, the shocking directness of his work being a function of the inseparable fusing of color, shape, and structure.

In the early 1960s, Stella's interest in the direct relationship of the framing edge of the painting to the surface design led to his first shaped canvases, the "Aluminum" and

Hollis Frampton, *The Secret World of Frank Stella #3*, 1958–62. Black-and-white photograph, 9½ × 7½". Copy print by Thomas Brown; courtesy Marion Faller, Buffalo

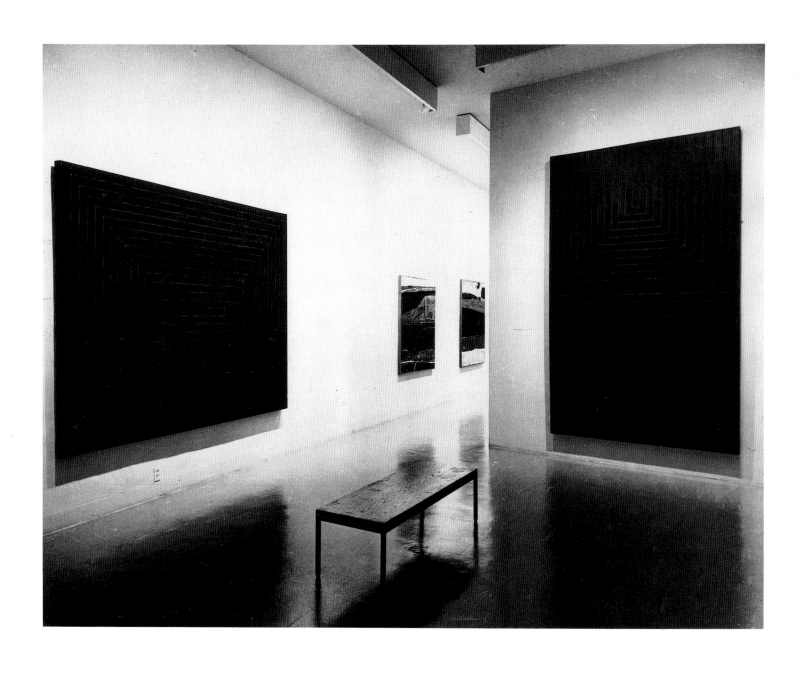

Installation view, *16 Americans*, The Museum of
Modern Art, New York, December 16, 1959–
February 17, 1960. Photograph courtesy The
Museum of Modern Art, New York

"Copper" series. Through these pictures he began to re-examine the concept of shape as a central element in painting. In the "Aluminum" paintings, the shape of the canvas is determined by the pattern of the bands. The notched or removed sections are areas not necessary to the completion of the design. The picture and canvas have been conceived as a single unit and not merely as a picture on a canvas that is attached to a stretcher. As in "The Black Paintings," the composition of the "Aluminum" pictures is designed to be perceived immediately. Rather than allowing the eye to meander narratively around the picture plane, these works tend to lock the viewer into a prolonged stare. Moreover, the metallic in the aluminum paint used in these paintings directs the eye to the surface of the work, paradoxically attracting and denying the viewer's penetration of that surface.

The linear designs of the "Aluminum" paintings are sharper and the surfaces flatter and harder than those of "The Black Paintings." In regard to the surfaces of these pictures, Stella has remarked:

I was interested in this metallic paint, particularly aluminum paint, and I was sure that that would be right in the sense that it was the kind of surface that I wanted, and I felt that this kind of pattern worked pretty well with this kind of surface. I'd have a real aggressive kind of controlling surface, something that would sort of seize the surface in a good way. I also felt, maybe in a slightly perverse way, that it would probably also be fairly repellent. I liked the idea, thinking about flatness and depth, that these would be very hard paintings to penetrate. All of the action would be on the surface, and that metallic surface would be, in effect, kind of resistant. You couldn't penetrate it, both literally and, I suppose, visually. It would appear slightly reflective and slightly hard and metallic.[210]

In the "Copper" paintings, Stella continued to explore his interest in reflective surfaces with the use of copper metallic paint, while experimenting with an even more radical shaping of large canvases. The silhouettes of the "Copper" paintings become equal in significance to the surface design in terms of total visual impact.

Perhaps most importantly, these paintings did not evoke the presence of the artist through "touch," the ultimate seismograph for expressionist art. For those who had come to accept Abstract Expressionism as the pinnacle of existential romanticism, Stella's works looked utterly conceptual and mechanical. Irving Sandler wrote that "an art as negative as Stella's cannot but convey utter futility and boredom."[211] It was in relation to Abstract Expressionists such as Pollock and de Kooning that Stella's art could be thought of as cold and unfeeling. Today, however, these early works appear austere but contemplative, an extension of Mark Rothko's meditative and symmetrical floating rectangles or Reinhardt's rigorously inert abstractions. Indeed, both Reinhardt and Stella drew their inspiration from sources outside of either the expressionist angst of Pollock or de Kooning or the metaphysical rhetoric of Newman. Stella's infamous statement regarding the content of his paintings — "What you see is what you see"[212] — stands as the legacy of Reinhardt's ultimately pure painting. Stella's early work also provided a unique abstract response to Jasper Johns's early *Flags* in which a repetitive, linear image established a design consistent with the shape of the canvas support, the outside edge of that support being the initial line of the composition.[213]

Throughout the 1960s and 1970s, Stella would explore the possibilities of parallel bands of color and shaped canvases, creating remarkably innovative and powerful variations (i.e., "Running V Series," 1964–65; "Purple Series," 1963; "Dartmouth Series," 1963; "Notched V Series," 1964–65; "Protractor Series," 1967–69). The "Protractor" paintings exist at the pinnacle of Stella's exploration of bold, flat patterning. Distinctly more decorative in terms of their color and design than any of his previous pictures, the "Protractor" paintings are the culmination of the artist's ambition to create a truly enlightened form of decorative and public fine art. The size of the "Protractor" paintings — his largest canvases to date — invests them with a quality "that verges on architecture."[214]

The "Protractor" paintings consist of a group of ninety-three paintings with thirty-one different canvas formats, each executed in three different designs. The half-circle of a protractor is the basic shape employed in all of the formats. The painted motifs consist primarily of wide bands of acrylic and fluorescent color that interweave to form highly complex patterns. Stella introduced the full circle, either as a design element or a canvas shape. The extremely bright colors, many of which were mixed by Stella himself, have been applied flatly and evenly. The combination of a smooth surface and the fact that each band that overlaps another is overlapped itself helps to prevent the illusion of receding space.

It is in these later works that one detects Stella's grasp and appreciation of various aspects of European modernism, particularly that of Matisse. William Rubin has noted that it is precisely Matisse's concept of a decorative high art that has most stimulated Frank Stella,[215] and the artist confirms that statement. "My main interest has been to make what is popularly called decorative painting truly viable in unequivocal abstract terms. Decorative, in the sense that is applied to Matisse."[216]

The search for a successor to the heroes of Abstract Expressionism gave rise to a wide range of potential candidates, as Greenberg's *Post-Painterly Abstraction* indicated, many of whom gave completely new meaning to the term geometric abstraction. In retrospect, however, the most potent challengers to "The Triumph of American Painting" came in the form of a rather diverse trio — what Robert Rosenblum would reverently refer to as "the Holy Trinity"[217] — Robert Rauschenberg, Jasper Johns, and Frank Stella. While both Johns and Rauschenberg employed some diplomacy in their images, in the sense of incorporating sensuous paint application associated with the work of their elders, Stella presented a deadpan geometry that seemed irreverent and hostile. At the same time, it counted as some of the most difficult and challenging art of the late 1950s and early 1960s and a model for yet another generation of American painters who would address geometric abstraction in their own terms.

MEASURED EMOTIONS: SYSTEMIC AND MINIMALIST PAINTING OF THE 1960s AND 1970s

By the mid- to late 1960s, yet another form of logic had entered the aesthetics of painting. Given the rapid succession of styles and proposed movements that had developed in American art since the early 1940s (biomorphic Surrealism, Abstract Expressionism, Post-Painterly Abstraction, Neo-Dada, Pop art) artists became increasingly self-critical and self-limiting. As Robert Mangold put it,

It's not that we didn't respect the art that preceded us, but we didn't necessarily want to be identified with it exclusively. We wanted to make our own inventions. However, that was much easier said than done. So much had been accomplished and exploited. There was the sense that what was needed was to really strip things down to basics; to re-analyze color, surface, structure in a way that was hopefully intelligent and even emotional in a very cool and considered way. To me, the late sixties had healthy elements of skepticism and introspection.[218]

The development of Conceptual art during this period — in which ideas and proposals were often elevated to the aesthetic status of finished objects — undoubtedly had its effect on the cerebral climate of the time. As Lawrence Alloway described it, painting as "action" essentially became painting as "system." In 1966, Alloway organized the highly influential exhibition *Systemic Painting* at the Guggenheim Museum. Although in a recent conversation he did not remember thinking of Greenberg's previous exhibition, Alloway's *Systemic Painting* amounted to a very pointed refinement of Greenberg's *Post Painterly Abstraction* show. Combining a number of the artists in Greenberg's exhibition with a new and more experimental generation, Alloway's presentation showcased a

group of geometric painters that would play a prominent role in American painting of the 1970s.[219]

Alloway's essay for the exhibition catalogue provides an insightful overview of geometric abstraction in America during the 1950s and early 1960s but is somewhat less clear in providing specific relationships between the use of the term "systemic" and the work included in the exhibition. A point that clearly emerges is that the author did not see the term as synonymous with a mechanistic or necessarily impersonal aesthetic. In a recent conversation, Alloway remarked,

I took the point of view that a system could be quite human, in the sense that it could involve a very idiosyncratic choice of variables. . . . I thought long and hard about the title, and I remember it took all summer. I would sometimes check titles with Barney Newman and I asked him about this one and he approved of it. My rationale had to do with a strong organizational principle I saw developing. I felt a similar sense of order was happening with some of the gesture painters, I think of Pollock now, in the sense of the drip or gesture being repeated and choreographed in an essentially orderly field. Orderly is of course relative, but orderly in the sense of a series of repeated marks. In the "Systemic" show the artists' mark had condensed in a more geometric way. It wasn't that one was more personal than the other. In retrospect I suppose a distinguishing element would be that in the gesture, painters' color seemed to be the more unorganized element. With the Systemic painters, color was more organized and it was more difficult to distinguish between line and color.[220]

The "organizing tendencies" Alloway identified were indeed interpreted and approached in a variety of ways by the artists in his exhibition. Agnes Martin's abstractions, created with ruler, pencil, and paint, provided a salient example of a gestural aesthetic evolving into a highly personal geometry. It is through Martin's work that one can imagine Newman approving of the term systemic in relation to an approach to painting that involved highly personal ideals. Like Newman, Martin's art approaches a sense of classical perfection through an intuitive, mystical geometry.

Martin's early work involved an evolution from still life and portraits into a biomorphic abstraction related to the early work of Gottlieb and Baziotes. Eventually line, rather than form, came to dominate Martin's images, as a delicate and fluid handwriting began meandering over the surface of the pictures. As these abstracted landscapes developed, the lines became more taut, the image more symmetrical and abstract. Eventually basic forms of geometry would provide her images with the qualities of monumentality and the serene, open, and planar space she saw in nature. As Martin noted, "I used to paint mountains here in New Mexico and I thought my mountains looked like ant hills. I saw the plains driving out of New Mexico and I thought that the plain had it, just the plane. . . . Anything can be painted without representation."[221] Martin's long-time interest in landscape and planar form eventually developed into what the artist called "an awareness of perfection,"[222] a "system" of proportion rather than representation.

When Martin moved to New York in 1957 and settled in Coenties Slip, an enclave of artists' lofts (Ellsworth Kelly and James Rosenquist were among those who lived there) near New York Harbor, the images of New Mexico lingered, but they were slowly being transformed. During the late 1950s and early 1960s, Martin's paintings recalled the loamy browns, deep siennas, clay yellows, and near-blacks of tundras, mesas, and prairies. She called her paintings *Wheat, Tideline, Earth,* and *Desert Rain*. The recurring motifs at the time were dark circlets that established a quiet, iconic symmetry. Intuitive geometric patterns and spatial rhythms were superseding the gestural and the descriptive line. Lizzie Borden has written that "In the mid-50s, Martin's work began to probe the idea rather than the representation of the object. She became increasingly interested in perceptual orders and systems, ordered at another level than the unpredictable and unequal consequences of contesting parts in nature."[223]

Like Reinhardt, who was a close friend, and Newman, Martin developed an increasingly abstract imagery in order to evoke pure, meditative states of mind. Eventually she

began producing canvases with only a central rectangular image divided by a subtle graphite grid. By 1964, this central rectangle, which had been covering increasingly larger portions of the canvases, reached the edges. At this point the grid and thin veils of color became the form and subject of Martin's art. By the mid-1960s, the grid became Martin's signature image, her early adaptation of this format predicting its prolific use in the 1970s.

A number of models have been suggested to locate Martin's grid in a historical context. The most consistently cited precedent is Mondrian. In her 1967 article on Martin's work, Annette Michelson centers her text on a long passage by Mondrian, as a means of describing the experience evoked in Martin's paintings. According to Michelson, Martin's exclusion of all curves in favor of a strict, rectilinear grid is related to Mondrian's concept of "the abolition of all particular form" and a new type of abstract space.[224] Lawrence Alloway also saw Mondrian as the closest precedent to Martin's aesthetic, citing specifically the Dutch artist's plus-and-minus drawings. According to Alloway, "Mondrian's plus-and-minus drawings of 1915 combine a comparable degree of formalization in the signifiers without losing contact with a signified scene. In Mondrian's case it was the dunes and the sea; in Martin's case it appears to be aspects of landscape that can be schematized by the repetition of identical or similar units."[225]

An equally kindred spirit can be found in the work of Newman. Like Newman, Martin has manipulated her geometry into something more personal and less utopian, using drawing as a point of subtle deviation from a purely rigid geometry. Although Martin uses a ruler to apply delicate lines of graphite on her canvases, the resulting image avoids the hard edge clarity of many geometric paintings. Graphite gently dragged across the weave of the canvas offers a gentle and sensuous irregularity. Invariably these lines, though ostensibly straight and regular, take on a life of their own, establishing a rhythmic buzz across the surface of the picture, creating a harmonious rhythm and a light-inflected fullness. In her use of drawing as a tool for painting, Martin is not only related to Newman but might also be seen as a geometric analogue to Cy Twombly's lyrical, gestural abstractions. Both artists, though through a very different sense of mark and touch, derive their inspiration from memories of nature.

The classic image that Martin has pursued confronts us with a composition that is geometrically stable on the one hand, yet visually illusive, a kind of geometric veil or what the artist has simply called an "atmosphere of information."[226] Martin describes this experience in the following manner: "My formats are square, but the grids never are absolutely square, they are rectangles a little bit off the square, making a sort of contradiction, a dissonance, though I didn't set out to do it that way. When I cover the square surface with rectangles, it lightens the weight of the square, destroys its power."[227]

As such, Martin does not depict nature but establishes a correlation for some of its more ethereal effects, such as wind, sunlight, the tremolo of a vast plain of wheat, earth, sand, or water. For Martin, the grid becomes a dramatic metaphor, at times detached from its original source of inspiration. She has described it as a state of "innocence," a "memory of perfection." Referring to the painting entitled *Tree*, Martin has written, "I asked myself why do I like trees so much and this grid came as a visual image in my mind. After I had finished it I recognized it as representing the innocence of a tree. Later in my untitled work most of my paintings are about innocence."[228]

Larry Poons also embraced the grid but with less metaphysical intentions. Like Martin, however, he saw the grid as a beginning point from which to establish subtle deviations toward a breakdown of form in favor of a new type of abstract space. Poons's work of the early 1960s suggested a number of comparisons with the work of Stella and the Op artists in its apparent systemic structure and vibrant opticality. Poons, who studied at the New England Conservatory of Music in Boston, redirected his career toward painting in 1957. In 1958 he attended the School of the Museum of Fine Arts, Boston, for six months

before moving to New York. Poons's unique approach to painting involved a synthesis of his interest in musical notation, small dots placed on a horizontal grid, and the concept of creating an expanded spatial field through unified large-scale images, which had come to dominate New York painting.

Poons's early mature works suggest the transcription of musical themes into visual geometric designs that employ crisp dots scattered across a complementary field of color, the combination of which created subtle after-images. During the late 1960s, the small, ordered areas of color such as the green "blips" in *Orange Crush* were replaced by more loosely painted ellipses in several colors, that appear to turn and flicker, moving within a larger and deeper space.

Like Stella's early work, the structure and color of Poons's paintings of the 1960s initially appear rigid and overly systematic. Upon a closer and prolonged analysis, however, the works reflect a complex, highly intuitive sense of composition that projects a provocative image between order and disorder.[229] The initial designs for Poons's so-called dot paintings begin with a pencil grid placed over a single-color ground on a large canvas. The pencil grid suggests the number of possible points the artist could place a dot of color. An initial system of composition is worked out and is then eventually discarded for an entirely intuitive approach. What appears to be precisely mathematical is, in fact, sophisticated guesswork. Poons's compositions ultimately deny the gridded structure he initially set up. The sequence and/or directional flow of the dots or ovals invariably counters the set rigidity of the pencil grid, which often remains visible on the canvas surface along with various revisions of dot placements. The "formula" to Poons's compositions thus remains illusive. Unlike Stella's bold sense of a grand decorative art, Poons's paintings challenge the concept of geometric regularity toward a more conceptual and less emblematic sense of unity. Sidney Tillim and Lucy Lippard both lauded Poons in the 1960s as the most logical successor to Mondrian, specifically in regard to Mondrian's achievement of a "dynamic equilibrium."[230]

Poons's most immediate model, however, would appear to have been Newman. Poons has stated, for instance, that one of his first important experiences with color came from watching the intensity of the red in Newman's *Vir Heroicus Sublimis*.[231] Poons first met Newman in 1959, after seeing the elder artist's exhibition at French and Co.; a friendship ensued, and Poons remembers that Newman was influential in convincing his father, who was adamantly against Poons's entry into the art world, that painting was in fact a legitimate, even "noble" profession.[232]

Newman's work was undoubtedly important in terms of Poons's employment of large spatial fields in which color becomes form rather than a descriptive accent. Regardless of their directional impulse, the dots in Poons's paintings are subsumed into a larger monochrome field in which color generates an optical fullness and scale that does not allow an individual reading of each dot. Poons has remarked, "Color is not part of technique. Color is painting. Red and blue, blue and green isn't a problem, it's a fact, and a fact of no interest. There cannot be a separation between color and form. The color is the form. They're inseparable."[233]

Poons's circles and ovals maintain a remarkable tension between stability and energetic movement. These experiential layers create a subtle but nervous buzz that contradicts a pure flatness in favor of spatial thickness and breadth. Poons's dot and oval paintings underplay the vertical in favor of the horizontal. As he describes it, his space maintains a constellational effect regardless of the fact that it is an essentially contained field. "The edges define but don't confine the painting. I'm trying to open up the space of the canvas and make a painting with a space that explodes instead of going into the painting."[234] In exploring subtle and ephemeral relationships between form and space, Poons creates a hyper visual reality, one that exists between unity and chaos. Like Martin, Poons clearly fulfills Alloway's proposal for an art based on highly personal and idiosyncratic systems and geometries.

Hollis Frampton, *Larry Poons*, 1963. Black-and-white photograph, 7½ × 9½". Copy print by Tom Loonan; courtesy Marion Faller, Buffalo

Along with those of a number of the younger artists in *Systemic Painting,* Robert Mangold's paintings presented a radically factual and physical image. It is important to note that *Systemic Painting* was closely followed by the Jewish Museum's exhibition *Primary Structures,* which heralded the development of Minimalism, the sculptural counterpart to Alloway's Systemic Painting. Minimalism, which dominated the late 1960s and the 1970s, was a movement of obdurate, factual, and often industrially fabricated objects. Although Stella's early work stood as an important precedent for Minimalism, a relatively small number of painters were able to adapt a painting analogue in this new object-sculpture environment. Of the few painters who were theoretically accepted into the Minimalist camp, Robert Mangold offers one of the most interesting and tactful adaptations. From the outset of his mature career, Mangold questioned some of the most basic elements of painting: physical structure, line, and color.

Born in North Tonawanda, New York, Mangold attended the Cleveland Art Institute from 1956 to 1959, and later Yale University, where he received a B.F.A. in 1961 and an M.F.A. in 1963. While at Yale, Mangold noticed the change in attitude toward painting, particularly in regard to viewing painting as a structured object rather than an arena of expressionist gesture. During the early 1960s Mangold also worked as a guard at The Museum of Modern Art, where Robert Ryman, Dan Flavin, Sol LeWitt, and Lucy Lippard were fellow employees; they were all among a group of artists and critics whose exchange of ideas would contribute to the development of Minimal art. At the Modern, Mangold found himself attracted to the paintings of Mondrian. The artist remembers, "I looked at them a lot. I'm not sure I understood them at the time, but I was definitely attracted to those paintings."[235]

The curiosity Mangold had for Mondrian's work, and its precise and reductive segmenting of form and space, was an attraction he shared with his Minimalist colleagues. Minimalism would apply Mondrian's precision to the physicality of sculpture, a lure that also affected the young painter from Yale. According to Mangold, "There is no question that at a certain point, say the mid or late 60s, I identified more with sculptors; I think of Andre and Judd immediately. We all shared an interest in industrial materials and industrial color."[236]

During the mid-1960s, Mangold developed a series of forms that bordered between painting and relief, forms that look like sections of an interior wall carved into neat geometric configurations. In 1964, the artist had at the Fischbach Gallery his first one-artist show, which he called *Walls and Areas.* Each painting was made from standard four-by-eight-foot sections of Masonite or plywood. The effect was that of a building scissored apart into sections and hung on a wall. The surfaces of some of the works were flat and opaque, while others were sprayed to impart a subtle quality of atmosphere. These works constituted an intellectual response not only to Minimalism (and in an oblique way Pop art) but also to the artist's interest in architectural structure.

When Mangold first moved to New York City, he and his wife Sylvia were building superintendents. Speaking of that job Mangold has said,

One of the things that used to fascinate me was those architectural sections between the buildings, sections of air that would glow, you know—sunsets or mornings, or whatever, you'd see these incredible areas of light and they were architectural shapes and yet they were nothing, because they were the voids of architecture—and I used to see those and I used to think about them, and I used to think about a painting that would be atmospheric and architectural. So the first ones that I did that way were literal translations almost of building gaps. And so when I had that show called "Walls and Areas" they were really that—they were pieces of architecture and the space between them. Although I don't think people really see them that way. It's just a secondary content.[237]

Because they were three-dimensional, object-like (suggestive of architectural elements), and painted in an impersonal way that concealed the artist's touch, these works can be viewed reasonably as examples of Minimal art. At the same time, they offer an abstract

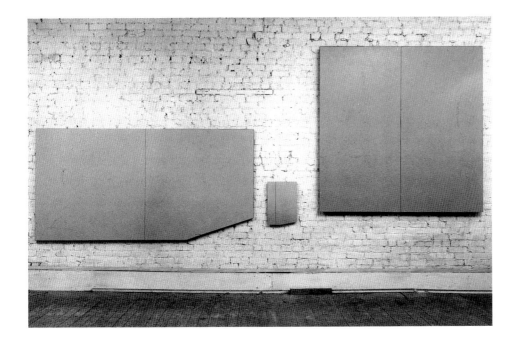

Robert Mangold, studio installation.
Left to right: *Pink Area*, 1965–66; untitled work;
Warm Gray Area, 1965–66. Photograph by
Rudolph Burckhardt; courtesy Robert Mangold

tongue-in-cheek interpretation of Pop art, using industrial, prefabricated urban archi-tecture as a model, rather than media-generated advertising.

Mangold was most interested, however, in the structure of his paintings and in exploring the nature of the part-to-whole relationship in painting. Part of the structure of Mangold's early paintings was based on the fact that his building materials came in a standard four-by-eight-foot size "so whatever other structural decisions were made I knew the work would have a seam every four feet. That established an essentially given relationship—though sometimes I would manipulate that—between interior lines that also related to the exterior shape."[238]

Mangold's early paintings established a unique structural paradox. On the one hand, the idiosyncratic shapes poised on the white ground of a wall presented a forceful, self-contained quality. At the same time, their notched structure activated the space surround-ing them like a kind of positive-negative puzzle, suggesting that what was not there was equally important. Mangold has remarked, "I was dealing with the notion of what was a fragment and what was a whole. When does a fragment become a contained whole."[239] Since his early works, sectioning has been an integral aspect of Mangold's painting. By dividing panels in the center of a painting, Mangold effectively underscored the objectness of the painting, while keeping the viewer's eye on the surface. The defined edge, that which gives a painting its solid, physical nature, was not only on the periphery of the work but in the center, as well. This did not allow the viewer to drift too far into an "infinite" monochrome space.

Although Mangold is often thought of in terms of his unique investigations into the structure of painting, he was also seminal in helping to redirect attitudes about color. For him, the color of many of the Post-Painterly Abstractionists had come to seem decorative or superficially psychological.[240] Mangold did not want the color to override the structure by becoming emotional. Thus he often uses gentle resonant shades that heighten the harmony inherent in his sense of proportion, chosen to enhance the line and shape of the work rather than to draw attention to itself. Moreover, his opaque yet subtly glowing colors tend to emphasize the flatness and materiality of the work while inviting a contemplative response. Mangold's colors are interesting in that they ingratiate them-selves to the overall, while also being specific. "I like colors that are unique because they don't scream at you, colors that have a kind of strong indifference."[241] Mangold's early palette had a subtle Pop and industrial character—staple-gun green, manila-folder cream, etc. Stella's use of commercial paint, and particularly iridescent color, offered an important precedent in this regard.

In 1969 Mangold replaced masonite with canvas as his support material. This eliminated the weight problem of the heavy masonite, as well as allowing for more variety in shape and size. Moreover, the edges of Mangold's sections developed into a form of drawing in which graphite lines replaced panel divisions and imaged squares, circles, and triangles, always, however, with an eye to the confining edge of the painting. In *Four Squares Within a Square*, 1974, for example, four squares of different sizes are drawn in pencil on a monochrome canvas ground of the same proportion. One is immediately attracted to the subtle relationship between the drawn squares and the canvas itself. The largest square swells outward to the edge of the canvas, taunting us to contemplate the relationship between image and object. Mangold's compositional strategy is typically to work from the outside inward, his interior lines being a direct function of the outer shape of the canvas. As Mangold says, "They hang from the edge. The structure of the picture begins at that point. In fact they all seem to start and end at the edge."[242] Although Mangold consistently reminds us that we are looking at a structured object, his vision remains essentially graphic. Indeed, his art presents a unique combination of drawing and painting, in which his sense of sectioning or shape becomes an analogous element to his graphite line drawn in response to that shape. As Mangold puts it, "For me, the edge of the picture is the first line."[243]

In the late 1970s, Mangold turned from applying paint by rolling to brushing it, in order to establish a surface activity that would add another competitive element in his structural vocabulary. Similarly, Mangold's colors have become increasingly more forceful and energetic. The intensity achieved in these areas continued to be balanced, however, by a new level of physical structuring. During that same time, he had been painting "X" marks and plus signs within canvases of various geometric configurations. Eventually these drawn lines emerged as actual X-shaped and plus-sign canvases. These serenely balanced structures led to the more recent series, which the artist calls "Frame Paintings." Here, Mangold constructed variously shaped and colored canvases suggesting actual frames. When the "frame" was hung on a wall, the wall itself became the central image—a framed wall area now fully integrated within the work, a subtle reminder of the architectural reference in his early *Walls and Areas* exhibition. Like Poons, Mangold looked to Newman as an important model. According to Mangold, "There is no question that Newman was a primary model for me. His way of balancing surface, structure and physicality was very important to me. It all has to fit, each element supporting the other. If that is geometric, then so be it. But like Newman, I'm a little nervous about the term geometry."[244] The new sense of surface brushwork and exuberance in Mangold's paintings should not distract one from the fact that Mangold has remained one of the most consistent artists in maintaining a clear sense of a tightly composed geometric vision. As the artist himself put it, "All of my work is centripetal in that it starts with a shape or edge and moves in by surface and structure. It's essentially a geometry that surrounds and encloses."[245]

Like Martin's and Mangold's works, Dorothea Rockburne's paintings are intently focused on traversing the edge between drawing and painting. She has been particularly interested in mathematical systems of order and proportion, using these systems as a drawing tool, not only from a diagrammatic or conceptual standpoint but as a means of drawing with the material support of her paintings. The effect is not that of an object drawn *on* but of an object virtually drawn into being. Rockburne's procedure or approach is summed up in the title used for a number of the artist's works: "Drawing Which Makes Itself." Rockburne has qualified that by writing, "The subject-object draws on relationships which are not intrinsic to the thing itself, but rather which inform through some action imposed by the situation."[246]

The situation imposed by Rockburne is the Golden Section. Invented by the Greeks and widely used in Renaissance Italy, it is a system of dividing a line so that the proportion of the smaller part to the larger is as the larger is to the whole. The Greeks thought it a

perfect means not only of dividing a line but also of composing proportion within an image, object, or building. A Golden Rectangle is formed by using two parts of a Golden Section; for example, the facade of the Parthenon is a perfect Golden Rectangle. In her Golden Section paintings, Rockburne started with a rectangle of linen, which she folded, sized, and gessoed, creating ironically and unconventionally shaped paintings that challenge the conventional rectangular format of painting while still being wholly derived from the rectangle itself.

The inspiration for Rockburne's imagery can also be found in the artist's long-standing involvement with Renaissance and Byzantine painting—most specifically with the sensuous folds depicted in garments. In her work, Rockburne has translated this pictorial phenomenon into something immediate and concrete: a unique marriage of the mathematical or rational with the libidinal.

Of all the paintings included in Alloway's exhibition, the works of Jo Baer remain some of the most perplexingly hypnotic. In Baer's early works, she concentrated on the peripheries of her canvases, using dark bands and subtly contrasting stripes to define borders and to create a complex relationship between the qualities of opticality and physicality in painting. Though her approach offers a parallel to that of Mangold, it is derived from different sources. Born in Seattle, Washington, Baer attended there the University of Washington, where she majored in biology and also studied art. She moved to New York in 1950, and in 1952 she worked with the graduate faculty at the New School for Social Research in physiological psychology. She moved to Los Angeles in 1953 and by 1957 began painting in an Abstract Expressionist mode. After returning to New York in 1960, Baer started to work with hard-edged, simplified forms. Baer's studies in physiology and Gestalt psychology provided the background for her exploration of the perceptual nuances in reductive color and form.

During the early 1960s, Baer arrived at a radically austere format that sent a number of mixed perceptual and metaphysical signals. Her basic format consisted of a six-foot white square bordered by black bands about four inches wide, placed several inches in from the outer edge of the canvas. A narrow border of color rims the inside edge of the black bands. Eventually these geometric bands were wrapped around the edges of the canvas, emphasizing the objectness of the work and establishing an ambiguous play between physical fact and the illusion of space created by the expansive white field. Hung below eye level, these works prove difficult to determine whether they were devised to be looked into or looked at.

Baer's ambition was not simply to create an inert, impenetrable object. On one level, she establishes an ethereal and ambiguous space reminiscent of a previous generation. Like Rothko's atmospheric fields, Baer's open white or later gray rectangles suggest a mysterious and deceptive sense of dimensionality. A paradoxically soft glare and sense of expansion occur in these amorphous fields, which appear to glow beyond their boundaries. As with Rothko's work, Baer's fields seem to be lighted from within. The artist's comments parallel these sensations. "I have always had the feeling that an object is larger than its outline, that it has a field or force beyond itself."[247]

These central fields impose themselves visually on the dark bordering bands at the edges of Baer's paintings as well as on the thinner color bands embedded within them. The phenomenon of Mach bands gives the illusion of illuminating the thin color line, as a result of a kind of retinal glare that occurs at the borders of two contrasting colors. The effect is one of a very subtle emanation, helping to establish the contemplative mood of the work.

Situated at the edges and sliced in between the border and the lighter field or running through the black band, the quiet illumination of the color line seeps into consciousness through our peripheral vision. What we are barely cognizant of at first becomes, over longer viewing, a dominant optical effect. The complex visual effects that Baer establishes in these paintings present not so much windows that open onto light, but rather a

surface that is essentially self-radiating, a kind of contemplative, two-dimensional atmosphere. In his essay for *The Responsive Eye* exhibition at The Museum of Modern Art, William Seitz identified the type of perceptual stare invoked by such works as being beyond simply the science of vision. He noted, "It is easy to associate these large paintings with religious and mystical states. The contemplation of nothingness, which they invite while retaining their identity, quickly goes beyond purely visual sensation."[248] Baer saw this sense of spareness in terms of literary minimalness. She remembers that at the time she initially conceived these works, she was reading Samuel Beckett.

Although, since the mid-1970s, Baer has radically altered her work from an abstract to a figurative mode, her paintings of the 1960s and early 1970s remain provocative contributions to American geometric abstraction, activating perhaps the primary paradox in painting, that between the optical and the physical. Baer forcefully challenged the increasing limitations set by the two-dimensional plane by imposing a union of extremes: the assertion of an impassive surface, and an almost invisible atmospheric haze fuse into a statement that is indeed as ambiguous and pregnant with emptiness as a Beckett play.

By using very different means, Brice Marden's paintings, while not included in Alloway's exhibition, tap an equally provocative paradox between an inert geometric form and the qualifying properties of surface and edge. By the time Marden had received his M.F.A. in 1963 from Yale University, he had adapted a reductive style of painting that was, like Baer's and Mangold's, physically direct and simple but theoretically complex. Before that, he had taken Albers's course in color at Boston University; this experience left him "confused and traumatized," according to Roberta Smith. As a result, he was painting primarily in black and white when he reached Yale. At Yale, Marden gradually rejected a gestural, Abstract Expressionist approach as he began to appreciate the possibilities of balance and clarity through rudimentary geometry, situating shapes in relation to the framing edge and establishing simple divisions of the canvas.[249] His exposure there to a wide historical range of artists whose colors were often subdued and intricately mixed (Manet, Velasquez, Zurbarán, Johns) convinced the artist that color needn't be declarative to be evocative.

Marden moved to New York City in 1963 and worked as a guard at the Jewish Museum through 1964. A major exhibition of Jasper Johns's works on view during this time particularly influenced his thinking. The complexity of Johns's surfaces and the elegant quietude of his color would have a profound effect on Marden's painting. In Marden's case, a figurative image was not necessary. Marden directed his ambitions to what one European artist referred to as "Fundamental Painting," or, "painting qua painting in a strict sense: on a flat plane, without representation and without image. . . . That is to say, those who restrict themselves in a most self-critical manner to anti-illusionistic painting, in which moreover all compositional elements are absent."[250]

Marden's paintings center on the most elemental aspects of modernist abstraction. "As a painter," Marden has said, "I believe in the indisputability of the plane."[251] In their holistic, rectangular presence, his paintings project the Platonic qualities of classical form through inert yet serene planes of color. These paintings are without question as much about light and mood as they are about geometry. Indeed, these stark rectangles of color are immaculate yet not mechanical in appearance. The surfaces are smooth but with a quality of hand-painted density that challenges the sleek surfaces of much Minimal art to which his work is often compared.

Indeed, in the end it is surface that distinguishes Marden from other geometric abstractionists. In postwar American art few painters have achieved in their work a surface quality as provocative and unclassifiable as has Marden. The early work consists of one, two, and, later, three simple rectangular panels. In the multiple-panel works, the identically sized canvases are joined flush but reveal an implied line. The process of painting these panels is significantly labor intensive and ritualistic. Marden's technique involves mixing melted beeswax and oil paint, applying it with a brush, and finally

smoothing it with a palette knife. He works toward a particular and even sense of color across the surface of each panel. This often requires a dense building up of layers. Through this skillful and ritualistic layering, what began as a simple, rectangular form becomes a mysteriously complex image.

Marden's paintings typically read from a distance as simple opaque planes of color. On closer inspection, however, their dense surfaces reveal their intimate layers of painterly expression and skillful restraint. One is often caught between the desire to appreciate the geometric simplicity and elegant sense of proportion these works project from a distance and the more intimate attraction of the innately personal, hand-wrought surface close up. Marden creates a space that is subtly organic. As Roberta Smith has written,

The space that opens up to the viewer in a Marden painting isn't the yawning void of Newman's or Rothko's Abstract Sublime. Marden's scale is more modest, tipped toward human size, and there's that compressed weighty feel to his surfaces. His color has its own physical substance; it's not absorbed into the canvas's weave. Nor does the viewer feel almost absorbed into the space and color of the painting. Instead, Marden gives you an object with a skin-like surface and a density which is almost that of another body.[252]

Marden's color is provocatively vague and elusive as well. Through surface and hue, Marden tends to compound our set psychological assumptions about color: a gentle pastoral green is given a subtle hardness that turns us away from nature to something man-made, while an industrial gray is softened to create an uncharacteristic sensuousness. At one point in the mid-1970s, Marden became intrigued with Mondrian's contention that only primary colors were suitable for the purposes of pure abstraction,[253] creating a series with the title "Red Yellow Blue Painting." In the initial work in the series, *Red Yellow Blue Painting #1,* Marden paints the primaries in essentially undiluted states on three abutted vertical panels. In the end, however, he was incapable of substituting Mondrian's logic for his own intuition. The subsequent paintings are identical in size and format, although the order of the three colors varies. In each, Marden transformed the red, yellow, and blue by subtly shifting and mutating their purity, transforming them into personal metaphors. He thought of the first painting as "the most classic," the second as "warm," the third as "cold," and the fourth as "dark."[254]

Following the "Red Yellow Blue" paintings, Marden's work began to take on a more classical air. Indeed, just prior to his recent surprising move to an image of weblike expressionist lines, Marden's work had achieved its most classical state, composed of simple elongated rectangles organized into a kind of post-and-lintel composition. Though these works are characteristically personal and surprisingly intuitive in his shifts from color to color, the precision with which Marden modulates his chromatic bars invariably establishes a balanced, rhythmic, and Platonic sense of space. His narrow panels can be read as figures or columns punctuated by shafts of light and space. As Roberta Smith has pointed out, identification of Marden's extremely narrow vertical panels with the human figure is not as oblique as it might appear. These panels first occur in paintings named after a specific person (*Helen* of 1967; *Star (for Patti Smith)* of 1972 and 1974) and their measurements are determined by the height and width of that person's body."[255]

Marden often titles his works with personal references to people and landscapes. In a period of puritanical reduction, this is undoubtedly his way of humanizing abstraction. Marden has infused the inherent geometry of the rectangular plane with a decidedly new range of emotional content. This has been his ambition all along. As Marden has stated flatly, "The rectangle, the plane, the structure, the picture are but sounding boards for a spirit."[256]

Like Mangold, David Novros's initial challenge was to align "systems" of painting with those of architecture, thereby creating a kind of architectural analogue within the

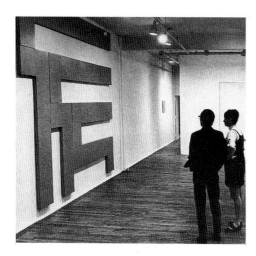

Installation view, *David Novros*, Bykert Gallery, New York, April 27–May 25, 1968.
Photograph by Richard Saunders, Scope; courtesy David Novros

domain of painting. Utilizing variously shaped and colored canvas sections which were arranged on a wall with large areas of space between them or tightly fitted together like a puzzle, Novros created what came to be described as "modular painting."[257] Whether fiberglass panels, L-shaped or rectangular canvases, his works invariably establish a dialogue with their supporting wall plane. Large, monochrome "L" forms that effectively bracketed expanses of bare wall, thus establishing the wall as a positive and assertive compositional element, would be Novros's major contribution to Systemic Painting.

Novros's use of ninety-degree angles relates to his appreciation of the architectural context in which paintings find themselves. Novros has remarked, "I don't want to compete with architecture. I want to relate to it, and if need be overcome it. In order to survive, a painting must relate to the room or hide from it."[258]

Through scale, a variety of color dynamics, and the modular sense of a painting as an aspect of architecture, Novros explores the possibility of eliminating the sense of a painting hung on the wall to create what the artist has called "the painting as wall."[259] Since the mid-1960s, Novros's paintings have forced viewers to be aware not only of the two-dimensional surface of a painting but also of the existence of that painting and viewer in a given space. In his 1965 exhibition at the Dwan Gallery in Los Angeles, Novros presented large modular units painted with Murano color, which have the ability to change as the viewer passes by. Viewed from various positions in the space, the works, in effect, became different pictures. As Novros's scale increased, the paintings commanded entire walls, and eventually he began actually to design the rooms that would support his geometric imagery, creating three- and four-sided paintings. Novros is one of the few prominent post-WPA artists to address the challenge of public murals, having now completed major works in Dallas and Miami.

Novros's architectural approach to painting derives from two primary sources. Following his graduation from the University of Southern California in 1963, the artist traveled in Europe and became particularly taken by the mosaics in Ravenna and the frescoes in Padua. These experiences clearly had a latent effect on the artist, in terms of the modular character of his work; he also cites the inspiration of the geometrically interlocked designs of American Indian pottery in this regard. More importantly, the frescoes ignited his larger ambition to create a kind of architectural painting using abstract forms.

Novros's admiration for fresco painting, which he has carefully studied, derives from his appreciation of the fact that it actually unites painting with the plane of the wall. Interestingly, though, it was through the artist's exposure to Abstract Expressionist painting that his thoughts in terms of the muralization of abstract imagery actually crystallized. Novros was particularly impressed with the large color fields of Still and Newman. He relates these painters in a sense to the fresco tradition, in that they created paintings that were "architectural." "They built the architecture into their pictures," Novros has said. "The place was the painting and the painting was the place."[260]

Novros was also impressed with the Rothko Chapel in Houston in terms of the artist's ability to manipulate architectural space and to eliminate gesture in his painting toward a firmer geometric image. In his turgid, and at times impenetrable essay on Rothko, Marden, and Novros for a catalogue documenting a three-artist exhibition in Houston, Sheldon Nodelman spoke of their works in terms of the "actuality" of painting, the sense of one's awareness of oneself in the spatial presence of these works.[261] It was Newman's geometry, however, that most poignantly linked intellect and psyche for Novros: "It wasn't till I saw Newman that I realized how color could work in an emotional, as well as architectural, sense. Seeing those planes of color on that scale really moved me."[262]

Novros completed his first fresco at Donald Judd's studio in 1969–70. "That was extremely important for me. It was the first time I had worked directly on the wall. The wall became a painting. All of my paintings since, whether on canvas or fresco, have

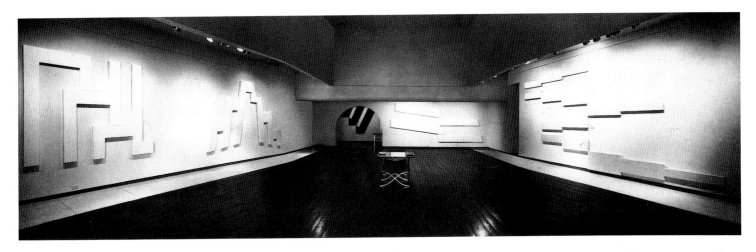

Installation view, *David Novros*, Dwan Gallery, Los Angeles, November 1–26, 1966. Photograph courtesy David Novros

been at least partially influenced by that experience."[263] Novros also saw a Kenneth Noland exhibition at the Jewish Museum in 1963, which had an important effect. "That show really re-affirmed the kind of potential projected in Newman's paintings, but by experimenting more with shape and new colors, Noland took it another half step."[264]

Novros's color areas are fitted together so that each section holds its place on the plane of the wall without receding or coming forward. On the one hand, he presents a kind of literalism. His presentation of painting as actual surface and shape rather than as allusion is underscored by his use of separate canvases whose edges are fitted together. Line becomes a physical entity formed by the canvas edges that separate the color areas. Yet the abstractions are by no means devoid of allusions. Novros employs modular and coloristic checks and balances that maintain a dynamic architectural tension between the vertical and horizontal that at times suggests a kind of post-and-lintel construction, as well as a color tension between light and dark that seems to relate to more natural phenomenon. Many of Novros's paintings offer the double sensation of looking into an interior space, at one point, and out onto a landscape at another. They suggest not only ancient frescoes but also earth, sea, and sky. That is to say, they vacillate between architectural structure and open light and space.

ABSTRACTION AND THEORY

Since the mid-1970s, abstract painting has increasingly attracted the theoretical wrath of critics who see it as a regressive form, a practice that was once revolutionary but now has been transformed through succeeding generations into a mute, at best, academic proposition. At the beginning of this decade it was possible to suggest that abstraction and particularly geometric abstraction was a thing of the past, overshadowed as it was by an international explosion of figurative expressionism in the late 1970s and early 1980s. Throughout the development of modern art, however, no single strategy has remained fixed for long before its antithesis surfaces. Indeed, geometric abstraction is again with us in full force. As with each previous decade, the role of geometry and its meaning in abstract painting is once more under reconsideration.

In many ways, Los Angeles suggests itself as the place to begin a discussion of abstract painting in the late 1980s. A city where painting has assumed the role of a kind of old-fashioned stepchild to the more overtly phenomenological concerns of performance and sculpture, it is a place where one can approach the two-dimensional canvas with relatively little historical baggage, a place where abstract painting might begin anew. John M. Miller's abstractions, which developed in the late 1970s, seem to epitomize the paradox between theoretical systems and expressive transcendence that abstract painting faces today. Miller's paintings initially appear shockingly methodical and mute. His signature image—a field of generic "hash" marks standing in for the once emotion-laden

brushstrokes of the 1950s—might indeed suggest the end of abstract painting as we have come to know it, existing now only as a series of computer-like blips in which every message is equally abstract and unvarying. However, the difference between a description of Miller's paintings and what in fact the paintings do constitutes the artist's essential content. Through description, Miller's works seem a bleak variation on Op art. Since the 1970s, Miller has not varied his format: short, crisply defined black slashes are repeated every inch or so across the surface of raw canvas. There is a vague suggestion of a warp and woof patterning in which double horizontal bars are bracketed by longer vertical units, creating an oblique sense of an interlace. Except in scale this format does not change from painting to painting. The marks extend to the edges of the canvas where they are abruptly cut off; and while the bottom edge of the canvas mirrors the top edge, the right and left edges appear to have stopped arbitrarily.

Despite this apparent randomness on one hand and severe geometric regularity on the other, Miller's paintings provide a remarkably meditative experience. These paintings are far less a variant on Op art than a considered outgrowth of the phenomenological concerns of a number of seminal Los Angeles artists of the 1960s and 1970s such as Robert Irwin, Larry Bell, and James Turrell, who, in turn, derived their positions from Newman and Reinhardt. One of the elements that binds these artists together is their goal of making the viewer acutely aware of himself. Miller's deceptively simple image, for instance, demands patient concentration and relatively prolonged periods of attention, much like Reinhardt's black cruciforms. Without a commitment to see what the painting can do, the viewer will find the work not only frustrating to look at but essentially impossible to see.

Miller's paintings force us to question how we see, and how we are dependent on certain visual conventions. Though we invariably try to make it so, the structure of the pattern formed by Miller's bars is not a grid but suggests instead a radial quality that spreads in many directions. At the same time, it appears as a discrete and contained pattern, emblematic on one hand, but with an implied center that is everywhere and nowhere.[265] We are confronted by a kind of planar buzz that diffuses the objectness of the painting. This is particularly clear in multipanel works where an actual physical division between the paintings appears to be obliterated by the strength of the image/ field. As Miller describes it, "The challenge I have been working with has been to create an image that suggests marked divisions, on the one hand, but that visually denies those divisions, on the other hand, because of the strength of the design or composition. I do not see spaces between the marks. It should be a single unified plane."[266]

Miller is particularly interested in investigating properties of light and color; indeed there is a unique quality of light and chroma that subtly emanates from Miller's paintings. While the bars that march across these canvases appear at first glance to be a solid black, they slowly reveal themselves to be a rich red or blue. This gradual metamorphosis in conjunction with the subtle radial character of Miller's compositions establishes a kind of ethereal chromatic plane. In essence, Miller humanizes geometry, bringing it into conjunction not so much with nature, per se, but with the nature of perception, though even Miller obliquely points to an organic or pastoral quality in the work. "I am interested in color that breathes and absorbs light, like all living things."[267]

In more recent years we have found ourselves in a theoretical climate that places abstract painting in a blatantly confrontational position. New strategies of appropriation, reference, and simulation associated with postmodernism have suggested that abstract painting is essentially incapable of inventing vital, self-referential forms that lead to new modes of perception and thinking. It is from this viewpoint that a new generation has emerged with geometric abstraction within its sight. Indeed, the relationship between this new generation and the American geometric tradition represents a complex mix of veneration and skepticism.

The conflict that vexes abstract painting in the late 1980s may be seen as a struggle between the ambitions of high art, with its metaphysical and spiritual connotations, and those of popular, postindustrial culture. While previous generations have agreed that these spheres exist as philosophical polarities, this new generation has attempted to meld one to the other, creating a strange and at times uncomfortable hybrid. Much of the new art stands as an emblem of this paradox, of this reckoning, as it were, of the signs and signals that have traditionally constituted the highest forms of abstract art. In Greenbergian terms, abstract painting was to be confined to the material or formal dimensions of the canvas. It was not to refer to anything outside those parameters. This new painting can be read from a formalist standpoint. Compositionally, the work is indebted to American abstraction in its emblematic directness, symmetry, and bold color, characteristics that have developed from Abstract Expressionism through the work of Stella. Indeed, these artists frankly acknowledge this heritage. At the same time, however, their art refers to a content outside the formalist realm of abstraction. Unlike those abstract painters who see themselves as the defenders of a unique faith in the universality of a powerful abstract image, these artists do not see themselves as guardians of perceptual or metaphysical values. There is a feeling that the search for spiritual resonance in archetypal forms has degenerated into a use of these forms as empty emblems of a bankrupt modernism. The new abstraction refers to the demystification of the concept of universality and to the equivocal nature of abstract images. This new art is more concerned with an object's cultural resonance than with the perceptual logic of its form. In so doing it refers to various modes of postindustrial society. This new geometry, often referred to as "Neo-Geo," has understandably met with its share of critical resistance. One critic related the "Neo-Geo" artists' position to that of the "Antichrist."[268]

The new abstraction has taken a variety of forms. Utilizing an essentially commercial technique, Los Angeles artist Tim Ebner buries canvases under layers of fiberglass polished to a glossy sheen. These cool, inert objects are attractive in an impersonal and sleekly industrial way; they are fine art accoutrement for today's slick, commodity-packed, postmodern environments. The sense of irony and cynicism are not lost on Ebner. Like a previous generation of artists who were seduced by the fiberglass technologies on the West Coast (among them Robert Irwin, Larry Bell, Craig Kauffman, and Peter Alexander), Ebner creates an object that passes for both fine art painting (a kind of industrial Brice Marden) and a common mass-produced product. "I am fascinated by ordinary, common things around me. In the new paintings, for instance, I'm more interested in fiberglass—this material that we live around all the time—and the beauty that can be extracted from such a common material."[269] Because of both his materials and the nature of his process, Ebner acknowledges a distance from the work of his elders. "Living at this particular moment, I can't derive the same kind of meanings that Brice Marden or Ellsworth Kelly did, for instance, but I do have a connection to their tradition, and I want to interject my own position."[270] Ebner's aesthetic may bear some connection to Marden and Kelly, but the source of his philosophy about art derives from Marcel Duchamp and Andy Warhol. For his more recent works, Ebner has had his panels made in a surfboard factory; after their fabrication he assembles them in sequence and has them framed. Speaking of this process the artist has said, "I enjoy going to the factory and watching them produce the panels. It's not craft in the sense of someone's intimate touch; it's more like following objects through their industrial process efficiently and cost-effectively."[271]

While Ebner's paintings may *refer* to the aesthetic of other artists, Philip Taaffe virtually quotes the signature styles of other geometric abstract painters, including Myron Stout, Bridget Riley, Barnett Newman, and Ellsworth Kelly. Taaffe's approach involves a disquieting irony in that the artist is not in a strict sense making abstractions as much as he is *representing* them as subject matter. The artist's appropriation of the Op art

style pays homage to Bridget Riley but more pointedly treats a style once innovative and transcendent but now long out of favor as a kind of artifact. Taaffe has stated flatly,

I am not interested in making a pretty object. It has to be ruthless. This painting on the left is of dinosaur vertebrae, a big dinosaur bone, but it also has the emphasis of a Color Field painting, a Kenneth Noland or a Barnett Newman. It is obliquely referential; I want to make it into a deeper artifact than either thing itself. That was my intent with the Rileys. I want my paintings to become primeval Riley or, with my Newman images, primeval Color Field painting. This is not just another Color Field painting—it's dinosaur vertebrae as a Color Field painting. Working this way is something I like to do. [272]

Tim Ebner, *Untitled*, 1988. Fiberglass and resin on panel, 81¼ × 91½". Collection Lynn and Jeffrey Slutsky; courtesy Wolff Gallery, New York. Photograph courtesy Wolff Gallery, New York

Taaffe's quotation of Newman—because of the elder artist's pervasive influence—is even more sacrilegious. In Taaffe's *Concordia*, referring to Newman's well-known *Concord* in The Metropolitan Museum of Art, Newman's famous "zip" is replaced by a twisted "cord" or rope. As one writer put it, "In *Concordia*, references ricochet between the sublimity of Barnett Newman and the look of a trademark Hermès rope-print scarf."[273] In Taaffe's painting, Newman's sublimity is twisted into an emblem of consumption, an artistic signature profaned into a commercial logo.

In the early 1980s, Ross Bleckner also focused on the appropriation of a signature geometric image, engaging a similar sense of irony but transforming that irony into his own peculiar form of transcendence. In 1981, Bleckner had an exhibition of Op paintings. In choosing to simulate the style of a movement long out of favor among "serious" abstract painters, Bleckner addressed the challenge of reinvesting that style with a kind of bittersweet sublime and in fact invests an element of melancholy in his imagery. Indeed, his emphasis is less optical than conceptual and metaphorical. According to Bleckner,

I chose Op art because that was a movement that had interested me. It attempted to construct a conceptual relationship to abstract painting. It was trying to fix art outside of itself onto ideas about a belief in idealism and the scientific notion of progress. As an artistic idea, it didn't go anywhere; built into it was its own obsolescence. It was a dead movement from its very inception. I like that idea because everything seems to have its own destruction built into it . . . I was interested in collapsing the idea of an image. So as soon as something begins to congeal, because of the retinal pulsation, if you will, it also almost expands and collapses at the same time. I felt this because of my own relationship to science, progress and methodology. I don't have that belief in the universality of image whether it be the world (media) or "in the person" (expressionism).[274]

This sense of melancholy is also referred to symbolically in Bleckner's stripes, which the artist sees

as a jail, as bars. . . . There were these lights inside the painting and as a viewer I would be this person who was perpetually locked out of the painting. I think a lot of the theme of death was also implied in the sense that you have ideas, you put them in a painting, and they are locked in there forever. They die in there. Then you move on. My work is very much about a kind of degraded sublime, like Barnett Newman's gone wild. [275]

Bleckner's paintings also reflect his interest in light as an evocative and disruptive perceptual force. By portraying a powerful sense of light pushing out from behind his bars, Bleckner attempts to produce the effect of a pulsating strobe and

the idea of dislocating yourself momentarily so that you can't really see anything, which on a metaphoric level calls into question the idea of values—the kind of wavering qualities of things around us and the fragility of perception. . . . This light has the ability to rupture what we see as opposed to also illuminating it as, let's say, in a classical still life where you get some light and you put it on an object and you have modeling. . . . I like the more subverting quality of psychedelic light. It's dissolved in this illusion of an object and I like the idea of that. [276]

Unlike Newman's geometry, Bleckner's is dissolved by a light that is not sublime but subversive.

Of all the artists of this new generation to question seriously the universality and contemporary viability of formalist abstraction, Peter Halley emerges as one of the most controversial figures. Widely considered to be one of the more cogent theoreticians on postmodern abstraction, Halley has in fact denied that his works are "abstract" in the modernist sense of the term, that is to say devoid of references beyond the pure concerns of surface, shape, and color, etc. If his works appear abstract, according to Halley, it is because "abstraction is the operative force in the realm of the social."[277] Halley's extensive writings—he has in effect become the spokesman for the "Neo-Geo" generation—attempt to theorize the practice of painting into images that have an allusionistic connection to contemporary experience. Although Halley's writings are inspired in part by the texts of Fredric Jameson and the French social scientist Jean Baudrillard, whose philosophies are a contemporary manifestation of Marx, his paintings are distinctly American in their scale and confrontational qualities.

Halley's work has evolved over the past decade from the use of geometry as a formal device to its use as a socio-economic metaphor. In graduate school, he was fascinated by primitive art and "the way it used geometric forms as a symbolic language for the absolute or natural order of things."[278] In 1980, Halley moved to New York when, as he puts it, "the paramount issue in my work became the effort to come to terms with the alienation, the isolation, but also the stimulation engendered by this huge urban environment."[279] His early paintings depicted blunt, walled-up spaces, in the form of images of brick walls. According to Halley, "They were about the spiritual space of Abstract Expressionism being walled up, and also about the subdividing and blocking of space that I found characteristic of the urban environment."[280] Using Baudrillard's texts on societal structure and alienation as a touchstone, Halley began directing his inquiries toward an art that addressed postindustrial society as a form of content.

Subsequent to painting the brick wall works,, Halley created a seminal group of "prison" images using elegantly diagrammed squares floating on a white ground and accented with simple black, vertical lines or "bars" in the middle. In Halley's hands, Albers's transcendant square of light appears to have been transformed into a void of containment and segregation. Despite the potentially bleak Orwellian character of these images, however, Halley's geometry blankets a range of seemingly contradictory material. The power of his vision can be attributed to the fact that it pivots on a thin edge between existentialist alienation and a quirky, almost "goofy" absurdism. Indeed, it is

Philip Taaffe, *Concordia*, 1985. Linoprint collage and acrylic on canvas, 90 × 54". Courtesy Pat Hearn Gallery, New York. Photograph courtesy Pat Hearn Gallery, New York

Ross Bleckner, *The Arrangement of Things*, 1982–85. Oil on canvas, 96 × 162". Collection Museum of Fine Arts, Boston. M. Theresa B. Hopkins Fund, 1986.21

Peter Halley, *Prison with Conduit*, 1981. Day-Glo acrylic and Roll-A-Tex on canvas, 54 × 36". Courtesy Sonnabend Gallery, New York. Photograph courtesy Sonnabend Gallery, New York

Halley's subtle and cynical humor that sets up the more awesome aspects of his vision, a vision inspired by comic book and cartoon imagery and sober networks of computer software diagramming. Halley consciously taps the visual vocabulary of the high and low ends of the information spectrum. It is this seemingly pervasive aspect of Halley's content—along with its bluntly disarming visual impact—that makes the work so unsettling.

Indeed, what Halley liked about the early brick wall images and the prison forms was that they were powerfully "frontal and contained," but more importantly "a little wacky and brutal."[281] For Halley, this brutal humor has an analogue in comic book, cartoon and advertising imagery, which James Rosenquist has described as "funny in a scary way. I mean, *these* things represent our culture?"[282] Halley has a deep respect for and perhaps a sense of affiliation with Pop art and its radical transformation of popular culture. "Pop art was a very important movement for me, and I identify with a number of its impulses. My early notebooks are filled with comic strip images that have fascinated me, and scared me a little too. The prison image was essentially inspired by various cartoons."[283]

Eventually the prisons began resembling monotonous tract homes in their blunt geometry and anonymity. Halley imagined it as an evolution from a prison image to what he would eventually call "a cell." "Cell seemed the best way to describe those things, whether they be a prison or a house. It encapsulated what I thought of simply as a contained unit of space."[284] Halley's pristine cells project contradictory emotions, suggesting, on one hand, the security of a contained space: the lines or "conduits" that connect and feed Halley's cells symbolize each home's secure and isolated place in a larger network. On the other hand, they also tap our innate fear of being locked in and isolated. It is the latter emotion that most, including Halley himself, seem to identify with more readily.

The more I thought about alienation, the more I thought of telephones, televisions, electricity, things zipping in and out of isolated spaces, and so I felt I had to depict the support system that these isolated cells had. In the real world, they usually come from underground, so I put a second panel underneath the first to depict in section an underground conduit network feeding into the cells. It's about above versus below ground, visible versus hidden, and maybe even the conscious and subconscious.[285]

Along with raw geometric form, one of the key signals in the emotional character of Halley's painting is the quality of light. While some of Halley's black cell images perhaps fall on the side of alienation or destruction, others are intensely and almost garishly bright—quivering, synthetic metaphors for the electronic movement of energy or information. In fact, Halley's colors are often primary and schematic, an analogue to the color coding of electrical wires. Halley is fascinated by the boldly synthetic quality of "Day-Glo" colors, which he describes as "creepy and unnatural. My blacks often seem more optimistic than my colors. For me, this 'Day-Glo' has a menacing buzz."[286] Asked if these eerie colors allude to nuclear power, Halley responded, "If not specifically nuclear, at least technological. Nuclear is so apocalyptic, but my own slant on the social is more that it's a kind of grinding on and on. Baudrillard said that the apocalypse has already occurred—not literally, in terms of bombs going off—but an end in terms of civilization. That's an intriguing thought."[287]

Ironically, Halley identifies to a certain extent with the works of Rothko and Newman but understandably from his own theoretical position. For Halley, Newman's and Rothko's paintings are less interesting in terms of their "natural" and sublime qualities, as identified by Robert Rosenblum,[288] than the fact that they mirror the social conditions of an electronic and industrial society. Halley appreciates Newman's paintings because they are "industrial and workmanlike."[289] He is also intrigued by the idea that Rothko's ethereal blocks of glowing color resemble the eerie blankness of a television screen. He has said, "I think the glow in their work, as well as the emptiness of it, relates to social issues."[290] In the end, the space projected in Halley's geometry derives from a wholly

Peter Halley, *Freudian Painting,* 1981. Acrylic and Roll-A-Tex on unprimed canvas, 72 × 144″. Courtesy Sonnabend Gallery, New York. Photograph courtesy Sonnabend Gallery, New York

different source from that of his elders. Newman's geometry brackets a seemingly boundless and optimistic space that can be related to the American landscape. Halley's geometry circumscribes an invisible labyrinth of power and communication.

Like Newman and the Minimalists, whose work Newman inspired, Halley is innately attracted to powerful and reductive geometric forms, images that declare themselves immediately and with authority. Yet like earlier American modernism, this is a hybrid form of abstraction, referring not only to painting but also to things in the world. Indeed, Halley's fascination with wires, pipes, and conduits is reminiscent of Ralston Crawford and Stuart Davis. Like his predecessors, Halley is fascinated by his landscape, but in this case it is a postindustrial one involving apartments, subdivisions, telephone lines, and underground cables. Mirroring the environment to which he refers, Halley's paintings project an almost surreal and anxious passivity. They are a visual manifestation of the buzz word of our generation: network.

Halley's paintings, like geometric abstraction in general, are a strategic component in the succeeding battle of avant-garde developments. In trying to establish landmarks in this developing tradition, one is struck less by smooth lines of stylistic developments than by the role geometric abstraction has played in establishing a theoretical tension in relation to various avant-garde movements. Geometric abstract painting has often found itself tangled up in a dialectical struggle, either as the accepted style to be overtaken by the gestural and/or figurative impulse or as the progressive intruder rationally undermining the romantic concept of unbridled self-expression. One should not think of this as an inherent quality or goal of geometric abstraction—which ranges from absolute rationalism to radical spirituality—but rather as a way of acknowledging its continued presence in modern art. For better or worse, this contrasting swing of "corrective" measures (the American Abstract Artists vs. the gestural Abstract Expressionists; de Kooning and Pollock vs. Pop art and Minimalism; Minimalism vs. Neo-expressionism; Schnabel, Clemente, and Kiefer vs. Peter Halley and the so-called Neo-Geo) remains as one of the driving forces of postwar American art.

The four decades represented in this exhibition have been extraordinarily explosive ones for American art, and the painters represented herein afford us the opportunity to re-examine these years through one of the key tendencies within the modernist vocabulary. Geometric abstraction is not an end in itself, but a theme that not only helped to direct postwar American art but was itself directed and distorted by larger events and themes. We might think of it in this case as a kind of litmus paper that has adapted in a chameleon-like way to a rapid succession of changes in American culture. What we see is a unique, though by no means comprehensive portrait of the period. From Newman and Stella to Mangold and Halley, geometric abstract painting has provided some of the major and more controversial signposts for avant-garde art in America.

NOTES

1. Cited in Max Kozlov, "Malevich as a Counter Revolutionary (East and West)," *Artforum* (New York), Jan. 1974, p. 36.

2. Quoted in Herschel B. Chipp, *Theories of Modern Art* (Berkeley: University of California Press, 1968), p. 22.

3. Christopher Greene, *Léger and the Avant-Garde* (New Haven and London: Yale University Press, 1976), p. 12 ff.

4. Alfred H. Barr, Jr., *Cubism and Abstract Art* (New York: The Museum of Modern Art, 1936), p. 19.

5. Wilhelm Worringer, *Abstraction and Empathy* (London: Routledge and Kegan Paul, 1953), pp. 3–25.

6. John Dornberg, "Art Vandals: Why They Do It?" *Art News* (New York), Mar. 1987, p. 103.

7. Quoted in Fairfield Porter, "Constructivism," in Rackstraw Downes, ed., *Art in Its Own Terms: Selected Criticism, 1935–1975* (New York: Taplinger Publishing Company, 1979), p. 66.

8. The author is grateful to Mrs. Annalee Newman for bringing this letter from her files to his attention. Reprinted courtesy of Mrs. Annalee Newman and The Barnett Newman Foundation insofar as their rights are concerned.

9. Barr, *Cubism and Abstract Art*, pp. 11–13.

10. *Webster's Ninth New Collegiate Dictionary* (Springfield, Mass.: Merriam-Webster, 1983).

11. H. H. Arnason, *The Classic Tradition in Contemporary Art* (Minneapolis: Walker Art Center, 1953), p. 7.

12. Lawrence Alloway, "Systemic Painting," in *Topics in American Art Since 1945* (New York: W. W. Norton and Company, 1975), p. 79.

13. Jules Langsner, *Four Abstract Classicists* (Los Angeles: Los Angeles County Museum of Art, 1959), p. 8.

14. Ibid.

15. A recent symposium devoted to the "Problem of Classicism" testified to the complex knotting together of stylistic, period, and ideological meaning associated with this term. See David Freedberg, "Editor's Statement: The Problem of Classicism: Ideology and Power," *Art Journal* (New York), Spring 1988, pp. 7–9.

16. Lawrence Alloway, "On the Edge," *Architectural Design* (London), Apr. 1960, pp. 164–65.

17. Ibid.

18. Ellsworth Kelly, in conversation with the author, Spencertown, New York, June 23, 1988.

19. Agnes Martin, in a telephone conversation with the author, Sept. 14, 1988.

20. John Gordon, "Geometric Abstraction in America," in *Geometric Abstraction in America* (New York: Whitney Museum of American Art, 1962), p. 9.

21. John Elderfield, "Introduction," in Magdalena Dabrowski, ed., *Contrasts of Form: Geometric Abstract Art 1910–1980* (New York: The Museum of Modern Art, 1985), p. 11.

22. Clement Greenberg, "American-Type Painting," in *Art and Culture* (Boston: Beacon Press, 1961), p. 227.

23. Charmion von Wiegand, "The White Plane," catalogue introduction to exhibition at the Pinacotheca, Mar. 19–Apr. 12, 1947.

24. Ellsworth Kelly, in conversation with the author, Spencertown, New York, June 23, 1988.

25. Gene Davis, in conversation with the author, Sarasota, Florida, Feb. 21 and 22, 1981.

26. Agnes Martin, "The Untroubled Mind," *Studio International* (London), Feb. 1973, pp. 64–65.

27. Brice Marden, statement in *Brice Marden: Paintings, Drawings and Prints 1975–80* (London: Whitechapel Gallery, 1981), p. 55. Reprinted from *Options and Alternatives: Some Directions in Recent Art* (New Haven: Yale University Art Gallery, 1973), n.p.

28. Robert Mangold, in conversation with the author, New York, Aug. 18, 1988.

29. David Novros, in conversation with the author, New York, May 18, 1988.

30. Susan C. Larsen, "Albert Gallatin: The 'Park Avenue Cubist' Who Went Downtown," *Art News* (New York), Dec. 1978, p. 80.

31. For an excellent and comprehensive discussion of early American abstraction, see Susan C. Larsen, "The Quest for an American Abstract Tradition, 1927–1944," in John R. Lane and Susan C. Larsen, eds., *Abstract Painting and Sculpture in America 1927–1944* (Pittsburgh and New York: Museum of Art, Carnegie Institute, and Harry N. Abrams, 1983), pp. 15–44.

32. Videotape interview with Ilya Bolotowsky, 1980. Collection Albright-Knox Art Gallery, Buffalo.

33. See Barr, *Cubism and Abstract Art*.

34. Ibid., p. 200.

35. Philip Larson, "Burgoyne Diller: An American Constructivist," in *Burgoyne Diller: Paintings, Sculpture and Drawings* (Minneapolis: Walker Art Center, 1971), p. 11.

36. Louise Averill Svendsen with Mimi Poser, "Interview with Ilya Bolotowsky," in *Ilya Bolotowsky* (New York: The Solomon R. Guggenheim Museum, 1974), p. 17.

37. Stuart Davis, quoted in "The Meanings of Abstraction," in *Abstract Painting in America* (New York: Whitney Museum of American Art, 1935), p. 11.

38. Ilya Bolotowsky, "On Neo Plasticism and My Own Work: A Memoir," *Leonardo* (London), vol. 2, 1969, pp. 221–30.

39. Ibid.

40. Robert M. Ellis, *Ilya Bolotowsky: Paintings and Columns* (Albuquerque: University Art Museum, 1970), p. 7.

41. Belle Krasner, "Fifty-Seventh Street in Review: Fritz Glarner," *Art Digest* (New York), Feb. 15, 1951, p. 20.

42. Fritz Glarner, "Relational Painting" (lecture delivered at Subject of the Artists School, Feb. 25, 1949), quoted in Nancy J. Troy, "Fritz Glarner," in Lane and Larsen, eds., *Abstract Painting and Sculpture in America 1927–1944*, p. 147. See also Virginia Pitts Rembert, "Mondrian, America and American Painting" (Ph.D. diss., Columbia University, 1970), p. 178.

43. Letter from the artist to Katherine S. Dreier, Jan. 28, 1946 in Katherine S. Dreier Papers, Yale Collection of American Literature, Beinecke Rare Book and Manuscript Library, Yale University, New Haven.

44. For further discussion on this aspect of Glarner's work, see this author's forthcoming article.

45. Virginia Pitts Rembert, "Charmion von Wiegand's Way Beyond Mondrian," *Women's Art Journal* (Knoxville, Tenn.), Fall 1983/Winter 1984, p. 30.

46. Ibid.

47. Charmion von Wiegand, "The Meaning of Mondrian," *Journal of Aesthetics and Art Criticism* (Greenvale, N.Y.), Fall 1943, pp. 62–70.

48. Rembert, "Charmion von Wiegand's Way Beyond Mondrian," p. 31.

49. Ibid., p. 30.

50. Quoted in Susan Krane, "Charmion von Wiegand: The Wheel of the Seasons," in *Albright-Knox Art Gallery/The Painting and Sculpture Collection: Acquisitions Since 1972* (Buffalo: Albright-Knox Art Gallery in association with Hudson Hills Press, 1987), p. 356.

51. Robert Coates, "The Art Galleries: Abstractionists and What About Them?" *The New Yorker* (New York), Mar. 1939, p. 57.

52. Margit Rowell, "On Albers' Color," *Artforum* (New York), Jan. 1972, pp. 26–37.

53. Ibid.

54. See Carel Blotkamp, "Annunciation of the New Mysticism, Dutch Symbolism and Early Abstraction," *The Spiritual in Art: Abstract Painting 1890–1985* (Los Angeles: Los Angeles County Museum of Art, 1986), pp. 89–111.

55. Georges Mathieu, quoted in Irving Sandler, *The Triumph of American Painting* (New York: Praeger, 1970), p. 25.

56. Paul Cummings, Interview with Carl Holty, Oct. 1, 1968. Archives of American Art, Smithsonian Institution, Washington, D.C. Quoted in Nancy J. Troy, "Piet Mondrian," in Lane and Larsen, eds., *Abstract Painting and Sculpture in America 1927–1944*, p. 196.

57. John Elderfield, "Introduction," in Dabrowski, ed., *Contrasts of Form*, p. 11.

58. Frank Stella, quoted in Bruce Glaser, "Questions to Stella and Judd," in Gregory Battcock, ed., *Minimal Art: A Critical Anthology* (New York: E. P. Dutton, 1968), p. 158.

59. Thomas B. Hess, *Barnett Newman* (New York: Walker and Co., 1969), p. 23.

60. George L. K. Morris, *American Abstract Artists* (New York: Ram Press, 1946), n.p.

61. Ilya Bolotowsky, "On Neo-Plasticism and My Own Work," pp. 221–30.

62. See Richard Shiff, "Performing an Appearance: On the Surface of Abstract Expressionism," in *Abstract Expressionism: The Critical Developments* (New York and Buffalo: Harry N. Abrams in association with Albright-Knox Art Gallery, 1987), pp. 94–123. Also see Kate Linker, "Abstraction: Form as Meaning," in *Individuals: A Selected History of Contemporary Art* (Los Angeles and New York: Museum of Contemporary Art in association with Abbeville Press, 1986), pp. 30–59.

63. John Graham, *System and Dialectics of Art* (New York: Delphic Studios, 1937), p. 88.

64. Harold Rosenberg, "The American Action Painters," *Art News* (New York), Dec. 1952, pp. 22–23, 48–50.

65. Greenberg, "American-Type Painting," p. 227.

66. William Carlos Williams, "The Poem as a Field of Action," in *Selected Essays of William Carlos Williams* (New York: Random House, 1954), pp. 280–91. For a later extension of this literary "field of action" see Charles Olsen, "Projective Verse," in Donald Allen, ed., *Human Universe and Other Essays* (New York: Grove Press, 1967), pp. 51–61.

67. Morton Feldman, in conversation with the author, Buffalo, May 20, 1986.

68. "The Irascibles," photographed by Nina Leen, *Life* (New York), Jan. 15, 1951.

69. Dore Ashton, "Artists and the New Deal," in *The New York School: A Cultural Reckoning* (New York: Viking Press, 1972), p. 44.

70. Barnett Newman, quoted in Ashton, "Artists and the New Deal," p. 44.

71. See Thomas B. Hess, *Barnett Newman* (New York: The Museum of Modern Art, 1971), pp. 23–25.

72. David Sylvester, "The Ugly Duckling," in *Abstract Expressionism: The Critical Developments*, p. 137.

73. Hess, *Barnett Newman*, 1969, p. 26.

74. Barnett Newman, Artist's statement in *New American Painting* (New York: The Museum of Modern Art, 1958), p. 56.

75. Barnett Newman, "Foreword," in *The Ideographic Picture* (New York: Betty Parsons Gallery, 1947), n.p.

76. Clement Greenberg, quoted in Harold Rosenberg, *Barnett Newman* (New York: Harry N. Abrams, 1977), p. 67.

77. Rosenberg, *Barnett Newman*, p. 67.

78. Barnett Newman, "The Sublime is Now," *The Tiger's Eye* (New York), Dec. 15, 1948, pp. 52–53.

79. Barnett Newman, "The Plasmic Image" in Hess, *Barnett Newman*, 1971, pp. 37–39.

80. Ibid., p. 38.

81. Ibid.

82. David Sylvester, interview with Barnett Newman, Easter 1965, reprinted in *Abstract Expressionism: The Critical Developments*, p. 144.

83. Newman quoted in Rosenberg, *Barnett Newman*, p. 41.

84. Sylvester, interview with Barnett Newman, Easter 1965, p. 144.

85. Ibid.

86. Barnett Newman, quoted in Rosenberg, *Barnett Newman*, p. 30.

87. Rosenberg, *Barnett Newman*, p. 30.

88. Ibid.

89. Sylvester, interview with Barnett Newman, Easter 1965, p. 144.

90. Rosenberg, *Barnett Newman*, p. 47.

91. See Hess, *Barnett Newman*, 1971, p. 57; Sandler, *The Triumph of American Painting*, p. 190; Sylvester, "The Ugly Duckling," p. 138; Ann Gibson, "Barnett Newman and Alberto Giacometti," *Issue* (New York), Spring 1985, pp. 2–9.

92. Yves-Alain Bois, "Perceiving Newman," in *Barnett Newman* (New York: Pace Gallery, 1988), p. IV.

93. Hess, *Barnett Newman*, 1971, p. 59.

94. Ibid., p. 71.

95. Sylvester, interview with Barnett Newman, Easter 1965, p. 144.

96. Lawrence Alloway, "The Abstract Sublime," in *Topics in American Art Since 1945* (New York: W. W. Norton and Company, 1975), p. 34.

97. For the implication of this type of space on a number of American artists of a succeeding generation, see this author's "Beyond the Sublime," in *Abstract Expressionism: The Critical Developments*, pp. 146–66.

98. John Elderfield, "Mondrian, Newman, Noland: Two Notes on Changes of Style," *Artforum* (New York), Dec. 1971, pp. 48–53.

99. See, for example, *The Third*, 1962, and the series "Who's Afraid of Red, Yellow and Blue" of 1966–67.

100. Barbara Rose, "Mondrian in New York," *Artforum* (New York), Dec. 1971, p. 59.

101. A number of authors have explored Newman's color for symbolic meaning. See Hess, *Barnett Newman*, 1971; Ann Gibson, "Regression and Color in Abstract Expressionism: Barnett Newman, Mark Rothko, and Clyfford Still," *Arts Magazine* (New York), Mar. 1981, p. 144; and Evan R. Firestone, "Color in Abstract Expressionism: Sources and Background for Meaning," *Arts Magazine* (New York), Mar. 1981, pp. 140–42.

102. Hess, *Barnett Newman*, 1969, p. 65.

103. Sylvester, "The Ugly Duckling," p. 143.

104. Clyfford Still, "An Open Letter to an Art Critic," *Artforum* (New York), Dec. 1963, p. 33.

105. Rosenberg, *Barnett Newman*, p. 41.

106. Ibid., p. 42.

107. For an excellent analysis of Reinhardt's work in relation to Mondrian, see Margit Rowell, "Ad Reinhardt: Style as Recurrence," in *Ad Reinhardt and Color* (New York: The Solomon R. Guggenheim Museum, 1980), pp. 10–26.

108. Hess has noted in *Barnett Newman*, 1971, p. 67, footnote 7:

In order to achieve the desired density and intensity of color, Newman almost always put many coats of paint on his pictures, sometimes using undercoats of different colors to arrive at a particularly deep or luminous hue. The use of oils necessitated long periods of waiting for each coat to dry, and he arranged to keep working on several pictures, so that while one was drying, he would work on another. Often he alternated mediums for what he called "separating coats": of paint—for example, egg tempera on oil on egg tempera on oil. In this way, he could increase the opacity and weight of his colors—especially those which usually are transparent. He continued this practice throughout his life, even when, in the 1960s, he made a more extensive use of fast-drying plastic paints.

He also often used shifts in medium within a single picture to contrast a shiny oil surface with a mat, egg-tempera, or acrylic coat—a subtle parallel to the soft-stroke versus hard-edge dualism already mentioned in his painting.

109. Ad Reinhardt, quoted in Rowell, "Ad Reinhardt," p. 21.

110. Ibid, p. 23.

111. Barbara Rose, ed., *Art as Art: The Selected Writings of Ad Reinhardt* (New York: Viking Press, 1975), p. 104.

112. Rowell, "Ad Reinhardt," p. 22.

113. Hilton Kramer, "Art," *The Nation* (New York), June 22, 1963, p. 534.

114. Rowell, "Ad Reinhardt," p. 26.

115. Ibid., p. 11.

116. Ad Reinhardt, in a lecture at the Skowhegan School of Painting and Sculpture, 1967. Quoted in Rowell, "Ad Reinhardt," p. 13.

117. Rough draft for final article published in Rose, ed., *Art as Art*, pp. 173–77. Quoted in Rowell, "Ad Reinhardt," p. 13.

118. Ibid., p. 9.

119. Frank Stella, "A Tribute to Ad Reinhardt," *Artscanada* (Toronto), Oct. 1967, p. 2.

120. Leon Polk Smith, quoted in Lawrence Alloway, "Leon Polk Smith," in *Topics in American Art*, pp. 71–72.

121. Ibid., p. 70.

122. Leon Polk Smith, in conversation with the author, New York, Nov. 15, 1988.

123. Leon Polk Smith, quoted in Alloway, "Leon Polk Smith," p. 70.

124. Ibid., p. 72.

125. Ibid., p. 69.

126. Leon Polk Smith, in conversation with the author, New York, Nov. 15, 1988.

127. Ibid.

128. For a good discussion of McLaughlin's background, see Donald F. MacCallum, "The Painting of John McLaughlin," *Los Angeles Institute of Contemporary Art Journal* (Los Angeles), May–June 1976, pp. 7–17.

129. See Jules Langsner's exhibition catalogue, *Four Abstract Classicists* (Los Angeles: Los Angeles County Museum of Art, 1959).

130. *John McLaughlin, Paintings 1949–75* (New York: André Emmerich Gallery, 1979), n.p.

131. McLaughlin expressed this intention to Robert C. Morgan. See Robert C. Morgan, "On McLaughlin's Paintings of the 1960s," *Arts* (New York), Mar. 1988, pp. 50–51.

132. Prudence Carlson, "John McLaughlin, The Other Order," in *John McLaughlin: Paintings of the Sixties* (New York: André Emmerich Gallery, 1987), p. 8.

133. *John McLaughlin, Paintings 1949–75*, n.p.

134. Dore Ashton, "Painting Toward the Art of John McLaughlin," *Arts Magazine* (New York), Nov. 1979, pp. 120–21.

135. *John McLaughlin: A Retrospective Exhibition* (Pasadena: Pasadena Art Museum, 1963), n.p.

136. Statement in *John McLaughlin Paintings 1949–75*, n.p.

137. John Coplans, "John McLaughlin, Hard Edge and American Painting," *Artforum* (New York), Jan. 1964, p. 29.

138. James Harithas, "Painting at the Degree Zero," *Art News* (New York), Nov. 1968, p. 71.

139. John McLaughlin, in conversation with the author on the occasion of the artist's visit to the exhibition *10 Major Works: Mark Rothko*, Newport Harbor Art Museum, Newport Beach, California, 1974.

140. Harithas, "Painting at the Degree Zero," pp. 53, 69, 70, 71.

141. B. H. Friedman, "Introduction," in Sanford Schwartz, *Myron Stout* (New York: Whitney Museum of American Art, 1980), p. 13.

142. Myron Stout, quoted in "Excerpts from the Journals of Myron Stout," in Schwartz, *Myron Stout*, pp. 79, 83.

143. Ibid., p. 83.

144. Myron Stout, quoted in "Excerpts from the Journals of Myron Stout," p. 86.

145. Sanford Schwartz, "Myron Stout," *Artforum* (New York), Mar. 1975, p. 41.

146. Jed Perl, "On Myron Stout," *Art in America* (New York), Mar. 1980, p. 110.

147. Myron Stout, quoted in "Excerpts from the Journals of Myron Stout," p. 88.

148. See also Serge Guilbaut, *How New York Stole the Idea of Modern Art* (Chicago: University of Chicago Press, 1983).

149. John Chamberlain, in conversation with the author, Sarasota, Florida, Oct. 1, 1981.

150. Clement Greenberg, *Post-Painterly Abstraction* (Los Angeles: Los Angeles County Museum of Art, 1964), n.p.

151. Ibid.

152. John Coplans, "Post Painterly Abstraction: The Long Awaited Greenberg Exhibition Fails to Make Its Point," *Artforum* (New York), Summer 1964, pp. 5–8.

153. Ellsworth Kelly, in conversation with the author, Spencertown, New York, June 23, 1988.

154. Ibid.

155. Diane Waldman, *Ellsworth Kelly: Drawings, Collages, Prints* (New York: New York Graphic Society, 1971), p. 14.

156. Ellsworth Kelly, in conversation with the author, Spencertown, New York, June 23, 1988.

157. Ellsworth Kelly, in conversation with the author, Spencertown, New York, June 23 and 24, 1988.

158. Ellsworth Kelly, "Notes from 1969," in *Ellsworth Kelly: Paintings and Sculptures 1963–1979* (Amsterdam: Stedelijk Museum, 1980), p. 30.

159. Ellsworth Kelly, in conversation with the author, Spencertown, New York, June 23 and 24, 1988.

160. Ibid.

161. Ibid.

162. Waldman, *Ellsworth Kelly*, p. 20.

163. Ellsworth Kelly, in conversation with the author, Spencertown, New York, June 23, 1988.

164. James Rosenquist, in conversation with the author, Buffalo, New York, Mar. 13, 1986. I am indebted to Rosenquist for pointing out the "cityscape" aspect of *New York, N. Y.*

165. Ellsworth Kelly, in a telephone conversation with the author, Apr. 11, 1988.

166. James Wood, press release accompanying the exhibition *Ellsworth Kelly: The Chatham Series*, Albright-Knox Art Gallery, Buffalo, July 11–Aug. 27, 1972.

167. Ellsworth Kelly, in conversation with the author, Spencertown, New York, June 23, 1988.

168. Ibid.

169. Ibid.

170. Clement Greenberg, "Modernist Painting," in Gregory Battcock, ed., *The New Art* (New York: E. P. Dutton, 1973); see also his writings: *Three New American Painters: Louis, Noland, Olitski.* (Regina, Canada: Norman Mackenzie Art Gallery, 1963); "Louis and Noland," *Art International* (Lugano), May 1963, pp. 26–29; and "After Abstract Expressionism," *Art International* (Lugano), Oct. 1962, pp. 24–32.

171. See, for example, the writings by Michael Fried: *Three American Painters: Kenneth Noland, Jules Olitski, Frank Stella* (Cambridge, Mass.: Fogg Art Museum, Harvard University, 1965); "Jules Olitski's New Paintings," *Artforum* (Los Angeles), Nov. 1965, pp. 36–40; "Shape as Form: Frank Stella's New Paintings," *Artforum* (Los Angeles), Nov. 1966, pp. 18–27; "Olitski and Shape," *Artforum* (Los Angeles), Jan. 1967, pp. 20–21; "The Achievement of Morris Louis," *Artforum* (Los Angeles), Feb. 1967, pp. 34–40; and "Recent Work by Kenneth Noland," *Artforum* (New York), Summer 1969, pp. 36–37.

172. The author is extremely grateful to Kenneth Noland and the Archives of American Art in Washington, D.C., for making available the unpublished, restricted interview between the artist and Paul Cummings, Dec. 9 and 21, 1971.

173. For a discussion of Noland's involvement with Albers at Black Mountain College, see Kenworth Moffett, *Kenneth Noland* (New York: Harry N. Abrams, 1977), pp. 13–15.

174. Ibid., p. 15.

175. Kenneth Noland, quoted in unpublished interview with Paul Cummings, Dec. 9 and 21, 1971.

176. Quoted in Diane Waldman, *Kenneth Noland: A Retrospective* (New York: The Solomon R. Guggenheim Museum, 1977), p. 17.

177. Ibid.

178. Diane Waldman, "Color, Format and Abstract Art: An Interview with Kenneth Noland," *Art in America* (New York), May–June 1977, p. 100.

179. Ibid.

180. Gene Davis, in conversation with the author, Sarasota, Florida, Feb. 21 and 22, 1981.

181. Ibid.

182. Ibid.

183. Barbara Rose, "Interview by Barbara Rose," in Donald Wall, ed., *Gene Davis* (New York: Praeger, 1975) pp. 134–37.

184. Ibid., pp. 133–34.

185. Gene Davis, in conversation with the author, Sarasota, Florida, Feb. 21 and 22, 1981.

186. "Interview by Donald Wall," in Wall, ed., *Gene Davis*, p. 32.

187. Ibid., p. 58.

188. Lisa Lyons, "Excerpts from an interview with Gene Davis," in *Gene Davis: Recent Paintings* (Minneapolis: Walker Art Center, 1978), n.p.

189. "Interview by Donald Wall," in Wall, ed., *Gene Davis*, p. 32.

190. See Charles Harrison, "Expression and Exhaustion: Art and Criticism in the Sixties," *Artscribe* (London), Feb./Mar. 1986, pp. 44–49.

191. Gene Davis, in conversation with the author, Sarasota, Florida, Feb. 21 and 22, 1981.

192. Al Held, in conversation with the author, New York, Aug. 18, 1988.

193. James Faure Walker, "Al Held, Interview," *Artscribe* (London), July 1977, p. 9.

194. Quoted in Nancy Grimes, "Al Held: Reinventing Abstraction," *Art News* (New York), Feb. 1988, p. 107.

195. See text by Irving Sandler, in *Concrete Expressionism* (New York: New York University, 1965).

196. Walker, "Al Held, Interview," pp. 6–8.

197. Ibid.

198. Ibid.

199. Ibid., p. 9.

200. Al Held, in conversation with the author, New York, Aug. 18, 1988.

201. Richard Anuszkiewicz, in conversation with the author, Buffalo, New York, Oct. 10, 1988, and in subsequent telephone conversations.

202. Ibid.

203. Irving Sandler, "Sander Paints a Picture," *Art News* (New York), Sept. 1959, p. 57.

204. See Robert Rosenblum, *Modern Painting and the Northern Romantic Tradition: Friedrich to Rothko* (New York: Harper and Row, 1975).

205. Irving Sandler, "1967: Out of Minimal Sculpture," in Janet Kardon, ed., *1967: At the Crossroads* (Philadelphia: Institute of Contemporary Art, 1987), p. 40.

206. Alan Solomon, *New York: The Second Breakthrough 1959–64* (Irvine, Calif.: Art Gallery, University of California, 1969) pp. 9–10.

207. Quoted in Brenda Richardson, "Preface and Acknowledgments," *Frank Stella: The Black Paintings* (Baltimore: The Baltimore Museum of Art, 1976), p. XI.

208. Lucy Lippard, "Cult of the Direct and the Difficult" in *Changing: Essays in Art Criticism* (New York: E. P. Dutton and Co., 1971), p. 115.

209. William Rubin, *Frank Stella* (New York: The Museum of Modern Art, 1970), p. 149.

210. Frank Stella, quoted in Emile de Antonio and Mitch Tuchman, *Painters Painting: A Candid History of the Modern Art Scene, 1940–1970* (New York: Abbeville Press, 1984), p. 140.

211. Irving Sandler, quoted in Alloway, "Systemic Painting," in *Topics in American Art Since 1945*, p. 90.

212. Frank Stella, quoted in Bruce Glaser, "Questions to Stella and Judd," in Battcock, ed., *Minimal Art: A Critical Anthology*, p. 158.

213. William Rubin addresses this comparison in Antonio and Tuchman, *Painters Painting*, pp. 138–39.

214. Robert Rosenblum, *Frank Stella* (Harmondsworth, England: Penguin Books, 1971), p. 48.

215. Rubin, *Frank Stella*, pp. 146, 149.

216. Frank Stella, quoted in Rubin, *Frank Stella*, p. 149.

217. Robert Rosenblum, "Excavating the 1950s," in Paul Schimmel, ed., *Action/Precision: The New Direction in New York 1955–60* (Newport Beach: Newport Harbor Art Museum, 1984), p. 13.

218. Robert Mangold, in conversation with the author, New York, Aug. 18, 1988.

219. Lawrence Alloway, *Systemic Painting* (New York: The Solomon R. Guggenheim Museum, 1966).

220. Lawrence Alloway, in a telephone conversation with the author, Dec. 15, 1988, and in previous telephone conversations.

221. Agnes Martin, "The Untroubled Mind" (statements recorded by Ann Wilson) in *Agnes Martin* (Philadelphia: Institute of Contemporary Art, 1973), p. 17.

222. Agnes Martin, quoted in Lizzie Borden, "Agnes Martin: Early Works," *Artforum* (New York), Apr. 1973, p. 39.

223. Ibid., p. 42.

224. Mondrian, quoted in Annette Michelson, "Agnes Martin: Recent Paintings," *Artforum* (New York), Jan. 1967, p. 46.

225. Lawrence Alloway, "Agnes Martin," *Artforum* (New York), Apr. 1973, p. 34.

226. Agnes Martin, in a telephone conversation with the author, Sept. 14, 1988.

227. Agnes Martin, quoted in Lucy Lippard, "Homage to the Square," *Art in America* (New York), July–Aug. 1967, p. 55.

228. Response to questionnaire, in Albright-Knox Art Gallery files.

229. See Lucy Lippard, "Larry Poons: The Illusion of Disorder," in *Changing: Essays in Art Criticism*, pp. 185–96.

230. Both Lippard and Sidney Tillim see Poons as the logical successor to Mondrian. See Ibid. and Sidney Tillim, "Larry Poons: The Dotted Line," *Arts* (New York), pp. 16–21.

231. See Lippard, "Larry Poons: The Illusion of Disorder," p. 186.

232. See Poons interview in Jeanne Siegal, *Artwords: Discourse on the 60's and 70's* (Ann Arbor, Mich.: UMI Research Press, 1985), pp. 44–45.

233. Larry Poons, quoted in Lippard, "Larry Poons: The Illusion of Disorder," p. 191.

234. Ibid., p. 190.

235. Robert Mangold, in conversation with the author, New York, Aug. 18, 1988, and in subsequent telephone conversations.

236. Ibid.

237. Robin White, "Interview with Robert Mangold," *View* (Oakland, Calif.), Dec. 1978, pp. 16–17.

238. Robert Mangold, in conversation with the author, New York, Aug. 18, 1988.

239. Ibid.

240. Robert Mangold, in conversation with the author, New York, Aug. 18, 1988, and in subsequent telephone conversations.

241. Ibid.

242. Ibid.

243. Ibid.

244. Ibid.

245. Robert Mangold, in conversation with the author, New York, Aug. 18, 1988.

246. Dorothea Rockburne, quoted in Naomi Spector, "Dorothea Rockburne," in *Bochner, LeVa, Rockburne, Tuttle* (Ohio: The Contemporary Arts Center, Cincinnati, 1975), n.p.

247. Jo Baer, quoted in Barbara Haskell, *Jo Baer* (New York: Whitney Museum of American Art, 1975) n.p.

248. William C. Seitz, *The Responsive Eye* (New York: The Museum of Modern Art, 1965), p. 17.

249. See Roberta Pancoast Smith, "Brice Marden's Painting," *Arts* (New York), May–June 1973, p. 36.

250. Rini Dippel, *Fundamental Painting* (Amsterdam: Stedelijk Museum, 1975), p. 10.

251. Brice Marden, quoted in *Eight Contemporary Artists* (New York: The Museum of Modern Art, 1974), p. 46.

252. Roberta Smith, "Brice Marden," in *Brice Marden: Paintings, Drawings, Prints 1975–80* (London: The Whitechapel Art Gallery, 1981), p. 46.

253. See Edit deAk, Alan Moore, and Mike Robinson, "Conversation with Brice Marden," *Art-Rite* (New York), Spring 1975, p. 42.

254. Response to questionnaire, Albright-Knox Art Gallery files.

255. Roberta Smith, "Brice Marden," p. 50.

256. Brice Marden, quoted in Stephen Bann, "From the Material to the Immaterial," in *Brice Marden: Paintings, Drawings, Prints 1975–80*, p. 8.

257. This term was applied to a group of works (including that of Novros, Mangold and Marden), in the exhibition *Modular Painting* (Buffalo: Albright-Knox Art Gallery, 1970).

258. Novros, in conversation with the author, New York, May 18, 1988.

259. Ibid.

260. Ibid.

261. See Sheldon Nodelman, *Marden, Novros, Rothko: Painting in the Age of Actuality* (Houston: Institute For the Arts, Rice University, 1978).

262. David Novros, in conversation with the author, New York, May 18, 1988.

263. Ibid.

264. Ibid.

265. Christopher Knight, "John Miller Moves Above Ground," *Los Angeles Herald Examiner*, Dec. 14, 1986, p. E5.

266. John M. Miller, in a telephone conversation with the author, July 29, 1988.

267. Ibid.

268. Donald Kuspit, "The Catastrophe that Happened to Art," *Newsletter* [Independent Curators Incorporated] (New York), Fall 1988, pp. 1–2.

269. Tim Ebner, interviewed by Elisabeth Sussman and David Joselit in *The Binational: German Art of the Late 80's* (Boston: The Institute of Contemporary Art, 1988), p. 78.

270. Ibid., p. 78.

271. Ibid.

272. Philip Taaffe, "Talking Abstract," *Art in America* (New York), Dec. 1987, p. 122.

273. Jan Avgikos, "Philip Taaffe," in Rainer Crone, ed., *Similia/Dissimilia* (Dusseldorf: Städtische Kunsthalle 1987/1988), p. 156.

274. Ross Bleckner, interviewed by Jeanne Siegel, "Geometry Desurfacing: Ross Bleckner," *Artwords 2: Discourse on the Early 80's* (Ann Arbor, Mich.: UMI Research Press, 1988), p. 230.

275. Ibid.

276. Ibid., p. 233.

277. Peter Halley, "Talking Abstract," *Art in America* (New York), Dec. 1987, p. 171.

278. Peter Halley, interviewed by Trevor Fairbrother, *The Binational: German Art of the Late 80's*, p. 95.

279. Ibid.

280. Ibid.

281. Peter Halley, in conversation with the author, New York, Jan. 10, 1989.

282. James Rosenquist, in conversation with the author, Buffalo, Mar. 13, 1986.

283. Peter Halley, in conversation with the author, New York, Jan. 10, 1989.

284. Ibid.

285. Peter Halley, interviewed by Trevor Fairbrother, p. 98.

286. Peter Halley, in conversation with the author, New York, Jan. 10, 1989.

287. Peter Halley, interviewed by Trevor Fairbrother, p. 99.

288. Rosenblum, *Modern Painting and the Northern Romantic Tradition: Friedrich to Rothko*

289. Peter Halley, interviewed by Trevor Fairbrother, pp. 97–98.

290. Ibid.

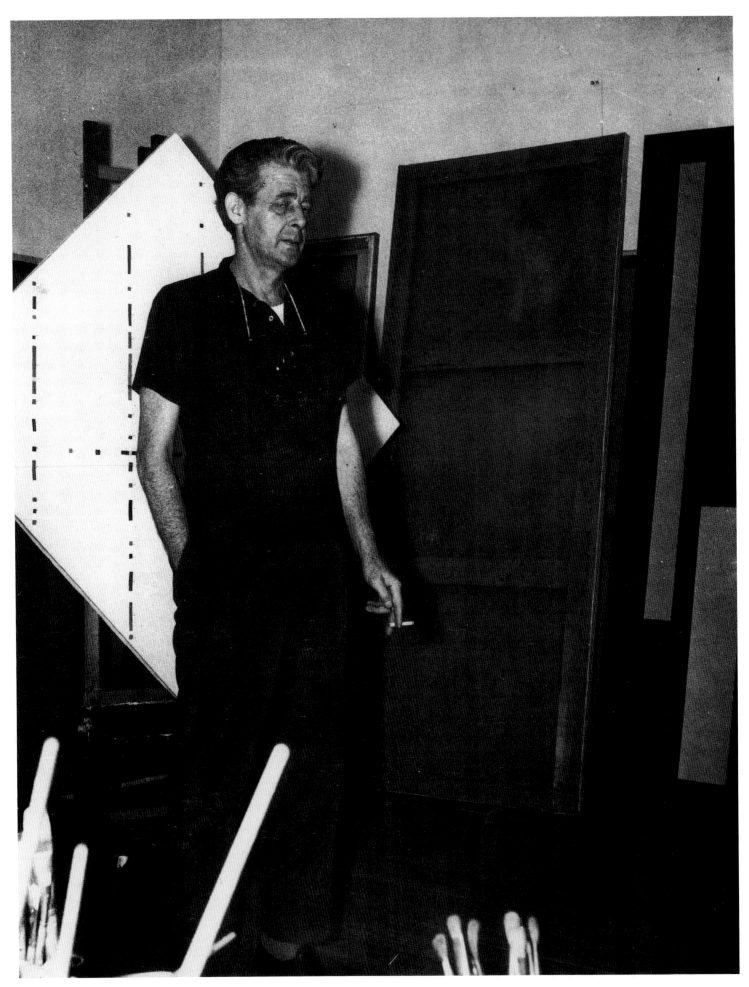

Bugoyne Diller
Photograph by Burton Wasserman
© Smithsonian Institution

I live with rules . . . I get out of bed by one . . . I eat with them . . . they nag me all day . . . I think I will tell them to go to hell with their rules . . . but I don't . . . I can't . . . which is a rule. I desire . . . above all . . . to get at my paint box . . . to feel the fat tubes of paint . . . to brush the rich color in luscious curves . . . in a design . . . damn! The thought . . . I live by rules now . . . not painting for one of the rabble.

How does one express the creative moment? . . . or the creative life? . . . the times of trial and error . . . of hope and despair of sweating work and quiet seeking. Times when you play tricks on yourself to get working . . . you tidy up the studio . . . wash your brushes, clean the palette . . . make little drawings . . . find yourself getting interested, then . . . (off you go?) to work. How much time there is . . . how little time there is . . . how much has been done . . . how much there is to do. Now there is no time . . . now minutes seem like the slow dripping of cold honey. There is no past . . . there is no future . . . there is only now. Time is the past, present, and future . . . now . . . and time is understood. Space is realized . . . the image is clear.

Quoted in Kenneth W. Prescott, "Preface." *Burgoyne Diller: 1906–1965.* Trenton: New Jersey State Museum, 1966, n.p.

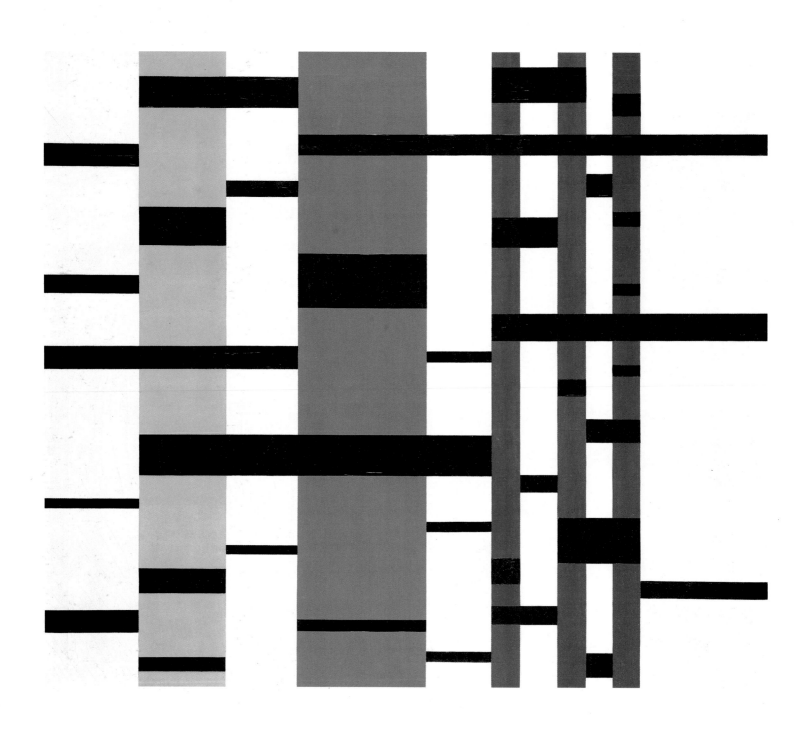

Composition #21, 1945
Oil on canvas, 36³/₁₆ × 42⅛"
Yale University Art Gallery,
Gift of Katherine S. Dreier to the
Collection Société Anonyme (1946.37)

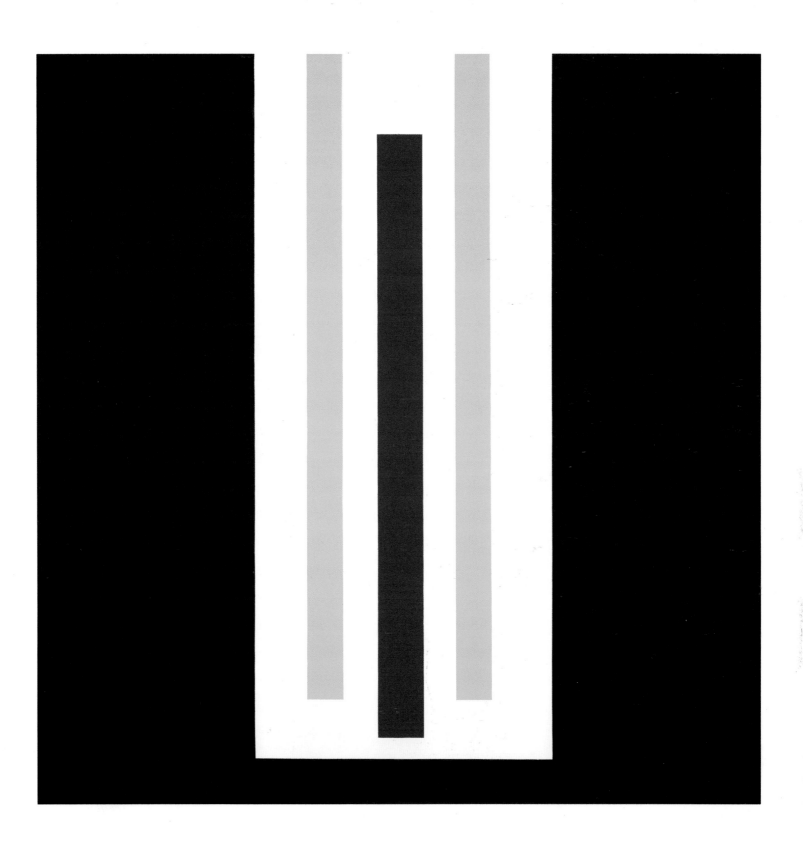

First Theme, 1963–64
Oil on canvas, 71¾ × 71″
Collection Albright-Knox Art Gallery, Buffalo
Gift of Seymour H. Knox, 1969

ILYA BOLOTOWSKY

LAS One thing that's noticeable in the forties, say from after the War until early in the fifties, was your use of a very predominant grid pattern. Why did you do this and how long did it last with you?

IB What you are referring to was a by-product of the influence of Mondrian's last two paintings, except that the result visually is not the same. I had the intention of creating a counterpoint of colors, so that if you separated out each color in one painting of this period and had all the yellows on one canvas, reds on another, blues on another, each one would be a rhythmic design in its own right. And all of them work together like a contrapuntal motif as in Bach, although it's a very approximate comparison. That was my idea—to create a continuous counterpoint. . . .

LAS Something else I have been particularly interested in—seeing your paintings from the forties especially and right up to the present day—is the way in which you define space. None of them seem to go very far backward into space. How do you define where the space is in relation to the surface and how do you range the colors and the shapes within this definable space?

IB In the early forties I still used diagonals. A diagonal, of course, creates ambivalent depth— diagonal depth might go either back or forth. It's not like perspective which goes only one way. This ambivalence I discovered was antithetical to my style. Although I hated to give up diagonals, I had to give them up finally. Mondrian gave them up quite early in his career. Although he had used them very well, he had to give them up too. Glarner, on the other hand, rediscovered diagonals and he held on to them. We all solve our own practical problems. I had to give up diagonals because the space going back and forth was becoming too violent. The diagonal space was getting in the way of the tension on the flat surface. You cannot get an absolute flatness in painting because of the interplay of the colors, the way they feel to us. But you can achieve relative flatness, within which the colors and the proportions might push back and forth creating an extra tension. This tense flatness must not destroy the overall flat tension, which, to my mind, in two-dimensional painting is the most important thing. . . .

LAS Another thing that has become quite characteristic of your work since the middle fifties and especially in the last three or four years is that you are working with diamonds and tondos instead of rectangles. How did you become interested in working with these shapes?

IB The first one I painted was a triangle. I found a triangular shape that was used by pool players and I stretched a canvas on it. Not a diamond shape, a triangular one, which is an interesting problem because, in general, I feel that a triangle is not a very pleasant shape. Wherever you look you feel you are confined by the angles, which are narrow. But the composition was curious. Then in Wyoming, I was given several wheels as a gift by some ranchers. I removed the spokes and I used a wagon wheel as a stretcher. This painting is included in the Guggenheim exhibition. This again was an interesting problem because straight lines or straight edges within a round format, a circle, or the area which we might call a tondo, are affected by the edges and seem to curve away from the edges. It's like a string which is being plucked away from the edge but, since there are two edges, first one edge pushes it away and then the other. It results in an almost vibrating effect that you do not get in a rectangular canvas. Of course the main reason that I started on odd shapes was the fact that the old masters used a variety of formats for their paintings and murals. . . .

Well, you see, since I use straight lines or, as you might say, straight tensions, they create a counterbalance to the curved format and, if properly used, prevent it from spiralling or rolling. . . .

The edge of the canvas is very important. But of course both with a tondo and an ellipse, and also a diamond shape, the shapes truncated by these formats are inclined to continue and to complete themselves as regular shapes beyond the canvas. The human eye will try to see them as complete geometric shapes. This is the reason we can create overlapping effects out of a lot of L-shaped planes in Cubism, for example. We feel they are a bunch of rectangles overlapping each other. The eye completes them and therefore you have this overlap effect. At least this is the explanation given by Gestalt psychologists. And so the active area of the diamond format canvas is larger psychologically than it is physically, which is something gained. Another reason the diamond is bigger is that the diagonal measurements of a canvas are bigger than the dimensions of the same canvas measured as a square. A sensation of freedom is gained through this seemingly larger size.

Excerpted from interview with Louise Averill Svendsen and Mimi Poser. *Ilya Bolotowsky*. New York: The Solomon R. Guggenheim Museum, 1974, p. 23 ff.

Ilya Bolotowsky at the opening of the Mural Show, Federal Art Gallery, 225 West 57th Street, New York, May 24, 1938. Photograph by Mipaas, Photographic Division, Federal Art Project W.P.A. © Smithsonian Institution

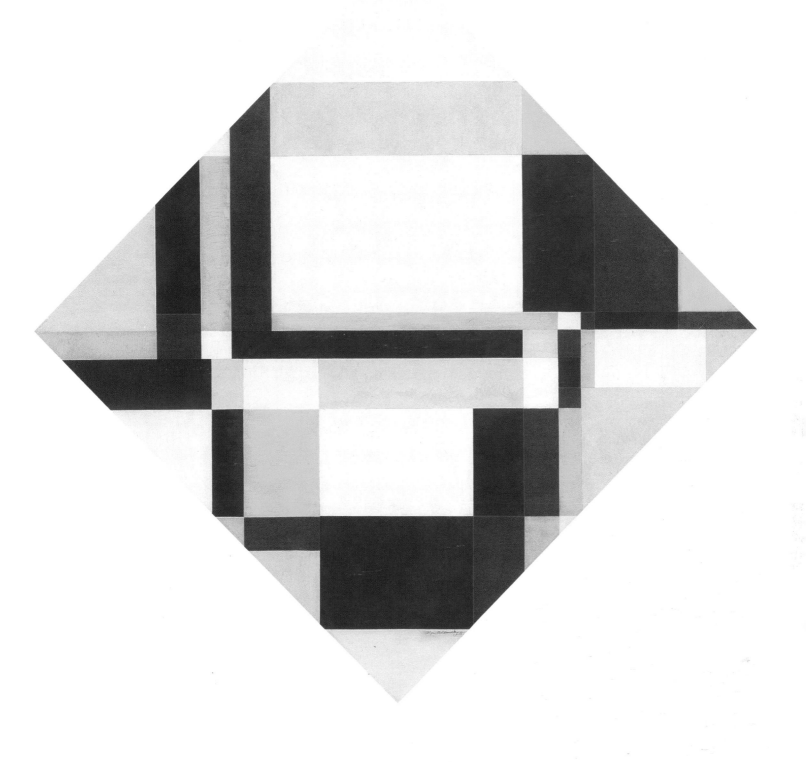

Doric Diamond, 1951
Oil on canvas, 19½ × 19½″ (sight)
Yale University Art Gallery,
Katharine Ordway Fund (1984.94)

Small White Tondo, 1960
Oil on composition board, 24″ diameter
Yale University Art Gallery,
Gift of Susan Morse Hilles (1984.75.18)

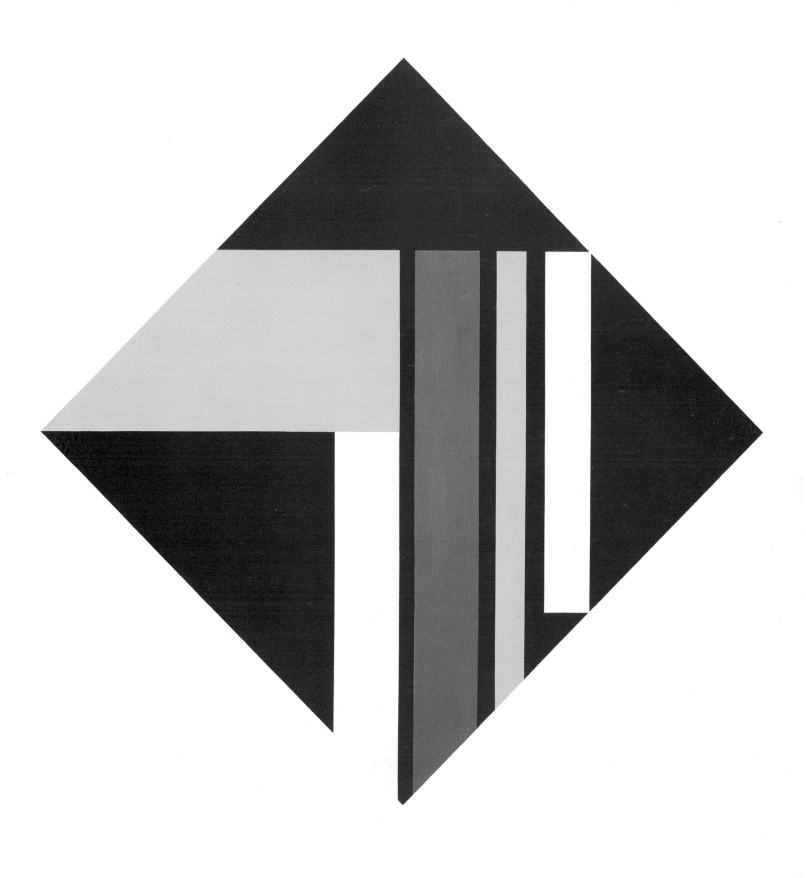

Scarlet Diamond, 1969
Oil on canvas, 48 × 48"
Collection Albright-Knox Art Gallery, Buffalo
Gift of Seymour H. Knox, 1969

FRITZ GLARNER

A visual problem is never put a priori as a mathematical problem but is born in the process of painting and evolves in a state of unawareness of the painter.

Throughout my search for the establishment of essential values, throughout my struggle to free my painting from the naturalistic, I was impelled little by little to dematerialize the object, eliminating all that appeared to me as superficiality, reducing it to an appearance no longer specific—to a form symbol. When the motive for the form-symbol can no longer be identified by the spectator, a degree of abstraction has been obtained.

To liberate form, it is necessary for the form-symbol to lose its particularity and become similar to space. To liberate form it is necessary to determine space so that their structures become identical. When the form area and the space area are of the same structure, a new aspect arises in which pure means can reveal their intrinsic expression. The differentiation between form and space has to be established by color, proportion, oppositions, etc. Color, pure color, no longer assigned to dress up a particular form-symbol is free to act by its own true identity. It is my belief that the truth will manifest itself more clearly through this new condition. . . .

Excerpted from "What Abstract Art Means to Me: Statements by Six American Artists." *The Museum of Modern Art/Bulletin* (New York), Spring 1951, p. 10.

The slant or oblique which I have introduced in my painting . . . determines the space and liberates the form. Differentiation is established by the opposition of color and space areas, and the receding and advancing properties of various colors which give a new kind of depth to the space. Differentiation of textures disturbs the unity of a painting of pure relationships. The same texture should be maintained throughout the work. . . .

It is my conviction that this relational painting is part of a step-by-step development toward the essential integration of all plastic art.

Excerpted from 1949 speech, "A Visual Problem," at The Club, 8th Street, New York reprinted in *Twelve Americans*. New York: The Museum of Modern Art, 1956, p. 28.

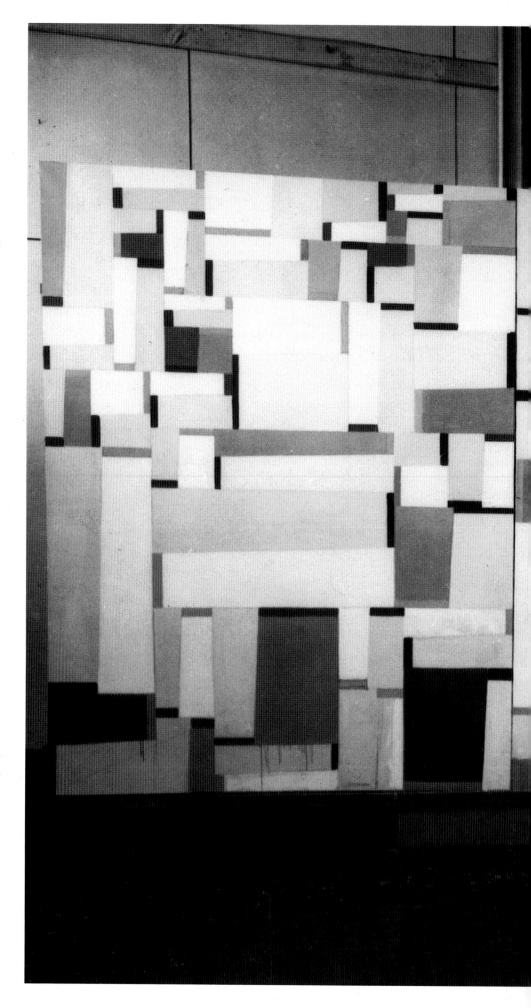

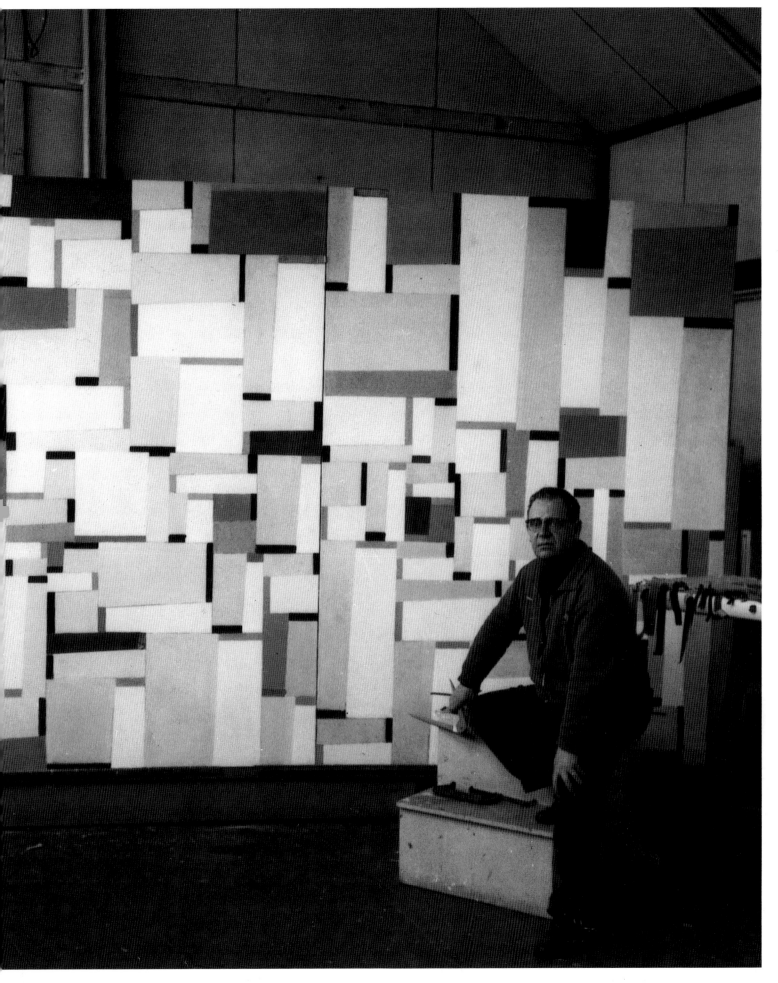

Fritz Glarner
Photograph by John D. Schiff
© Smithsonian Institution

Relational Painting, 1943
Oil on canvas, 42⅛ × 40⅛"
Yale University Art Gallery,
Gift of Katherine S. Dreier to the
Collection Société Anonyme (1946.65)

Opposite:
Relational Painting #93, 1962
Oil on canvas, 66⅞ × 44"
Collection Albright-Knox Art Gallery, Buffalo
Gift of The Seymour H. Knox Foundation, Inc., 1966

CHARMION
VON WIEGAND

It was coincidental that I was particularly inclined to understand Mondrian and his Theosophic philosophy, due to the fact that I grew up in San Francisco, my father had exposed me to Oriental philosophy, and I had even looked into Theosophy on my own. So Mondrian's ideas were not foreign to me. . . .

The first paintings I saw by Mondrian were in the Gallatin Collection here in New York. My first reaction was that they were mathematical compared to the art I was interested in and I did not understand them. At the time Mondrian arrived in New York, I was writing art criticism and I had been a painter in my own right for some fifteen years. I was interested in Expressionism and Picasso and had recently written an article on *Guernica* for the magazine *Decision*. As for my paintings, that was a period of landscapes, in which I was having trouble with spatial relations. The background kept coming up to the surface plane. Without knowing it, I was approaching the plane in a semi-realistic manner.

I didn't meet Mondrian right away, although many of my friends did, his work was widely discussed, and some of it was reproduced. It was in the pamphlet *Five on Revolutionary Art* that I first saw his name in print and decided that it was time I met the man. I was sure, when I went to his studio the first time, that I would find it excessively disciplined. How wrong I was! From the first moment I met Mondrian, I was a total convert to his way of thinking and seeing. Our contact was a rare experience which only occurs once or twice in a lifetime. And from that first meeting, my eyes were transformed. When I went out into the street again, I saw everything differently from before: the streets, the buildings, my total visual environment. . . .

He changed the direction of my whole life and for that I will always be grateful to him. I stopped painting for a year and a half and plunged myself into Neo-plasticism, going to the New York Public Library every day and reading everything I could get my hands on (which meant all the European magazines on abstract art). Mondrian and I corresponded frequently (he had no phone, so we wrote each other little notes). . . .

I would compare his mentality to that of a Tibetan lama. This is not as strange as it sounds. Madame Blavatsky, the famous Theosophist, wrote about Egyptian cosmology. But Theosophy also draws a great deal on Indian Buddhism. There is a strong relationship between the two. Mondrian was ascetic in all aspects of his existence. In his life as in his art there were never any extremes. This is the Buddhist way, where knowledge and awareness of all extremes are sublimated and transcended in a new unity.

His ascetic bearing made one aware of an incredible self-discipline. This had been imposed on him partly through the extreme poverty he knew all his life and partly because he had a sole, unique goal, toward which he channeled all his energies. Any feelings or cause for distraction which might interfere with his work were consistently pruned from his existence. Notwithstanding this, he was a total human being, endowed with a strong intellect, spiritual power, and sensuousness, and this comes across in his art. His art is not bloodless. He used to say it was "sensual" and I would say, "No, Mondrian, you mean sensuous." He had difficulty distinguishing between the two. But I would support this by saying that whereas Malevich's painting is *sensual*, cruder, more biological, with an animal sensuality about it, Mondrian's art is *sensuous*.

Excerpted from Margit Rowell, "Interview with Charmion von Wiegand, June 20, 1971." *Piet Mondrian*. New York: The Solomon R. Guggenheim Museum, 1971, pp. 77, 78, 86.

Charmion von Wiegand
Photograph by T. Meisel, New York

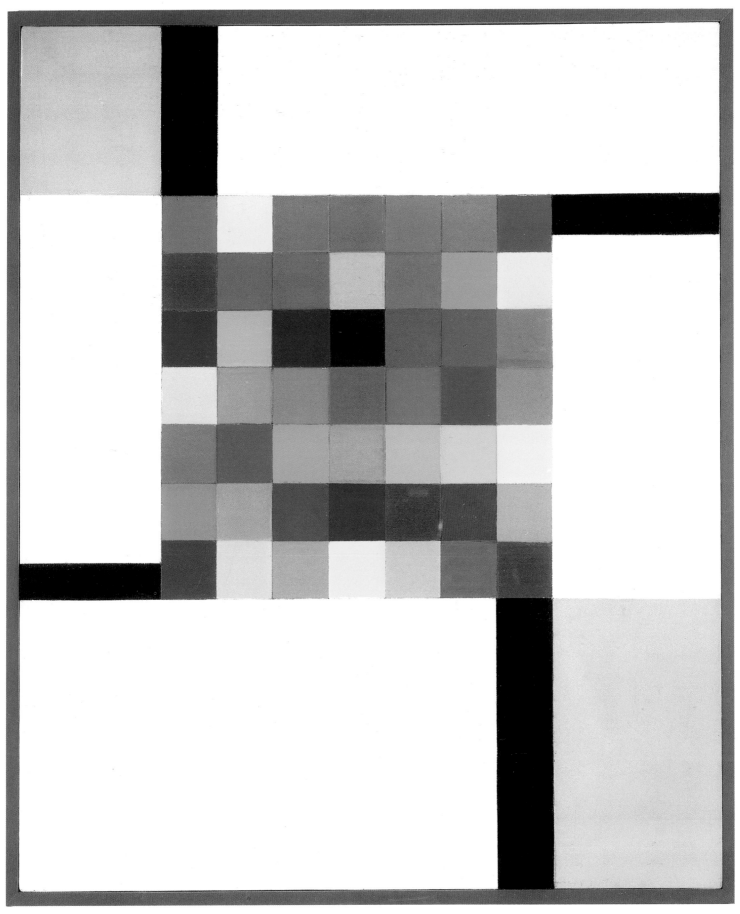

The Wheel of the Seasons, 1957
Oil on canvas, 39 × 32½″
Collection Albright-Knox Art Gallery, Buffalo
Charles Clifton Fund, 1981

JOSEF ALBERS

THE COLOR IN MY PAINTINGS

They are juxtaposed for various and changing visual effects. They are to challenge or to echo each other, to support or oppose one another. The contacts, respectively boundaries, between them may vary from soft to hard touches, may mean pull and push besides clashes, but also embracing, intersecting, penetrating.

Despite an even and mostly opaque application, the colors will appear above or below each other, in front or behind, or side by side on the same level. They correspond in concord as well as in discord, which happens between both, groups and singles.

Such action, reaction, interaction—or interdependence—is sought in order to make obvious how colors influence and change each other: that the same color, for instance—with different grounds or neighbors—looks different. But also, that different colors can be made to look alike. It is to show that 3 colors can be read as 4, and similarly 3 colors as 2, and also 4 as 2.

Such color deceptions prove that we see colors almost never unrelated to each other and therefore unchanged; that color is changing continually: with changing light, with changing shape and placement, and with quantity which denotes either amount (a real extension) or number (recurrence). And just as influential are changes in perception depending on changes of mood, and consequently of receptiveness.

All this will make aware of an exciting discrepancy between physical fact and psychic effect of color.

But besides relatedness and influence I should like to see that my colors remain, as much as possible, "face"—their own "face," as it was achieved—uniquely—and I believe consciously—in Pompeian wallpaintings—by admitting coexistence of such polarities as being dependent and independent—being dividual and individual.

Often, with paintings, more attention is drawn to the outer, physical, structure of the color means than to the inner, functional, structure of the color action described above. Here now follow a few details of the technical manipulation of the colorants which in my painting usually are oil paints and only rarely casein paints.

Compared with the use of paint in most painting today, here the technique is kept unusually simple, or more precisely, as uncomplicated as possible.

On a ground of the whitest whites available—half or less absorbent—and built up in layers—on the rough side of panels of untempered masonite—paint is applied with a palette knife directly from the tube to the panel and as thin and even as possible in one primary coat. Consequently there is no under or over painting or modeling or glazing and no added texture—so-called.

As a rule there is no additional mixing either, not with other colors nor with painting media. Only a few mixtures—so far with white only—were unavoidable: for tones of red, as pink and rose, and for very high tints of blue, not available in tubes.

As a result this kind of painting presents an inlay (intarsia) of primary thin paint films—not layered, laminated, nor mixed wet, half or more dry, paint skins.

Such homogenous thin and primary films will dry, that is, oxidize, of course, evenly—and so without physical and/or chemical complication—to a healthy, durable paint surface of increasing luminosity.

Josef Albers, 1963
Photograph by Henri Cartier-Bresson
© Smithsonian Institution

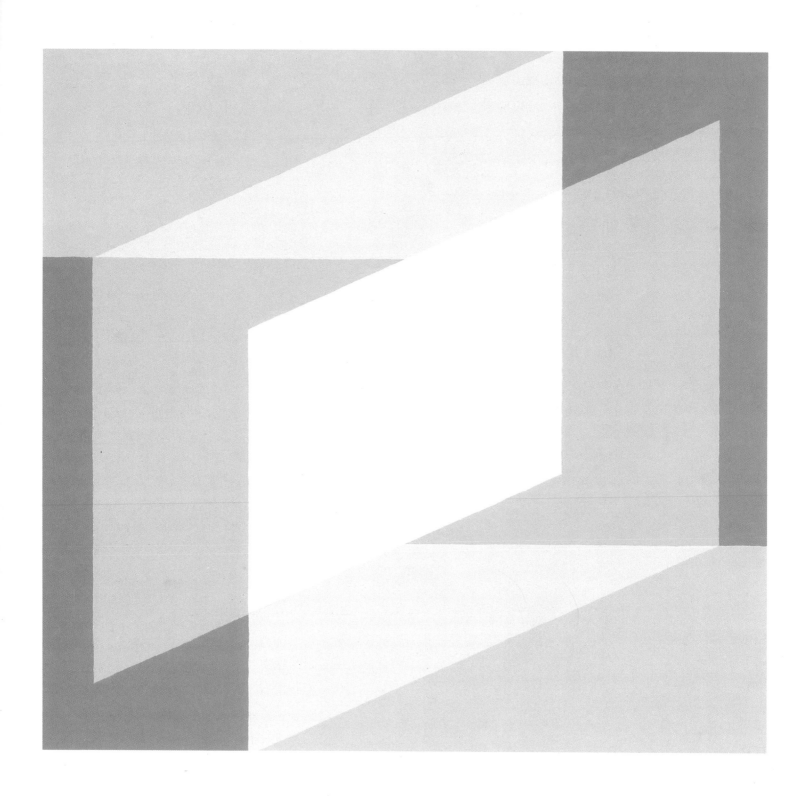

Either . . . Or, 1948
Oil on masonite panel, 25⅞ × 27⅞"
Yale University Art Gallery,
Gift of Anni Albers and The Josef Albers
Foundation, Inc. (1977.160.7)

ON MY "HOMAGE TO THE SQUARE"

Seeing several of these paintings next to
 each other
makes it obvious that each painting
is an instrumentation in its own.

This means that they are all of different
 palettes,
and, therefore, so to speak, of different
 climates.

Choice of the colors used, as well as their
order, is
aimed at an interaction—
influencing and changing each other forth
 and back.

Thus, character and feeling alter from
 painting to painting
without any additional "hand writing"
or, so-called, texture.

Though the underlying symmetrical and quasi-
 concentric
order of squares remains the same in all
 paintings
—in proportion and placement—
these same squares group or single
 themselves,
connect and separate in many different ways.

In consequence, they move forth and back,
 in and out,
and grow up and down and near and far,
 as well as enlarged and diminished.
All this, to proclaim color autonomy
as a means of a plastic organization.

Quoted in *Josef Albers: Homage to the Square*. New York:
The Museum of Modern Art, New York, 1964, n.p.

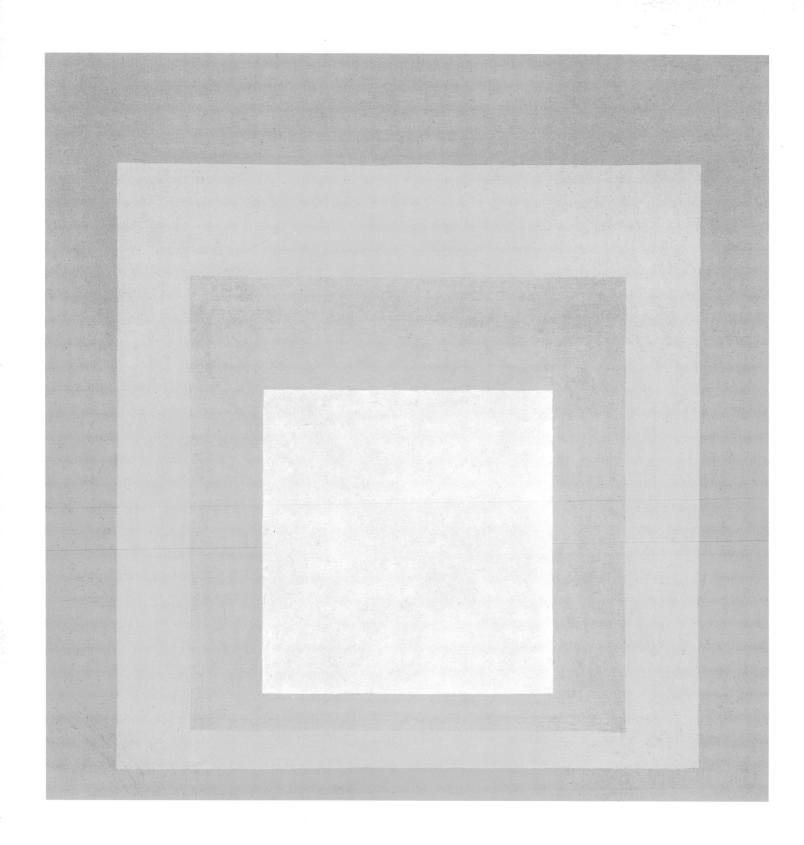

Homage to the Square: Dedicated, 1955
Oil on masonite, 43 × 43"
Collection Albright-Knox Art Gallery, Buffalo
Gift of The Seymour H. Knox Foundation, Inc., 1969

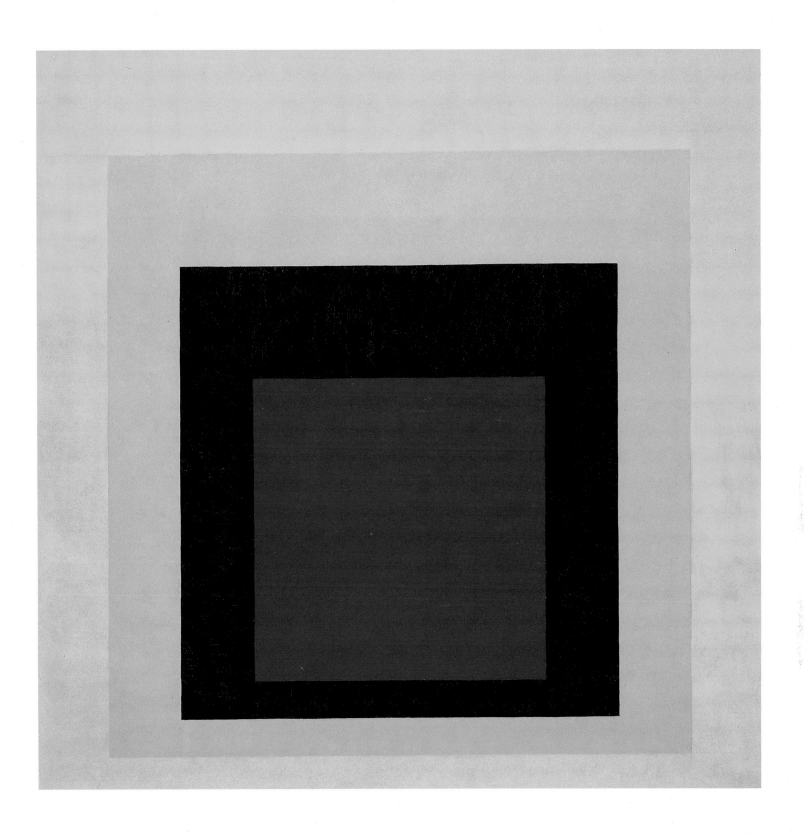

Homage to the Square: Terra Caliente, 1963
Oil on masonite, 48 × 48″
Collection Albright-Knox Art Gallery, Buffalo
Gift of The Seymour H. Knox Foundation, Inc.,
and Evelyn Rumsey Cary Fund, 1968

AD REINHARDT

ABSTRACT ART REFUSES

It's been said many times in world-art writing that one can find some of painting's meanings by looking not only at what painters do but at what they refuse to do.

A glance at modern-art history shows that for Courbet—no antiques or angels, no traditional authorities or academies, no classical idealisms or romantic exoticisms, no fantasies, no world beyond our world. For Manet and Cézanne—no myths or messages, no actions or imitations, no orgies, no pains, no dreams, no stories, no disorders. For Monet, no subjects or objects, no fixities or absolutes, no chiaroscuro or plasticities, no textures or compositions, no timelessness, no terror, no studio setups, no imaginary scenes, no muddy colors. For the cubists—no pictures or puzzles, no closed or natural forms, no fixed arrangements, no irrationalism, no unconsciousness. For Mondrian—no particularities or local elements, no irregularities or accidents or irrelevancies, no oppression of time or subjectivity, no primitivism, no expressionism.

And today many artists like myself refuse to be involved in some ideas. In painting, for me no fooling-the-eye, no window-hole-in-the-wall, no illusions, no representations, no associations, no distortions, no paint-caricaturings, no cream pictures or drippings, no delirium trimmings, no sadism or slashings, no therapy, no kicking-the-effigy, no clowning, no acrobatics, no heroics, no self-pity, no guilt, no anguish, no supernaturalism or subhumanism, no divine inspiration or daily perspiration, no personality-picturesqueness, no romantic bait, no gallery gimmicks, no neo-religious or neo-architectural hocus-pocus, no poetry or drama or theater, no entertainment business, no vested interests, no Sunday hobby, no drug-store museums, no free-for-all history, no art history in America of ashcan-regional-WPA-Pepsi-Cola styles, no professionalism, no equity, no cultural enterprises, no bargain-art commodity, no juries, no contests, no masterpieces, no prizes, no mannerisms or techniques, no communication or information, no magic tools, no bag of tricks-of-the-trade, no structure, no paint qualities, no impasto, no plasticity, no relationships, no experiments, no rules, no coercion, no anarchy, no anti-intellectualism, no irresponsibility, no innocence, no irrationalism, no low level of consciousness, no naturemending, no reality-reducing, no life-mirroring, no abstracting from anything, no nonsense, no involvements, no confusing painting with everything that is not painting.

THE BLACK-SQUARE PAINTINGS

A clearly defined object, independent and separate from all other objects and circumstances, in which we cannot see whatever we choose or make of it anything we want, whose meaning is not detachable or translatable. A free, unmanipulated and unmanipulatable, useless, unmarketable, irreducible, unphotographable, unreproducible, inexplicable icon. A non-entertainment, not for art commerce or mass-art publics, non-expressionist, not for oneself.
1955

A square (*neutral, shapeless*) canvas, five feet wide, five feet high, as high as a man, as wide as a man's outstretched arms (*not large, not small, sizeless*), trisected (*no composition*), one horizontal form negating one vertical form (*formless, no top, no bottom, directionless*), three (*more or less*) dark (*lightless*) no-contrasting (*colorless*) colors, brushwork brushed out to remove brushwork, a matte, flat, free-hand painted surface (*glossless, textureless, non-linear, no hard edge, no soft edge*) which does not reflect its surroundings—a pure, abstract, non-objective, timeless, spaceless, changeless, relationless, disinterested painting—an object that is self-conscious (*no unconsciousness*) ideal, transcendent, aware of no thing but art (*absolutely no anti-art*).
1961

Quoted in Barbara Rose. *Art as Art: The Selected Writings of Ad Reinhardt.* New York: The Viking Press, 1975, pp. 50–51; 82, 83.

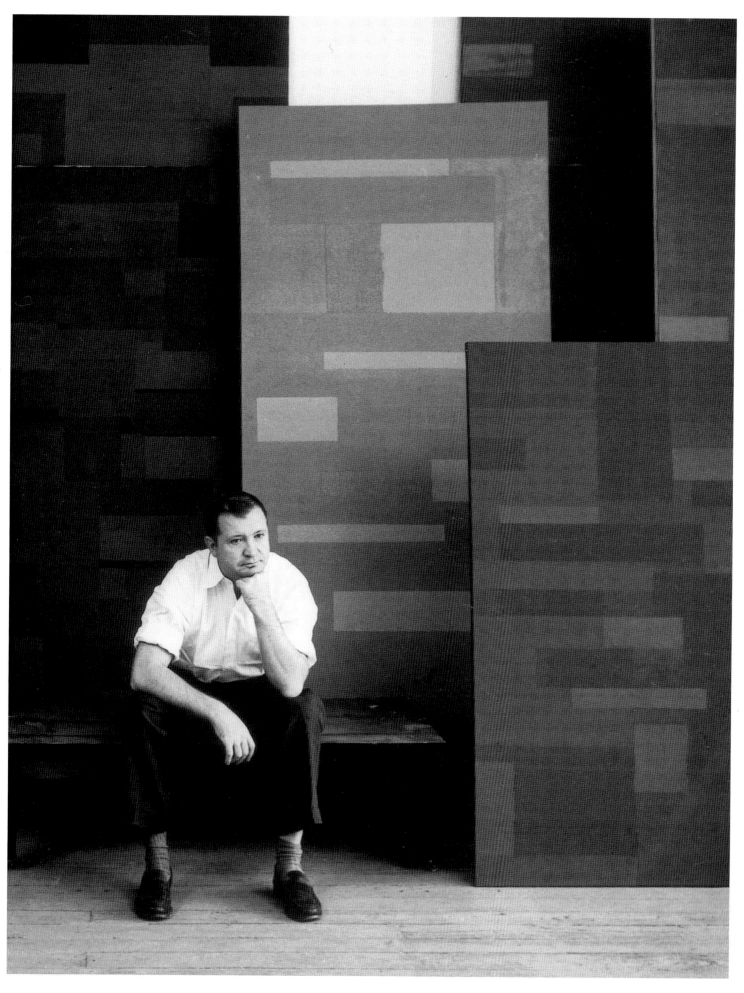

Ad Reinhardt in his studio, c. 1959
Photograph by Walter Rosenblum
Courtesy The Pace Gallery, New York

Abstract Painting, 1948
Oil on canvas, 40 × 80"
Collection Allen Memorial Art Museum,
Oberlin, Ohio. Ruth C. Roush Fund for Contemporary Art (67.26)

No. 15, 1952, 1952
Oil on canvas, 108 × 40"
Collection Albright-Knox Art Gallery, Buffalo
Gift of Seymour H. Knox, 1958

Opposite:
Red Abstract, 1952
Oil on canvas, 60 × 39⅞"
Yale University Art Gallery,
Gift of The Woodward Foundation (1977.49.22)

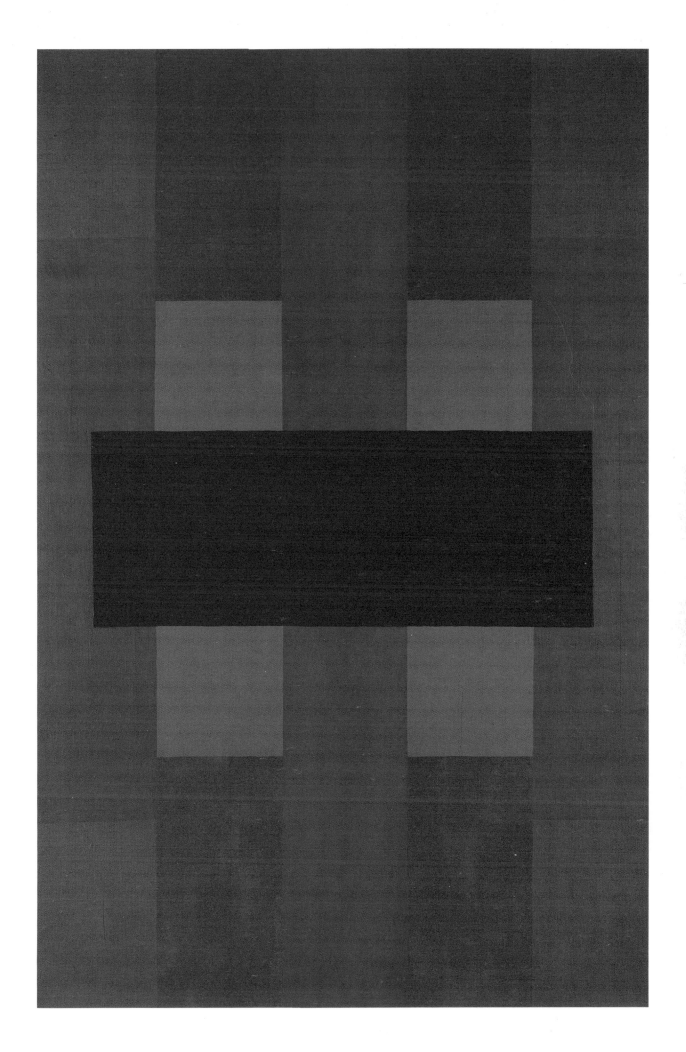

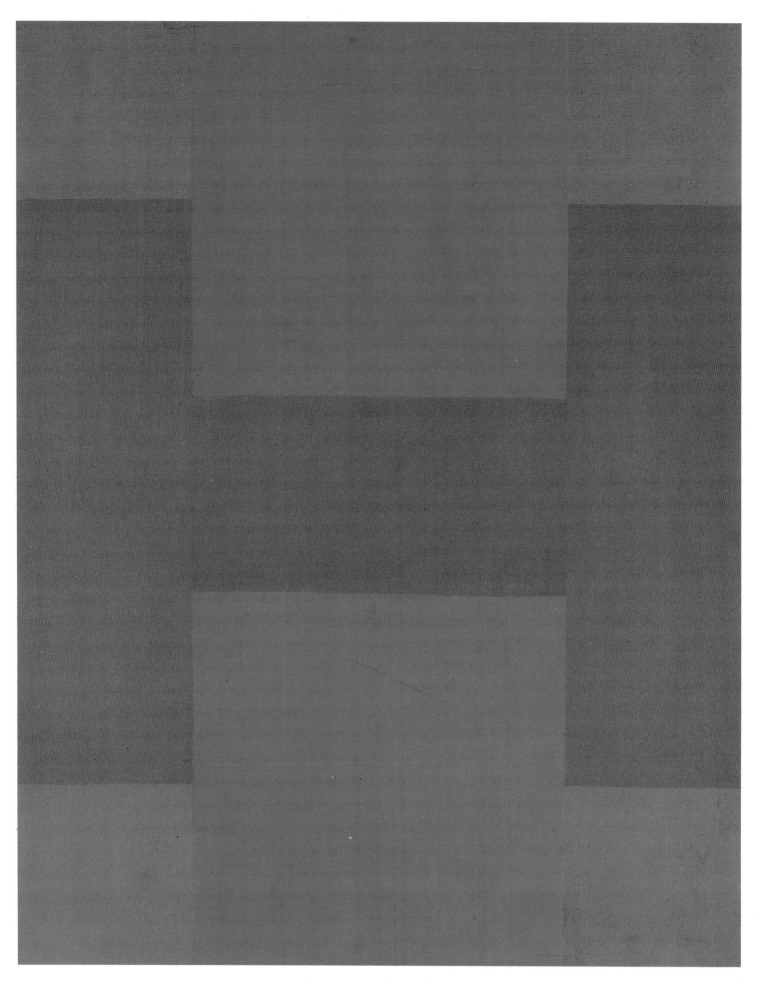

Blue Abstract, c. 1953
Oil on canvas, 20 × 16"
Yale University Art Gallery, Gift of
The Woodward Foundation (1977.49.23)

Abstract Painting, 1963
Oil on canvas, 60 × 60″
Collection Milwaukee Art Museum,
Gift of Friends of Art

LEON POLK SMITH

I think that the proportion of the canvas comes first. I have a feeling that I want to do a canvas about a certain size and I don't know just what I am going to paint so I stretch it to size and hang it on the wall, and sit down and look at it. Sometimes I figure: Oh, should I do anything to it? A well stretched canvas is very beautiful, just to sit and contemplate. And then the proportion, the size of the canvas often suggest a form. I will get up and draw this one line through the canvas which creates two forms, one on either side of the line, and while I am drawing this line, it seems that I am travelling many, many miles in space instead of just fifty inches or sixty inches whatever the canvas happens to be, but it is a great, great distance from one point to the next and around the curve, and I begin to feel the tensions develop and the forces working on either side of this line; there is a color often suggested, usually the color that I am going to use, that comes to me before the line reaches the other side of the canvas. . . .

I am not just drawing one form, I am drawing two forms with one line, and I am having to think of both sides of the line, feel both sides, know both sides, and one side is no more important to me than the other. I figure that this way of drawing is important in all drawing, that it should be important and considered. If one is drawing naturalistically and thinks that one is drawing only what would be enclosed in the line, there is much less power than if he is aware of the fact that he is really drawing on both sides of the line. This does create two worlds, in direct opposition to each other and yet so well related that they fit into each other as a jigsaw puzzle must. . . .

I discovered in 1954 the particular space concept which I have been working with since . . . a circle. I was looking at an athletic catalogue and the illustrations in this catalogue were drawings rather than photographs of the tennis ball, football, baseball and basketball. They were just line circles with a drawing of the seams on the covering of the balls. I was fascinated by the space that was between these lines and felt bound to them and started immediately drawing some of my own, taking off from this space concept. I did about twelve large circular paintings before I was able to carry this particular space concept, using two or three forms and two or three colors, over into the rectangle. And I still don't know what this space is. It isn't just the earthy space that we have been familiar with for centuries, but I think that it has something to do with the other spaces that the whole world has really been interested in for the past decade.

Excerpted from "The Paintings of Leon Polk Smith: A Conversation between Leon Polk Smith and d'Arcy Hayman." *Art and Literature* (Lausanne), vol. 3, 1964, pp. 82–85.

Opposite:
Leon Polk Smith (detail)
© Fred W. McDarrah 1988

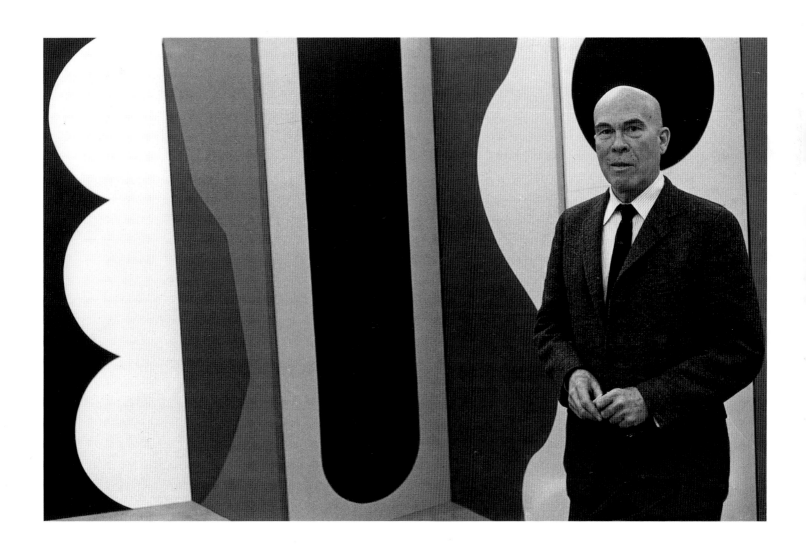

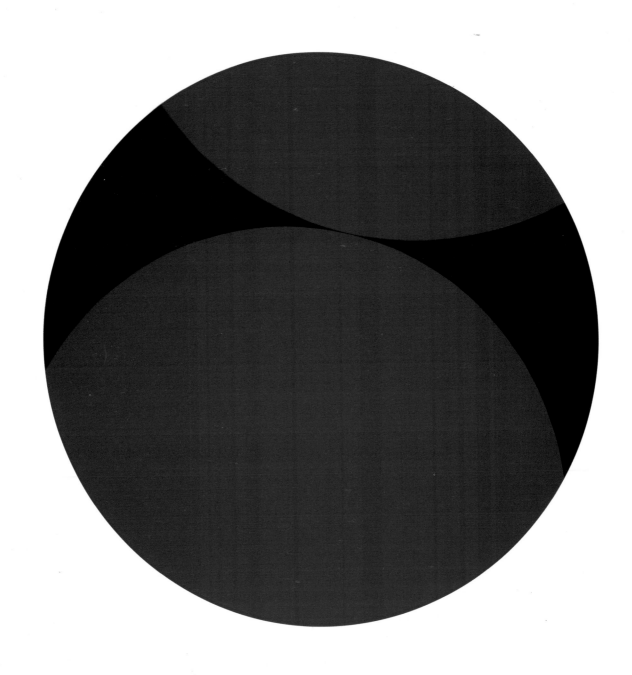

Stone Wall, 1956
Oil on canvas, 35½″ diameter
Collection the artist

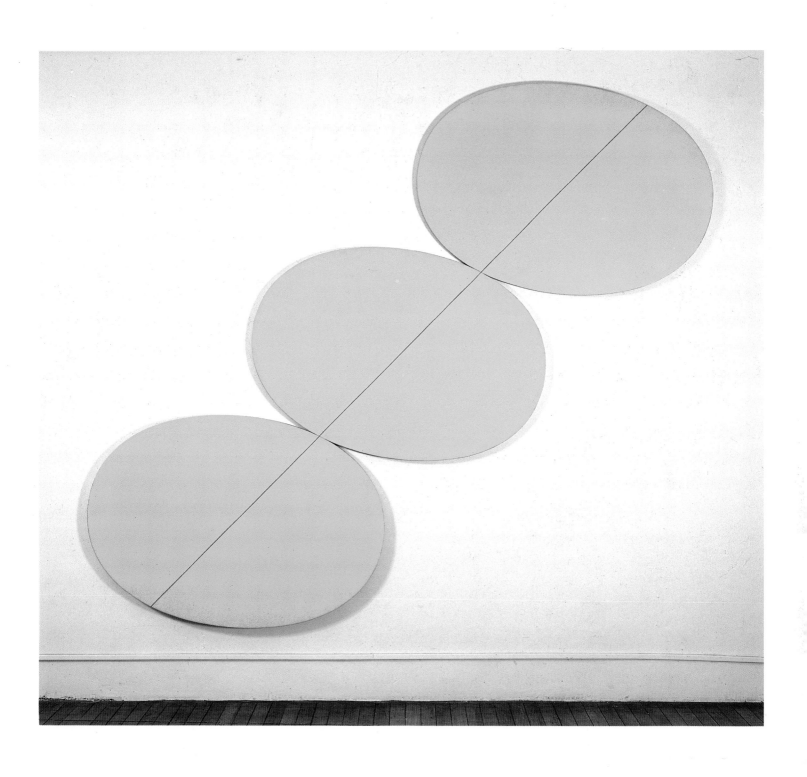

Three Yellow Ovals, 1967
Acrylic on canvas, 124½ × 52"
Collection the artist

127

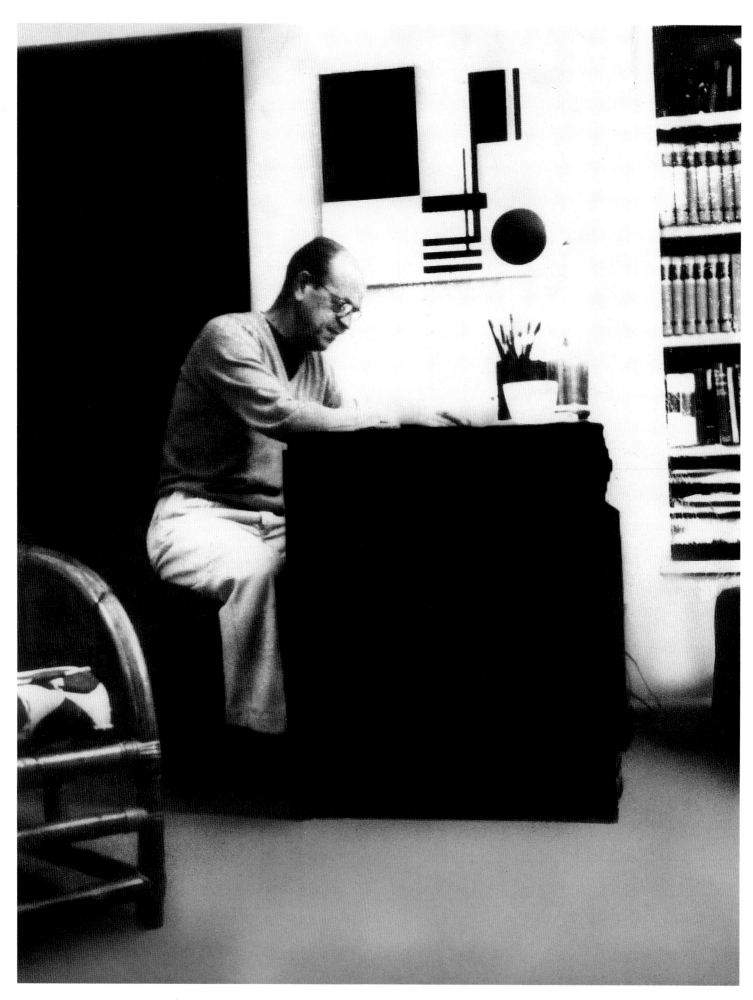

John McLaughlin
Photograph courtesy the Archives of American Art,
Washington, D.C. © Smithsonian Institution

My purpose is to achieve the totally abstract. I want to communicate only to the extent that the painting will serve to induce or intensify the viewer's natural desire for contemplation without benefit of a guiding principle. I must therefore free the viewer from the demands or special qualities imposed by the particular by omitting the image (object). This I manage by the use of neutral forms.

If I were to paint a "thing" or "conclusive idea" I would in effect be asking the spectator to believe with me that I had discovered or recognized a truth. This to me would be unreasonable. On the other hand I do not hesitate to present an anonymous structure designed to provoke in him a desire to consider further and without restriction his relationship to nature.

Certain Japanese painters of centuries ago found the means to overcome the demands imposed by the object by the use of large areas of empty space. This space was described by Sesshu as the "Marvelous Void." Thus the viewer was induced to "enter" the painting unconscious of the dominance of the object. Consequently there was no compulsion to ponder the significance of the object as such. On the contrary, the condition of "Man versus Nature" was reversed to that of man at one with nature and enabled the viewer to seek his own identity free from the suffocating finality of the conclusive statement.

Throughout the years, the deepest satisfaction I have experienced in the arts have derived from communication expressed by stringently structured means. I refer especially to the neutral form as it appears in painting, music and literature.

The uncompromised form by virtue of its power to withhold neither reveals or conceals. Its function is merely to indicate that reality may be sensed by the viewer when released from the insistent demands of substantive quality. The reservoir of total experience may be reflected by the void or anonymous form.

Painting, I believe, is uniquely suited to this approach inasmuch as such nonessential baggage as the elements of time, movement and the third dimension, which is to say the object, can the more successfully be eliminated.

My position contradicts the time-honored methods of self-expression, which nominally serve to delineate the artist's responses to an endless variety of particularities.

With respect to direct influences I must stress my interest in 15th and 16th century Japanese painters. I have found comfort in some aspects of thought expressed by Malevitch, and I am indebted to Mondrian because his painting strongly indicates that the natural extension of Neo-Plasticism is the totally abstract.

Quoted in *John McLaughlin*. Pasadena: Pasadena Art Museum, 1963, n.p.

Untitled, 1956, 1956
Oil on canvas, 48 × 32"
Courtesy André Emmerich Gallery, New York

#28-1960, 1960
Oil on canvas, 48 × 36″
Collection Albright-Knox Art Gallery, Buffalo
Gift of Alfred J. Jensen, 1979

MYRON STOUT

Myron Stout, Provincetown, Massachusetts, 1950
Photograph by Bill Witt
© Smithsonian Institution

Opposite:
Untitled (Number 3—1956), 1956
Oil on canvas, 26 × 18"
Collection The Carnegie Museum of Art,
Pittsburgh, Gift of Leland Hazard, 1958

January (?) 1954

In western art—say from the 14th century on, painting did take on the psychological effect of a iew through a window. It is an intimate effect—it allows us to inhabit our own interior—our *personal* interior that is, and still have those windows, which are paintings. . . . But I still say it's not essential. The Chinese, Japanese, Hindu, Persian, most of all, primitive cultures—in fact, no art I can think of except western European art since the 14th century has used this device. They are all none the less art, and art of the very highest quality.

October 9, 1955

Re: Mondrian's "Home-Street-City"

Mondrian's "universal" concept is an amazing thing. He is obsessed by oneness, and his ability to conceive in terms of oneness, wholeness and no disparity of parts should be a model to all who have trouble rising above the immediate and particular. And in spite of the rarefaction of the realm which he thus inhabited, he never lost the feeling of his anchor in the process by which he came to his universal concept—the tangible and sensational world was still the raw material of the universality which he would create for himself and everyone else not only in painting terms but in every aspect of life which lends itself to aesthetic expression. Aesthetics was to him a higher morality—an ethics—an absolutely basic and guiding principle through which all aspects of life could come together.

May 12, 1957

Expressionism;—the turning away from the traditional means of expression, and move inwardly for the sake of the personalness of a possible expression—the insistence on discovering one's own mode of expression in spite of the fact that there is a community mode of great adequacy.

March 21, 1960

The connection between the Greek theory of symmetry and proportion . . . and the modern conceptions of "composition"—as Hofmann, for instance, would put it. They are, basically, the same thing. All the Greek (and post-Greek—or out-of-the-Greek) thinking on the subject leave out of account the element of expression, or expressiveness, which is so important to the modern person, though. The Greek took so for granted that art was a human expression, I suppose, that it was not necessary to mention it. So he concentrated on the quality in art which made it what it was—an elevated and elevating thing—elevated, that is, above—lifted out of the realm of the habitually known and necessary, and tried to determine what it was that made it "way out."

November 26, 1964

. . . seeing a part of the "shape" out of kilter, I know that the edge has not, say, the proper curvilinear quality to reveal the shape—to define the substance that's *in* the shape (and it's *in* it, *not* at the edges!) so my consciousness works with the *curve* at that particular place, trying to see and develop its necessary degree of curvedness, its continuousness, whether it is properly swelling or contracting the shape. . . .

 The source of a curve—of "circularity"—is in one's body—*not* in the idea, "circularity," or "curvedness," and in my painted shapes every curve has its source in my body movements—or in my sense of them, my feeling of them. Every curve painted, I believe, is an analogue of some particular movement felt and sensed.

October 20, 1965

I believe that *flatness* (as of the canvas, for instance) is something we never see, but only *know*. The eyes are not constructed to see flatness, and we come nearer knowing it through the sense of touch. If this is true, the basis of our apprehension of a painting has a duality of see-touch, or maybe better—touch-see, which sets up what is probably the primary, vivifying *tension* on the basis of which the "living"—the "created" quality of a painting depends.

 If this is so, is this why I must pay such endless and infinite attention to the topography of the paint on my canvases?

Excerpted from Myron Stout quoted in Sanford Schwartz, *Myron Stout,* exhibition catalogue. New York: Whitney Museum of American Art, 1980, pp. 80, 82, 86, 88.

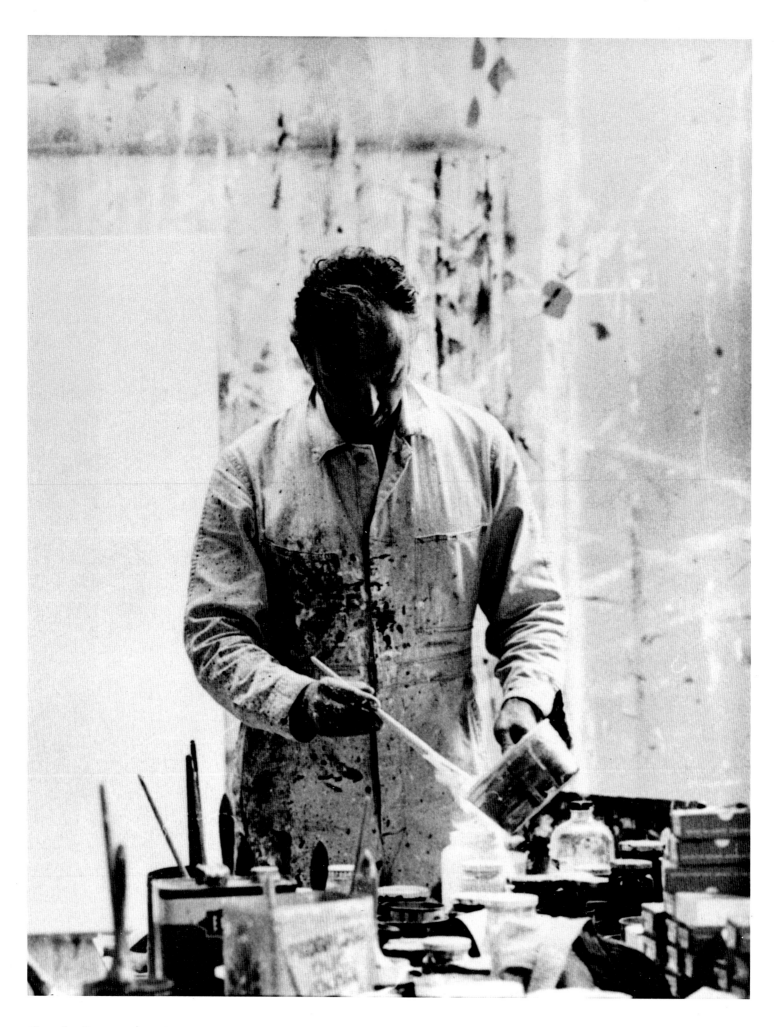

Ellsworth Kelly
Photograph by Gianfranco Gorgoni

I don't like most Hard Edge painting. I'm not interested in edges. I'm interested in the mass and color, the black and white. The edges happen because the forms get as quiet as they can be. I want the masses to perform. When I work with forms and colors, I get the edge. In a Chamberlain, the edges of the forms are hard but you don't think about the edges. In my work, it is impossible to separate the edges from the mass and color. . . .

I like to work from things that I see whether they're man-made or natural or a combination of the two. Once in a while I work directly from something I've seen, but not very often now. A lot of the earlier pictures were paintings of things I'd seen, like a window, or a fragment of a piece of architecture, or someone's legs; or sometimes the space between things, or just how the shadows of an object would look. The things I'm interested in have always been there. The idea of the shadow of a natural object has always existed, like the shadow of the pyramids and the pyramids, or a rock and its shadow and the separation of the rock and the shadow; I'm not interested in the texture of the rock, or that it is a rock but in the mass of it, and its shadow. . . .

I work from drawings and sometimes collage; the drawing always comes first and then collage later because it's easier to think about color that way. I usually let them lie around for a long time. I have to get to really like it. And then when I do the painting I have to get to like that too. Sometimes I stay with the sketch, sometimes I follow the original idea exactly if the idea is solved. But most of the time there have to be adjustments during the painting. Through the painting of it I find the color and I work the form and play with it and it adjusts itself. . . .

It grows out of what I understand. I don't really understand anything but America and sometimes I feel it a limitation. I admire France, but I never felt like anything but a foreigner there, that's what I liked about it. I don't want my work involved with complications, I feel like I'm free, to do anything I want to do, that it's possible. The quality of living in New York is more open. When I did paintings in panel sections in the early fifties, a lot of Europeans thought they looked American. Then I brought them here and Americans thought they looked European.

Excerpted from Henry Geldzahler, "Interview with Ellsworth Kelly." *Art International* (Lugano), Feb. 1964, pp. 47–48.

136

Kite I, 1952
Oil on canvas, seven
joined panels, overall,
39¼ × 90¾″
Private Collection

Opposite:
La Combe III, 1951
Oil on canvas, 63½ × 44½″
Private Collection

New York, N.Y., 1957
Oil on canvas, 73¾ × 90"
Collection Albright-Knox Art Gallery, Buffalo
Gift of Seymour H. Knox, 1959

Opposite:
Charter, 1959
Oil on canvas, 95½ × 60"
Yale University Art Gallery,
Gift of Helen W. Benjamin in memory
of Robert M. Benjamin (1966.143)

Blue, Yellow and Red, 1968
Oil on canvas, 101½ × 30"
Collection Albright-Knox Art Gallery, Buffalo
Gift of Seymour H. Knox, 1969

Chatham #11, Blue/Yellow, 1971
Oil on canvas, 90 × 77"
Collection Albright-Knox Art Gallery, Buffalo
Gift of Seymour H. Knox, 1972

KENNETH NOLAND

PC What kind of painting did you do at Black Mountain? How would you describe it?

KN Well, it was abstract painting I guess of the Mondrian-Bauhaus type of painting but coming from the influence of Bolotowsky and Albers. Bolotowsky had closer affinities with Mondrian so we had the advantage of his experience. So my original education really had to do with abstract art right from the first . . . at that time Bolotowsky and Albers were in the A.A.A. (American Abstract Artists). . . . They were a small group of artists but a group dedicated to the principles of abstract art. And at that time it wasn't a very popular activity. And so they had to be committed men. They did a great service for later generations.

PC . . . What was Paris like in those days? You had a studio there so you could work. Did you see lots of Americans? Did you get involved with French life?

KN No, for some reason—I guess that was so close after the war that most of the Americans kind of stayed together. There wasn't very much communication back and forth with the French art students. I'm not sure exactly why but we didn't really get involved in French cultural life so much. Mostly we stayed together, most of the Americans did. And to me it was just that we had a different idea about art. I think we were willing to find out more about how art had been in Europe than being interested in like getting into it, as it were. We wanted to find out about the past more. We'd had the advantage of having had a lot of the best European artists that came to the United States. It was true at Black Mountain and it was also true in New York. Mondrian had been over here. We already knew that there had been work done by another generation of artists such as Pollock or even, say, the American Abstract Artists that somehow had absorbed a lot that had developed in Europe. So we weren't even that interested in, let's say, Picasso. We felt that it had been absorbed by an older generation, brought over here, and then picked up by the first generation abstract expressionists. We were aware of that. . . .

PC When did you get to know [Louis]?

KN Morris [Louis] was the first artist that I met in Washington [1952–53]. I knew a lot of the other artists but I had really become a close friend of Morris's mostly because our interest in art coincided. I felt an affinity with his preferences in art more than I did with most of the other artists in Washington that I knew. So we became painting buddies. . . .

PC You mentioned that he was working with very similar ideas and things. How would you describe them?

KN When I first met Morris he was very interested in Jackson Pollock, and so was I. . . . He had arrived at this independently. I had arrived at it mostly through having had contact with Clement Greenberg. There was idealism, personal idealism kind of involved in that. By checking and comparing and bringing other kinds of information to each other—for instance, we both liked Bob Motherwell's work. Which was kind of unique, I mean at that particular point. By comparisons and by discussions and so forth it was mutually benefitting. . . .
PC You mentioned Clem Greenberg. When did you meet him?

KN I met Clem at Black Mountain College about 1950 or 1951 when he was there for a summer session. I found him a very interesting man right from the first. We've been very good friends ever since.

PC [The] stained canvas. . . . Did this develop through Morris Louis?

KN Actually it was through Pollock and from Pollock to Helen Frankenthaler and from Helen to me and Morris. Morris adapted it to his work first, I mean in relation to me he did. I was still experimenting around with all different kinds of paints. But he adapted that to his primary use first. That came from Pollock. . . .

PC When did you start using tape? Do you find it gives you a different edge? More controlled?

KN Well, it just made it simpler to use tape when I was making straight lines. Actually I began to use tape when I started making the horizontal stripe paintings . . . if you've got enough material to use and can devise ways of working with it more quickly, that way you can get at the sense of what you want to do.

PC But when you start do you have any idea of what the proportions are going to be? Or the length? Or the height? Or some kind of idea. Or is it just, you know, here is canvas and materials and away you go?

KN When you're dealing with the problem of proportions, which I do, and you know how much of different parts that you can use to make art, you're dealing with—you're in the problem of

proportions. So you can be fairly arbitrary about at what point you start. You can take any given size and let that size set the conditions for other proportions in paintings. So it's not as if you have to plan it out. You're already in it, as it were, if you're in it . . .

PC But it's still based on chance in a way, isn't it?

KN It's based not so much on chance as on like juggling in a way. I mean you handle simultaneously a lot of factors, such as: opacity of color, transparency of color, tactility, sheer quantity, scale, size; you're dealing with all those things thrown up in the air, as it were. And then the final result is where you bring all of those things into a certain accordance of size, shape, coolness, warmth, density, transparency. . . .

PC So, abstract painting is more exploration of materials than outside subject matter, outside objects.

KN In abstract painting there is some sense of the reality of the third dimension, you know, in terms of spatial distances, or coolness or warmth, or concreteness, or transparency, translucency, and so forth. Those are all different perceptual realities that kind of get into painting in a kind of emotionally expressive way. . . .

PC ·One of the things that interests me again is the fact that there are so many shapes.

KN There were chevron pictures that came before the diamond shapes. They were a step in between. I think that, you know, even though the pictures look different like there are circles, chevrons or diamonds, horizontal paintings, and so forth, I think generally the same preoccupations pertain in all the different kinds of pictures. When you play back and forth between the arbitrariness and the strictness of the conditions of making pictures it's a very delicate threshold back and forth. . . .

PC You've also said that you don't really plan colors ahead and it's all . . . like juggling.

KN But you can plan the conditions for color ahead, as it were. I mean you can get together, you know, all the frame of reference that will get you into the condition of using color in relation to shape, to size, to focus, to depth, to tactility. You can get all these things kind of together I guess probably akin to the way a composer gets his sounds together or something.

Excerpted from Paul Cummings, Unpublished interview recorded at the artist's studio, Dec. 9 and 21, 1971. Washington, D.C.: Archives of American Art. Revised by the artist, Mar. 1989.

Kenneth Noland
Photograph © Fred W. McDarrah 1988

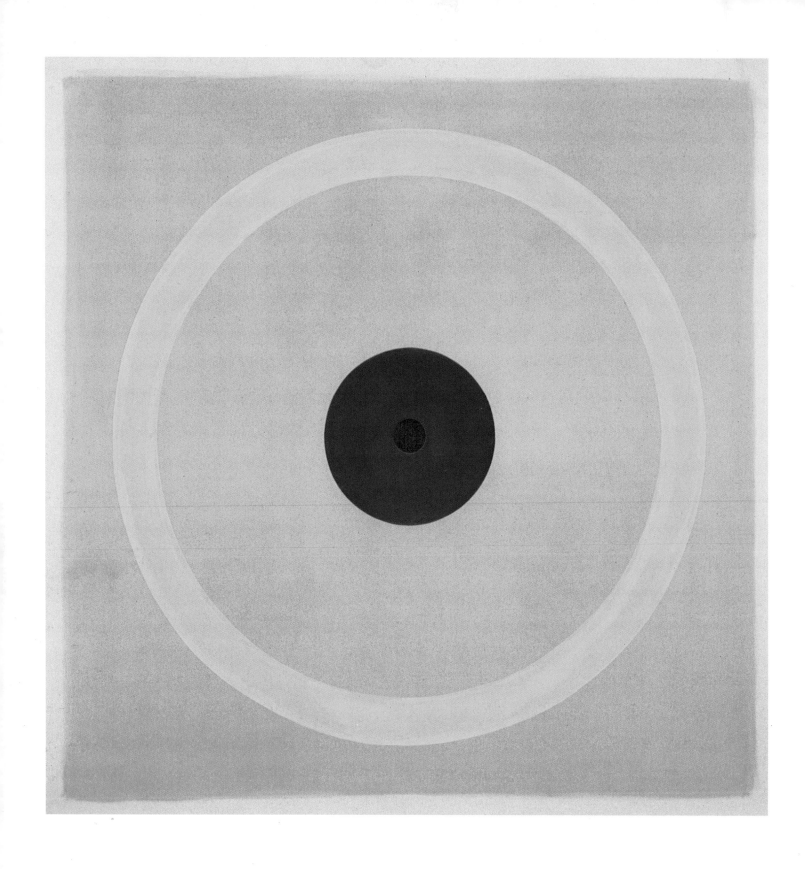

Brass Sound, 1962
Acrylic on canvas, 72 × 72"
Collection Mike and Penny Winton

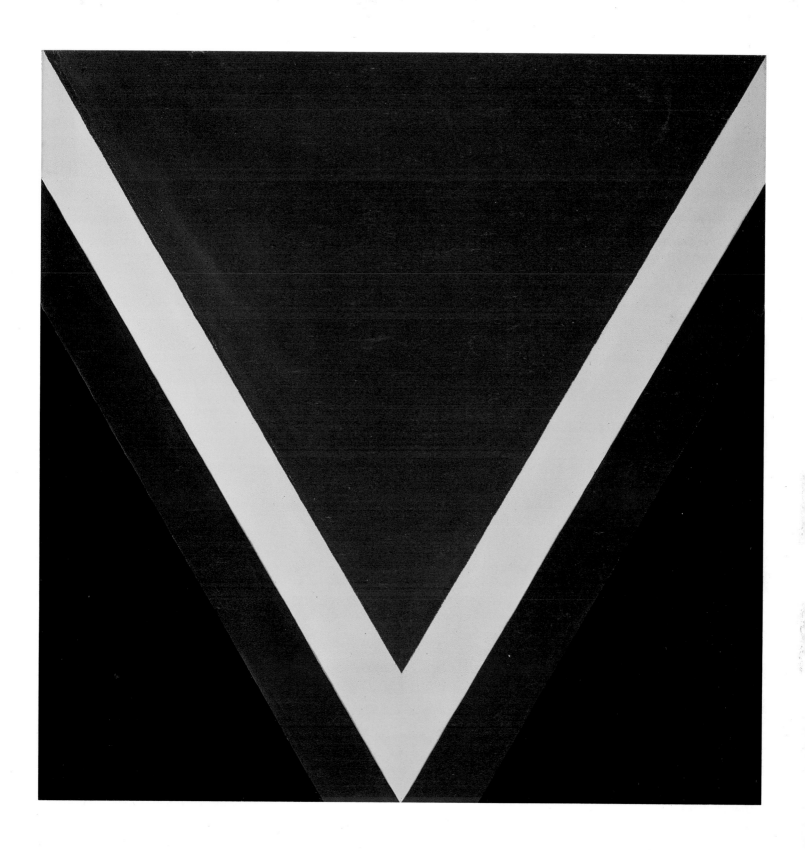

Yellow Half, 1963
Acrylic resin on canvas, 70 × 70"
Collection Albright-Knox Art Gallery, Buffalo
Gift of Seymour H. Knox, 1964

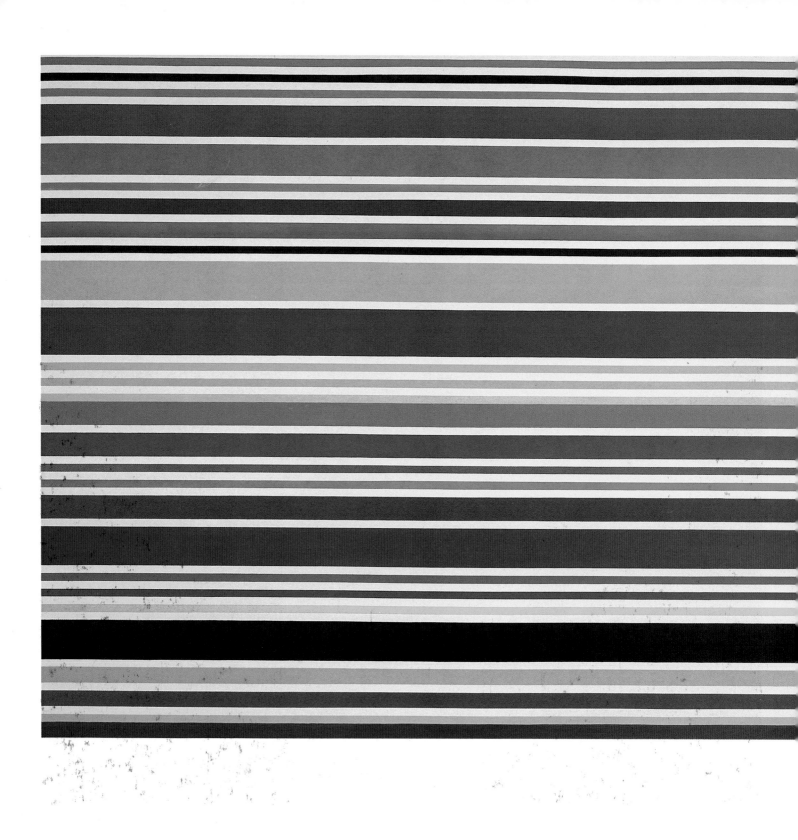

Wild Indigo, 1967
Acrylic on canvas, 89 × 207"
Collection Albright-Knox Art Gallery, Buffalo
Charles Clifton Fund, 1972

GENE DAVIS

Gene Davis
Photograph courtesy Mrs. Gene Davis

I was keenly aware of Newman in the Fifties as a kind of alternative to Pollock or de Kooning, and the other informal types of artists—the ones who slashed and poured paint. He stood as a constant reminder that there were other ways to paint pictures. I'm sure that a number of my paintings of that period—particularly some of them that even preceded the edge to edge stripe paintings—were influenced by Newman.

For example, certain late abstract expressionist works of mine have bands of color down the right or left edge. This was a kind of a parody of Newman, who did many works using single or double edge bands. It seemed to represent for me a kind of timid attempt to break out. And of course, I saw Newman's first one-man show at Betty Parsons' gallery in the early Fifties. It was unforgettable. You sort of stash that kind of experience away in the back of your mind for future reference. . . .

I think it's a little too easy to classify me as a color painter. All painters are color painters in one way or another. It's a matter of emphasis. Actually my primary interest is interval. And one can define interval through space or through color or through both. For some time, I did it almost exclusively with color because I limited myself to equal width stripes. In recent work, I have been concerned with spatial intervals.

I don't want to oversimplify, but I don't give a great deal of conscious thought to color selection. I kind of take my color sense for granted. I use color simply to fill out the form and get the painting sewed up.

I'll start out with a matrix of vertical pencil lines. And while it sounds mechanical to describe it, I take colors and in my own particular way, begin to fill in these bands. And I keep working at it until I think I've filled in enough of the holes in the painting. And the route by which I get to this goal is always a surprise since I don't consciously understand how I do it. But yet, when I look at the finished product, I can see that there's a system there—an order—which I discover after the fact. I realize it's there after I have achieved it.

I tend to select colors by some kind of whim. And when I get through somehow everything's in the right place—especially if I've succeeded. I don't always succeed.

It's this quality, I think, that more than anything else, differentiates my work from that of the hard edge, heraldic painters of the Sixties—most of whom are serial artists and also very intellectual in their approach to what they're doing. . . .

I've found that, looked at superficially and with the same kind of a quick glance approach that's used on most two or three color emblematic paintings, my work is really not as interesting.

It's only when you, as a spectator, allow yourself to—if you want to call it that—get hooked on the painting that you really understand what I'm about. And the way I have found to do this is to look at the painting in terms of individual colors. In other words, instead of simply glancing at the work, select a specific color such as a yellow or a lime green, and take the time to see how it operates across the painting. Approached this way, something happens. I can't explain it. But one must enter the painting through the door of a single color. And then, you can understand what my painting is all about.

Excerpted from Interview by Donald Wall in Donald Wall, editor. *Gene Davis*. New York: Praeger Publishers, 1975, pp. 27–31.

Citadel, 1962
Magna on canvas,
94¾ × 148½"
Private Collection

AL HELD

AL HELD

JFW You once said that you wanted to combine the "total subjectivity" of Pollock with the "total objectivity" of Mondrian.

AH That was twenty years ago! I said it facetiously for that Whitney catalogue. I was really recounting my youth, how naive I was to think that I could simply take this and this and put it together . . . it's not that easy. At the time of that quote I was about 22 in Paris. I was dripping paint and putting it into geometric pigeon-holes. I figured that if I took the geometry and the dripped paint and put them together in a simplistic way I would get a universal. I've come a long way since those paintings. . . .

I think they are different, the concerns are very different. I remember one of the real issues then was that I strived to go from the general to the specific. My feeling about other minimal work is that they really went the opposite way, from the specific to the general. I really refer to my minimalist things as icons. My paintings came out of the nervousness of not knowing what was true, painting and painting and painting on the same painting until I could become convinced that at least through the metamorphosis of the activity I began to believe in *that* form, *that* object. I got hooked on each painting for a very long time. Looking back on it, it was like self-hypnosis. . . . it wasn't any circle, but that particular circle. I tried to hook up to something that was real. . . .

As contrasted with the work of the sixties when I wanted to make everything highly specific, now I'm involved with structures, how they go together and come apart. What I try to avoid continually is an eccentric shape, or eccentric situations. I don't want you to focus in on a particular point and say, "what is this? what is this really? is it an odd thing that I have to figure out?" I want the eye and the mind to relate to it in terms of equations. I'd like to think of these paintings as algebraic—as circle is to square is to triangle. So the quotations are abstracted insofar as I want you to deal with the algebraic configurations rather than the uniqueness or oddity of each individual form. What this depends on is some kind of gestalt completion. A lot of these things are fragmented, and I count on your completing them. I can play all kinds of games. If you focus on those small opaque marks the other things begin to recede. . . .

At times I'm confused about where the space and the structures in these things come from. I'm still trying to figure out where they fit in. I know that with the Constructivist group, the De Stijl, or Mondrian, there's a 19c. Idealism, where they believe in the perfectability of man, some absolute plateau of perfection. The minimalists are tied to that too by their absolutism. I can't believe in that, we've experienced too much to believe in that kind of perfectability. But I still believe in a utopian world of some kind, but not in that 19c. way. So the space is a space that is in constant flux, that is never at rest, that is relational. The notion of simultaneity, of constant change, of paradox, was something that 19c Idealism couldn't deal with.

Excerpted from James Faure Walker, "Al Held [interview]." *Artscribe* (London), July 1977, pp. 5–9.

Al Held, 1965
© Hans Namuth 1988

B/WX, 1968
Acrylic on canvas, 114 × 114"
Collection Albright-Knox Art Gallery, Buffalo
Gift of Seymour H. Knox, 1969

C-Y-1, 1978
Acrylic on canvas, 114 × 114"
Collection Albright-Knox Art Gallery, Buffalo
Gift of Seymour H. Knox, 1979

RICHARD ANUSZKIEWICZ

For me, one of the most exciting aspects of creative work is its progressive development and change. Art is a continuous process, and the artist's statement is not made in just one work, but in the total. I would not only like to discuss briefly the paintings in this exhibition, which date from 1966 to 1974, but also the earlier work.

My interest in the contributions of the Impressionists, Neoimpressionists, and Josef Albers (with whom I studied from 1953 to 1955), is at least in part responsible for my involvement with color. The color phenomenon in my work from the mid fifties can be summed up in my statement for the "Americans 1963" exhibition at the Museum of Modern Art: "My work is of an experimental nature and has centered on an investigation into the effects of complementary colors of full intensity when juxtaposed and the optical changes that occur as a result, and the study of the dynamic effect of the whole under changing conditions of light, and the effect of light on color."

These earliest paintings consisted of a free juxtaposition of shapes over a field of color with as few as two, or at the most three, colors. I also discovered how "light sensitive" colors can be, and that to achieve the dynamic luminous effect of juxtaposing complementary (chromatically opposite) colors of equal intensity, I must control the color of light. I have since always made my mixtures under a warm incandescent light.

In the early sixties the images in the paintings began to organize into precise systematic structures with a square format. This precisionism was further accentuated by using masking tape to achieve and control the severe, straight, calculated lines. The principle of visual mixtures, or mixing colors by eye rather than on the palette, was used with fine lines and sometimes small squares or dots juxtaposed over a field of color.

By the late sixties and early seventies, the period represented in this exhibition, the introduction of more colors began to dictate changes of image and format to a "series" involvement by using multiple squares, vertical bands, and bands around a center. The colors of the bands or squares adhered to a sequential and spectrum-like arrangement. This kind of family grouping had a much softer appearance than the earlier stark complementary two or three color paintings, and I refer to them as "soft" hard edge paintings. The sequential arrangement of color also led to works dealing with the reversal of color order as evidenced by a number of paired paintings in this exhibition. The two paintings from 1974 deal with visual mixture against solid color, interacting on two sides as a soft edge that alternates in color.

Finally, I would like to point out that the image in my work has always been determined by what I wanted the color to do. Color function becomes my subject matter and its performance is my painting.

Quoted in *Anuszkiewicz: Acrylic Paintings 1966–1974*. Jerusalem: Billy Rose Pavilion, Israel Museum, 1976, n.p.

Richard Anuszkiewicz
Photograph by Frank Kaino

Water from the Rock, 1961–63
Oil on canvas, 56 × 52"
Collection Albright-Knox Art Gallery, Buffalo
Gift of Seymour H. Knox, 1963

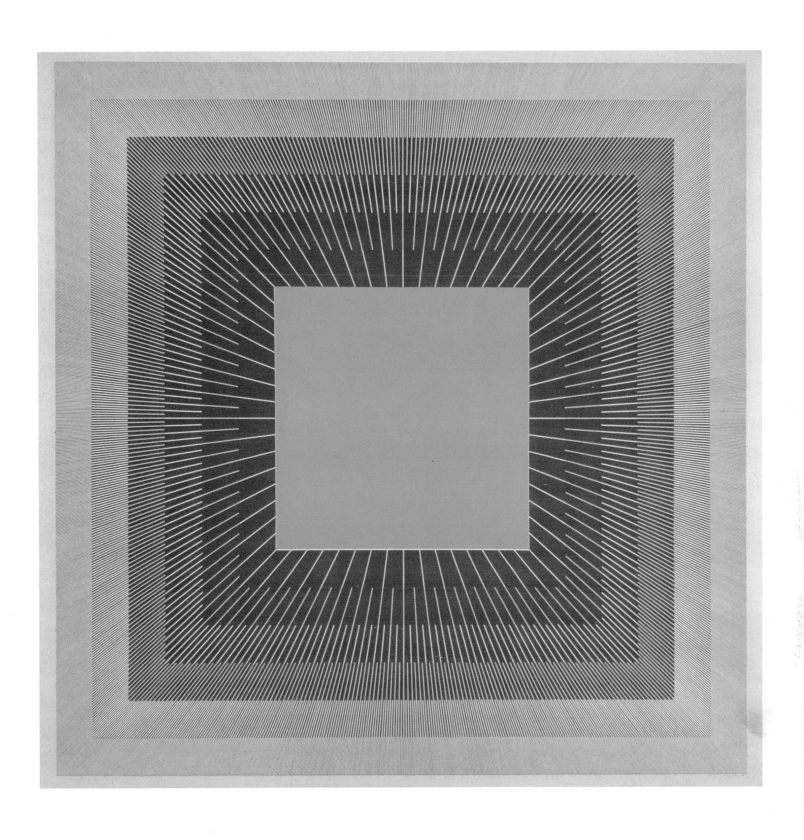

Iridescence, 1965
Acrylic on canvas, 60 × 60"
Collection Albright-Knox Art Gallery, Buffalo
Gift of Seymour H. Knox, 1966

LUDWIG SANDER

In general, my paintings do not lend themselves to any literary embroidery on my part; that is more the task of the critic. The painting is a thing in itself; no little note I may send along . . . is going [to] enhance or change this plastic entity. In fact, I have nothing to say—never had anything to say about my paintings because I have always felt that ex post facto thoughts by artists about their paintings sound a bit hollow. They certainly would if I did so.

Excerpted from letter to Robert Murdoch, Albright-Knox Art Gallery, October 25, 1968; in Gallery files.

Ludwig Sander
Photograph by Marvin P. Lazarus

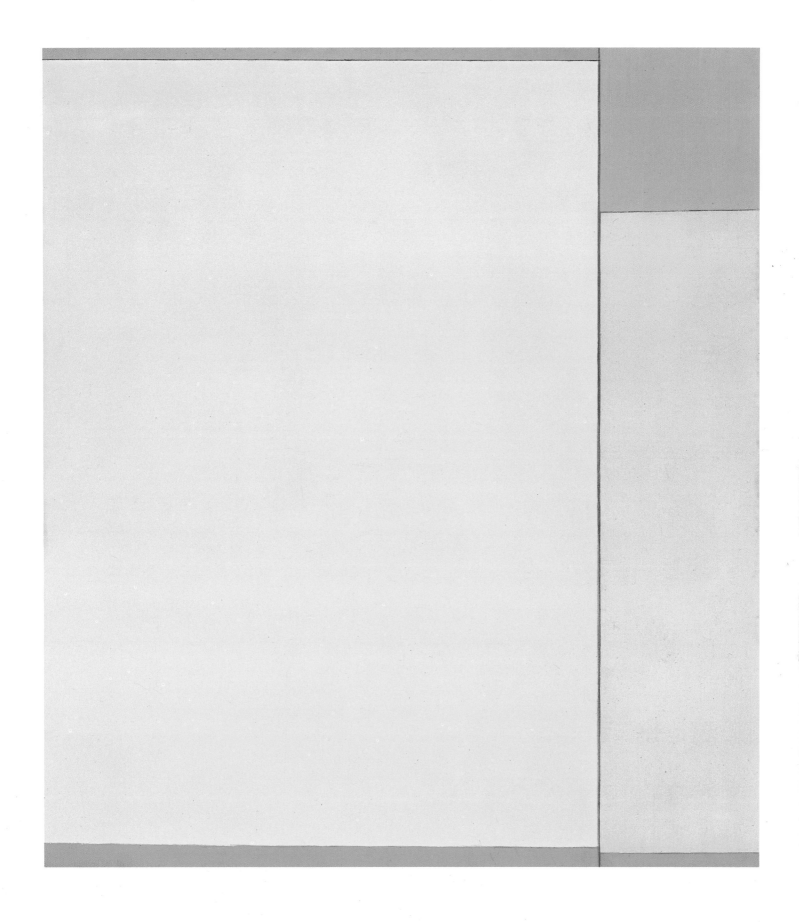

Untitled, 1963
Oil on canvas, 60 × 54″
Collection Albright-Knox Art Gallery, Buffalo
Gift of Seymour H. Knox, 1964

Frank Stella
Photograph by Brigitte Lacombe

There are two problems in painting. One is to find out what painting is and the other is to find out how to make a painting. The first is learning something and the second is making something.

One learns about painting by looking at and imitating other painters. I can't stress enough how important it is, if you are interested at all in painting, to look and to look a great deal at painting. There is no other way to find out about painting. After looking comes imitating. In my own case it was at first largely a technical immersion. How did Kline put down that color? Brush or knife or both[?] Why did Guston leave the canvas bare at the edges? Why did H. Frank[enthaler] use unsized canvas? And so on. Then, and this was the most dangerous part I began to try to imitate the intellectual and emotional processes of the painters I saw. So that rainy winter days in the city would force me to paint Gandy Brodies as [a] bright clear day at the shore would invariably lead me to De Staels. I would discover rose madder and add orange to make a Hoffman [sic]. Fortunately, one can stand only so much of this sort of thing. I got tired of other people's painting and began to make my own paintings. I found, however, that I not only got tired of looking at my own paintings but that I also didn't like painting them at all. The painterly problems of what to put here and there and how to do it to make it go with what was already there, became more and more difficult and the solutions more and more unsatisfactory. Until finally it became obvious that there had to be a better way.

There were two problems which had to be faced. One was spatial and the other methodological. In the first case I had to do something about relational painting, i.e., the balancing of the various parts of the painting with and against each other. The obvious answer was symetry [sic]—make it the same all over. The question still remained, though, of how to do this in depth. A symetrical [sic] image or configuration symetrically [sic] placed on an open ground is not balanced out in the illusionistic space. The solution I arrived at, and there are probably quite a few, although I only know of one other, color density forces illusionistic space out of the painting at constant intervals by using a regulated pattern. The remaining problem was simply to find a method of paint application which followed and complemented the design solution. This was done by using the house painter's technique and tools.

Transcription of text of lecture delivered at the Pratt Institute, January or February 1960. The original sheets on which the lecture is written in Stella's hand are from Passport, Carl Andre, New York, 1961. In Frank Stella: The Black Paintings. Baltimore: Baltimore Museum, 1976, p. 78.

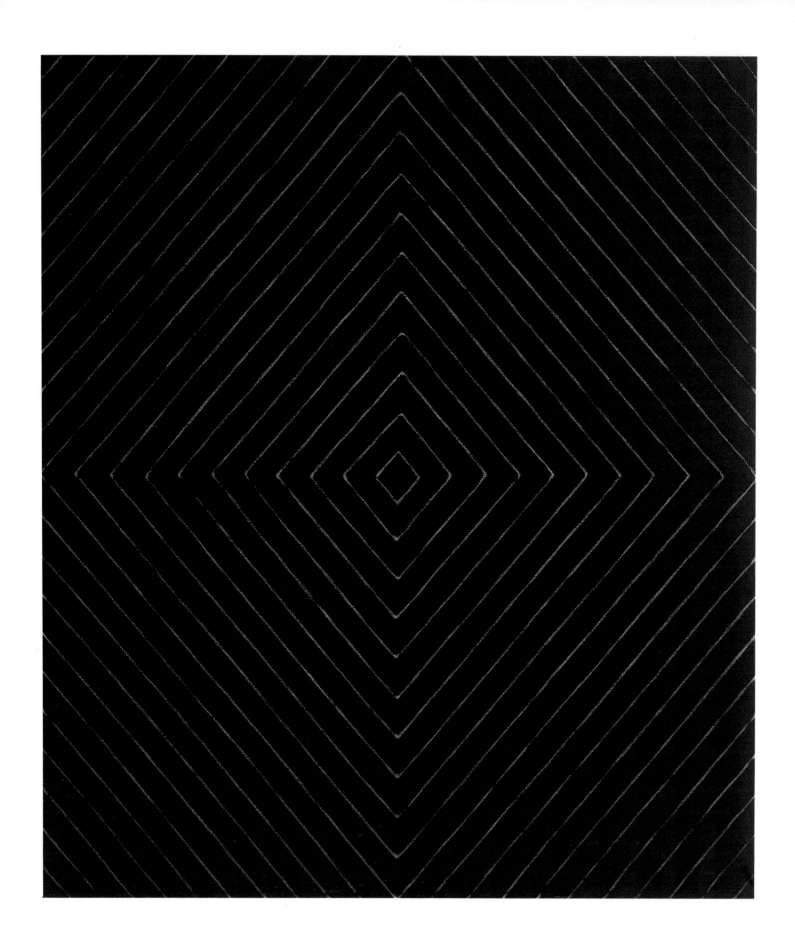

Jill, 1959
Enamel on canvas, 90¾ × 78¾″
Collection Albright-Knox Art Gallery, Buffalo
Gift of Seymour H. Knox, 1962

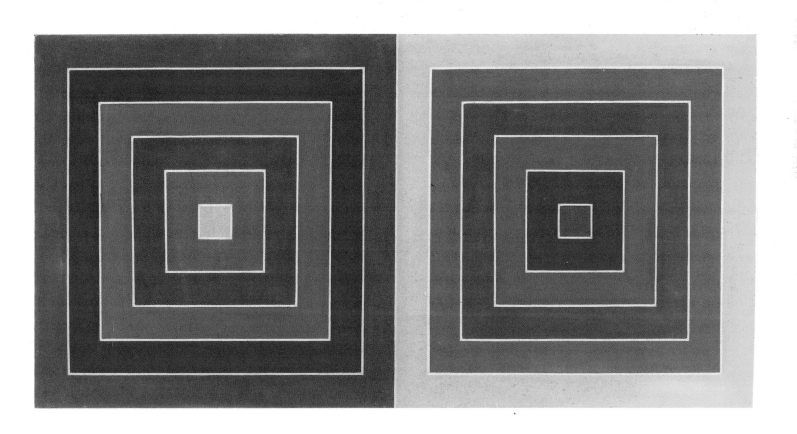

Newburyport, 1962
Oil on canvas, 30½ × 60¾"
Yale University Art Gallery
Gift of The Woodward
Foundation (1977.49.25)

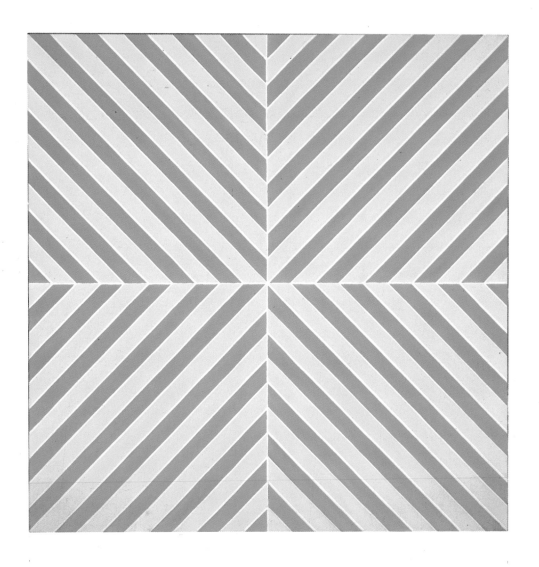

Fez, 1964
Fluorescent alkyd on canvas, 77 × 77"
Collection Albright-Knox Art Gallery, Buffalo
Gift of Seymour H. Knox, 1964

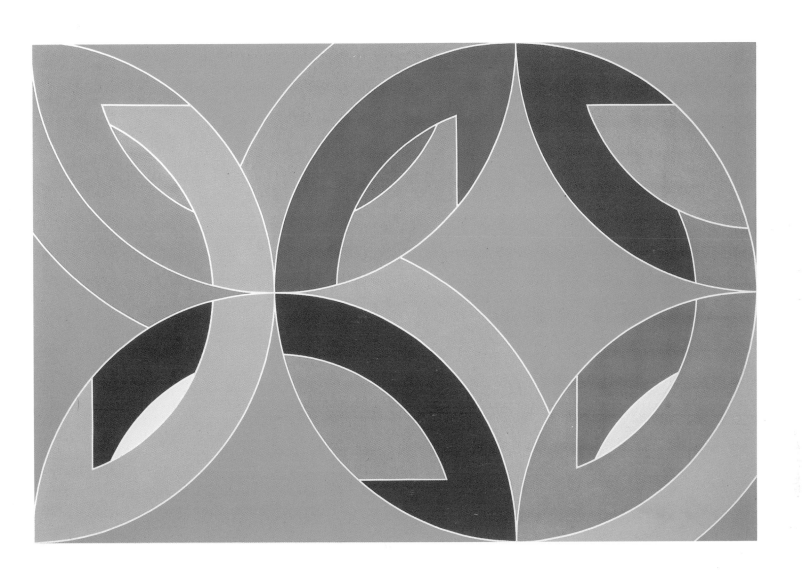

Lac Laronge III, 1969
Polymer paint on canvas, 108 × 162"
Collection Albright-Knox Art Gallery, Buffalo
Gift of Seymour H. Knox, 1970

AGNES MARTIN

We must not think of self-expression as something we may do or something we may not do. Self-expression is inevitable. In your work, in the way that you do your work, and in the results of your work your self is expressed. Behind and before self-expression is a developing awareness in the mind that affects the work. This developing awareness I will also call "the work." It is the most important part of the work. There is the work in our minds, the work in our hands, and the work as a result.

To some these moments are very clear and to others of a vagueness that can only be described as below the level of consciousness. Whether conscious or unconscious they do their work and they are the incentive to life. A stockpile of these moments gives us an awareness of perfection in our minds, and this awareness of perfection in our minds makes all the difference in what we do.

We must surrender the idea that this perfection that we see in the mind or before our eyes is obtainable or attainable. It is really far from us. We are no more capable of having it than the infant that tries to eat it. But our happiness lies in our moments of awareness of it.

The function of artwork is the stimulation of sensibilities. The renewal of memories of moments of perfection.

Excerpted from handwritten notes for a lecture, "On the Perfection Underlying Life," given at the Institute of Contemporary Art, University of Pennsylvania, Philadelphia, February 14, 1973. Reprinted in *Agnes Martin*. Munich: Kunstraum München, 1973, p. 35ff.

The paintings are not landscapes. They derive from the non-objective. They're from the mind. They are classical, which is a kind of imperfect nature but as close as our minds can get to that kind of perfection.

Geometry is a kind of abstraction but in itself is not enough. It is a means of getting to a content in ourselves; a plane of attention and awareness, a plane of self-understanding.

I use geometry because it allows a frontal and direct experience and when handled in a certain way is intimate and tranquil.

In conversation with Michael Auping, August 9 and September 15, 1988.

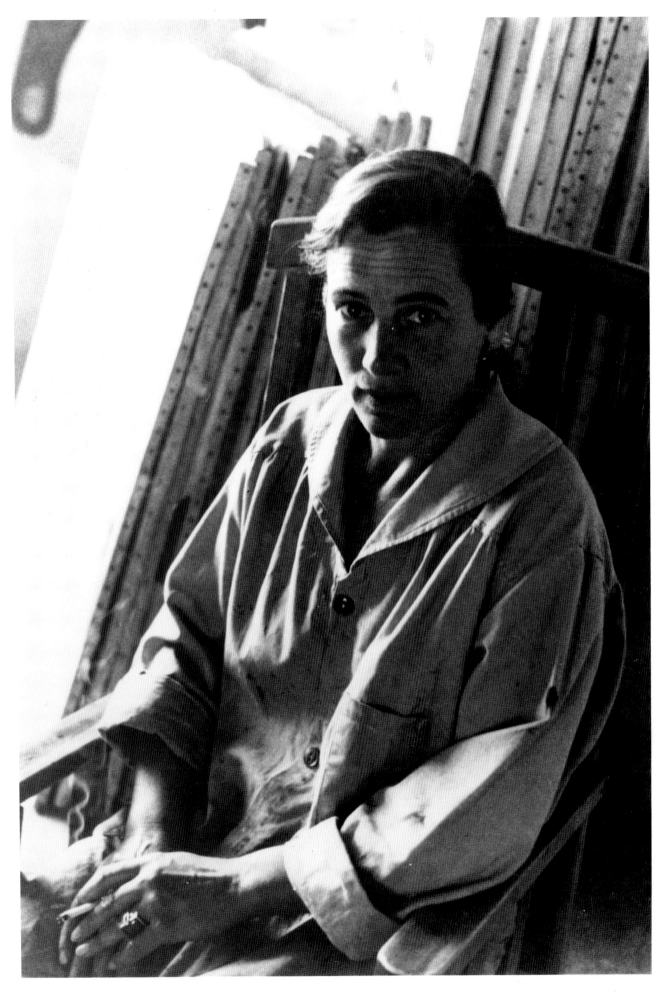

Agnes Martin, 1954
Photograph by Mildred Tolbert
Courtesy of The Pace Gallery, New York

The Tree, 1965
Acrylic and graphite on canvas, 72 × 72"
Collection Albright-Knox Art Gallery, Buffalo
Gift of Seymour H. Knox, 1976

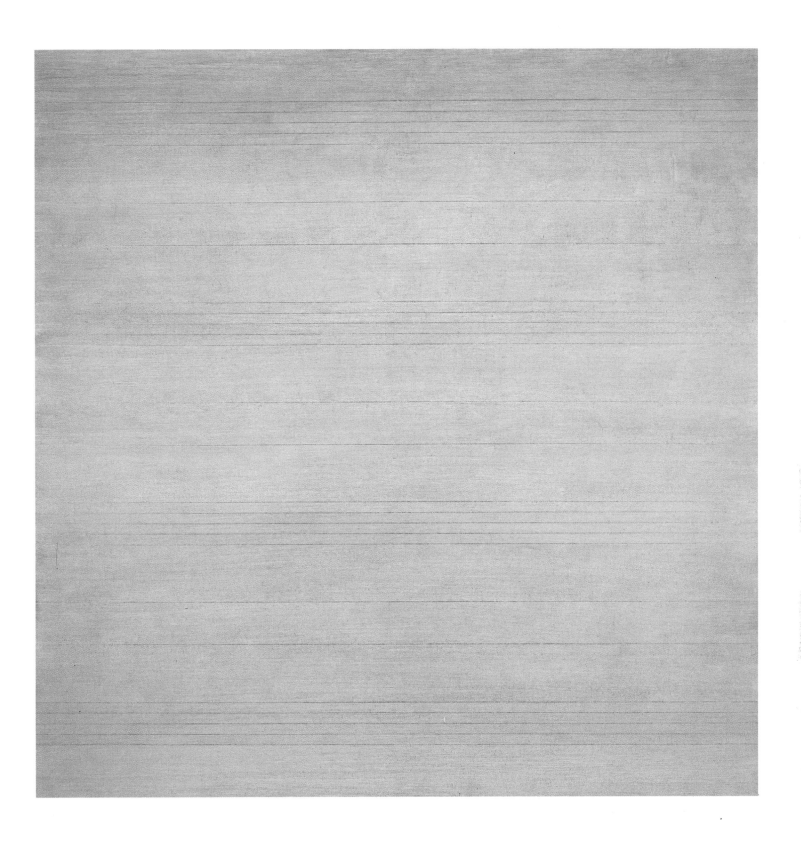

Untitled #2, 1977
India ink, graphite, and gesso
on canvas, 72 × 72"
Collection The Museum of Contemporary Art,
Los Angeles, The Barry Lowen Collection

LARRY POONS

PT How important were the drawings to the dotted grid paintings?

LP Not important whatsoever.

PT But they were made and they do relate to them.

LP It's like scaffolding, right. When the picture was finished, hopefully, the scaffolding wasn't to be seen.

PT Like structure?

LP That's a kind of simplistic idea of structure. If it's on graph paper, people feel it's structure. It's no more structure than anything else. It's just a lot of people began to think of structure in terms of if you can count them, if you can subtract them, if you can see the whole canvas divided equally, that's structure. Now, that's not structure. That's just divisions. That's not structure, at least not structure in the sense that a painting assumes structure if it's a painting. A really nice, good painting has a structure, but it's a structure that's integral to the painting and not to any rules. Your experience of the painting is an experience of structure. . . .

Someone who once liked my work—I thought he liked my work—came down to my place and looked at a new painting where the dots were of very close values and it was a very dark painting. .I asked him, "What do you think?" "I don't like it." I was surprised. "What's wrong with it?" "Well, I can't see the dots, I can't see the outline of the ellipses." I said, "Well, what are you talking about?" He said, "Well, I like your paintings when I can see the shapes." All the guy was looking at were the shapes, you know. That's why he liked my work, because he could see clearly defined ellipses or dots. That was bringing it all home—and very surprising. Guys who were writing about my work and liking it were seeing it in the same way. It's sometimes very surprising why people like it and what you assume is just absolutely ninety degrees wrong. Eventually, I think you're able to round up maybe two or three people who are the audience for your work, who know what you're doing, what you're trying to do. But more important than that is that you know these people like painting. They experience painting in a way that may not be in agreement with you, but for what they are. Not for reasons, but for what they are, whatever they are. A friend of mine once said, talking about a very good painter's work—talking about a series of paintings— they look awful, but they never got worse. Bad paintings just get worse and worse. Others can stay terrible for twenty years, but they never get worse. And joyfully, better.

Excerpted from Phyllis Tuchman, "An Interview with Larry Poons." *Artforum* (New York), Dec. 1970, pp. 45, 50.

Larry Poons
Photograph © Fred W. McDarrah 1988

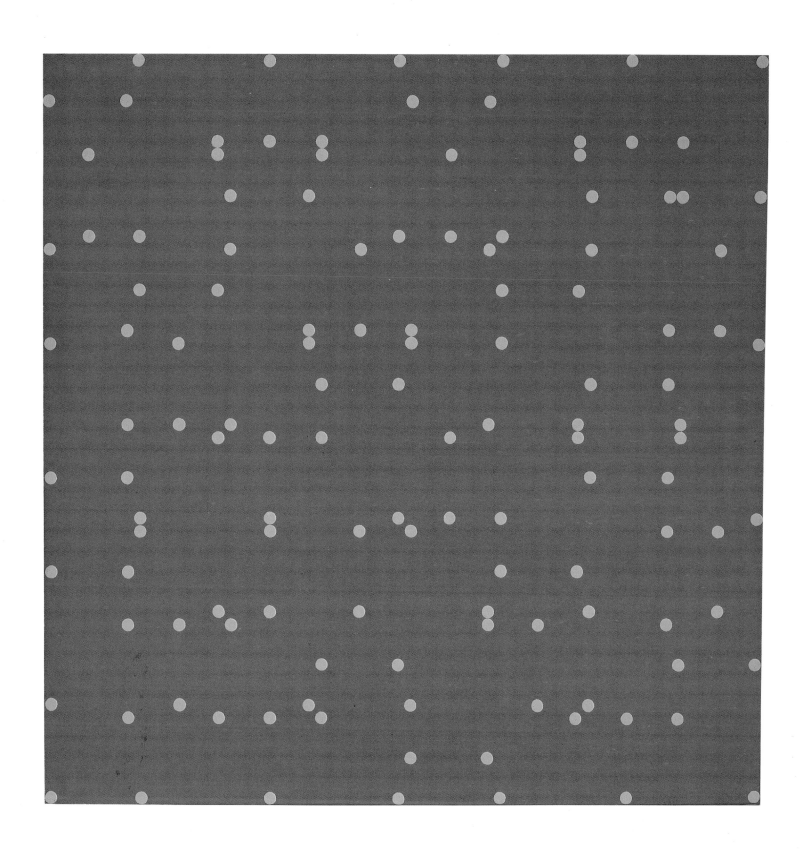

Orange Crush, 1963
Acrylic on canvas, 80 × 80"
Collection Albright-Knox Art Gallery, Buffalo
Gift of Seymour H. Knox, 1964

ROBERT MANGOLD

In the 1960s, for me, Abstract Expressionism was important, and Newman was pivotal. He addressed painting in an exceptionally basic way. His understanding of scale, divisions and structure, and color was very impressive to me. You could read them from an intellectual or emotional standpoint. Their sense of containment and directness, even though they were so big, was influential, and that much color really affected you. I think I learned how I might work with structure from Newman.

I see my pieces as structural paintings: geometric but intuitive divisions and shapes that explore the question of whether a work can stand as a contained, holistic image yet also seem to be a part of something else. . . .

In the late sixties, we also had to find our own approach to color. I wanted an effective color but color that wasn't emotionally overbearing, that didn't distract from the structure of the paintings. At the time, I was attracted to generic or "industrial" colors; paper bag brown, file cabinet gray, industrial green, that kind of thing. I didn't want color that looked like Matisse or Abstract Expressionism and a lot of the post-painterly abstraction people seemed too decorative. I wanted something straightforward and simple, even if it was pedestrian. In a way, it was dealing with color the way the Pop artists dealt with image.

In conversation with Michael Auping, August 18 and September 8, 1988.

RM I was interested in the idea of a sectionalized kind of painting that could be fragmented into parts and still exist as a whole; I mean the total piece could be four sections and you could split it in half and still have a piece. And even complete in four sections, it implied that there was more.

RK You mean modular units adding up to a single whole?

RM But the whole was never there, there was an implied continuation. In the earliest work which dealt with the image extending beyond, there might actually be another unit which would fit next to the panel you were looking at, and there could have been a third. It really didn't matter as the outside shape of the work was arrived at arbitrarily.

RK And what established the continuity between these things?

RM The sectional units were constructed in terms of a four-foot division because that is the standard size of the building materials which were used. I would build the wall with the openings occurring roughly the way window breaks might occur, the earliest looking quite literally like a real wall section. Later pieces shed the references almost completely.

I liked the idea of a section of something implying more and yet being a complete thing. I was in a way testing what makes a complete shape and what doesn't, and what is or is not arbitrary. . . .

I've been more inclined to think about painting as a combination surface-shape rather than as object. I've never worked on or painted the edges; the works were always strictly frontal, and the shape of the piece was arrived at in a subtractive method. I would cut away from the basic rectangle or square, a taking away from the edge or as in the frame pieces of 1970, from the center.

One point I should make is that throughout the work, I've been very much an intuitive artist, I have followed intuitive feelings or hunches. And, in some cases, I do not have a clearly rational justification for the decisions I've made.

© *Artforum*, March 1974, Excerpts from "Robert Mangold: An Interview," by Rosalind Krauss, p. 36.

Robert Mangold
Photograph by Michael Halsband

X Series Central Diagonal No. 2, 1968
Acrylic on masonite, plywood, and metal, 48¼ × 96¾"
Collection The Solomon R. Guggenheim Museum, New York

Four Squares Within a Square #3, 1974
Acrylic and pencil on canvas, 78 × 78"
Collection Albright-Knox Art Gallery, Buffalo
National Endowment for the Arts
Purchase Grant and Matching Funds, 1975

Three Color Frame Painting, 1985–86
Acrylic and pencil on canvas, 91 × 80⅛"
Collection Emily Leland Todd, Houston

DOROTHEA ROCKBURNE

Dorothea Rockburne at The Metropolitan Museum
of Art, New York, 1988
Photograph by Fred R. Conrad,
The New York Times

As one's thought and experience are formed and used a delicate moment occurs when the discovered becomes understood, known, and consequently incorporated. This then is substructure, those many irretrievable operations behind the frontally evident. I had wanted to approach painting in a way which takes as a given certain conventions while questioning others. Consider the convention of the rectangle itself. When I focus my seeing, my peripheral vision does not frame itself into a rectangle. It therefore became necessary to consider the rectangle as perhaps generating itself through itself. With this in mind I chose a Golden Section and the square of that as a beginning format. The choice of the Golden Section is based on the notion of substructure. The opened size of linen from which the work is made measures 68 × 178 inches. The Golden Section is 110 inches long, combined to the determining square of 68 inches. The square and the Golden Section remain joined throughout.

Quoted in *Eight Contemporary Artists*. New York: The Museum of Modern Art, 1974, p. 48.

JL What led you to the form your work takes now, and why did you choose paper as your predominant material?

DR I don't like material as such, whether it's oil paint or anything else, because it leads you into a trap. The trap is that materials, in themselves, present a certain truth which one has to work with. I didn't want to work with the truth in materials, except in a very limited way. The paper curls, because it comes on a roll, and I don't mind that. It can have that much license but not too much more, because I'm interested in the ways in which I can experience myself, and my work is really about making myself. . . .

My work deals with color very clearly. I am interested in color but in such a way that what the color does, in terms of identity and what it physically is, are not separate. That is to say that graphite is a surface which distinguishes one part from another. The oil is a permeating sheet of its own color. . . .

My interest in Set Theory is not that Set Theory has to do with art because it doesn't. I am an artist and it is one of my tools, the way graphite is. The usage of it comes from personal experience. In college I had the good fortune to meet a theoretical mathematician. Mathematics didn't interest me but somehow Max Dehn's enthusiasm was contagious. He erased the panic and showed me how to put one foot in front of the other. He introduced me to math as a consistent history of thought, the thing I responded to in art.

Then too, I was angered by the fiction I read, because to read novels, on no matter what level, requires some empathy with the people who are being portrayed. Women are usually depicted as plodders, fools, or victims. I couldn't in any sense identify with them, and started to read books on mathematics. Math, by contrast, was straight, simple thinking and it never enclosed its own situation. If it did, it was only a situation to be set aside for later consideration in relation to something else, which would again open the total concept. I was excited by this and bored by art school instruction. I knew, though, that I was an artist and not a mathematician.

© *Artforum*, March 1972, "Dorothea Rockburne: An Interview," by Jennifer Licht, pp. 28–36.

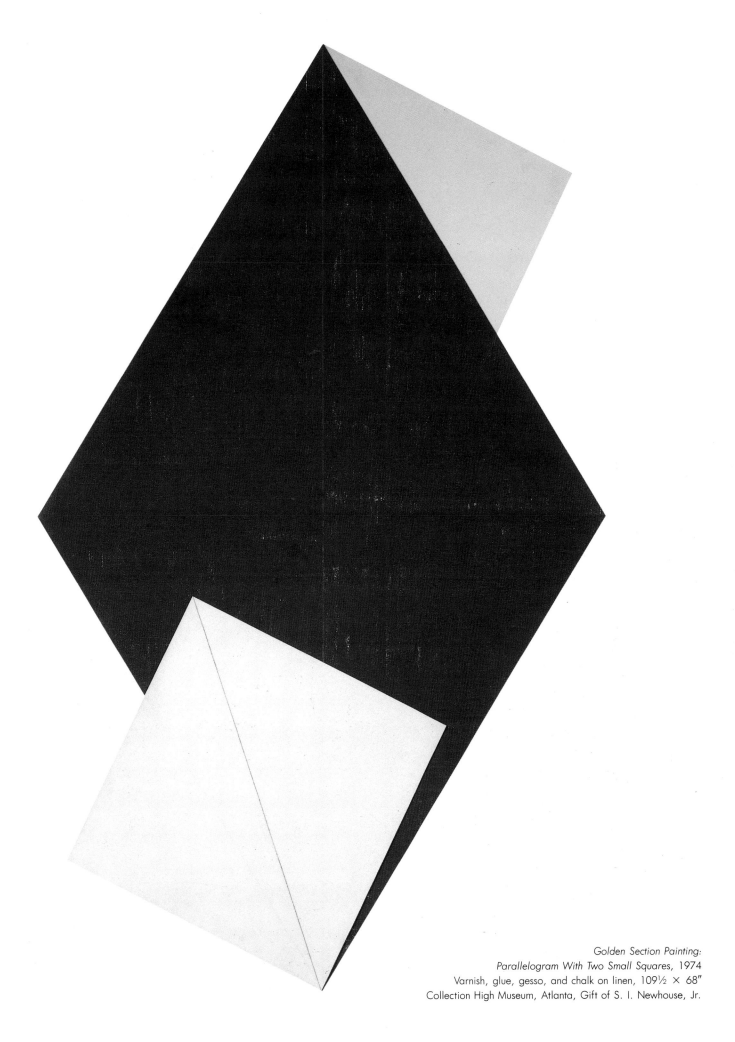

Golden Section Painting:
Parallelogram With Two Small Squares, 1974
Varnish, glue, gesso, and chalk on linen, 109½ × 68"
Collection High Museum, Atlanta, Gift of S. I. Newhouse, Jr.

JO BAER

My paintings from '62–75 . . . engaged and occupied a strong position in the dialectic of object versus sleight-of-hand. In part my work was congruent with the sculptors', especially in their focus on objecthood, then a primary and timely concern. This act of looking long to the nature of the object and into its specific organization stood for a hard look at integrity and the motions of deceit—an inquiry which further projected a quasi-political, visionary stance. But paintings, while objects, are not sculptures: flat and round are different intentions, and painted space is definitive deception. There can be no mark within a painting's format which does not deceive. The sculptors preferred isometric drawings and fabrication by nonisometric, straightforward measure; instead, I painted my straight edges curved to make them look straight (entasis) preferring an open dialogue of illusion/physically to simplistic, one-dimensional fiat. Even more disrupt, my use of color was disreputable, being neither grisaille, nor unaccompanied nor uniform. Choosing instead color worked in a context—with others or with black and white—I obtained duplicity through color's standard double-face. In these and other ways my differences with the sculptors were more than esthetic: to face illusion boldly is also an ideological act, for illusion necessarily exists in reality as much as in art. Programmatics aside, the real challenge in painting was to make poetic objects that would be discrete yet coherent, legible yet dense. Double-dealing, double-edged, the elegant course was through color.

Excerpted from Maurice Poirier and Jane Necol, "The '60s in Abstract: 13 Statements and an Essay." *Art in America* (New York), October 1983, p. 137.

Jo Baer
Photograph by Maria Gilissen

Untitled, 1972–75
Oil on canvas, 72 × 72"
Collection Albright-Knox Art Gallery, Buffalo
National Endowment for the Arts
Purchase Grant and Matching Funds, 1976

Brice Marden
Photograph by Joe Maloney
Courtesy The Pace Gallery, New York

I paint paintings made up of one, two, or three panels. I work from panel to panel. I will paint on one until I arrive at a color that holds the plane. I move to another panel and paint until something is holding that plane that also interestingly relates to the other panels. I work the third, searching for a color value that pulls the planes together into a plane that has aesthetic meaning. This process is not as simple as explained. There is much repainting of panels which follows no given order. The ideas of a painting can change quite fast and drastically or they can evolve very slowly. I want to have a dialogue with the painting; it works on me and I work on it.
1973

Quoted in *Eight Contemporary Artists*. New York: The Museum of Modern Art, 1974, p. 44.

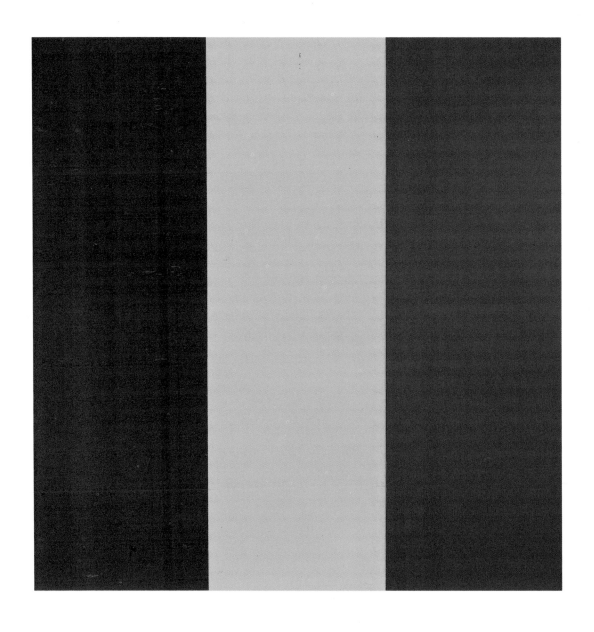

Red Yellow Blue Painting #1, 1974
Oil and wax on canvas, 74 × 72"
Collection Albright-Knox Art Gallery, Buffalo
James S. Ely Fund, 1974

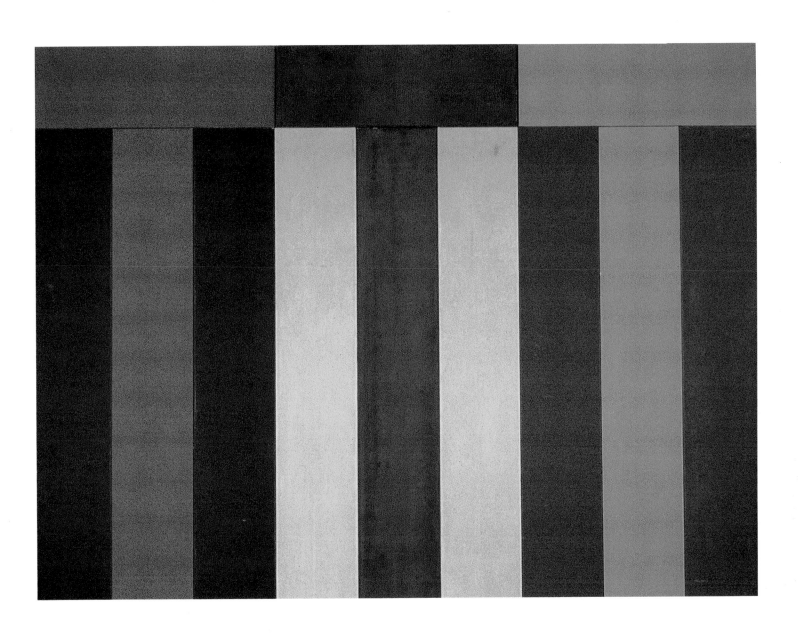

Number Two, 1983–84
Oil on canvas, 84 × 109"
Collection Anne and Martin Z. Margulies

DAVID NOVROS

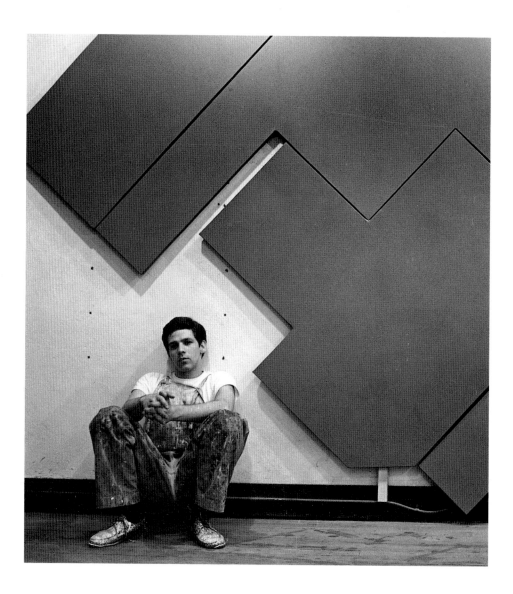

I am a painter who feels an affinity for painting (fresco, stained glass, mosaic, etc.) which is either made for a place or becomes a place . . . this sort of painting creates certain physical + moral conditions that are the basis for my work. When I haven't been able to work directly in place I have tried to make paintings that can carry the same ambitions.

I resist talking about any one aspect of my painting because I don't know how to separate the parts . . . to talk about "color" or "scale" or "meaning" would suggest a kind of compartmental-ization that I have spent my time as a painter trying to overcome.

There is only the experience of the painting . . . and for each person it is different. I hope the marraige [sic] of painting and place will produce a situation that transcends interpretation but encourages participation. The painting is meant to be for every one and belong to no one.

First something is
seen and then it is
named
Birds come with
the first and last
light
Standing in the abyss
at the end of the day
wading thru the
fire.

David Novros
Photograph © Fred W. McDarrah 1988

September 1988, New York

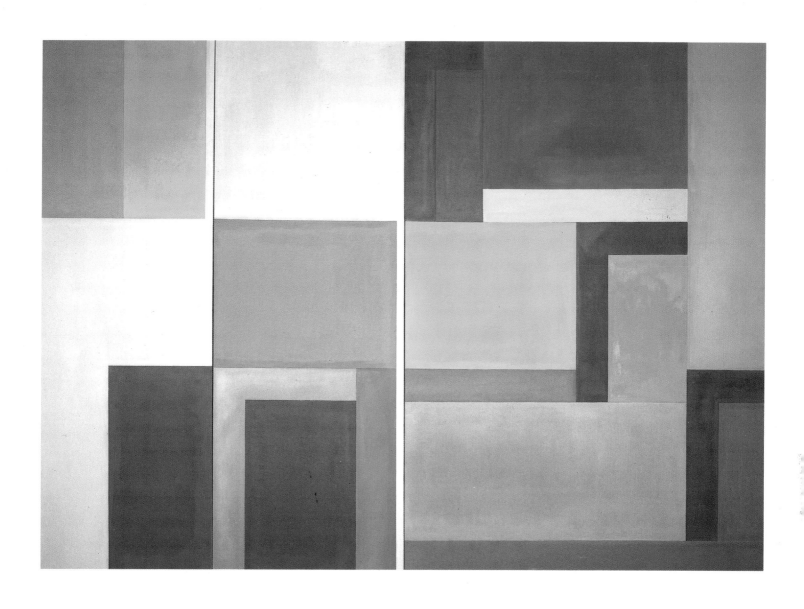

Untitled, 1970
Oil on canvas, 96 × 132"
Collection the artist

JOHN M. MILLER

John M. Miller
Photograph by the artist

The notion of a creative act is to anticipate the arrival—a creation for me, the canvas and stretcher bars are the support for the visual reality to arrive. It is a frontal experience. All time—no time, paradoxically influx and in present time.

Singular in its intent, a unified structured plane where the elements of existence are not separated, reductive or minimal, but rather an essential balance in clarity. Nothing added—nothing taken away.

The painter is the first viewer. The facilitor, correspondent for the intuitive, conceptual idea to arrive physically. A prelinguistic cognition where language is re-invented from the experiencing of *it*.

In the early works, scale was just beyond fingertips with outstretched arms and being ten to twelve inches from the floor. A physical step into superimposing viewer with the painting.

A singular, unified, structured plane contained in the present, paradoxically influx and absorbing light.

September 1988, Los Angeles

Number Two, 1976
Magna on raw canvas,
86⅝ × 73⅝"
Collection the artist

PETER HALLEY

I see myself as having set out elements of an imaginary or theoretical world and that slowly I'm building in more and more elements. It's sort of a through-the-looking-glass thing, as if one were inside this imaginary world and gradually walking around and discovering or finding out more and more elements. I'm reminded of that movie *Tron* that came out a few years ago; it described somebody playing a video game who was actually thrown into the video game environment. This person was walking around in an entirely synthetic geometric world, and that's what I'm trying to describe in my painting more and more.

There's one other thing about the geometry that I really would like to emphasize. I don't think of my work as abstract at all; instead of using the word abstract I always use the word diagrammatic. The issue to me is that at a certain point when all these artificial systems of communication and transportation were being laid out, *that* was the age of abstract art. So in a Mondrian or even in a Frank Stella, what you have is an ideal of depiction of what circulation and the flow of information or transportation would be like if this goal of circulation were completed. But I think in the contemporary world this has been completed and the geometric has become the real in terms of what's out there in the world. Geometry is backtracking and enclosing the old idea of the natural in the diagrammatic. I think the video game is very important in this regard, as are computer graphics. In a video game you might have a little geometric man walking across the screen and you have a situation in which these ideal geometric elements are being deployed to represent an old kind of organic natural reality.

I wanted to transform some of those issues into a vocabulary where that connection becomes more explicit. I tried to take that simple geometry and transform it into figures such as jails and cells with smokestacks, and put in a schematic landscape-type setting that would point to the connection between those configurations and actual configurations in the world. The jails came about as a way of describing the Minimalist square as a confining structure. I thought if I put bars on the square, it would very quickly go from being a classical or pure element to a sort of negative one, or one that would be a quick way of making it into a critical element. The other part of the iconography is the idea of the conduit. I'm using shapes that refer to buildings or structures that you can't enter or leave, but information or something can get into or out of them by means of a conduit that goes into and out of the cell from underground. I think that's a description of a psychological condition, and it's very relevant to industrial and postindustrial social structure in which you have apartments and subdivisions and telephone lines that come in, and water and radio and TV.

Excerpted from Jeanne Siegel. "The Artist/Critic of the 80s: Peter Halley." Jeanne Siegel, editor. *Artwords 2: Discourse on the Early 80s*. Ann Arbor/London: UMI Research Press, 1988, pp. 235–37.

Peter Halley, 1987
Photograph © Hans Namuth 1988

Final Sequence, 1987
Acrylic on canvas, 62 × 192"
Collection San Francisco Museum
of Modern Art, Purchase 87.94

ARTISTS' BIBLIOGRAPHIES
AND
SELECTED EXHIBITIONS
AND
REVIEWS

Bibliography and exhibitions listings for each artist
cover the period from 1945 to the present
and are arranged chronologically.

BURGOYNE DILLER

By the Artist

Interviews

Bowman, Ruth. Interview, Mar. 3, 1964. Unpublished transcript, Archives of American Art, Washington, D.C.

Phillips, H. Interview, *Archives of American Art Journal* (New York), vol. 16, pt. 2, 1976, pp. 14–21.

On the Artist

Selected Articles

De Kooning, Elaine. "Diller Paints a Picture." *Art News* (New York), Jan. 1953, pp. 26–29, 55–57.

Tillim, Sidney. "What Happened to Geometry?" *Arts Magazine* (New York), June 1959, pp. 38–44.

Campbell, Lawrence. "The Rule that Measures Emotion." *Art News* (New York), May 1961, pp. 34–35, 56–58.

Campbell, Lawrence. "Diller: The Ruling Passion." *Art News* (New York), Oct. 1968, pp. 36–37, 59–61.

Henning, E. B. "Two New Paintings in the Neo-Plastic Tradition." *Bulletin of the Cleveland Museum of Art,* Apr. 1975, pp. 106–19.

Abadie, Daniel. "Autour de Mondrian" in *Paris–New York.* Paris: Centre national d'art et de culture Georges Pompidou, 1978, pp. 436–43.

Marko, Eleanor. "History May be Catching up to Diller." *The Sunday Register* (Shrewsbury, N.J.), Mar. 4, 1979, page unknown.

Rosenthal, D. "Seeing Burgoyne Diller." *Artforum* (New York), May 1979, pp. 38–39.

Agee, William C. "Burgoyne Diller: Drawing and the Abstract Tradition in America." *Arts Magazine* (New York), Oct. 1984, pp. 80–83.

Selected One-Artist Exhibitions and Reviews

The Pinacotheca, New York. *Burgoyne Diller: Paintings-Constructions, 1934–1946,* Dec. 16, 1946–Jan. 18, 1947.

Rose Fried Gallery, New York. *Diller.* Nov. 5–Dec. 8, 1951.

Galerie Chalette, New York. *Diller: Paintings, Constructions, Drawings, Watercolors.* May 3–31, 1961. Cat., text by Madeleine Chalette-Lejwa.
 Tillim, Sidney. "Month in Review." *Arts Magazine* (New York), May 1961, pp. 78–81.

Art Gallery, Glassboro State College, New Jersey. *Burgoyne Diller,* opening date unknown–Apr. 18, 1962.

Galerie Chalette, New York. Title unknown, Nov. 12–Dec. 30, 1962.
 C[ampbell], L[awrence]. "Reviews and Previews." *Art News* (New York), Dec. 1962, p. 15.
 Judd, Donald. "In the Galleries: Burgoyne Diller." *Arts Magazine* (New York), Jan. 1963, p. 52.

Galerie Chalette, New York. *Burgoyne Diller* [Spring], 1964.
 C[ampbell], L[awrence]. "Reviews and Previews." *Art News* (New York), May 1964, p. 11.
 H[arrison], J[ane]. "In the Galleries: Burgoyne Diller." *Arts* (New York), May–June 1964, p. 33.

New Jersey State Museum, Trenton. *Burgoyne Diller: 1906–1965,* Feb. 11–Apr. 3, 1966. Cat., preface by Lawrence Campbell.

Noah Goldowsky Gallery, New York. *Burgoyne Diller,* Apr. 16–May 7, 1968.
 Feldman, Anita. "In the Galleries: Burgoyne Diller." *Arts Magazine* (New York), May 1968, p. 56.

Noah Goldowsky Gallery, New York. *Burgoyne Diller,* May 7–25, 1968.
 C[ampbell], L[awrence]. "Reviews and Previews." *Art News* (New York), May 1968, p. 12.

Los Angeles County Museum of Art. *Burgoyne Diller,* June 18–July 21, 1968.

Walker Art Center, Minneapolis. *Burgoyne Diller: Paintings, Sculptures, Drawings,* Dec. 12, 1971–Jan. 16, 1972. Cat., text by Philip Larson. Circulating exhibition.
 Pincus-Witten, Robert. "Minneapolis: Burgoyne Diller." *Artforum* (New York), Feb. 1972, pp. 58–60.

Washburn Gallery, New York. *Burgoyne Diller,* Apr. 18–May 20, 1978.

Meredith Long Contemporary, New York, and Meredith Long Contemporary, Houston. *Burgoyne Diller 1938–1962: Paintings Drawings and Collages,* Jan. 27–Feb. 21 (New York) and Mar. 28–Apr. 21 (Houston), 1979. Cat., text by K. W. Prescott.
 Kramer, Hilton. "Burgoyne Diller." *The New York Times,* Feb. 2, 1979, page unknown.
 Moser, Charlotte. "Burgoyne Diller Rediscovered." *Houston Chronicle,* Mar. 25, 1979, page unknown.
 Moser, Charlotte. "Artist's Work Exploits Three Minimal Themes." *Houston Chronicle,* Mar. 31, 1979, page unknown.
 Crossley, Mimi. "Burgoyne Diller." *Houston Post,* Apr. 6, 1979, page unknown.
 Gibson, E. "New York Letter." *Art International* (Lugano), Apr. 1979, pp. 44–51.
 Burnside, Madeleine. "Burgoyne Diller." *Art News* (New York), May 1979, p. 167.
 Rosenthal, Deborah. "Seeing Burgoyne Diller." *Artforum* (New York), May 1979, p. 38.

Meredith Long Contemporary, New York and Meredith Long & Company, Houston. *Burgoyne Diller: Constructions, Related Drawings and Paintings,* Apr. 23–May 10 (New York) and June (Houston), 1980. Cat., text by Harry Rand.
 Buonagurio, E. [Exhibition Reviews]. *Arts Magazine* (New York), Sept. 1980, p. 34.

André Emmerich Gallery, New York. *Burgoyne Diller: Paintings, Sculpture, Collages, Drawings, 1938 to 1964,* Sept. 10–Oct. 3, 1981. Cat.
 Henry, Gerrit. "Reviews and Previews." *Art News* (New York), Dec. 1981, p. 190.

Gimpel-Hanover & André Emmerich Galerien, Zurich. *Burgoyne Diller,* dates unknown, 1982.
 "Burgoyne Diller." *Neue Zürcher Zeitung* (Zurich), Jan. 21, 1982, page unknown.
 Anker, Valentina. "Lettre de Suisse: Burgoyne Diller." *Art International* (Lugano), May–June 1982, pp. 69–70.

Galerie Reckermann, Cologne, West Germany. Title and exact dates unknown, 1982.

André Emmerich Gallery, New York. *Burgoyne Diller: Drawings, 1945 to 1964,* Feb. 9–Mar. 3, 1984. Cat.

André Emmerich Gallery, New York. *Burgoyne Diller: Studies for the 3 Themes,* May 8–June 6, 1986. Cat., text excerpt from Nancy J. Troy, "Mondrian and Neo-Plasticism in America," 1979.

Margo Leavin Gallery, Los Angeles. *Burgoyne Diller,* Feb. 14–Mar. 14, 1987.

ILYA BOLOTOWSKY

By the Artist

Writings

[Statement in] *Réalités nouvelles* (Paris), no. 4, 1950, p. 43.

[Statement in] *Réalités nouvelles* (Paris), no. 6, July 1952, p. 8.

Lassaw, Ibram and Bolotowsky, Ilya. "Russian Constructivism: An Interview with Naum Gabo." *The World of Abstract Art,* The American Abstract Artists, ed. New York: George Wittenborn, c. 1957, pp. 87–101.

"On Neoplasticism and My Own Work: A Memoir." *Leonardo* (Oxford, Eng.), vol. 2, 1969, pp. 221–30.

American Abstract Artists: Three Yearbooks (1938–1939, 1946). New York: American Abstract Artists, 1969, pp. 96, 191.

"Concerning My Tondo Paintings." *Art Now: New York,* vol. 2, no. 2, 1970, n.p.

"Moholy Nagy. Ed. Richard Kostelanetz." *Leonardo* (Oxford, Eng.), vol. 6, no. 1, Winter 1973, page unknown.

Interviews

Larsen, Susan Carol. "Going Abstract in the '30s; an interview with Ilya Bolotowsky." *Art in America* (New York), Sept./Oct. 1976, pp. 70–79.

Cummings, Paul. Adventures with Bolotowsky [interview]. *Archives of American Art Journal* (Washington, D.C.) no. 1, 1982, pp. 8–31.

Stories

1962	*A Picnic* (in Russian and English)
	A Patient (in Russian and English)
1964	*Thieves I*
1967	*Maecenas*
1969	*Pride*
	Thieves II
1969–70	*Thieves III*
1970	*The Mattress*
1971	*A Pioneer*
	Elger J. Toomer

Films

Various Dates	
1953–57	*Bolotowsky Shows*
	Early Shorts
	Western Shorts
1953	*David Smith*
1954	*Haunted House*
1955	*Broadway* (color)
	Constant
	Dead End (color)
	Gabo
	Highways
	George L. K. Morris
	The Museum of Modern Art
	The National Gallery
	The Philadelphia Museum
	Xceron
1956	*Ruth Asawa*
	Avery
	Nell Blaine
	Rhys Caparn
	De Rivera
	Duchamp
	Fire Escapes
	Wolf Kahn Paints a Picture
	Nevelson
	David Smith
	Knute Stiles

1956–57	Sand Creek
1958	De Rivera
	Subways
	Andrew Winter
1959–60	Narcissus in a Gothic Mood
1961	Positive Negative (Metanoia)
1961–62	Metanoia
1961	The Last Orpheus
1967	Waking Dream
1968	Afternoon of a Fawn
	The Eye
1969	The Ambassadors (color)
	Torreon
1971	The Parnassian

Plays

1962	Shadowcave
	Visitation
1964	Prologue
	Sixty Fifth Parallel
1965	Lofts
	A Neurotic Lion
1965–present	The Geese of Rome
1967	Banana Oil (a happening)
1968	Darling, Poor Darling
	Sixty Miles per Hour (with Andrew Bolotowsky)
1974	Darling, Poor Darling (an opera)

On the Artist

Selected Articles

Morris, George L. K. "La Peinture abstraite aux U.S.A." Art d'aujourd'hui (Paris), June 1951, p. 20.

Philadelphia Museum of Art. A. E. Gallatin Collection, 1954, p. 28.

Tillim, Sidney. "What Happened to Geometry?" Arts Magazine (New York), June 1959, p. 40.

Taylor, Brie. "Towards a Plastic Revolution." Art News (New York), Mar. 1964, pp. 48–49.

Sjöberg, Leif. "Ilya Bolotowsky." Konstrevy (Stockholm), vol. 40, no. 2–3, 1964, pp. 82–85.

Welsh, Robert. "The Growing Influence of Mondrian." Canadian Art (Toronto), Jan. 1966, p. 45.

Campbell, Lawrence. "Squaring the Circle and Vice-Versa." Art News (New York), Feb. 1970, pp. 38–41, 68–72.

Elderfield, John. "American Geometric Abstraction in the Late Thirties." Artforum (New York), Dec. 1972, p. 37.

Burnham, J. "Mondrian's American Circle." Arts (New York), Sept. 1973, p. 37.

Lane, John R. "Ilya Bolotowsky's 'Abstraction,' 1936–37." Carnegie Magazine (Pittsburgh), June–Aug. 1981, pp. 4–7.

Glueck, Grace. "Ilya Bolotowsky, 74, Dies; a Neo-Plasticist Painter." The New York Times, Nov. 24, 1981, page unknown.

Berman, Greta. "Abstractions for Public Places, 1935–1943." Arts Magazine (New York), June 1982, pp. 81–86.

Selected One-Artist Exhibitions and Reviews

New Art Circle, J. B. Neumann, New York. Ilya Bolotowsky, Feb. 11–28, 1946.
 W[olf], B[en]. "Ilya Bolotowsky, Non-Objective." Art Digest (New York), Feb. 15, 1946, p. 14.

The Pinacotheca, New York. Ilya Bolotowsky, Nov. 10–29, 1947.
 L., A., "Fifty-Seventh Street in Review: Ilya Bolotowsky." Art Digest (New York), Dec. 1, 1947, p. 22.

"Reviews and Previews." Art News (New York), Dec. 1947, p. 46.

The Rose Fried Gallery (The Pinacotheca), New York. Ilya Bolotowsky, Apr. 4–21, 1950.
 Krasne, Belle. "Bolotowsky, Mondrian in Russian Translation." Art Digest (New York), Apr. 15, 1950, p. 16.
 H[ess], T[homas] B. "Reviews and Previews." Art News (New York), May 1950, pp. 51–52.

New Art Circle, J. B. Neumann, New York. Ilya Bolotowsky, Mar. 3–29, 1952.
 A[shton], D[ore]. "Fifty-Seventh Street in Review: Ilya Bolotowsky." Art Digest (New York), Mar. 15, 1952, p. 19.
 G[oodnough], R[obert]. "Reviews and Previews." Art News (New York), Mar. 1952, p. 46.

Grace Borgenicht Gallery, New York. Ilya Bolotowsky, Jan. 4–23, 1954.
 S[awin], M[artica]. "Fifty-Seventh Street in Review: Ilya Bolotowsky." Art Digest (New York), Jan. 1, 1954, p. 19.
 L[ansner], K[ermit] I. "Reviews and Previews." Art News (New York), Jan. 1954, p. 79.

Grace Borgenicht Gallery, New York. Ilya Bolotowsky, Jan. 3–21, 1956.
 G., B. "In the Galleries: Ilya Bolotowsky." Arts (New York), Jan. 1956, p. 50.
 T[yler], P[arker]. "Reviews and Previews." Art News (New York), Jan. 1956, p. 51.

Grace Borgenicht Gallery, New York. Ilya Bolotowsky, Jan. 6–25, 1958.
 B[urrey], S[uzanne]. "In the Galleries: Ilya Bolotowsky." Arts (New York), Jan. 1958, p. 56.
 S[chuyler], J[ames]. "Reviews and Previews." Art News (New York), Jan. 1958, p. 21.

Grace Borgenicht Gallery, New York. Ilya Bolotowsky: Recent Paintings, Oct. 6–24, 1959.
 D., G. "In the Galleries: Ilya Bolotowsky." Arts Magazine (New York), Nov. 1959, p. 68.

State University College of Education, New Paltz, New York. Ilya Bolotowsky, Jan. 10–28, 1960.

Grace Borgenicht Gallery, New York. Ilya Bolotowsky, Oct. 3–21, 1961.
 S[chuyler], J[ames]. "Reviews and Previews." Art News (New York), Nov. 1961, p. 16.

Grace Borgenicht Gallery, New York. Ilya Bolotowsky, Oct. 1–26, 1963.
 B[eck], J[ames] H. "Reviews and Previews." Art News (New York), Nov. 1963, p. 15.
 J[udd], D[onald]. "In the Galleries: Ilya Bolotowsky." Arts Magazine (New York), Nov. 1963, p. 35.

Art Depot Gallery, La Grangeville, New York. Ilya Bolotowsky, Aug. 6–16, 1964.

Grace Borgenicht Gallery, New York. Ilya Bolotowsky, Jan. 4–22, 1966.
 Benedikt, Michael. "New York Letter: Op; Neo-Neo-Plasticism." Art International (Lugano), Mar. 20, 1966, p. 56.
 S[wain], R[ichard]. "In the Galleries: Ilya Bolotowsky." Arts Magazine (New York), Mar. 1966, pp. 61–62.

East Hampton Gallery, New York. Ilya Bolotowsky, July 1966.

Gorham State College Art Gallery, Maine. Ilya Bolotowsky, Apr. 15–May 15, 1967.

Grace Borgenicht Gallery, New York. Ilya Bolotowsky, Mar. 16–Apr. 5, 1968.
 K[eller], H[arold]. "In the Galleries: Ilya Bolotowsky." Arts Magazine (New York), Apr. 1968, p. 63.
 E[dgar], N[atalie]. "Reviews and Previews." Art News (New York), May 1968, p. 11.

George Gershwin College, Stony Brook, New York. Bolotowsky Weekend, Nov. 15–17, 1968.

Newport Harbor Art Museum, Newport Beach, California. Ilya Bolotowsky Paintings and Columns, Jan. 27–Mar. 1, 1970. Organized by the University Art Museum, The University of New Mexico, Albuquerque. Cat., text by Robert M. Ellis. Circulating exhibition.
 Stiles, Knute. "A Twelve Year Retrospective Travels the West." Artforum (New York), Apr. 1970, pp. 52–55.

Grace Borgenicht Gallery, New York. Ilya Bolotowsky, Jan. 31–Feb. 26, 1970.
 Campbell, Lawrence. "Squaring the Circle and Vice-Versa." Art News (New York), Feb. 1970, pp. 38–41, 68–72.

London Arts Gallery, England. Ilya Bolotowsky: Paintings and Screenprints, Apr. 1–May 1, 1971.

Grace Borgenicht Gallery, New York. Ilya Bolotowsky: Recent Paintings and Columns, Feb. 26–Mar. 23, 1972.
 Shirey, David L. "Bolotowsky Shows a Vertical Format." The New York Times, Mar. 4, 1972, p. 23.
 Mellow, James R. "Bolotowsky: An Old Style Gets New Life." The New York Times, Mar. 12, 1972, page unknown.
 Ratcliff, Carter. "New York Letter." Art International (Lugano), Apr. 20, 1972, p. 31.

David Barnett Gallery, Milwaukee. Ilya Bolotowsky: Recent Paintings and Columns, Oct. 15–31, 1972.

Wichita Art Museum, Kansas. Ilya Bolotowsky: Recent Serigraphs, Jan. 19–Feb. 20, 1973.

Grace Borgenicht Gallery, New York. Ilya Bolotowsky: Paintings and Columns, Mar. 30–Apr. 25, 1974.
 Hess, Thomas B. "Hello, Old Paint." New York, Apr. 22, 1974, pp. 72–73.
 Frank, Peter. "Ilya Bolotowsky." Art News (New York), Summer 1974, pp. 115–16.
 Kingsley, April. "New York Letter." Art International (Lugano), Summer 1974, p. 44.

The Solomon R. Guggenheim Museum, New York. Ilya Bolotowsky, Sept. 20–Nov. 10, 1974. Text by Adelyn Breeskin; interview with the artist by Louise Averill Svendsen and Mimi Poser. Circulating exhibition.
 Schjeldahl, Peter. "Bolotowsky—'A Triumph As Much For a Personality As For a Talent'." The New York Times, Oct. 6, 1974, page unknown.
 Tannenbaum, J. "Ilya Bolotowsky." Arts Magazine (New York), Oct. 1974, pp. 40–41.
 Derfner, Phyllis. "New York Letter." Art International (Lugano) Nov. 1974, pp. 53–55, 57.
 Herrera, Hayden. "Ilya Bolotowsky: Pure, Precise Loveliness." Art News (New York), Nov. 1974, pp. 34–36.
 Cohen, R. H. "Ilya Bolotowsky." Art in America (New York), Nov.–Dec. 1974, pp. 123–24.
 Smith, Roberta. "Ilya Bolotowsky at the Guggenheim." Artforum (New York), Dec. 1974, pp. 32–33.
 "Solomon R. Guggenheim Museum, New York: Exhibition." Pantheon (Munich), Jan. 1975, p. 76.

Galerie Schloss Remseck, Stuttgart. Ilya Bolotowsky: Gemälde, Säulen, Wandteppiche, May 11–July 15, 1975.
 Wirth, Gunther. "Ilya Bolotowsky, Umberto Buscioni." Kunstwerk (Stuttgart), July 1975, p. 75.

Hooks-Epstein Galleries, Inc., Houston. Ilya Bolotowsky: Paintings and Prints, Oct. 15–Nov. 9, 1975.

Grace Borgenicht Gallery, New York. Ilya Bolotowsky, Feb. 28–Mar. 25, 1976.
 Tannenbaum, Judith. "Ilya Bolotowsky." Arts Magazine (New York), May 1976, p. 23.

Grace Borgenicht Gallery, New York. Ilya Bolotowsky, Feb. 25–Mar. 24, 1978.
 Ratcliff, Carter. "New York Letter." Art International (Lugano), Mar. 1978, p. 53.

Rosenthal, D. "Ilya Bolotowsky." *Arts Magazine* (New York), Mar. 1978, p. 2.

Fort Wayne Museum of Art, Indiana. *Ilya Bolotowsky,* Apr. 21–May 28, 1978. Cat., text by John Krushenick.

Museum of Fine Arts, St. Petersburg, Florida. *Ilya Bolotowsky.* May 13–June 10, 1979. Cat., text by Jeannette Crane.

Grace Borgenicht Gallery, New York. *Ilya Bolotowsky: Paintings and Columns,* Mar. 29–Apr. 24, 1980.

Washburn Gallery, 42 East 57 Street, New York. *Ilya Bolotowsky: Paintings from 1935 to 1945,* Oct. 1–Nov. 1, 1980.

Washburn Gallery, 113 Greene Street, New York. *Ilya Bolotowsky: WPA Murals,* Oct. 1–Nov. 1, 1980.

Raynor, Vivien. "Art: Washburn Annex Opens With 2 Murals." *The New York Times,* Oct. 10, 1980, page unknown.

Yares Gallery, Scottsdale, Arizona. *Ilya Bolotowsky: Selected Paintings,* Oct. 10–31, 1982.

Washburn Gallery, 42 East 57 Street, New York. *Ilya Bolotowsky: Paintings from 1950,* Jan. 6–Feb. 23, 1983.

Washburn Gallery, 113 Greene Street, New York. *Ilya Bolotowsky: Paintings from 1980,* Jan. 6–Feb. 23, 1983.

Cohen, Ronny. "Reviews and Previews." *Art News* (New York), Apr. 1983, p. 156.

Gallati, Barbara. "Ilya Bolotowsky." *Arts Magazine* (New York), Apr. 1983, pp. 40–41.

Rub, Timothy F. "Ilya Bolotowsky." *Arts Magazine* (New York), Apr. 1983, p. 32.

Washburn Gallery, New York. *Ilya Bolotowsky: Five Decades,* Apr. 4–May 5, 1984.

Fine Arts Center Art Gallery, State University of New York at Stony Brook. *Homage to Bolotowsky 1935–1981,* June 17–Sept. 19, 1985. Cat., statement by the artist.

Sid Deutsch Gallery, New York. *Ilya Bolotowsky, 1930's Works on Paper,* Jan. 3–28, 1987.

Brummer, Miriam. "Reviews and Previews." *Art News* (New York), Apr. 1987, pp. 162, 164.

Washburn Gallery, New York. *Ilya Bolotowsky,* Jan. 7–31, 1987.

Brummer, Miriam. "Reviews and Previews." *Art News* (New York), Apr. 1987, pp. 162, 164.

Kuspit, Donald. "Ilya Bolotowsky: Washburn Gallery." *Artforum* (New York), Apr. 1987, pp. 124–25.

FRITZ GLARNER

By the Artist

Writings

"What Abstract Art Means to Me." *Bulletin, The Museum of Modern Art* (New York), Spring 1951.

On the Artist

Books

Staber, Margit. *Fritz Glarner.* Zurich: ABC Edition, 1976.

Hrikova, Dagmar. *Fritz Glarner in Kunsthaus Zürich.* Zurich: Kunsthaus, 1982.

Selected Articles

Gibbs, Jo. "Ascetic Aesthetics." *Art Digest* (New York), May 1, 1945, p. 14.

Seuphor, Michel. *L'Art Abstrait, ses Origines, ses Premiers Maîtres.* Paris: Maeght, 1949, p. 86.

Hess, Thomas B. "Is Abstraction Un-American?" *Art News* (New York), Feb. 1951, pp. 38–41.

Dorazio, Piero. *La Fantasia dell'arte nella Vita Moderna.* Rome: Polveroni Quitti, 1955, pp. 89, 121, 122.

Ashton, Doré. "L'Apport Artistique des Etats-Unis." *XX Siècle* (Paris), June 1956, pp. 71–72.

Miller, Dorothy. "Fritz Glarner." *New Art in America.* New York: New York Graphic Society and Frederick A. Praeger Inc., 1957, pp. 224–26.

Adlow, Dorothy. "Fritz Glarner." *Christian Science Monitor* (Boston), June 13, 1960, page unknown.

Ashton, Dore. "Fritz Glarner." *Art International* (Lugano), Jan. 1963, pp. 48–55.

Staber, Margit. "Fritz Glarner." *Werk* (Bern), Feb. 1968, pp. 105–9.

Castelman, Riva. "Fritz Glarner's Recollection." *Art International* (Lugano), Nov. 1969, pp. 33–35.

Staber, Margit. "Der Maler Fritz Glarner." *Du* (Zurich), Sept. 1972, pp. 664–71.

Selected One-Artist Exhibitions and Reviews

Louis Carré et Cie, Paris. *Glarner: Rythme de New York,* Oct. 14–Nov. 12, 1955.

Galerie Louis Carré, Paris. *Fritz Glarner: Peintures (1949–1962),* Feb. 18–Mar. 13, 1966. Cat.

34e Biennale, Venice. *Fritz Glarner,* June 22–Oct. 20, 1968. Cat., text by Hans Aeschbacher and the artist.

San Francisco Museum of Art. *Fritz Glarner: 1944–1970,* Nov. 13, 1970–Jan. 3, 1971. Cat., text by Natalie Edgar. Circulating exhibition.

Tarshis, J. "San Francisco: Fritz Glarner 1944–1970." *Artforum* (New York), Feb. 9, 1971, pp. 85–86.

Shirey, David L. "Display Pays Tribute to Glarner Art." *The New York Times,* Feb. 19, 1971, p. 24.

"Fritz Glarner." *Art International* (Lugano), May 15, 1971, p. 53.

Gimpel Fils, London. *Fritz Glarner: Drawings,* Jan. 11–Feb. 5, 1972. Cat., text by Margit Staber. Circulating exhibition.

"Fritz Glarner." *Arts Review* (London), Jan. 1, 1972, p. 803.

Kunsthalle Bern, Switzerland. *Fritz Glarner,* Aug. 12–Sept. 24, 1972. Cat., texts by Max Bill, Carlo Huber, and the artist.

Gimpel & Hanover Galerie, Zurich. *Fritz Glarner: Bilder, Bildprojekte, Zeichnungen,* Oct. 6–Nov. 14, 1976.

Musée d'Art et d'Histoire, Geneva, Switzerland. *Fritz Glarner: Dessins, Peintures, 1940–1969,* Oct. 4–Nov. 11, 1979. Cat., text by Daniel Abadie.

CHARMION VON WIEGAND

By the Artist

Writings

"The Meaning of Piet Mondrian." *Journal of Aesthetics and Art Criticism* (New York), Fall 1943, pp. 63–70.

"The Oriental Tradition in Western Art." *The Works of Abstract Art.* New York: George Wittenborn, 1957, pp. 55–67.

"The Adamantine Way." *Art News* (New York), Apr. 1969, pp. 38–41.

Interviews

Cummings, Paul. Taped interviews, Oct. 9, Nov. 3, Nov. 15, 1968. Washington, D.C.: Archives of American Art.

Rowell, Margit. "Interview with Charmion von Wiegand June 20, 1971." *Piet Mondrian.* New York: The Solomon R. Guggenheim Museum, 1971, pp. 77–86.

Film

The Circle of Charmion von Wiegand, 1978. Narrated by Ce Roser; produced by Fay Lanser.

On the Artist

Selected Articles

Rembert, Virginia Pitts. "Charmion von Wiegand's Way Beyond Mondrian." *Woman's Art Journal* (Knoxville, Tenn.), Fall 1983/Winter 1984, pp. 32–33.

Larsen, S. C. "Charmion von Wiegand: Walking on a Road with Milestones." *Arts Magazine* (New York), Nov. 1985, pp. 29–31.

Krane, Susan. "Charmion von Wiegand: The Wheel of the Seasons." *Albright-Knox Art Gallery/The Painting and Sculpture Collection: Acquisitions since 1972.* New York: Hudson Hills Press in association with Albright-Knox Art Gallery, 1987, pp. 356–57.

Selected One-Artist Exhibitions and Reviews

The Pinacotheca, New York. *Charmion Wiegand,* Apr. 21–May 10, 1947.

B[renning], M[argaret]. "Charmion von Wiegand." *Art Digest* (New York), Jan. 1, 1948, pp. 20–21.

Rose Fried Gallery, New York. Title and exact dates unknown, 1948.

Saidenberg Gallery, New York. *Charmion von Wiegand,* Apr. 22–May 24, 1952.

Zoe Dusanne Gallery, Seattle. Titles and exact dates unknown for exhibitions in 1954, 1955, and 1958.

John Heller Gallery, New York. *Charmion von Wiegand: Paintings,* Jan. 2–21, 1956.

Porter, Fairfield. "Reviews and Previews." *Art News* (New York), Jan. 1956, p. 55.

Rose Fried Gallery, New York. *Charmion von Wiegand,* Dec. 12–31, 1956.

Howard Wise Gallery, New York. Titles and exact dates unknown for exhibitions in 1961 and 1963.

Richard Gray Gallery, Chicago. *Charmion von Wiegand: Paintings, Drawings and Collages,* Apr. 6–May 2, 1964.

James Goodman Gallery, Buffalo. *Charmion von Wiegand: Gouache and Collage,* Feb. 16–29, 1964.

Howard Wise Gallery, New York. Title unknown, Apr. 27–May 15, 1965.

The University of Texas Art Museum, Austin. *Charmion von Wiegand: Oils, Gouaches, Collages,* Sept. 21–Oct. 22, 1969.

Birmingham Art Museum, Alabama. Title and exact dates unknown, 1970.

Galleria Fiamma Vigo, Rome and Venice. Title and exact dates unknown, 1973.

JOSEF ALBERS

Annely Juda Fine Art, London. *Charmion von Wiegand: Retrospective*, May 29–June 29, 1974. Cat.

Noah Goldowsky, Inc., New York. *Charmion von Wiegand: Collages*, Mar. 25–May 3, 1975.

Bell, Jane. "Charmion von Wiegand." *Arts Magazine* (New York), June 1975, p. 27.

André Zarre Gallery, New York. Title and exact dates unknown, 1975.

André, Michael. "Reviews and Previews." *Art News* (New York), Dec. 1975, p. 120.

Frank, Peter. "Reviews." *Art in America* (New York), Mar. 1976, p. 110.

André Zarre Gallery, New York. Title and exact dates unknown, 1977.

Zucker, Barbara. "Reviews and Previews." *Art News* (New York), May 1977, p. 136.

Marilyn Pearl Gallery, New York. *Charmion von Wiegand: Thirty Years of Collage*, Oct. 31–Nov. 25, 1978.

Schwab, C. "Charmion von Wiegand." *Arts Magazine* (New York), Dec. 1978, p. 11.

Marilyn Pearl Gallery, New York. *Charmion von Wiegand and Her Circle*, Mar. 5–Apr. 4, 1981. Brochure.

Marilyn Pearl Gallery, New York. *Charmion von Wiegand: Retrospective Exhibition 1945–1965*, May 1–June 1, 1985.

Birmelin, B. T. "Reviews." *Art in America* (New York), Oct. 1985, p. 154.

By the Artist

Writings

Introduction to *Catalogue of Black Mountain College Summer Art Institute* (Asheville, N.C.), 1945, page unknown.

"Abstract-Presentational." In *American Abstract Artists*. New York: Ram Press, 1946, pp. [63–64].

"Present and/or Past." *Design* (Columbus, Ohio), Apr. 1946, pp. 16–17.

"Letter to the Editor." *Art News* (New York), May 1948, p. 6.

"Modular Brick Wall Partition." In Eleanor Bitterman, *Art in Modern Architecture*. New York: Reinhold, 1952, pp. 148–49.

"Color is the most relative medium in art." Mimeographed statement in *New Work by Josef Albers*. New York: Sidney Janis Gallery, Jan. 7–26, 1952.

Drawings. New York: Wittenborn, 1956. German edition, *Zeichnungen*. Bern: Spiral Press, 1956.

Poems and Drawings. New Haven: The Readymade Press, 1958. Revised and enlarged edition, with bilingual text. New York: George Wittenborn, 1961.

"Homage to the Square." *Art News* (New York), Oct. 1961, pp. 26–27.

"The Yale School—Structural Sculpture." *Art in America* (New York), vol. 49, no. 3, 1961, p. 75.

Structural Constellations. New York: George Wittenborn, 1961.

Homage to the Square. New Haven: Ives-Sillman, 1962.

"The Interaction of Color." *Art News* (New York), Mar. 1963, pp. 33–35, 56–59.

Interaction of Color. New Haven: Yale University Press, 1963. Reprinted, 1971. German edition, Cologne: Verlag M. DuMont Schauberg, 1970.

"Op Art and/or Perceptual Effects." *The Yale Scientific Magazine* (New Haven), Nov. 1965, pp. 1–6.

"My Courses at the Hochschule für Gestaltung at Ulm." *Form* (Cambridge, England), Apr. 1967, pp. 8–10.

"Selected Writings." *Origin* (Kyoto), Jan. 1968, pp. 21–32.

Search Versus Re-Search: Three Lectures by Josef Albers at Trinity College, April 1965. Hartford: Trinity College Press, 1969.

Josef Albers. Formulation: Articulation. New York: Harry N. Abrams, and New Haven: Ives-Sillman, 1972.

Interviews

Reilly, Maude. "The Digest Interviews: Josef Albers." *Art Digest* (New York), Jan. 15, 1945, p. 15.

Chaet, Bernard. "Color is Magic: Interview with Josef Albers." *Arts* (New York), May 1958, pp. 66–67.

O'Doherty, Brian. "Invitation to Art." *Museum of Fine Arts* (Boston), Apr. 25, 1960. Taped interview.

Sjöberg, Leif. "Fragen an Josef Albers." *Das Kunstwerk* (Baden-Baden), Apr.–May 1961, pp. 55–59.

Kuh, Katharine. *The Artist's Voice: Talks with Seventeen Artists*. New York: Harper and Row, 1962, pp. 11–22.

Welliver, Neil. "Albers on Albers." *Art News* (New York), Jan. 1966, pp. 48–51, 68–69.

Holloway, John H. and John A. Weil. "A Conversation with Josef Albers." *Leonardo* (Oxford), Oct. 1970, pp. 459–64.

On the Artist

Books

Schreyer, Lothar. *Erinnerungen an Sturm und Bauhaus*. Munich: Langen-Müller, 1956.

Bucher, François. *Josef Albers: Despite Straight Lines; An Analysis of His Graphic Constructions*. Captions by Josef Albers. New Haven: Yale University Press, 1961. Revised and enlarged edition, Cambridge, Mass., and London: MIT Press, 1977. German edition, *Trotz der Geraden*. Bern: Bentel Verlag, 1961.

Wingler, Hans M. *Das Bauhaus: 1919–1933, Weimar, Dessau, Berlin*. Bramsche: Gebr. Rasch and Cologne: Verlag M. DuMont Schauberg, 1962.

Gomringer, Eugen. *Josef Albers*. New York: George Wittenborn, 1968.

Spies, Werner. *Albers*. New York: Harry N. Abrams, 1970.

Wissman, Jürgen. *Josef Albers*. Recklinghausen: Verlag Aurel Bongers, 1971.

Moynihan, J. P. "The Influence of the Bauhaus on Art and Art Education in the United States." Ph.D. diss., Northwestern University, 1980.

Benezra, Neal. "The Murals and Sculpture of Josef Albers." Ph.D. diss., Stanford University, 1983. Published in revised form, New York and London: Garland, 1985.

Weber, Nicholas Fox. *The Drawings of Josef Albers*. New Haven and London: Yale University Press, 1985.

Selected Articles

De Kooning, Elaine. "Albers Paints a Picture [*Homage to the Square*]." *Art News* (New York), Nov. 1950, pp. 40–43, 57–58.

Göpel, Erhard. "Der Bauhaus-Meister Josef Albers." *Süddeutsche Zeitung* (Munich), Jan. 16–17, 1954, page unknown.

"Optical Tricks Train Yale Artists." *Life* (New York), Mar. 26, 1956, pp. 71–72, 75–76.

Loew, Michael. "Albers: Impersonalization in Perfect Form." *Art News* (New York), Apr. 1956, pp. 28–29.

"Think." *Time* (New York), June 18, 1956, pp. 80–83.

Charlot, Jean. "Nature and the Art of Albers." *College Art Journal* (New York), vol. 15, no. 3, 1956, pp. 190–96.

Hamilton, George H. "Unconditioned: Homage to the Square. Josef Albers." *Bulletin of the Associates in Fine Arts* (New Haven), Feb. 1957, pp. 14–15.

Henze, Anton. "Josef Albers." *Baukunst und Werkform* (Heidelberg), vol. 10, no. 10, 1957, pp. 604–6.

Grohmann, Will. [Tribute to Josef Albers on his Seventieth Birthday]. *Frankfurter Allgemeine Zeitung* (Frankfurt), Mar. 19, 1958. Reprinted in *Yale University Art Gallery Bulletin* (New Haven), Oct. 1958, pp. 26–27 and *Museumjournaal* (Otterlo), Apr.–May 1961, pp. 212–14, 232–33.

"Salute to Albers." International Issue, *Yale Literary Magazine* (New Haven), 1958. See also "Arts at Yale." *Yale Alumni Magazine* (New Haven), Apr. 1958, page unknown.

Rhodes, Richard. "Profile: Josef Albers, Teacher and Artist." *Yale Daily News* (New Haven), Apr. 25, 1958, page unknown.

Bill, Max. "Josef Albers." *Werk* (Bern), Apr. 1958, pp. 135–38.

Meyer-Waldeck, Wera. "Dank an Josef Albers: Zu Seinem 70. Geburtstag." *Werk und Zeit* (Dusseldorf), vol. 7, no. 12, 1958, page unknown.

"Cheating Art Lovers Makes Life Exciting for Albers." *New Haven Register*, Feb. 22, 1959, page unknown.

Tillim, Sidney. "What Happened to Geometry?" *Arts* (New York), June 1959, pp. 38–44.

Huxtable, Ada Louise. [Review of mural in the Corning Glass Works Building, New York.] *The New York Times*, Sept. 13, 1959, page unknown.

Kepes, Gyorgy, ed. "The Visual Arts Today." *Daedalus* (Cambridge, Mass.), Winter 1960, p. 105.

Feininger, T. Lux. "The Bauhaus: Evolution of an Idea." *Criticism* (Detroit), Summer 1960, pp. 260–77.

Lohse, Richard B. "Josef Albers 'City' 1928," *Zürcher Kunstgesellschaft Jahresbericht* (Zurich), 1960, pp. 53–56.

[Article on Albers's mural in the Time-Life Building, New York.] *Yale Daily News* (New Haven), Mar. 15, 1961, page unknown.

Hopkins, H. T. "Homage to The Square II: Josef Albers." *Los Angeles Museum Art Bulletin*, vol. 14, no. 1, 1962, pp. 3–9.

Yamawaki, I. & M. "The World of Josef Albers." *Graphic Design* (Tokyo), no. 11, 1963, pp. 8–17, 31.

Hopkins, Henry. "Josef Albers." *Artforum* (San Francisco), Feb. 1964, p. 26.

Robbins, Daniel and Eugenia. "Josef Albers. Art is Looking at Us." *Studio International* (London), Feb. 1964, pp. 54–57.

Welliver, Neil. "Albers on Albers." *Art News* (New York), Jan. 1966, pp. 48–51, 68–69.

Finkelstein, Irving. "Albers' Graphic Tectonics, from a Doctoral Dissertation on 'The Life and Art of Josef Albers'." *Form* (Cambridge, Eng.), no. 4, 1967, pp. 10–14.

Hunter, Sam. "Josef Albers: Prophet and Presiding Genius of American Op Art." *Vogue* (New York), Oct. 15, 1970, pp. 70–73, 126–27.

Shapiro, D. "Homage to Albers." *Art News* (New York), Nov. 1971, pp. 30–33, 96–97.

Rowell, Margit. "On Albers' Color." *Artforum* (New York), Jan. 1972, pp. 26–37.

Gibbs, M. L. "Albers and Stella." *Record of the Art Museum, Princeton University*, vol. 31, pt. 1, 1972, pp. 8–11.

"Josef Albers Enseignant." *Art Press International* (Paris), Mar.–Apr. 1973, pp. 10–11.

Hermann, R. D. "Josef Albers." *Journal of Aesthetic Education* (Springfield, Ill.), Apr. 1974, pp. 65–72.

Enckell, C. "Johdatus Käsitteeseen Josef Albers." *Taide* (Helsinki), vol. 15, pt. 2, 1974, pp. 28–30, 58.

Geldzahler, Henry. "Josef Albers (1888–1976): Homage to Man the Maker." *Art News* (New York), May 1976, p. 76.

Broos, K. "Josef Albers 1888–1976: Twee Brieven en een Bijlage." *Museumjournaal* (Otterlo), June 1976, pp. 126–30.

Miller, J. "Josef Albers and His Prints: Notes from the 1960s." *Print Review* (New York), no. 6, 1976, pp. 76–80.

Marrommatis, E. "Albers: perception et intelligibilité. *XXe Siècle* (Paris), Dec. 1978, pp. 70–71.

Goldstein, C. "Teaching Modernism: What Albers Learned in the Bauhaus and Taught to Rauschenberg, Noland, and Hesse." *Arts Magazine* (New York), Dec. 1979, pp. 108–16.

Elsen, Albert E. "A 'Stunning Presence' at Stanford." *Art News* (New York), Jan. 1981, pp. 64–65.

Lee, A. "A Critical Account of Some of Josef Albers' Concepts of Color." *Leonardo* (Oxford, Eng.), Spring 1981, pp. 99–105.

Krane, Susan. "Josef Albers: Structural Constellation FME #3, 1962." *Albright-Knox Art Gallery, The Painting and Sculpture Collection: Acquisitions Since 1972*. New York: Hudson Hills Press, 1987, p. 42.

Selected One-Artist Exhibitions and Reviews

For a listing of exhibitions prior to 1945, see *Josef Albers: A Retrospective*. New York: The Solomon R. Guggenheim Museum, 1988.

Drake University, Des Moines. *Josef Albers*, dates unknown, 1945.

[Review in] *Des Moines Tribune*, Jan. 23, 1945, page unknown.

New Art Circle, J. B. Neumann, New York. *Josef Albers*, Jan. 2–17, 1945. Cat.
 [Review in] *The New York Times*, Jan. 7, 1945, page unknown.
 [Review in] *Art News* (New York), Jan. 15–31, 1945, p. 28.

University Gallery, Minneapolis. *Josef Albers*, dates unknown, 1946.
 [Review in] *The Minnesota Daily* (Minneapolis), Oct. 2, 1946, page unknown.

Hollins College, Roanoke, Virginia. *Oils by Josef Albers*, Feb. 1946.

Memphis Academy of Arts, Tennessee. *Twenty-five Paintings by Josef Albers*, Jan. 15–28, 1947. Cat.

Philadelphia Art Alliance. *Five American Printmakers*, Feb. 11–Mar. 16, 1947. Cat.

California Palace of the Legion of Honor, San Francisco. *Josef Albers: Oils, Lithography, Woodcuts*, Aug. 24–Sept. 24, 1947.
 [Review in] *San Francisco Chronicle*, Sept. 28, 1947, page unknown.

Cranbrook Academy, Bloomfield Hills, Michigan. *Josef Albers: Paintings*, Feb. 1948.

Egan Gallery, New York. *Albers: Paintings in Black, Grey, White*, and Sidney Janis Gallery, New York, *Albers: Paintings Titled 'Variants,'* Jan. 24–Feb. 12, 1949.
 [Review in] *Time* (New York), Jan. 31, 1949, p. 37.
 Lowengrund, Margaret. "Variations on Albers." *Art Digest* (New York), Feb. 1, 1949, p. 14.
 Greenberg, Clement. "Albers Exhibition." *The Nation* (New York), Feb. 19, 1949, pp. 221–22.
 De K[ooning], E[laine]. "Albers." *Art News* (New York), Feb. 1949, pp. 18–19.

Cincinnati Art Museum. *Josef Albers*. Oct. 27–Nov. 22, 1949. Cat., text by Edward H. Dwight.
 [Reviews in] *The Cincinnati Times Star*, Sept. 1, 1949; Nov. 14, 1949, pages unknown.
 [Review in] *The Cincinnati Post*, Nov. 1, 1949, page unknown.
 [Review in] *The Cincinnati Enquirer*, Nov. 11, 1949, page unknown.
 [Review in] *The Courier Journal* (Louisville), Nov. 13, 1949, page unknown.

The Northeon, Easton, Pennsylvania. *Josef Albers*, Nov. 1–30, 1949.
 McGiffert R. [Review in] *Easton Express*, Nov. 29, 1949, p. 16.

Contemporary House, Dallas. Title unknown, Nov. 1949.
 [Review in] *The Dallas Morning News*, Nov. 17, 1949, page unknown.

Yale University Art Gallery, New Haven, Connecticut. *Paintings by Josef Albers*, Dec. 7, 1949–Jan. 30, 1950.

Allen R. Hite Art Institute, University of Louisville, Kentucky. *Josef Albers: 1931–1948*, Apr. 17–May 27, 1950. Cat., text by Creighton Gilbert.
 Bier, Justus K. [Review in] *The Courier Journal* (Louisville), May 14, 1950, page unknown.

Sidney Janis Gallery, New York. *Albers: Homage to the Square—Transformation of a Scheme*, Jan. 7–26, 1952.
 [Review in] *Christian Science Monitor* (Boston), Jan. 12, 1952, page unknown.

University Fine Arts Gallery, Albuquerque. *Josef Albers*, Feb. 1953.
 [Review in] *New Mexico Quarterly* (Albuquerque), Winter 1953, page unknown.

Essex Art Association, Connecticut. *Josef Albers*, June 12–28, 1953.

[Review in] *The Middletown Press* (Conn.), June 15, 1953, page unknown.

San Francisco Museum of Art. *Paintings by Josef Albers*, Nov. 4–22, 1953.
 Frankenstein, Alfred. "Josef Albers Shows What Thinking and Planning Will Do for Art." *San Francisco Chronicle*, Nov. 22, 1953, page unknown.

Sidney Janis Gallery, New York. *Acting Colors: Albers*, Jan. 31–Feb. 26, 1955.

Hayden Gallery, Massachusetts Institute of Technology, Cambridge. *Josef Albers*, Mar. 6–27, 1955.

Yale University Art Gallery, New Haven, Connecticut. *Josef Albers: Paintings, Prints, Projects*, Apr. 25–June 18, 1956. Cat., text by George Heard Hamilton.
 Loew, Michael. "Albers: Impersonalization in Perfect Form." *Art News* (New York), Apr. 1956, pp. 28–29, 94–95.
 "Think." *Time* (New York), June 18, 1956, pp. 80–83.
 McHale, John. "Josef Albers." *Architectural Design* (London), June 1956, p. 205.

Karl-Ernst-Osthaus-Museum, Hagen, West Germany. *Josef Albers*, Jan. 20–Feb. 17, 1957.
 [Review in] *Das Kunstwerk* (Baden-Baden), Jan.–Feb. 1957, p. 54.
 [Review in] *Werk und Zeit* (Dusseldorf), no. 2, 1957, pp. 2–3.

Staatliche Werkkunstschule/Kunstsammlung Kassel, West Germany. *Josef Albers*, May 28–June 8, 1957.

Schlosschen Bellevue, Kassel, West Germany. [*Josef Albers Works of the 1920's and New Works*], May 28–June 8, 1957.

Museum der Stadt, Ulm, West Germany. *Josef Albers*, Sept. 8–Oct. 6, 1957.
 "Zeichnungen." *Werk* (Bern), Sept. 1957, p. 171.

Galerie Denise René, Paris. *Albers*. Oct.–Nov. 1957. Cat., texts by Josef Albers, Jean Arp, Will Grohmann, and Franz Roh.

Kunstverein Freiburg im Breisgau, West Germany. *Josef Albers*, Mar. 16–Apr. 13, 1958.
 Binder-Hagelstange, Ursula. "Farben machen Räume." *Frankfurter Allgemeine Zeitung*, Mar. 25, 1958, p. 7.

Sidney Janis Gallery, New York. *Albers, 70th Anniversary*, Mar. 24–Apr. 19, 1958.
 Kramer, Hilton. "Recent Paintings at the Sidney Janis Gallery." *Arts* (New York), Apr. 1958, pp. 52–53.
 Chaet, Bernard. "Color is Magic: Interview with Josef Albers." *Arts* (New York), May 1958, pp. 66–67.

Verkehrsverein, Bottrop, West Germany. [*Josef Albers Retrospective*], May 20–27, 1958.
 [Review in] *Bottroper Standanzeiger* (Bottrop), May 17, 1958, page unknown.
 [Review in] *Bottroper Stadt-Chronik* (Bottrop), May 21, 1958, page unknown.

The Contemporaries, New York. *Josef Albers: Inkless Intaglios*, Jan. 26–Feb. 7, 1959.
 [Review in] *Time* (New York), Feb. 16, 1959, page unknown.
 [Review in] *The New York Times*, Jan. 27, 1959, page unknown.
 [Review in] *New York Herald Tribune*, Jan. 31, 1959, page unknown.

Sidney Janis Gallery, New York. *Homage to the Square*, Nov. 30–Dec. 26, 1959.
 S[chuyler], J[ames]. "Reviews and Previews." *Art News* (New York), Dec. 1959, p. 16.
 Judd, Donald. "Exhibition at the Janis Gallery." *Arts* (New York), Dec. 1959, pp. 56–57.
 Genauer, Emily. [Review in] *New York Herald Tribune*, Dec. 6, 1959, page unknown.

Galerie Suzanne Bollag, Zurich. *Josef Albers*, Jan. 6–30, 1960.

Staber, Margit. "Josef Albers." *Schwabische Donau-Zeitung* (Ulm), Jan. 14, 1960, page unknown.

Schmidt, G. [Review in] *Werk* (Bern), Mar. 1960, p. 50.

Stedelijk Museum, Amsterdam. *Albers*, June–July 1961. Cat., texts by Will Grohmann, Hans Arp, and the artist. Circulating exhibition.

Galleria La Palma, Locarno. *Josef Albers*, July 31–Aug. 21, 1961. Cat.

Sidney Janis Gallery, New York. *Recent Paintings by Josef Albers*, Oct. 2–28, 1961. Cat.

O'Doherty, Brian. "Dialectic of the Eye." *The New York Times*, Oct. 3, 1961, p. 44.

H[ess], T[homas] B. "Homage to the Square, the Nude." *Art News* (New York), Oct. 1961, pp. 26–27.

The Solomon R. Guggenheim Museum, New York. *American Abstract Expressionists and Imagists*, Oct. 13–Dec. 31, 1961. Cat., text by H. H. Arnason.

North Carolina Museum of Art, Raleigh. *Josef Albers*, Feb. 3–Mar. 11, 1962. Cat., texts by Justus Bier, B. F. Williams, Will Grohmann, and the artist.

Pace Gallery, Boston. *Josef Albers at the Pace Gallery*, Nov. 5–24, 1962.

Driscoll, Edgar, Jr. "This Week in the Art World." *The Boston Sunday Globe*, Nov. 18, 1962, p. 60.

Museum Folkwang, Essen, West Germany. *Josef Albers*, Feb. 6–Mar. 3, 1963. Cat., with statements by François Bucher, Jürgen Morschel, Margit Staber, and the artist.

Sidney Janis Gallery, New York. *Albers*, Mar. 4–30, 1963.

Dallas Museum of Fine Arts. *The Interaction of Color and Paintings by Josef Albers*, Apr. 30–May 26, 1963. Circulating exhibition.

Galerie Buren, Stockholm. *Josef Albers*, Jan.–Feb. 1964.

Smith College Museum of Art, Northampton, Massachusetts. *An Exhibition of the Work of Josef Albers*, Feb. 5–23, 1964. Cat., text by Charles Chetham.

Wilhelm-Morgner Haus, Westfalen, West Germany. *Albers*, Feb. 15–Mar. 1, 1964.

Sidney Janis Gallery, New York. *Albers: Homage to the Square*, Sept. 28–Oct. 24, 1964.

Genauer, Emily. "Cleansed Perceptions of Hopper and Albers." *New York Herald Tribune*, Oct. 4, 1964, p. 27.

Preston, Stuart. "A Square World." *The New York Times*, Oct. 4, 1964, pp. x–21.

International Council, The Museum of Modern Art, New York, organizer. *Josef Albers: Homage to the Square*, 1964. Cat., texts by Kynaston L. McShine and the artist. Circulating exhibition.

Galerie Gimpel Hanover, Zurich. *Josef Albers: Homage to the Square*, June 23–Aug. 7, 1965. Cat., texts by Margit Staber and the artist. Circulating exhibition.

The Washington Gallery of Modern Art, Washington, D.C. *Josef Albers: The American Years*, Oct. 30–Dec. 31, 1965. Cat., text by Gerald Nordland.

"Washington: Albers and the Current Generation." *Arts* (New York), Dec. 1965, pp. 34–35.

Welliver, Neil. "Albers on Albers" (interview). *Art News* (New York), Jan. 1966, pp. 48–51, 68–69.

Frankenstein, Alfred. "Homage to the Square." *San Francisco Chronicle*, May 31, 1966, p. 53.

Galeria de Arte Mexicano, Mexico City. *Homenaje a Josef Albers*, Aug. 9–Sept. 7, 1966.

Los Angeles County Museum of Art. *Josef Albers: White Line Squares*, Oct. 26, 1966–Jan. 29, 1967. Cat.,

texts by Henry Hopkins, Kenneth E. Tyler, and the artist.

Galerie Wilbrand, Munster, West Germany. [*Albers at Galerie Wilbrand*], Mar.–Apr. 1967.

Galerie Denise René, Paris. *Albers*, Mar.–Apr. 1968. Cat., texts by Jean Clay and Max Imdahl.

Selz, Guy. "Deux Galeries rendent hommage au 'carré'." *Elle* (Paris), Apr. 4, 1968, p. 25.

Sidney Janis Gallery, New York. *New Paintings by Josef Albers*, Apr. 10–May 4, 1968.

Westfalisches Landesmuseum für Kunst und Kulturgeschichte, Münster, West Germany. *Albers*, Apr. 28–June 2, 1968. Cat., texts by Will Grohmann, Jürgen Wissmann, and the artist. Circulating exhibition.

Lober, Hermann. "Null Punkt für neue Ordnungen." *Munstersche Zeitung* (Munster), Apr. 27, 1968, page unknown.

Kestner-Gesellschaft Hanover, West Germany. *Josef Albers: Zu Seinem 80. Geburtstag*, May 15–June 9, 1968. Cat., texts by Justus Bier and Hans Arp.

Galerie Thomas, Munich. *Look at Albers*, Oct. 1969.

Artestudio Macerata, Milan. *Albers*, Mar. 1970.

Städtische Kunsthalle Düsseldorf. *Josef Albers*, Sept. 4–Oct. 4, 1970. Cat., texts by Werner Spies, Max Imdahl, Eugen Gomringer, Jürgen Wissmann, Max Bill, Buchminster Fuller, and Robert le Ricolais; poems by the artist.

Catoir, Barbara. "Josef Albers' Works of Color and Vexation Shown at Düsseldorf." *The German Tribune* (Hamburg), Oct. 1, 1970, page unknown.

Sidney Janis Gallery, New York. *Paintings by Josef Albers*, Oct. 5–31, 1970.

Kramer, Hilton. "Taeuber—Arp and Albers: Loyal Only to Art." *The New York Times*, Oct. 18, 1970, p. D23.

Princeton University Art Museum, New Jersey. *Josef Albers Paintings and Graphics, 1915–1970*, Jan. 5–26, 1971. Cat., texts by Neil A. Chassman, Hugh M. Davies, Mary Laura Gibbs, and Sam Hunter.

Davis, Douglas. "Man of a Thousand Squares." *Newsweek* (New York), Jan. 18, 1971, pp. 77–78.

The Metropolitan Museum of Art, New York. *Josef Albers at the Metropolitan Museum of Art*, Nov. 1971–Jan. 11, 1972. Cat., text by Henry Geldzahler.

Spies, Werner. "Nach einem Wimpernschlag: Neues, fremdes." *Frankfurter Allgemeine Zeitung* (Frankfurt), Dec. 31, 1971, p. 27.

Rose, Barbara. "The Return of the Image." *Vogue* (New York), Jan. 17, 1972.

Strand, Mark. "Principles of Paradox, Josef Albers: Master Illusionist at the Metropolitan." *Saturday Review* (New York), Jan. 29, 1972, pp. 52–53.

Pollock Gallery, Toronto. *Josef Albers*, Sept. 28–Oct. 20, 1972.

Kestner Gesellschaft, Hanover, West Germany. *Josef Albers*, Jan.–Feb. 11, 1973. Cat., texts by Wieland Schmid and the artist.

Rathaus der Stadt Bottrop, West Germany. *Albers in Bottrop*, Mar. 18–Apr. 15, 1973. Cat., text by Jürgen Wissmann.

Galerie Beyeler, Basel. *Josef Albers*, Mar.–Apr. 1973. Cat., texts by Thomas B. Hess, Werner Spies, Wieland Schmied, Will Grohmann, and Jean Arp.

Galerie Gmurzynska, Cologne, West Germany. *Josef Albers*, Sept. 12–Oct. 25, 1973. Cat., texts by Jasper Johns and Thomas B. Hess.

Art Gallery of York University, Downsview, Canada. *Homage to Josef Albers*, Oct. 26–Nov. 16, 1973. Cat., text by Michael Greenwood; statements by the artist.

Galerie Melki, Paris. *Albers*, Nov. 13–Dec. 8, 1973. Cat., texts by Max Imdahl, Karl Ruhrberg, and Werner Spies.

The American Academy and Institute of Arts and Letters, New York. *Josef Albers, Leonid Burman, Mark Tobey*, Mar. 14–Apr. 30, 1977.

Yale University Art Gallery, New Haven, Connecticut. *Paintings by Josef Albers*, Feb. 22–Mar. 26, 1978. Cat., texts by Alan Shestack, Jean Arp, Fronia Wissman, and Gene Baro; statements by the artist.

Galerie Christel, Stockholm. [*Albers-Paintings*], Jan.–Feb. 1980.

Moderne Galerie Bottrop, West Germany. *Josef Albers: Werke aus dem Besitz der Stadt Bottrop*, Dec. 17, 1980–Feb. 6, 1981.

Montclair Art Museum, New Jersey. *Josef Albers: His Art and His Influence*, Nov. 15, 1981–Jan. 17, 1982. Cat., texts by Robert J. Koenig, Alan Shestack, and Nicholas Fox Weber; statement by the artist.

Shirey, David L. "The Many Legacies of Josef Albers." *The New York Times*, Jan. 10, 1982, p. XI–26.

Goethe House, New York. *Josef Albers: Graphics and Paintings*, May 3–June 11, 1983.

Sidney Janis, New York. *Commemorative Exhibition of Paintings by Albers*, Oct. 4–Nov. 3, 1984. Cat., text by Nicholas Fox Weber.

Raynor, Vivien. [Review in] *The New York Times*, Oct. 19, 1984, pp. 111–30.

Margo Leavin Gallery, Los Angeles. *Josef Albers*, Jan. 8–Feb. 9, 1985.

Muchnic, Suzanne. [Review in] *Los Angeles Times*, Jan. 18, 1985, p. IV–16.

Gimpel Fils Gallery, London. *Josef Albers: Homage to the Square*, May 8–June 1, 1985.

Overy, Paul. "Josef Albers." *Art Monthly* (London), June 1985, pp. 8–9.

Sidney Janis, New York. *Exhibition of Works in All Media by Josef Albers*, Feb. 1–Mar. 1, 1986. Cat., text by Kelly Feeney.

Raynor, Vivien. *The New York Times*, Feb. 28, 1986, p. III–21.

Gibson, Eric. "Josef Albers: In the Engine Room of Modern Art." *The New Criterion* (New York), Apr. 1986, pp. 34–41.

Satani Gallery, Tokyo. *Josef Albers: Homage to the Square*, Apr. 4–26, 1986.

Galerie Hans Strelow, Dusseldorf. *Josef Albers: Homage to the Square/Bilder aus dem Nachlass*, Feb. 19–Mar. 28, 1987.

Galerie Denise René, Paris. *Albers*, May 14–July 15, 1987.

Dobbels, Daniel. "Albers carrément bon." *Liberation* (Paris), June 26, 1987, p. 26.

Pélz-Audan, Annick. "Hommage au carré: Albers ou l'ambiguité." *Cimaise* (Paris), Summer 1987, pp. 99–100.

The American Federation of Arts, New York, organizer. *The Photographs of Josef Albers: A Selection from the Collection of the Josef Albers Foundation*, 1987. Cat., text by John Szarkowski.

The Solomon R. Guggenheim Museum, New York. *Josef Albers: A Retrospective*, Mar. 25–May 29, 1988. Cat., text by Nicholas Fox Weber.

Grimes, Nancy. "Josef Albers: The Modest Master." *Art News* (New York), Summer 1988, p. 177.

AD REINHARDT

By the Artist

Writings

"Reinhardt Paints a Picture." *Art News* (New York), Mar. 1965, pp. 39–41.

"The Artists Say . . . Ad Reinhardt: 39 Art Planks." *Art Voices* (New York), Spring 1965, pp. 86–87.

"Art vs. History: *The Shape of Time*, by George Kubler." *Art News* (New York), Jan. 1966, pp. 19, 61–62.

"Three Statements." *Artforum* (New York), Mar. 1966, pp. 34–35.

"Art in Art Is Art as Art." *Lugano Review*, Summer 1966, page unknown.

"Black." *Artscanada* (Toronto), Oct. 1967, pp. 2–19.

"Ad Reinhardt on His Art." *Studio International* (London), Dec. 1967, pp. 265–68.

Fuller, Mary. "Ad Reinhardt Monologue." *Artforum* (New York), Oct. 1970, pp. 36–41.

"The Prize: An Exchange of Letters between Ajoy and Reinhardt." *Art in America*, Nov.–Dec. 1971, pp. 106–9.

Art as Art: The Selected Writings of Ad Reinhardt, edited, with an introduction, by Barbara Rose. New York: Viking Press, 1975.

Masheck, Joseph. "Five Unpublished Letters from Ad Reinhardt to Thomas Merton and Two in Return." *Artforum* (New York), Dec. 1978, pp. 23–27.

Interview

Glaser, Bruce. "Interview with Ad Reinhardt." *Art International* (Lugano), Dec. 20, 1966, pp. 18–21.

On the Artist

Books

Kosuth, Joseph and Kozlov, Christine. "Ad Reinhardt: Evolution into Darkness—The Art of an Informal Formalist: Negativity, Purity, and the Clearness of Ambiguity." Mimeographed. New York: School of Visual Arts, 1966.

Warner, Beverly June. "A Psychological-Historical Investigation of the Interrelationships of the Arts as Seen in the Painting 'Ultimate Painting No. 19' (1953–1960) by Ad Reinhardt and the Musical Composition 'Filigree Setting for String Quartet' by Mel Powell." Ph.D. diss., Ohio University, 1969.

Hess, Thomas B. *The Art Comics and Satire of Ad Reinhardt*. Dusseldorf: Kunsthalle and Rome: Marlborough Galerie, 1975.

Schjeldahl, Peter. *Ad Reinhardt: Art Comics and Satires*. New York: Truman Gallery, 1976.

Lippard, Lucy. *Ad Reinhardt*. New York: Harry N. Abrams, 1981.

Selected Articles

Sowers, Robert. "Art and the Temptation of Ad Reinhardt." *ARC directions*, June 1966, pp. 3–4, 6.

Rose, Barbara. "Reinhardt." *Vogue* (New York), Nov. 1, 1966, p. 183.

Kramer, Hilton. "Ad Reinhardt's Black Humor." *The New York Times*, Nov. 27, 1966, page unknown.

Michelson, Annette. "Ad Reinhardt or the Artist as Artist." *Harper's Bazaar* (New York), Nov. 1966, pp. 176, 223.

Rosenstein, Harris. "Black Pastures." *Art News* (New York), Nov. 1966, pp. 33–35, 72–73.

Smithson, Robert. "Quasi-infinities and the Wanting of Space." *Arts Magazine* (New York), Nov. 1966, pp. 26–31.

Sandler, Irving. "Reinhardt: The Purist Backlash." *Artforum* (New York), Dec. 1966, pp. 40–47.

McShine, Kynaston. "More than Black." *Arts* (New York), Dec. 1966–Jan. 1967, pp. 49–50.

Bourdon, David. "Master of the Minimal." *Life* (New York), Feb. 3, 1967, pp. 45–52.

Ashton, Dore. "New York Commentary." *Studio International* (London), Feb. 1967, pp. 98–100.

Kramer, Hilton. "Ad Reinhardt's Quest." *The New York Times*, Sept. 10, 1967, pp. 41–42.

Hess, Thomas B. "Ad (Adolph Dietrich Friedrich) Reinhardt." *Art News* (New York), Oct. 1967, p. 23.

Lippard, Lucy. "Ad Reinhardt: 1913–1967." *Art International* (Lugano), Oct. 1967, p. 19.

Stella, Frank. "A Tribute to Ad Reinhardt." *Artscanada* (Toronto), Oct. 1967, p. 2.

Special section on Ad Reinhardt. *Studio International* (London), Dec. 1967, pp. 245–73.

Denny, Robyn. "Ad Reinhardt, an Appreciation." *Studio International* (London), Dec. 1967, p. 264.

Kallick, Phyllisann. "Ad Reinhardt on His Art." *Studio International* (London), Dec. 1967, pp. 269–73.

Smithson, Robert. "A Museum of Language in the Vicinity of Art." *Art International* (Lugano), Mar. 1968, pp. 21–27.

Müller, Grégoire. "After the Ultimate." *Arts* (New York), Mar. 1970, pp. 28–31.

Kozloff, Max. "Andy Warhol and Ad Reinhardt: The Great Acceptor and the Great Demurer." *Studio International* (London), Mar. 1971, pp. 113–17.

Millet, Catherine. "Ad Reinhardt par Ad Reinhardt." *Art Press* (Paris), May–June 1973, pp. 4–7.

"Ad Reinhardt: Writings." In *The New Art, A Critical Anthology*, edited by Gregory Battcock. New York: Dutton, 1973, pp. 167–77.

Hess, Thomas B. "The Art Comics of Ad Reinhardt." *Artforum* (New York), Apr. 1974, pp. 46–51.

Kuspit, Donald. "Ad Reinhardt." *Art in America* (New York), May–June 1974, pp. 111–12.

Lippard, Lucy. "Ad Reinhardt: One Work." Part I. *Art in America* (New York), Sept.–Oct. 1974, pp. 65–75.

Lippard, Lucy. "Ad Reinhardt: One Work." Part II. *Art in America* (New York), Nov.–Dec. 1974, pp. 95–101.

McConathy, Dale. "Keeping Time: Some Notes on Reinhardt, Smithson and Simonds." *Artscanada* (Toronto), June 1975, pp. 52–57.

Whelan, Richard. "Review of Books: *Art-as-Art: The Selected Writings of Ad Reinhardt*." *Art in America* (New York), Mar.–Apr. 1976, pp. 33–34.

Kramer, Hilton. "Satirizing the Art World." *The New York Times*, Oct. 17, 1976, p. 27.

Lippard, Lucy. "Ad Reinhardt, Black Painting." *Art and Australia* (Sydney), Jan.–June 1977, pp. 286–88.

"Ad Reinhardt, 1913–1967: 'Number 1, 1951'." *Toledo Museum of Art Museum News* (Ohio), vol. 19, no. 4, 1977, pp. 102–3.

Howe, Susan. "The End of Art." *Archives of American Art Journal* (New York), vol. 14, pt. 4, 1977, pp. 2–7.

Flagg, Nancy. "Reinhardt Revisiting." *Art International* (Lugano), Feb. 1978, pp. 54–57.

Hobbs, Robert C. "Ad Reinhardt, 1913–1967." In Robert C. Hobbs and Gail Levin, *Abstract Expressionism, The Formative Years*. Ithaca: Cornell University Press, 1978, pp. 110–15.

Kramer, Hilton. "Ad Reinhardt." *The New York Times* (New York), Jan. 20, 1980, pp. D27–28.

Stevens, Mark. "Art of Darkness." *Newsweek* (New York), Jan. 28, 1980, p. 55.

Brach, Paul. "Ad Reinhardt: Ultimate Chroma." *Art in America* (New York), Mar. 1980, pp. 96–99.

Larson, Kay. "Classicist in an Expressionist Era." *Art News* (New York), Apr. 1980, pp. 60–61.

McConathy, Dale. "Ad Reinhardt: 'He Loved to Confuse and Confound'." *Art News* (New York), Apr. 1980, 56–59.

Beck, James H. "Ad Reinhardt in Retrospect." *Arts Magazine* (New York), June 1980, pp. 148–50.

Ruhrberg, Karl. " 'Ich Mache Gerade die Letzten Bilder': Ad Reinhardt, ein conservativer Utopist." *Museen der Stadt Köln Bulletin* (Cologne), 1982, pp. 5–9.

Gaudin, Catherine. "Ad Reinhardt: Unicité." *Opus International* (Paris), Summer 1983, pp. 44–45.

Scherrmann, C. "The End-of-Art-Is-Not-The End-The Painter Ad Reinhardt." *Merkur-Deutsche Zeitschrift für Europaisches Denken*, vol. 39, no. 9–10, 1985, pp. 938–46.

Selected-One-Artist Exhibitions and Reviews

Betty Parsons Gallery, New York. *Paintings, Black, 1953–65*, Mar. 2–27, 1965.
 Lippard, Lucy R. "New York Letter." *Art International* (Lugano), May 1965, pp. 52–53.

Graham Gallery, New York. *Paintings, Red, 1950–53*, Mar. 2–27, 1965.
 Lippard, Lucy R. "New York Letter." *Art International* (Lugano), May 1965, pp. 52–53.

Stable Gallery, New York. *Paintings, Blue, 1950–53*, Mar. 9–Apr. 3, 1965.
 Lippard, Lucy R. "New York Letter." *Art International* (Lugano), May 1965, pp. 52–53.

The Jewish Museum, New York. *Ad Reinhardt: Paintings*, Nov. 23, 1966–Jan. 17, 1967. Cat., texts by Lucy Lippard, Sam Hunter, and the artist.

Marlborough Gallery, New York. *Ad Reinhardt: Black Paintings 1951–1967*, Mar. 7–Apr. 10, 1970. Cat., texts by H. H. Arnason and Barbara Rose.
 Pincus-Witten, Robert. "New York." *Artforum* (New York), May 1970, pp. 75–76.

Städtische Kunsthalle Dusseldorf. *Ad Reinhardt*, Sept. 15–Oct. 15, 1972. Cat., texts by Dale McConathy and the artist. Circulating exhibition.

Marlborough Gallery, New York. *Ad Reinhardt: A Selection from 1937 to 1952*, Mar. 2–23, 1974. Cat., text by Dale McConathy.

Galleria Morone 6, Milan. *Ad Reinhardt*, June 6–July 1, 1974.

Marlborough Galerie, Zurich. *Ad Reinhardt*, Nov. 27, 1974–Jan. 31, 1975. Cat., text by Dale McConathy.

The Pace Gallery, New York. *Ad Reinhardt*, Oct. 2–30, 1976.

Truman Gallery, New York. *Ad Reinhardt Cartoons and Collages*, Oct. 2–30, 1976. Cat.

Marlborough Gallery, New York. *Ad Reinhardt: Early Works Through Late Black Paintings, 1941–1966*, Oct. 15–Nov. 12, 1977.

Staatliche Kunsthalle, Baden-Baden. *Epitaphe für Ad Reinhardt*, Nov. 19, 1977–Jan. 8, 1978. Cat., texts by Ingrid Jenderko and Max Imdahl.

Marlborough Gallery, New York. *Ad Reinhardt*, Jan. 5–26, 1980.

The Solomon R. Guggenheim Museum, New York. *Ad Reinhardt and Color*, Jan. 11–Mar. 9, 1980. Cat., text by Margit Rowell.

Whitney Museum of American Art, New York. *Ad Reinhardt: A Concentration of Works from the Permanent Collection*, Dec. 10, 1980–Feb. 8, 1981. Cat., text by Patterson Sims and the artist.

The Pace Gallery, New York. *Ad Reinhardt: Paintings and Watercolors 1945–1951*, Dec. 11, 1981–Jan. 9, 1982. Cat.

Corcoran Gallery of Art, Washington, D.C. *Ad Reinhardt: Seventeen Works*, Sept. 22–Dec. 16, 1984. Cat., text by Jane Livingston.

Staatsgalerie Stuttgart. *Ad Reinhardt*, Apr. 12–June 2, 1985. Cat., text by Gudrun Inboden.

LEON POLK SMITH

By the Artist

Writings

with Hayman, D'Arcy. "The Paintings of Leon Polk Smith."
Art and Literature (Lausanne), Autumn/Winter, 1964.
Torn Drawings. New York: Galerie Chalette, 1965.
"A Statement from My Paintings." *Art Now: New York*
(New York), Oct. 1969.

On the Artist

Selected Articles

Alloway, Lawrence. "Leon Polk Smith: New Work and its
Origins." *Art International* (Lugano), Apr. 1963, pp.
51–53.
Alloway, Lawrence. "Leon Polk Smith: Dealings in
Equivalence." *Art in America* (New York), July/Aug.
1974, pp. 58–61.
Castle, Ted. "Leon Polk Smith: The Completely Self-
Referential Object." *Artforum* (New York), Sept. 1979,
pp. 34–39.
Alloway, Lawrence. "Leon Polk Smith: Large Abstract
Paintings 1969–1981." *Arts Magazine* (New York),
Dec. 1981, pp. 149–51.
Parks, A. "Life Line, Leon Polk Smith." *Arts Magazine*
(New York), Feb. 1986, pp. 26–27.

Selected One-Artist Exhibitions and Reviews

Egan Gallery, New York. *Paintings by Leon P. Smith,*
opening date unknown–Mar. 23, 1946.
Rose Fried Gallery, New York. Title and exact dates
unknown.
Mills College, New York. *Leon Polk Smith,* Nov. 22–Dec.
31, 1955.
Tyler, Parker. "Reviews and Previews." *Art News* (New
York), Jan. 1956, p. 68.
Camino Gallery, New York. *Leon Smith,* Nov. 2–22,
1956.
Tyler, Parker. "Reviews and Previews." *Art News* (New
York), Dec. 1956, p. 11.
Camino Gallery, New York. *Leon Smith,* Jan. 24–Feb.
13, 1958.
Ashbury, John. "Reviews and Previews." *Art News*
(New York), Jan. 1958, p. 19.
Section 11, New York. *Leon Polk Smith,* Nov. 10–29,
1958.
Burckhardt, Edith. "Reviews and Previews." *Art News*
(New York), Nov. 1958, p. 16.
Butler, Barbara. "Leon Polk Smith." *Art Digest* (New
York), Nov. 1958, p. 58.
Betty Parsons Gallery, New York. Title and exact dates
unknown, 1958.
Section 11, New York. *Leon Polk Smith,* Feb. 9–27,
1960.
Mott, Helen de. "Leon Polk Smith." *Arts* (New York),
Feb. 1960, p. 67.
Seelye, Anne. "Reviews and Previews." *Art News* (New
York), Feb. 1960, p. 15.
Betty Parsons Gallery, New York. Title and exact dates
unknown, 1960.
Stable Gallery, New York. Title and exact dates
unknown, 1961.
Oeri, Georgine. "Leon Polk Smith." *Quadrum*
(Brussels), no. 12, 1961, pp. 150–51.
Stable Gallery, New York. *Leon Polk Smith,* Jan. 2–21,
1962.
Raynor, Vivien. "Leon Polk Smith." *Arts* (New York),
Feb. 1962, p. 41.
Swenson, G. R. "Reviews and Previews." *Art News*
(New York), Feb. 1962, p. 12.
Ashton, Dore. "New York Commentary." *Studio
International* (London), Apr. 1962, p. 157.

Museo de Bellas Artes, Caracas, Venezuela. *Leon Polk
Smith,* Sept. 16, 1962–closing date unknown.
Brochure.
Stable Gallery, New York. *Leon Polk Smith: Recent
Paintings, Sculpture and Reliefs,* Mar. 12–30, 1963.
Campbell, Lawrence. "Reviews and Previews." *Art
News* (New York), Mar. 1963, p. 14.
Tillim, Sidney. "Leon Polk Smith." *Arts* (New York),
May 1963, p. 107.
Galerie Chalette, New York. *Leon Polk Smith: Recent
Works,* Oct. 2, 1965–closing date unknown. Cat.
Goldin, Amy. "In the Galleries: Leon Polk Smith." *Arts
Magazine* (New York), Nov. 1965, p. 57.
Lippard, Lucy R. "New York Letter." *Art International*
(Lugano), Jan. 1966, pp. 92–93.
Galerie Chalette, New York. *Leon P. Smith,* May 1–31,
1967.
Galerie Chalette, New York. *Leon Polk Smith: Recent
Paintings,* Feb. 10–Mar. 1968. Circulating exhibition.
Campbell, Lawrence. "Reviews and Previews." *Art
News* (New York), Apr. 1968. p. 57.
Galerie Chalette, New York. *Leon Polk Smith:
Constellations,* Oct. 14–Nov. 1969.
Calas, Nicolas. "Leon Polk Smith." *Arts Magazine*
(New York), Nov. 1969, p. 60.
Edgar, Natalie. "Leon Polk Smith." *Art News* (New
York), Dec. 1969, p. 70.
Ratcliff, Carter. "New York Letter." *Art International*
(Lugano), Jan. 1970, p. 90.
Galerie Chalette, New York. *Leon Polk Smith: Geometric
Paintings 1945–1953,* Nov. 7, 1970–Jan. 16, 1971.
Brochure, text by Lawrence Alloway.
Campbell, Lawrence. "Reviews and Previews." *Art
News* (New York), Jan. 1971, p. 58.
Pincus-Witten, Robert. "Leon Polk Smith: Galerie
Chalette." *Artforum* (New York), Feb. 1971, p. 76.
Ratcliff, Carter. "New York Letter." *Art International*
(Lugano), Feb. 1971, p. 66.
Galerie Denise René, New York. *Leon Polk Smith:
Selected Paintings 1945–1973,* Dec. 4, 1973–Jan.
12, 1974. Cat.
Hughes, Robert. "A Disciple's Progress." *Time* (New
York), Dec. 31, 1973, p. 46.
Derfner, Phyllis. "New York Letter." *Art International*
(Lugano), Feb. 1974, p. 49.
Frank, Peter. "Reviews and Previews." *Art News* (New
York), Feb. 1974, p. 99.
Smith, Roberta. "Reviews." *Artforum* (New York), Feb.
1974, p. 71.
Von Baron, Judith. "Leon Polk Smith." *Arts Magazine*
(New York), Feb. 1974, p. 58.
Galerie Denise René, New York. *Leon Polk Smith: New
Paintings and Collages,* May 23–June 21, 1975.
Andre, Michael. "Reviews and Previews." *Art News*
(New York), Sept. 1975, p. 116.
Galerie Denise René, New York. *Leon Polk Smith,* Feb.
15–Mar. 12, 1977.
Tannenbaum, Judith. "Leon Polk Smith." *Arts Magazine*
(New York), Apr. 1977, p. 31.
Pelham-von Stoffler Gallery, Houston. Title and exact
dates unknown, 1977.
Moser, Charlotte. "Exhibit Helps Fill in Modern Art
Gaps Here." *Houston Chronicle,* Aug. 26, 1977,
Section 2, p. 8.
Art Gallery, State University College at Old Westbury,
New York. *Leon Polk Smith: A Dialogue in Black and
White: An Exhibition of Paintings from 1946–1978,*
opening date unknown–Nov. 25, 1978.
Susan Caldwell, New York. *Leon Polk Smith,* Apr. 6–28,
1979.
Gallery Paule Anglim, San Francisco. *Leon Polk Smith:
Paintings and Collages 1954–1977,* Apr. 17–May 12,
1979.

McDonald, R. "Space Equals Form." *Artweek*
(Oakland, Calif.), May 5, 1979, p. 6.
Ace Gallery, Vancouver, Canada. *Leon Polk Smith:
Paintings from 1945–1978,* Sept. 23–Oct. 15, 1979.
Gallery Paule Anglim, San Francisco. *Leon Polk Smith:
Paintings and Collages,* Oct. 1–Nov. 9, 1979.
International Art Fair 1979, Cologne. Nov. 7–12, 1979.
Washburn Gallery, New York. *Leon Polk Smith:
Constellations 1967–1973,* Jan. 11–Feb. 25, 1980.
Anderson Gallery, Virginia Commonwealth University,
Richmond. *Leon Polk Smith: Eight Works/Paintings and
Collages,* Sept. 23–Oct. 12, 1980.
Washburn Gallery, New York. *Leon Polk Smith,* Mar. 4–
Apr. 4, 1981.
Russell, John. "Art: Leon Polk Smith, Uptown and
Downtown." *The New York Times,* Mar. 20, 1981,
page unknown.
Parks, Addison. "Leon Polk Smith." *Arts Magazine*
(New York), May 1981, p. 37.
Gallati, Barbara. "Leon Polk Smith." *Arts Magazine*
(New York), June 1981, p. 29.
Baro, Gene. "Leon Polk Smith." *Art International*
(Lugano), Aug./Sept. 1981, p. 120.
Washburn Gallery, New York. *Leon Polk Smith: Black and
White Tondos,* Dec. 11, 1981–Jan. 30, 1982.
Art Gallery, Fine Arts Center, State University of New
York, Stony Brook. *Leon Polk Smith: Large Paintings
1979–1981,* Oct. 28–Dec. 15, 1981.
Washburn Gallery, 42 East 57th Street, New York. *Leon
Polk Smith: Paintings 1945–1950,* Sept. 22–Oct. 30,
1982, and Washburn Gallery, 113 Greene Street,
New York. *Leon Polk Smith: Recent Paintings,* Sept.
22–Oct. 30, 1982.
Gallati, Barbara. "Leon Polk Smith." *Arts Magazine*
(New York), Nov. 1982, p. 53.
Rub, Timothy F. "Leon Polk Smith." *Arts Magazine*
(New York), Dec. 1982, pp. 34–35.
Washburn Gallery, New York. *Leon Polk Smith:
Constellations,* Jan. 11–Feb. 25, 1984.
Cohen, R. "Reviews and Previews." *Art News* (New
York), May 1984, pp. 157, 159.
Nationalgalerie, Berlin. *Leon Polk Smith: Collages 1981–
1983,* May 31–July 29, 1984. Cat., text by Lucius
Grisebach.
DiLaurenti Gallery, New York. *Leon Polk Smith,* Jan. 23–
Mar. 1, 1986.
Loughery, J. "Leon Polk Smith." *Arts Magazine* (New
York), Apr. 1986, pp. 129–30.
Ruth Siegel, New York. *Leon Polk Smith,* Jan. 3–24,
1987.
Edelman, Robert G. "Leon Polk Smith at Ruth Siegel."
Art in America (New York), Apr. 1987, pp. 218–
19.
Burnett Miller, Los Angeles. *Leon Polk Smith,* May 15–
June 20, 1987.
Lazzari, M. "Minimalism in the Mainstream." *Artweek*
(Oakland, Calif.), June 6, 1987, p. 8.
Hammond, P. "Reviews and Previews." *Art News* (New
York), Oct. 1987, pp. 195, 197.
DiLaurenti Gallery, New York. *Leon Polk Smith: 50
Decades of Geometric Inventions,* Nov. 6–Dec. 19,
1987. Cat., text by Carter Ratcliff. Circulating
exhibition.

JOHN McLAUGHLIN

On the Artist

Selected Articles

Frankenstein, Alfred. "Some Reassurance from Abstract Classicists." *San Francisco Chronicle*, July 8, 1959, p. 35.

Seldis, Henry J. "Precise Forms Mach Style." *Los Angeles Times*, Sept. 20, 1959, part 5, p. 3.

Alloway, Lawrence. "Classicism or Hard Edge." *Art International* (Lugano), Feb.–Mar. 1960, p. 60.

Coplans, John. "John McLaughlin, Hard Edge and American Painting." *Artforum* (San Francisco), Jan. 1964, p. 28.

Nordland, Gerald. "McLaughlin and the Totally Abstract." *Frontier* (Los Angeles), Jan. 1964, p. 22.

Fractor, Don. "Southern California Original Hard-Edge Painters." *Artforum* (San Francisco), June 1965, p. 12.

Seldis, Henry J. "McLaughlin—A Gateway to Ourselves." *Los Angeles Times*, Jan. 1973, p. 8.

Larsen, Susan C. "John McLaughlin." *Art International* (Lugano), Jan. 1978, p. 8.

Larsen, Susan C. "John McLaughlin." *Artweek* (Oakland, Calif.), Jan. 1979, p. 9.

Zimmer, William. "John McLaughlin." *Soho Weekly News* (New York), Sept. 27, 1979, page unknown.

Ashton, Doré. "Painting Toward: The Art of John McLaughlin." *Arts Magazine* (New York), Nov. 1979, pp. 120–21.

Ratcliff, Carter. "John McLaughlin's Abstinent Abstraction." *Art in America* (New York), Dec. 1979, pp. 100–01.

Figoten, Sheldon. "An Appreciation of John McLaughlin." *Archives of American Art Journal* (Washington, D.C.), vol. 20, no. 4, 1980, pp. 10–16.

Selected One-Artist Exhibitions and Reviews

Felix Landau Gallery, Los Angeles. Title and exact dates unknown, 1953.

Pasadena Art Museum, California. *John McLaughlin*, Apr. 20–May 20, 1956.
 Langsner, Jules. "Art News from Los Angeles." *Art News* (New York), May 1956, p. 15.

Felix Landau Gallery, Los Angeles. *John McLaughlin*, June 2–21, 1958.
 Selz, Peter. "Los Angeles." *Arts Magazine* (New York), Feb. 1958, p. 20.

Felix Landau Gallery, Los Angeles. *John McLaughlin: Recent Paintings*, Jan. 29–Feb. 17, 1962.
 Seldis, Henry J. "Contemplation Goal of Total Abstraction." *Los Angeles Times*, Feb. 11, 1962, p. 24.
 Nordland, Gerald. "Paintings at the Felix Landau Gallery in Los Angeles." *Arts* (New York), Feb. 1962, p. 50.

Felix Landau Gallery, Los Angeles. *John McLaughlin, Lithographs*, Aug. 12–Sept. 7, 1963.

Pasadena Art Museum, California. *A Retrospective Exhibition—John McLaughlin*, Nov. 12–Dec. 12, 1963. Cat., text by Walter Hopps; statement by the artist.
 Perkins, Constance. "Reviews." *Artforum* (San Francisco), Oct. 1963, p. 41.
 Perkins, Constance. "In the Galleries: McLaughlin's Works Encourage Meditation." *Los Angeles Times*, Nov. 22, 1963, p. 8.
 Langsner, Jules. "Art News from Los Angeles." *Art News* (New York), Jan. 1964, p. 50.

Felix Landau Gallery, Los Angeles. *John McLaughlin*, Feb. 28–Mar. 19, 1966. Cat., statement by the artist.
 Coplans, John. "Reviews and Previews." *Art News* (New York), Summer 1966, p. 57.

Landau-Alan Gallery, New York. *John McLaughlin: Paintings 1966–1967*, Mar. 5–23, 1968.

Corcoran Gallery of Art, Washington, D.C. *John McLaughlin—Retrospective Exhibition 1946–1967*, Nov. 16, 1968–Jan. 5, 1969. Cat., texts by James Harithas and the artist.
 Richard, Paul. "Corcoran Has Powerful and Special Show." *The Washington Post*, Nov. 24, 1968, Art Section, page unknown.

Felix Landau Gallery, Los Angeles. *John McLaughlin: Paintings from the Early Fifties*, May 11–June 6, 1970.

André Emmerich Gallery, New York. *John McLaughlin: Recent Paintings*, Mar. 30–Apr. 17, 1971.

University of California, Irvine. *John McLaughlin—Recent Paintings 1970–1971*, Apr. 7–May 3, 1971.

Nicholas Wilder Gallery, Los Angeles. *Recent Paintings by John McLaughlin*, exact dates unknown, 1972.

La Jolla Museum of Contemporary Art, California. *John McLaughlin: A Retrospective Exhibition*, July 7–Aug. 12, 1973.

Corcoran and Corcoran Ltd., Coral Gables, Florida. *Paintings by John McLaughlin*, exact dates unknown, 1973.

Whitney Museum of American Art, New York. *John McLaughlin*, Feb. 21–Mar. 17, 1974.
 Smith, Roberta. *Artforum* (New York), June 1974, p. 56.

André Emmerich Gallery, New York. *John McLaughlin: Recent Paintings*, Mar. 30–Apr. 17, 1974. Cat.

Laguna Beach Museum of Art, California. *John McLaughlin*, Sept. 6–28, 1975. Brochure.

Felicity Samuel Gallery, London. *John McLaughlin*, Sept. 8–Oct. 10, 1975.

California State University, Fullerton. *John McLaughlin Retrospective Exhibition 1946–1975*, Sept. 19–Oct. 9, 1975. Cat., text by Vic Smith.
 Danieli, Fidel. "John McLaughlin Retrospective." *Artweek* (Oakland, Calif.), Oct. 4, 1975, pp. 1–2.

Galerie André Emmerich, Zurich. *John McLaughlin: Paintings 1949–1974*, exact dates unknown, 1976.

University of California, Santa Barbara. *John McLaughlin: Prints and Paintings*, exact dates unknown, 1978.

Nicholas Wilder Gallery, Los Angeles. *John McLaughlin: Late Work*, Jan. 1979. Cat., text essay by Nicholas Wilder.

André Emmerich Gallery, New York. *John McLaughlin: Paintings 1949–1975*, Sept. 11–Oct. 3, 1979. Cat.
 Cavaliere, Barbara. "Review, André Emmerich Gallery." *Arts Magazine* (New York), Nov. 1979, p. 21.
 Saltzman, Cynthia. "John McLaughlin Paintings, 1949–1975." *Art News* (New York), Dec. 1979, p. 170.
 Ffrench-Frazier, Nina. "John McLaughlin. *Art International* (New York), Dec. 1979, p. 41.
 Perrone, Jeff. "Review, André Emmerich Gallery." *Artforum* (New York), Jan. 1980, pp. 68–69.

Annely Juda Fine Art, London. *John McLaughlin: Paintings 1950–1975*, Apr. 14–May 23, 1981.
 Taylor, John Russell. "Review." *The Times* (London), Apr. 28, 1981, p. 13.
 Einzig, Hetty. "Review, Annely Juda." *Arts Review* (London), May 8, 1981, p. 192.

Gimpel-Hanover & André Emmerich Galerien, Zurich. *John McLaughlin*, June 13–July 18, 1981.

Quadrat Bottrop-Moderne Galerie, Bottrop, West Germany. *John McLaughlin*, Oct. 25–Dec. 6, 1981. Cat., text by Sheldon Figoten.

Galerie André Emmerich, Zurich. *John McLaughlin: Black and White*, exact dates unknown, 1981. Circulating exhibition.

Galerie D & C Mueller-Roth, Stuttgart, West Germany. *John McLaughlin*, Jan. 29–Mar. 3, 1982.

James Corcoran Gallery, Los Angeles. *John McLaughlin, Selected Paintings*, Jan. 29–Feb. 27, 1982.

Ulmer Museum, Ulm, West Germany. *John McLaughlin*, Mar. 21–May 9, 1982. Cat., text by Sheldon Figoten.

André Emmerich Gallery, New York. *John McLaughlin: Paintings 1951–1974*, Oct. 7–30, 1982.
 Klein, Michael R. "John McLaughlin." *Arts* (New York), Jan. 1983, p. 5.

Gatodo Gallery, Tokyo. *John McLaughlin: Paintings 1951–66*, July 1–23, 1983. Cat.

Daniel Weinberg Gallery, Los Angeles. *John McLaughlin*, Oct. 9–Nov. 3, 1984.

Gatodo Gallery, Tokyo. *John McLaughlin: Late Work*, May 13–June 8, 1985.

Washburn Gallery, New York. *Alice Trumbull Mason and John McLaughlin—Two Decades: 1950–1960*, June 18–July 31, 1986. Brochure.

André Emmerich Gallery, New York. *Paintings of the Fifties*, Feb. 5–28, 1987. Cat., introduction by Prudence Carlson.

Donald Young Gallery, Chicago. *John McLaughlin: Paintings 1952–1974*, June 5, 1987–closing date unknown.

André Emmerich Gallery, New York. *Paintings of the Sixties*, Nov. 5–28, 1987. Cat., introduction by Prudence Carlson.

MYRON STOUT

By the Artist

Interview
Maartens, Katherine. "Myron Stout." Master's thesis, Hunter College, 1979.

On the Artist

Selected Articles
Tillim, Sidney. "What Happened to Geometry?" *Arts* (New York), June 1959, pp. 38–44.
Kaprow, Allan. "Impurity." *Art News* (New York), Jan. 1963, pp. 30–33, 52–55.
Schwartz, Sanford. "Myron Stout." *Artforum* (New York), Mar. 1975, pp. 38–43.
Bell, Tiffany. "Stout's Complexity in Simplicity." *Artforum* (New York), Jan. 1980, pp. 47–51.

Selected One-Artist Exhibitions and Reviews
Stable Gallery, New York. *Myron Stout*, Apr. 5–24, 1954.
Feinstein, Sam. "The Unified Image." *Art Digest* (New York), Apr. 1, 1954, p. 16.
Porter, Fairfield. "Reviews and Previews." *Art News* (New York), Apr. 1954, p. 58.
Hansa Gallery, New York. *Myron Stout*, Mar. 4–23, 1957.
Pollet, Elizabeth. "Myron Stout." *Art Digest* (New York), Mar. 1957, p. 58.
Tyler, Parker. "Reviews and Previews." *Art News* (New York), Mar. 1957, p. 12.
Whitney Museum of American Art, New York. *Myron Stout*, Feb. 5–Apr. 6, 1980. Cat., text by B. H. Friedman.
Kramer, Hilton. "Art: Myron Stout Ushered Into Limelight." *The New York Times*, Feb. 8, 1980, p. C26.
Ashbery, John. "Art: Stylish Stouts." *New York*, Mar. 3, 1980, pp. 97–99.
Perl, J. "Myron Stout." *Art in America* (New York), Mar. 1980, pp. 107–11.
Shuebrook, R. "Myron Stout." *Arts Magazine* (New York), Apr. 1980, p. 9.

ELLSWORTH KELLY

By the Artist

Books
Ellsworth Kelly: Third Curve Series. Los Angeles: Gemini G.E.L., c. 1976.
Ellsworth Kelly at Gemini, 1979–1982. Los Angeles: Gemini G.E.L., 1982.
Ellsworth Kelly. Los Angeles: Margo Leavin Gallery, and New York: Leo Castelli Gallery, 1984.
Ellsworth Kelly at Gemini, 1983–1985. Los Angeles: Gemini G.E.L., c. 1985.

Interview
Geldzahler, Henry. "Interview with Ellsworth Kelly." *Art International* (Lugano), Feb. 1964, pp. 47–48.

On the Artist

Books
Waldman, Diane. *Ellsworth Kelly: Drawings, Collages, Prints*. Greenwich, Connecticut: New York Graphic Society, 1971.
Coplans, John. *Ellsworth Kelly*. New York: Harry N. Abrams, 1973.
Goossen, Eugene C. *Ellsworth Kelly*. New York: The Museum of Modern Art, 1973.
Axsom, Richard H. *The Prints of Ellsworth Kelly*. New York: The American Federation of Arts in association with Hudson Hills Press, 1987.

Selected Articles
Goossen, Eugene C. "Kelly." *Derrière le miroir* (Paris), no. 110, c. 1958. Special issue devoted to the artist.
McConathy, Dale. "Kelly." *Derrière le miroir* (Paris), no. 149, 1964. Special issue devoted to the artist.
Ashbery, John. "Art News from Paris: Kelly and Bishop." *Art News* (New York), Jan. 1965, pp. 50–51.
Johnson, Charlotte Buel. "New York, New York." *School Arts* (Worcester, Mass.) Apr. 1965, p. 47.
Menna, Filberto. "Ellsworth Kelly." *Marcatrè* (Milan), Dec. 1966, pp. 155–59.
Rose, Barbara. "The Sculpture of Ellsworth Kelly." *Artforum* (New York), June 1967, pp. 51–55.
Coplans, John. "The Earlier Work of Ellsworth Kelly." *Artforum* (New York), Summer 1969, pp. 48–55.
Waldman, Diane. "Kelly, Collage and Color." *Art News* (New York), Dec. 1971, pp. 44–47, 53–55.
Debs, Barbara Knowles. "Ellsworth Kelly's Drawings." *The Print Collector's Newsletter* (New York), Sept./Oct. 1972, pp. 73–77.
Gordon, Leah. "Art Notes: Kelly–'My Work is Difficult'." *The New York Times*, Sept. 9, 1973, pp. 29, 37.
Goossen, Eugene C. "The Paris Years." *Arts Magazine* (New York), Nov. 1973, pp. 32–37.
Millet, Catherine. "Kelly, Noland, Olitski, Poons, Stella: Après l'expressionisme abstrait." *Art Press* (Paris), Nov./Dec. 1973, pp. 10–15.
Goossen, Eugene C. "Color and Light." *Arts Magazine* (New York), Jan. 1974, pp. 32–41.
Tuchman, Phyllis. "Ellsworth Kelly's Photographs." *Art in America* (New York), Jan./Feb. 1974, pp. 55–61.
Barron, Stephanie. "Giving Art History the Slip." *Art in America* (New York), Mar./Apr. 1974, pp. 80–84.
Barron, Stephanie. "Matisse and Contemporary Art." *Arts Magazine* (New York), May 1975, pp. 66–67.
Stanfill, Francesca. "Portrait of a Painter." *Women's Wear Daily* (New York), Sept. 19, 1975, pp. 16–17.
Stanfill, Francesca. "Three Painters." *Women's Wear Daily* (New York), Oct. 1, 1975, p. 5.
Baker, Kenneth. "Ellsworth Kelly's 'Rebound'." *Arts Magazine* (New York), Sept. 1976, pp. 110–11.

Lemaire, G.-G. "La Forme (contenue) de Kelly (The Form [as content] of Kelly)." *Opus International* (Paris), Autumn 1980, pp. 31–32.
Ratcliff, Carter. "Mostly Monochrome." *Art in America* (New York), Apr. 1981, pp. 111–31.
Ratcliff, Carter. "Ellsworth Kelly's Spectrum of Experience." *Art in America* (New York), Summer 1981, pp. 98–101.
Brenson, Michael. "In Sculpture too, He is an Artist of Surprises." *The New York Times*, Dec. 12, 1982, pp. 1, 37–38.
Raynor, Vivien. "Ellsworth Kelly Keeps His Edge." *Art News* (New York), Mar. 1983, pp. 52–59.
Debs, B. K. "Precise Implications." *Art in America* (New York), Summer 1983, pp. 119–26.
Truppin, A. "Colors that Vibrate: Ward Bennett Draws from the Palette of Ellsworth Kelly." *Interiors* (New York) July 1984, pp. 106–7.
Rosenthal, M. "Diagonal with Curve III." *Philadelphia Museum of Art Bulletin* (Philadelphia), Summer/Fall 1984, pp. 34–36.
Morgan, S. "Bread and Circuses [La Grande parade: highlights of painting after 1940, Stedelijk Museum, Amsterdam, exhibit]." *Artforum* (New York), Mar. 1985, pp. 82–86.
Karlen, P. H. "Public Commissions: The Ellsworth Kelly Case." *Artweek* (Oakland, Calif.), Feb. 1, 1986 pp. 2–3; Mar. 1, 1986, p. 17.

Selected One-Artist Exhibitions and Reviews
Galerie Arnaud, Paris. *Peintures, Ellsworth Kelly*, Apr. 26–May 9, 1951.
Betty Parsons Gallery, New York. *Ellsworth Kelly*, May 21–June 8, 1956.
Butler, Barbara. "Ellsworth Kelly." *Arts Magazine* (New York), June 1956, p. 52.
Tyler, Parker. "Reviews and Previews." *Art News* (New York), Summer 1956, p. 51.
Betty Parsons Gallery, New York. *Ellsworth Kelly*, Sept. 23–Oct. 12, 1957.
Burrey, Suzanne. "Ellsworth Kelly." *Arts Magazine* (New York), Oct. 1957, pp. 56–57.
Tyler, Parker. "Reviews and Previews." *Art News* (New York), Oct. 1957, pp. 17–18.
Galerie Maeght, Paris. *Ellsworth Kelly*, Oct. 24–Nov. 30, 1958. Cat., text by Eugene C. Goossen in *Derrière le Miroir* (Paris), Oct. 1958.
Betty Parsons Gallery, New York. *Ellsworth Kelly: Painting and Sculpture*, Oct. 19–Nov. 7, 1959.
Tillim, Sydney. "Month in Review." *Arts Magazine* (New York), Oct. 1959, pp. 48–51.
Betty Parsons Gallery, New York. *Ellsworth Kelly*, Oct. 19–Nov. 4, 1961.
Sandler, Irving H. "Reviews and Previews." *Art News* (New York), Nov. 1961, p. 13.
Tillim, Sydney. "Ellsworth Kelly." *Arts Magazine* (New York), Dec. 1961, p. 48.
Arthur Tooth & Sons, Ltd., London. *Ellsworth Kelly*, May 19–June 23, 1962. Cat., text by Lawrence Alloway.
Betty Parsons Gallery, New York. *Ellsworth Kelly: Painting and Sculpture*, Oct. 29–Nov. 23, 1963.
Rubin, William. "Ellsworth Kelly: The Big Form." *Art News* (New York), Nov. 1963, pp. 32–35, 64–65.
Fried, Michael. "New York Letter: Ellsworth Kelly at Betty Parsons Gallery." *Art International* (Lugano), Jan. 1964, pp. 54–56.
Gallery of Modern Art, Washington, D.C. *Paintings, Sculpture and Drawings by Ellsworth Kelly*, Dec. 11, 1963–Jan. 26, 1964. Cat., text by Adelyn D. Breeskin; interview with Kelly by Henry Geldzahler. Circulating exhibition.

Galerie Maeght, Paris. *Ellsworth Kelly*, Nov. 20–Dec. 31, 1964. Cat., text by Dale McConathy, in *Derrière le Miroir* (Paris), Nov. 1964.

Ferus Gallery, Los Angeles. *An Exhibition of Recent Lithography Executed in France by the Artist Ellsworth Kelly*, Mar. 9–Apr. 5, 1965.

Petlin, Irving B. "Ellsworth Kelly, Ferus Gallery." *Artforum* (San Francisco), May 1965, p. 16.

Sidney Janis Gallery, New York. *Recent Paintings by Ellsworth Kelly*, Apr. 6–May 1, 1965. Cat.

Levin, Kim. "Ellsworth Kelly." *Art News* (New York), May 1965, p. 10.

Barnitz, J. "Ellsworth Kelly." *Arts Magazine* (New York), May–June 1965, pp. 58–59.

Ashton, Dore. "Kelly's Unique Spatial Experiences." *Studio International* (London), July 1965, pp. 40–42.

Galerie Adrien Maeght, Paris. *Kelly: 27 Lithographs*, June 1965. Cat., text by Dale McConathy.

Knoll International, Dusseldorf. *Ellsworth Kelly, Neue Lithographien*, Oct. 18–Nov. 19, 1965.

Galerie Ricke, Kassel, West Germany. *Ellsworth Kelly, Neue Lithographien*, Nov. 22, 1965–Jan. 5, 1966.

Ferus Gallery, Los Angeles. *New Work by Ellsworth Kelly*, Mar. 15–Apr. 20, 1966.

Danieli, Fidel A. [Review in] *Artforum* (New York), May 1966, p. 15.

Sidney Janis Gallery, New York. *An Exhibition of New Work by Ellsworth Kelly*, Mar. 1–25, 1967. Cat.

Irving Blum Gallery, Los Angeles. *A Suite of Twelve Lithographs by Ellsworth Kelly*, Nov. 7–Dec. 8, 1967.

Hoag, Jane. "Ellsworth Kelly." *Art News* (New York), Jan. 1968, p. 52.

Livingston, Jane. "Los Angeles: Ellsworth Kelly at Irving Blum." *Artforum* (New York), Jan. 1968, pp. 60–61.

Sidney Janis Gallery, New York. *An Exhibition of Paintings & Sculpture by Ellsworth Kelly*, Oct. 7–Nov. 2, 1968. Cat.

Waldman, Diane. "Kelly Color." *Art News* (New York), Oct. 1968, pp. 40–41, 62–64.

Wasserman, Emily. "Ellsworth Kelly." *Artforum* (New York), Dec. 1968, p. 58.

Irving Blum Gallery, Los Angeles. *Four Paintings and One Sculpture by Ellsworth Kelly*, Nov. 5–30, 1968.

Dayton's Gallery 12, Minneapolis. *Ellsworth Kelly*, May 1–June 5, 1971.

Sidney Janis Gallery, New York. *Recent Paintings by Ellsworth Kelly*, Nov. 3–27, 1971. Cat.

Perreault, John. "Wavering Home: Kelly's Light Slabs." *The Village Voice* (New York), Nov. 11, 1971, pp. 23–24.

Mellow, James R. "Too Much with Too Little and Too Little with Too Much." *The New York Times*, Nov. 21, 1971, page unknown.

Elderfield, John. "Color and Area: New Paintings by Ellsworth Kelly." *Artforum* (New York), Nov. 1971, pp. 45–49.

Domingo, Willis. "Ellsworth Kelly." *Arts Magazine* (New York), Dec. 1971/Jan. 1972, p. 60.

Galerie Ziegler, Geneva, Switzerland. *Ellsworth Kelly: Lithographies en couleur de 1964*, Mar. 10–Apr. 12, 1972.

Galerie Denise René-Hans Mayer, Dusseldorf. *Ellsworth Kelly: Paintings*, July 1–31, 1972. Cat.

Friedrichs, Yvonne. [Review in] *Das Kunstwerk* (Baden-Baden), Sept. 1972, p. 43.

Albright-Knox Art Gallery, Buffalo. *Ellsworth Kelly: The Chatham Series*, July 11–Aug. 27, 1972.

Willig, Nancy Tobin. "Kelly's L-Shaped Paintings Shown." *Courier Express* (Buffalo), July 16, 1972, p. 4.

Reeves, Jean. "Daring Intuition in Abstract Art." *Buffalo Evening News*, July 17, 1972, page unknown.

Kramer, Hilton. "Color Lures the Eye to Kelly's Paintings." *The New York Times*, July 26, 1972, p. 22.

Irving Blum Gallery. *Ellsworth Kelly: Four Paintings, Chatham Series*, Mar. 15–Apr. 15, 1973.

Greenberg Gallery, St. Louis. *Ellsworth Kelly: Paintings*, Mar. 1973.

Leo Castelli Gallery, New York. *Ellsworth Kelly: Curved Series*, Apr. 7–18, 1973.

Crimp, Douglas. "New York Letter." *Art International* (Lugano), Summer 1973, p. 89.

Siegel, Jeanne. "Reviews and Previews." *Art News* (New York), Summer 1973, p. 99.

Stitelmann, Paul. "Ellsworth Kelly." *Arts Magazine* (New York), Sept./Oct. 1973, p. 59.

The Museum of Modern Art, New York. *Ellsworth Kelly* (Retrospective), Sept. 12–Nov. 4, 1973. Cat., text by E. C. Goossen. Circulating exhibition.

Hughes, Robert. "Classic Shapes." *Time* (New York), Sept. 17, 1973, p. 72.

Kramer, Hilton. "Kelly: Extremely Individual and Extremely Traditional." *The New York Times*, Sept. 23, 1973, p. 25.

Baker, Elizabeth C. "The Subtleties of Ellsworth Kelly." *Art News* (New York), Nov. 1973, pp. 30–33.

Masheck, Joseph. "Ellsworth Kelly at the Modern." *Artforum* (New York), Nov. 1973, pp. 54–57.

Kingsley, April. "New York." *Art International* (Lugano), Dec. 1973, p. 34.

Leo Castelli Gallery, New York. *Ellsworth Kelly: Sculptures*, Mar. 8–Apr. 5, 1975.

Leo Castelli Gallery, New York. *Ellsworth Kelly: Gray Series*, Apr. 12–May 3, 1975.

Zimmer, William. "Ellsworth Kelly." *Arts Magazine* (New York), May 1975, p. 17.

Zucker, Barbara. "Reviews and Previews." *Art News* (New York), May 1975, p. 96.

Hoesterey, Ingeborg. "Kelly (Castelli)." *Art International* (Lugano), June 1975, p. 77.

Derfner, Phyllis. "Ellsworth Kelly at Castelli Uptown." *Art in America* (New York), July/Aug. 1975, pp. 97–98.

Zucker, Barbara. "Ellsworth Kelly." *Art News* (New York), Summer 1975, p. 145.

Smith, Roberta. "Ellsworth Kelly: Leo Castelli Gallery (Uptown)." *Artforum* (New York), Sept. 1975, pp. 69–71.

Ace Gallery, Venice, California. *Ellsworth Kelly: Sculpture*, June 12–July 15, 1975.

Blum Helman Gallery, New York. *Ellsworth Kelly: Paintings*, Sept.–Oct., 1975.

Janie C. Lee Gallery, Houston. *Ellsworth Kelly: Recent Sculptures*, Mar. 6–Apr. 3, 1976.

Castelli Uptown Gallery, New York. *Ellsworth Kelly: Colored Paper Images*, Jan. 7–20, 1977.

Frackman, Noël. "Ellsworth Kelly." *Arts Magazine* (New York), Mar. 1977, p. 31.

Perrone, Jeff. "Ellsworth Kelly: Leo Castelli Graphics." *Artforum* (New York), Apr. 1977, p. 62.

Leo Castelli Gallery, New York. *Ellsworth Kelly: Paintings*, Feb. 5–26, 1977.

Russell, John. "Art: Ellsworth Kelly, A Grand Showing." *The New York Times*, Feb. 18, 1977, page unknown.

Schwarz, Ellen. "Reviews and Previews." *Art News* (New York), Apr. 1977, p. 126.

Zimmer, William. "Ellsworth Kelly." *Arts Magazine* (New York), Apr. 1977, p. 34.

Blum Helman Gallery, New York. *Ellsworth Kelly: Paintings*, Feb. 5–26, 1977.

Margo Leavin Gallery, Los Angeles. *Ellsworth Kelly: Colored Paper Images*, Mar. 5–20, 1977.

The Museum of Modern Art, New York. *Ellsworth Kelly: Colored Paper Images*, Dec. 11, 1978–Jan. 30, 1979.

The Metropolitan Museum of Art, New York. *Ellsworth Kelly: Recent Paintings and Sculpture*, Apr. 26–June 24, 1979. Cat., text by Elizabeth C. Baker.

Whelan, Richard. "Ellsworth Kelly." *Art News* (New York), Sept. 1979, p. 180.

Blum Helman Gallery, New York. *Ellsworth Kelly*, Apr. 28–May 31, 1979.

Whelan, Richard. "Ellsworth Kelly." *Art News* (New York), Sept. 1979, p. 180.

Galerie Maeght, Zurich. *Ellsworth Kelly, Lithographien*, Oct. 4–Nov. 5, 1979.

Stedelijk Museum, Amsterdam. *Ellsworth Kelly: Schilderigen, en beelden 1963–1979 (paintings and sculptures 1963–1979)*, Dec. 13, 1979–Feb. 3, 1980. Cat., texts by Barbara Rose and Ellsworth Kelly. Circulating exhibition.

Von Graevenitz, A. "Bilder und Skulpturen 1963–1979: Stedelijk Museum, Amsterdam." *Pantheon* (Munich), Apr. 1980, pp. 126–27.

Blum Helman Gallery, New York. *Ellsworth Kelly*, Dec. 1, 1982–Jan. 8, 1983.

Licht, Matthew. "Ellsworth Kelly." *Arts Magazine* (New York), Feb. 1983, p. 41.

Kohn, M. "Ellsworth Kelly." *Flash Art* (Milan), Mar. 1983, p. 58.

The Whitney Museum of American Art, New York. *Ellsworth Kelly: Sculpture*, Dec. 17, 1982–Feb. 27, 1983. Cat., texts by Patterson Sims and Emily Pulitzer. Circulating exhibition.

Russell, John. "Art: Ellsworth Kelly." *The New York Times*, Dec. 17, 1982, page unknown.

Cohen, R. "New York Reviews: In Great Shape." *Art News* (New York), Feb. 1983, p. 154.

Debs, Barbara Knowles. "Precise Implications." *Art in America* (New York), Summer 1983, pp. 119–25.

Goldman-Kraft Gallery, Chicago. *Ellsworth Kelly: Painted Wall Sculpture/Graphics*, Apr. 6–May 1, 1984.

Blum Helman Gallery, New York. *Ellsworth Kelly: Works in Wood*, May 2–June 2, 1984. Cat.

Robinson, John. "Ellsworth Kelly." *Arts Magazine* (New York), Sept. 1984, p. 35.

McEvilly, Thomas. "Ellsworth Kelly." *Artforum* (New York), Nov. 1984, p. 98.

Castelli Uptown, New York. *Ellsworth Kelly New Editions*, Nov. 10–Dec. 1, 1984.

Blum Helman Gallery, New York. *Ellsworth Kelly: New Paintings*, Mar. 6–30, 1985.

Gemini G.E.L., Los Angeles. *Ellsworth Kelly: New Wall Reliefs & Lithographs*, Mar. 29, 1985–closing date unknown.

Blum Helman Gallery, New York. *Ellsworth Kelly: Paintings and Sculptures, 1986*. Paintings: Blum Helman Gallery, Apr. 30–June 7, 1986; Sculptures: Blum Helman Warehouse, May 3–June 7, 1986. Cat., text by the artist.

Bankowsky, J. "Ellsworth Kelly." *Flash Art* (Milan), Oct./Nov. 1986, p. 74.

Blum Helman Gallery, New York. *Ellsworth Kelly: Coral Leaf Drawings*, May 4–June 6, 1987.

The Fort Worth Art Museum. *Ellsworth Kelly: Works on Paper*, Sept. 13–Oct. 25, 1987. Cat., text by Diane Upright. Circulating exhibition.

Kutner, Janet. "Reviews and Previews." *Art News* (New York), Nov. 1987, p. 216.

Museum of Fine Arts, Boston. *Ellsworth Kelly: Seven Paintings, 1952–55/87*, Dec. 2, 1987–Jan. 31, 1988. Cat., text by Trevor Fairbrother.

Massachusetts Institute of Technology, Cambridge. *Ellsworth Kelly: Small Sculpture 1958–87*, Dec. 19, 1987–Mar. 27, 1988.

Des Moines Art Center. *Ellsworth Kelly: A Print Retrospective*, Feb. 6–Apr. 3, 1988.

Neuberger Museum, State University of New York, Purchase. *The Prints of Ellsworth Kelly*, Apr. 17–June 12, 1988.

KENNETH NOLAND

By the Artist

Writings

"Editor's Letters." *Art News* (New York), Nov. 1962, p. 6.

"Jackson Pollock; an Artist's Symposium, Part 2." *Art News* (New York), May 1967, pp. 26–29, 69–71.

"Kenneth Noland at Emma Lake." *Ten Washington Artists: 1950–1970*. Edmonton: Edmonton Art Gallery, 1970.

In Paul Cummings, *Artists in Their Own Words*. New York: St. Martin's Press, 1979, p. 149.

Interviews

Cummings, Paul. Unpublished interview recorded at the artist's studio, Dec. 9 and 21, 1971. Washington, D.C.: Archives of American Art.

Waldman, Diane. "Color, Format and Abstract Art: An Interview with Kenneth Noland." *Art in America* (New York), May/June 1977, pp. 99–105.

De Antonio, Emile, and Tuchman, Mitch. *Painters and Painting: A Candid History of the Modern Art Scene, 1940–1970*. New York: Abbevile Press, 1984.

Love, Richard. Interview, Oct. 29, 1985. Videorecording. Chicago: American Art Forum with Richard H. Love.

Love, Richard. Interview, Apr. 1986. Chicago: Richard H. Love Galleries Archives.

On the Artist

Books

Moffett, Kenworth. *Kenneth Noland*. New York: Harry N. Abrams, 1977.

Goldman, Judith. *Kenneth Noland: Handmade Papers*. Bedford Village, N.Y.: Tyler Graphics, 1978.

Selected Articles

Greenberg, Clement. "Louis and Noland." *Art International* (Lugano), May 25, 1960, pp. 26–29.

Rose, Barbara. "Kenneth Noland." *Art International* (Lugano), Summer 1964, pp. 58–61.

Fried, Michael. "Anthony Caro and Kenneth Noland: Some Notes on Not Composing." *The Lugano Review*, Summer 1965, pp. 198–206.

McConogha, Al. "Noland Wants His Painting to Exist as Sensation." *Minneapolis Tribune*, Mar. 13, 1966, p. 4.

Hudson, Andrew. "Kenneth Noland: Sarah's Reach: A Mixture of Stillness and Movement, of Austerity and Exuberance." *The Washington Post*, May 8, 1966, Potomac Section, pp. 14–17.

Brunelle, Al. "The Sky-Colored Popsicle." *Art News* (New York), Nov. 1967, pp. 42–43, 76–78.

Cone, Jane Harrison. "Kenneth Noland's New Paintings." *Artforum* (New York), Nov. 1967, pp. 36–41.

Elderfield, John. "Mondrian, Newman, Noland: Two Notes on Changes of Style." *Artforum* (New York), Dec. 1971, pp. 48–53.

Moffett, Kenworth. "Noland." *Art International* (Lugano), Summer 1973, pp. 22–33, 91–93, 100.

Carpenter, Ken. "To Re-examine the Work of Kenneth Noland." *Studio International* (Lugano), July/Aug. 1974, pp. 21–26.

Ratcliff, Carter. "Notes on a Transitional Period: Noland's Early Circle Paintings." *Art in America* (New York), May–June 1975, pp. 66–67.

Carmean, E. A., Jr. "Kenneth Noland and the Compositional Cut." *Arts Magazine* (New York), Dec. 1975, pp. 80–85.

Moffett, Kenworth. "Kenneth Noland's New Paintings and the Issue of the Shaped Canvas." *Art International* (Lugano), Apr.–May 1976, pp. 8–15, 28–30, 74.

Hess, Thomas B. "Kenneth Noland, Hesitant Prophet." *New York*, May 23, 1977, pp. 76–78.

Rosenberg, Harold. "The Art World: Kenneth Noland." *The New Yorker* (New York), June 20, 1977, pp. 98–102.

Edwards, Ellen. "Pay Attention to Kenneth Noland." *The Miami Herald*, Mar. 5, 1978, page unknown.

Kayami, T. "Kenneth Noland's Paintings: The Whole and the Substance." *Mizue* (Tokyo), Oct. 1978, pp. 88–99.

Mackie, Alwynne. "Kenneth Noland and Quality in Art." *Art International* (Lugano), Summer 1979, pp. 40–45.

Goldstein, Carl. "Teaching Modernism: What Albers Learned in the Bauhaus and Taught to Rauschenberg, Noland, and Hesse." *Arts Magazine* (New York), Dec. 1979, pp. 108–16.

Richard, Paul. "$300,000 Surprise: Kenneth Noland's Washington Color Canvas Hits the Bull's-Eye." *The Washington Post*, Nov. 21, 1981, p. C1.

Telley, C. "The Navajo Tapestry: A Medium of Exchange." *Craft International* (New York), Apr. 1983, pp. 16–20.

"Kenneth Noland's Market." *The Artnewsletter* (New York), May 3, 1983, pp. 5–6.

Wilkin, Karen. "Kenneth Noland: Sensual Made Visual." *Art Press* (Paris), July/Aug. 1984, pp. 24–26.

Tuchman, Phyllis. "Architectural Digest Visits Kenneth Noland." *Architectural Digest* (Los Angeles), July 1985, pp. 110–15.

Selected One-Artist Exhibitions and Reviews

Galerie Creuze, Paris. *Ken Noland*, Apr. 23–May 5, 1949.

Devoluy, John. "Art News in Paris." *International Herald Tribune* (Paris), Apr. 29, 1949, page unknown.

Watkins Gallery, American University, Washington, D.C. *Paintings by Ken Noland*, Dec. 3–22, 1950.

Dubin Gallery, Philadelphia. Title and exact dates unknown, 1951.

Dubin Gallery, Philadelphia. Title and opening dates unknown–Oct. 13, 1952.

Dupont Theater, Washington, D.C. *Kenneth Noland*, opening date unknown–Dec. 15, 1952.

"Noland Abstractions." *The Sunday Star* (Washington, D.C.), Nov. 30, 1952, p. E7.

Dubin Gallery, Philadelphia. Title and opening date unknown–Nov. 10, 1953.

Tibor de Nagy Gallery, New York. *Kenneth Noland*, Jan. 2–19, 1957.

A[shton], D[ore]. "Kenneth Noland Abstractions on Display." *The New York Times*, Jan. 4, 1957, p. 20.

M[ellquist], J[erome]. "Kenneth Noland." *Arts Magazine* (New York), Feb. 1957, p. 65.

S[chuyler], J[ames]. "Kenneth Noland." *Art News* (New York), Feb. 1957, p. 10.

Margaret Dickey Gallery of Art, District of Columbia Teachers College, Washington, D.C. *An Exhibition of Paintings by Kenneth Noland*, Jan. 7–30, 1957.

Jefferson Place Gallery, Washington, D.C. *Kenneth Noland*, Jan. 31–Feb. 22, 1958.

Portner, Leslie Judd. "Art in Washington." *The Washington Post and Times Herald*, Feb. 1958, p. E7.

Tibor de Nagy Gallery, New York. *Kenneth Noland*, Oct. 14–Nov. 6, 1958.

S[chuyler], J[ames]. "Reviews and Previews." *Art News* (New York), Oct. 1958, p. 13.

V[entura], A[nita]. "In the Galleries." *Arts* (New York), Oct. 1958, p. 57.

French and Co., New York. *Kenneth Noland: Paintings,* Oct. 14–Nov. 4, 1959. Cat.

Ashton, Dore. "Art: An Emphasis on Size." *The New York Times,* Oct. 16, 1959, p. 61.

Campbell, Lawrence. "Kenneth Noland." *Art News* (New York), Oct. 1959, p. 16.

Sawin, Martica. "Kenneth Noland." *Arts Magazine* (New York), Nov. 1959, p. 58.

Sawin, Martica. "New York Letter." *Art International* (Lugano), vol. III, no. 9, 1959, pp. 10–11.

Jefferson Place Gallery, Washington, D.C. *Paintings by Kenneth Noland Selected from His Recent Exhibit at French and Co., New York,* Jan. 5–21, 1960.

Wolfe, Thomas. "Artist's New Technique Goes All Over." *The Washington Post,* Jan. 5, 1960, p. A10.

Ahlander, Leslie Judd. "American Art in Microcosm." *The Washington Post,* Jan. 17, 1960, p. E7.

Sawyer, Kenneth B. "Art Notes: Noland and Hartigan Exhibits." *The Sun* (Baltimore), Jan. 31, 1960, p. 5.

Galleria dell'Ariete, Milan. *Kenneth Noland,* Nov. 3–18, 1960. Cat., text by Clement Greenberg, excerpted from "Louis and Noland." *Art International* (Lugano), vol. 4, no. 5, 1960.

Curonici, Giuseppe. "Pittura di Kenneth Noland." *Cenobio* (Lugano), Nov.–Dec. 1960, page unknown.

André Emmerich Gallery, New York. *Kenneth Noland: New Work,* Mar. 14–Apr. 1, 1961.

Preston, Stuart. "Art." *The New York Times,* Mar. 18, 1961, p. 17.

Burrows, Carlyle. "Noland Art 'Purist'." *New York Herald Tribune,* Mar. 19, 1961, Section 4, p. 20.

Sandler, Irving H. "New York Letter." *Art International* (Lugano), May 1, 1961, pp. 52–53.

S[andler], I[rving] H[ershel]. "Reviews and Previews." *Art News* (New York), May 1961, p. 15.

R[aynor], V[ivien]. "In the Galleries." *Arts* (New York), May–June 1961, p. 98.

The New Gallery, Bennington College, Vermont. *Kenneth Noland,* Apr. 18–May 15, 1961. Cat., text by E. C. Goossen.

Galerie Neufville, Paris. *Kenneth Noland,* Apr. 25–May 27, 1961.

Ashbery, John. "Paris Notes." *Art International* (Lugano), June–Aug. 1961, pp. 42, 92.

Galerie Alfred Schmela, Dusseldorf. *Kenneth Noland,* Mar. 30–Apr. 30, 1962.

Galerie Charles Lienhard, Zurich. *Kenneth Noland,* Mar. 1962. Cat., text by E. C. Goossen.

André Emmerich Gallery, New York. *Kenneth Noland,* Apr. 10–May 5, 1962.

O'Doherty, Brian. "Targets by Noland." *The New York Times,* Apr. 14, 1962, p. 22.

Sandler, Irving. "In the Art Galleries." *The New York Post,* Apr. 22, 1962, Magazine Section, p. 12.

C[ampbell], L[awrence]. "Reviews and Previews." *Art News* (New York), May 1962, p. 11.

Judd, Donald. "Kenneth Noland." *Arts Magazine* (New York), Sept. 1962, p. 49.

Kozloff, Max. "New York Letter." *Art International* (Lugano), Sept. 1962, p. 38.

Kasmin Limited, London. *Kenneth Noland: Paintings, 1959–62,* Apr. 18, 1963–closing date unknown. Cat., text by Clement Greenberg, excerpted from "Louis and Noland." *Art International* (Lugano), vol. 4, no. 5, 1960.

"Abstract Painting from Paris and the United States." *The Times* (London), Apr. 24, 1963, p. 15.

Lucie-Smith, Edward. [Review in] *The Listener* (London), May 2, 1963, page unknown.

Lynton, Norbert. "London Letter." *Art International* (Lugano), May 25, 1963, p. 58.

Mullins, Edwin. "In Search of a Line." *Apollo* (London), May 1963, p. 416.

Melville, Robert. "Exhibitions Painting and Sculpture." *Architectural Review* (London), July 1963, p. 58.

Galerie Lawrence, Paris. *Kenneth Noland,* Apr. 23–May 16, 1963. Cat.

Ashbery, John. "American Gallery in Paris Sells U.S. Art to Europeans." *International Herald Tribune* (Paris), May 2, 1963, p. 7.

André Emmerich Gallery, New York. *Kenneth Noland,* Apr. 23–May 18, 1963.

Fried, Michael. "New York Letter." *Art International* (Lugano), May 25, 1963, pp. 69–70.

Sandler, Irving H. "Reviews and Previews." *Art News* (New York), May 1963, p. 11.

Judd, Donald. "In the Galleries." *Arts* (New York), Sept. 1963, pp. 53–54.

Galerie Alfred Schmela, Dusseldorf. *Kenneth Noland,* May 22–June 19, 1964.

André Emmerich Gallery, New York. *Kenneth Noland: New Work,* Nov. 10–28, 1964.

Canaday, John. "Straw Without Bricks." *The New York Times,* Nov. 15, 1964, p. 23.

Campbell, Lawrence. "Reviews and Previews." *Art News* (New York), Dec. 1964, p. 14.

Ashton, Dore. "Visual Pleasure from Austerity: New York Commentary." *Studio International* (London), Feb. 1965, p. 92.

Lippard, Lucy R. "New York Letter." *Art International* (Lugano), Feb. 1965, pp. 34–35.

Galleria Notizie, Turin, Italy. *Noland e Stella,* Nov. 16–Dec. 20, 1964. Cat., text by Alan Solomon.

The Jewish Museum, New York. *Kenneth Noland,* Feb. 4–Mar. 7, 1965. Cat. text by Michael Fried.

Preston, Stuart. "Jewish Museum has Noland in Variety." *The New York Times,* Feb. 5, 1965, p. 34.

Campbell, Lawrence. "Reviews and Previews." *Art News* (New York), Mar. 1965, p. 12.

Judd, Donald. "Kenneth Noland." *Arts Magazine* (New York), Mar. 1965, pp. 54–55.

Judd, Don. "New York Letter." *Art International* (Lugano), Apr. 1965, p. 74.

Harrison, Jane. "On Color in Kenneth Noland's Painting." *Art International* (Lugano), June 1965, pp. 36–38.

David Mirvish Gallery, Toronto. *Recent Works by Kenneth Noland,* Feb. 21–Mar. 16, 1965.

Kasmin Limited, London. *Kenneth Noland: New Paintings,* Apr. 2–May 2, 1965.

Gosling, Nigel. "Art: Surprises from New York." *The Observer* (London), Apr. 4, 1965, p. 25.

Thompson, David. "Art: Provocative New Talent." *The Queen* (London), Apr. 7, 1965, page unknown.

"Six Paintings by Mr. K. Noland." *The Times* (London), Apr. 8, 1965, p. 6.

Mullins, Edwin. "Art: Most Important American." *Sunday Telegraph* (London), Apr. 11, 1965, page unknown.

Wraight, Robert. "On the Galleries: Ringing the Non-bells." *Tatler* (London), Apr. 21, 1965, p. 163.

Baro, Gene. "London Letter." *Art International* (Lugano), June 1965, pp. 68–70.

Melville, Robert. "Gallery: The Amazing Continuity." *Architectural Review* (London), July 1965, p. 57.

André Emmerich Gallery, New York. *Kenneth Noland,* Feb. 22–Mar. 13, 1966.

Kramer, Hilton. "Art: The Postwar European Scene Documented." *The New York Times,* Feb. 26, 1966, p. 21.

Bourdon, David. [Review in] *The Village Voice* (New York), Mar. 10, 1966.

C[ampbell], L[awrence]. "Reviews and Previews." *Art News* (New York), Apr. 1966, p. 52.

Lippard, Lucy R. "New York Letter." *Art International* (Lugano), Apr. 1966, pp. 73–75.

Swenson, G. R. "New York: The Boundaries of Chaos." *Art and Artists* (London), Apr. 1966, p. 62.

Ashton, Dore. "Conditioned Historic Reactions: New York Commentary." *Studio International* (London), May 1966, p. 206.

B[erkson], W[illiam]. "Kenneth Noland." *Arts Magazine* (New York), May 1966, p. 59.

Nicholas Wilder Gallery, Los Angeles. *Kenneth Noland: Recent Paintings,* Nov. 8–26, 1966.

David Mirvish Gallery, Toronto. *Kenneth Noland: 1966–67 Paintings,* Sept. 14–Oct. 15, 1967.

Russell, Paul. "Kenneth Noland." *Artscanada* (Toronto), Nov. 1967, p. 8.

André Emmerich Gallery, New York. *Kenneth Noland,* Nov. 11–30, 1967.

Kramer, Hilton. "Kenneth Noland." *The New York Times,* Nov. 18, 1967, p. 31.

Perreault, John. "Art: Stripes as Stripes." *The Village Voice* (New York), Nov. 30, 1967, pp. 21, 26.

Kozloff, Max. "Art." *The Nation* (New York), Dec. 18, 1967, p. 668.

F[eldman], A[nita]. "Kenneth Noland." *Arts Magazine* (New York), Dec. 1967–Jan. 1968, p. 60.

Mellow, James R. "New York Letter." *Art International* (Lugano), Jan. 20, 1968, pp. 62–64.

Ashton, Dore. "New York." *Studio International* (London), Feb. 1968, p. 93.

Kasmin Limited, London. *Kenneth Noland,* June 7–July 6, 1968.

Lynton, Norbert. "Wide Open Spaces." *The Guardian* (Manchester, Eng.), June 15, 1968, p. 6.

Robertson, Bryan. "Arts: The Straight and Narrow." *Spectator* (London), June 21, 1968, pp. 861–62.

Harrison, Charles. "Recent Works by Kenneth Noland at Kasmin until July 6." *Studio International* (London), July/Aug. 1968, pp. 35–36.

Gordon, Alistair. "Art in the Modern Manner." *Connoisseur* (London), Sept. 1968, pp. 38–39.

Lawrence Rubin Gallery, New York. *Kenneth Noland,* Apr. 5–30, 1969.

"Noland: The Spectrum is the Message." *Time* (New York), Apr. 18, 1969, pp. 74–75.

K[line], K[atherine]. "Reviews and Previews." *Art News* (New York), Summer 1969, p. 20.

Schjeldahl, Peter. "New York Letter." *Art International* (Lugano), Summer 1969, pp. 64–65.

Galerie Renée Ziegler, Zurich. *Kenneth Noland,* Dec. 12, 1969–Jan. 31, 1970.

C[urjel], H[ans]. "Zürich: Kenneth Noland." *Werk* (Basel), Mar. 1970, p. 207.

Kasmin Limited and The Waddington Galleries, London. *Kenneth Noland: New Paintings,* June 9–July 4, 1970. Cat.

J. L. Hudson Gallery, Detroit. *Kenneth Noland,* opening date unknown–Sept. 1970.

Jack Glenn Gallery, Corona del Mar, California. *Kenneth Noland,* Oct. 9–Nov. 13, 1971.

André Emmerich Gallery, New York. *Kenneth Noland: New Paintings,* Oct. 9–Nov. 3, 1971. Cat.

Kramer, Hilton. "Noland Paintings Begin a New Series." *The New York Times,* Oct. 23, 1971, p. 25.

Moffett, Kenworth. "Noland Vertical." *Art News* (New York), Oct. 1971, pp. 48–49, 76–78.

Bannard, Walter D. "Noland's New Paintings." *Artforum* (New York), Nov. 1971, pp. 50–53.

Domingo, Willis. "Kenneth Noland: André Emmerich." *Arts Magazine* (New York), Nov. 1971, p. 59.

Ratcliff, Carter. "New York Letter." *Art International* (Lugano), Dec. 20, 1971, pp. 59–60.

Irving Blum Gallery, Los Angeles. *Kenneth Noland,* Nov. 9, 1971–closing date unknown.

Galerie Mikro, Berlin. *Kenneth Noland,* Apr. 28–Aug. 15, 1972.

The Waddington Galleries II, London. *Kenneth Noland: New Paintings,* July 10–Aug. 4, 1973.

Denvir, Bernard. "Hans Hofmann and Kenneth Noland at the Waddington Gallery." *Studio International* (London), Sept. 1973, pp. 107–8.

André Emmerich Gallery, New York. *Kenneth Noland: New Paintings,* Feb. 17–Mar. 7, 1973. Cat.

Kramer, Hilton. "Kenneth Noland and the New Romanticism." *The New York Times,* Mar. 4, 1973, p. 25.

Rose, Barbara. "Beyond the Madding Crowd." *New York,* Mar. 12, 1973, p. 74.

Alloway, Lawrence. "Art: Kenneth Noland." *The Nation* (New York), Mar. 19, 1973, pp. 381–82.

Bell, Jane. "Kenneth Noland/Emmerich Uptown." *Arts Magazine* (New York) Apr. 1973, pp. 78–79.

Siegel, Jeanne. "Reviews and Previews." *Art News* (New York), Apr. 1973, pp. 78–79.

Borden, Lizzie. "Kenneth Noland: André Emmerich Gallery Uptown." *Artforum* (New York), May 1973, pp. 77–78.

Weinstein, David. "Noland and Zox at Emmerich." *Art in America* (New York), Sept.–Oct. 1973, pp. 94–96.

Galerie André Emmerich, Zurich. *Kenneth Noland,* Sept. 7–Oct. 20, 1973.

Janie C. Lee Gallery, Houston. *Kenneth Noland,* Mar. 2–Apr. 6, 1974.

Galerie Wentzel, Hamburg, West Germany. *Kenneth Noland Bilder,* May 17–June 12, 1974.

David Mirvish Gallery, Toronto. *Kenneth Noland,* June 1–29, 1974.

Jack Glenn Gallery, Corona del Mar, California. *Kenneth Noland,* July 1–31, 1974.

The Waddington Galleries II, London. *Kenneth Noland: New Paintings,* July 10–Aug. 4, 1974.

Rutland Gallery, London. *Kenneth Noland,* Nov. 12–Dec. 14, 1974. Cat.

Walker, Richard. "Kenneth Noland: Rutland Gallery." *Arts Review* (London), Nov. 1974, p. 712.

Rees, R. J. "Kenneth Noland." *Studio International* (London) Jan.–Feb. 1975, p. 14.

Visual Arts Gallery, School of Visual Arts, New York. *Kenneth Noland: Early Circle Paintings,* Jan. 6–31, 1975. Cat., text by Jeanne Siegel.

Russell, John. "Art: Noland's Early Circles, Genuine Contributions." *The New York Times,* Jan. 11, 1975, p. 19.

Edmonton Art Gallery, Canada. *Kenneth Noland,* Mar. 6–Apr. 21, 1975. Cat., text by Karen Wilken.

Watson/de Nagy and Company, Houston. *Kenneth Noland,* Oct. 23–Nov. 8, 1975.

André Emmerich Gallery, New York. *Kenneth Noland: New Paintings,* Nov. 15–Dec. 6, 1975.

Russell, John. "Art: In Show of New Noland Paintings, Consistency Takes Unexpected Forms." *The New York Times,* Nov. 22, 1975, p. 38.

Perreault, John. "Now That The War is Over." *The Soho Weekly News* (New York), Nov. 27, 1975, p. 18.

Bourdon, David. "Art: Abstract Painting Changes Shape." *The Village Voice* (New York), Dec. 8, 1975, pp. 130, 133.

Wooster, Ann-Sargent. "Kenneth Noland: Emmerich." *Art News* (New York), Jan. 1976, p. 119.

Derfner, Phyllis. "New York Letter." *Art International* (Lugano), Jan.–Feb. 1976, p. 59.

Patton, Phil. "Kenneth Noland: André Emmerich Gallery, Downtown." *Artforum* (New York), Feb. 1976, p. 65.

Hoesterey, Ingeborg. "New York." *Art International* (Lugano), Feb.–Mar. 1976, pp. 64–65.

Gablik, Suzi. "Kenneth Noland at Emmerich Downtown." *Art in America* (New York), Mar.–Apr. 1976, p. 104.

Galleria la Polena, Genoa, Italy. *Noland,* Feb. 26–Mar. 23, 1976. Cat., text by Germano Beringheli.

Galleria Morone 6, Milan. *Kenneth Noland,* Apr. 8–May 10, 1976. Cat., text by Germano Beringheli.

David Mirvish Gallery, Toronto. *Kenneth Noland: An Exhibition of Paintings from 1958–1973,* Apr. 10–May 5, 1976.

Galerie André Emmerich, Zurich. *Kenneth Noland,* Oct. 9–Nov. 13, 1976.

Galerie Daniel Templon, Paris. *Kenneth Noland,* Oct. 16–Nov. 12, 1976.

Crichton, Fenella. "Paris and the F.I.A.C." *Art International* (Lugano), Dec. 1976, pp. 42–43.

Leo Castelli Gallery, New York. *Kenneth Noland,* Oct. 23–Nov. 13, 1976.

Frackman, Noel. "Kenneth Noland: Leo Castelli Uptown." *Arts Magazine* (New York), Jan. 1977, p. 26.

Skoggard, Ross. "Kenneth Noland: Leo Castelli Gallery Uptown." *Artforum* (New York), Jan. 1977, p. 64.

Galerie Wentzel, Hamburg, West Germany. *Kenneth Noland: Neue Bilder 1976,* Nov. 12, 1976–Jan. 29, 1977. Cat., consisting of announcement and supplement of German translation of article by Kenworth Moffett, "Kenneth Noland's New Paintings and the Issue of the Shaped Canvas." *Art International* (Lugano), Apr.–May 1976, pp. 8–15, 28–30, 74.

Winter, Peter. "Kenneth Noland." *Kunstwerk* (Stuttgart), Feb. 1977, p. 79.

The Solomon R. Guggenheim Museum, New York. *Kenneth Noland: A Retrospective,* Apr. 15–June 19, 1977. Cat., text by Diane Waldman. Circulating exhibition.

Kramer, Hilton. "Art: Landmarks on the Color Field." *The New York Times,* Apr. 22, 1977, p. 20.

Russell, John. "Gallery View: A Show to Lighten Your Step and Bring Smiles." *The New York Times,* May 1, 1977, pp. 29, 34.

Bourdon, David. "Kenneth Noland: Retreating from Olympus." *The Village Voice* (New York), May 2, 1977, p. 85.

Hughes, Robert. "Art: Pure, Uncluttered Hedonism." *Time* (New York), May 2, 1977, p. 69.

Kingsley, April. "But What Does It Mean?" *The Soho Weekly News* (New York), May 12, 1977, pp. 20–21.

Stevens, Mark. "Noland's Garden of Color." *Newsweek* (New York), May 16, 1977, p. 72.

Ratcliff, Carter. "New York Letter." *Art International* (Lugano), July–Aug. 1977, p. 82.

Polcari, Stephen. "Kenneth Noland: Independence in the Face of Conformity." *Art News* (New York), Summer 1977, pp. 153–55.

Richard, Paul. "Look Who's Back, Letting Color Sing." *The Washington Post,* Sept. 30, 1977, pp. C1–2.

Bremer, Nina. "Review." *Pantheon* (Munich), Oct.–Dec. 1977, p. 374.

Wright, Martha McWilliams. "Washington." *Art International* (Lugano), Jan. 1978, pp. 65–66.

André Emmerich Gallery, New York. *Kenneth Noland: New Paintings,* Dec. 10, 1977–Jan. 11, 1978. Cat.

Kaufman, Betty. "Noland's Pitch." *Art/World* (New York), Dec. 10, 1977–Jan. 13, 1978, p. 6.

Burnside, Madeline. "Kenneth Noland: André Emmerich." *Art News* (New York), Feb. 1978, p. 138.

Perrone, Jeff. "Kenneth Noland: André Emmerich Gallery." *Artforum* (New York), Feb. 1978, pp. 65–66.

Frackman, Noel. "Kenneth Noland/Hans Hofmann: André Emmerich." *Arts Magazine* (New York), Mar. 1978, pp. 23–24.

Theo Waddington Galleries, Toronto. *Kenneth Noland: Recent Paintings,* June 7–24, 1978. Cat.

Meredith Long & Co., Houston. *Kenneth Noland: Paper Works,* Oct. 4–27, 1978.

André Emmerich Gallery, New York. *Kenneth Noland: Recent Watercolors,* Oct. 21–Nov. 11, 1978.

Cavaliere, Barbara. "Kenneth Noland." *Arts Magazine* (New York), Jan. 1979, p. 20.

Schwartz, Ellen. "Kenneth Noland." *Art News* (New York), Jan. 1979, pp. 138–39.

The Parke-McCullough House, North Bennington, Vermont. *Handmade Papers by Kenneth Noland,* Nov. 18–Dec. 9, 1978.

Waddington, London. *Kenneth Noland: Recent Paintings,* Mar. 6–31, 1979.

Waddington Graphics, London. *Kenneth Noland: Paper Works 1978,* Mar. 6–31, 1979.

Waddington, Montreal. *Kenneth Noland Handmade Papers,* Mar. 17–Apr. 6, 1979.

Theo Waddington, Toronto. *Handmade Papers by Kenneth Noland,* June 16, 1979–closing date unknown.

Thomas Segal Gallery, Boston. *Kenneth Noland: New Works on Paper,* Nov. 3–28, 1979.

Katonah Gallery, New York. *Kenneth Noland: Ceramics and Handmade Papers,* Nov. 11, 1979–Jan. 6, 1980.

Leo Castelli Gallery, New York. *Kenneth Noland,* Nov. 17–Dec. 8, 1979.

Morgan, S. "Kenneth Noland." *Flash Art* (Milan), Jan.–Feb. 1980, p. 28.

Castelli Uptown, New York. *Kenneth Noland: Handmade Rag Papers,* Feb. 16–Mar. 8, 1980.

André Emmerich Gallery, New York. *Noland,* May 24–June 30, 1980.

Galerie Wentzel, Hamburg, West Germany. *Kenneth Noland: Handmade Paper,* Sept. 1980.

Ulrich Museum of Art, Wichita State University, Kansas. *Kenneth Noland: Paintings,* Oct. 1–Nov. 2, 1980.

André Emmerich Gallery, New York. *Kenneth Noland: New Paintings,* Nov. 1–19, 1980. Cat.

Ffrench-Frazier, Nina. "New York's Winter Set: Kenneth Noland." *Art International* (Lugano), Jan.–Feb. 1981, p. 142.

Asher/Faure, Los Angeles. *Kenneth Noland: Handmade Paper Collages,* Nov. 29–Dec. 31, 1980.

Heath Gallery, Atlanta. *Kenneth Noland: First Atlanta Exhibition, Paperworks,* Mar. 7–Apr. 1981.

Waddington, Montreal. *Kenneth Noland: Handmade Papers,* May 6–30, 1981.

André Emmerich Gallery, New York. *Kenneth Noland: New Paintings,* May 27–June 26, 1981.

Waddington, London. *Kenneth Noland,* Oct. 7–31, 1981.

Burr, James. "Round the Galleries: Savage Images." *Apollo* (London), Oct. 1981, p. 268.

Theo Waddington Galleries, Toronto. *Kenneth Noland,* Oct. 24–Nov. 14, 1981.

Clarke-Benton Gallery, Santa Fe. *Kenneth Noland Paper Works*, Dec. 1981.

Downstairs Gallery, Edmonton, Canada. *Kenneth Noland: New Works of Handmade Rag Paper*, Jan. 18–30, 1982.

School of Visual Arts Gallery, New York. Title unknown, Mar. 8–26, 1982.

André Emmerich Gallery, New York. *Kenneth Noland: Monotypes*, May 6–28, 1982.

Ameringer, Will. "Kenneth Noland." *Arts Magazine* (New York), May 1982, p. 3.

Thomas Segal Gallery, Boston. *Kenneth Noland: Chevrons*, May 8–June 5, 1982.

Douglas Drake Gallery, Kansas City, Missouri. *Kenneth Noland: Ceramic Reliefs and Handmade Paper*, June 11–July 17, 1982.

B. R. Kornblatt Gallery, Washington, D.C. *Kenneth Noland*, Oct. 30–Dec. 1, 1982.

Lewis, JoAnn. "Noland's Paper Art." *Washington Post*, Oct. 30, 1982.

André Emmerich Gallery, New York. *Kenneth Noland: New Paintings*, Mar. 3–Apr. 2, 1983. Cat.

Tatransky, Valentin. "Kenneth Noland: As Great As Ever." *Arts Magazine* (New York), June 1983, pp. 118–19.

Henry, Gerrit. "Kenneth Noland at André Emmerich." *Art in America* (New York), Summer 1983, pp. 157–58.

Duke University Museum of Art, Durham, North Carolina. *Kenneth Noland Recent Paperworks*, Mar. 15–Apr. 5, 1983. Cat., text by Elizabeth Higdon.

Galeria Joan Prats, Barcelona. *Kenneth Noland: Monotypes*, May 1983.

André Emmerich Gallery, New York. *Kenneth Noland: Winds, Painted Monotypes*, Nov. 10–Dec. 3, 1983. Cat., text by Henry Geldzahler.

Glaberson, Barbara. "Kenneth Noland." *Art World* (New York), Nov. 1983, p. 6.

Museo de Arte Moderno, Taller de Grafica Mexicana, Mexico City. *Kenneth Noland "Vientos" (Winds)*, exact dates unknown, 1983. Cat., text by Henry Geldzahler.

Galeria Joan Prats, New York. *Kenneth Noland "Barcelona Suite" Monotypes*, Apr. 3–30, 1984.

Waddington & Shiell, Toronto. *Paintings 1960–1982 by Kenneth Noland*, Apr. 14–May 5, 1984.

Galerie de France, Paris. *Kenneth Noland in Paris, 1984*, June 14–July 29, 1984. Cat., text by Ann Hindry.

"Espace-lumière." *Connaissance des Arts* (Paris), June 1984, p. 25.

Reinhard Onnasch Galerie, Berlin. *Kenneth Noland: Neue Bilder, New Paintings, 1984*, Sept. 22–Nov. 3, 1984. Cat., texts by Ilona Linderberg, Michael Pauseback. Circulating exhibition.

Ohff, Heinz. "Kenneth Noland." *Kunstwerk* (Stuttgart), Dec. 1984, pp. 49–50.

Makler Gallery, Philadelphia. *Kenneth Noland: Sketches at Spain Monotypes*, Oct. 1–31, 1984.

André Emmerich Gallery, New York. *Kenneth Noland: New Paintings*, Dec. 6–29, 1984. Cat.

McEvilley, Thomas. "Kenneth Noland, André Emmerich Gallery." *Artforum* (New York), Mar. 1985, pp. 91–92.

André Emmerich Gallery, New York. *Kenneth Noland: Doors and Ghosts, Painted Monotypes*, Mar. 6–30, 1985. Cat.

André Emmerich Gallery, New York. *Kenneth Noland: Paintings of the 1960's, Chevrons and Stripes*, Oct. 31–Nov. 30, 1985. Cat.

Gallery 10, New York. *Kenneth Noland and American Indian Weavers: Gloria F. Ross Tapestries*, Nov. 7, 1985–Jan. 4, 1986.

André Emmerich Gallery, New York. *Kenneth Noland: New Paintings*, Apr. 3–26, 1986. Cat.

[Review in] *Art & Antiques* (New York), Apr. 1986, p. 37.

Richard H. Love Modern, Chicago. *Kenneth Noland: Major Works*, May 3–June 21, 1986. Cat., text by Richard H. Love. Circulating exhibition.

Morgan, Ann Lee. "Kenneth Noland." *Art Examiner* (Chicago), Summer 1986, p. 45.

Moser, Charlotte. "Reviews and Previews." *Art News* (New York), Nov. 1986, p. 29.

Gallery One, Toronto. *Kenneth Noland: Rains, Painted Monotypes*, May 17–June 4, 1986. Cat.

Robert Martin Gallery, Westchester Financial Center, White Plains, New York. *Kenneth Noland: "Rains"*, June 23–July 10, 1986. Cat.

Butler Institute of American Art, Youngstown, Ohio. *Kenneth Noland: Major Works*, July 20–Aug. 31, 1986.

André Emmerich Gallery, New York. *Kenneth Noland: New Paintings*, Jan. 28–Feb. 20, 1988.

Mixografia Gallery, Los Angeles. *Kenneth Noland: "Rains" Printed Monotypes*, May 21–June 17, 1988. Cat.

GENE DAVIS

By the Artist

Writings

"Statement." *Art Now: New York* (New York), vol. 2, no. 2, 1970 [pp. 1–2].

"Random Thoughts on Art." *Art International* (Lugano), Nov. 6, 1971, pp. 39–42.

Wall, Donald. "Gene Davis on Gene Davis." *Art in America* (New York), May–June 1973, pp. 36–41.

"Painters Reply . . ." *Artforum* (New York), Sept. 1975, pp. 26–36.

"Gorky Taught Me That: A Remembrance of Arshile Gorky." *Arts Magazine* (New York), Mar. 1976, p. 81.

"Starting Out in the '50's." *Art in America* (New York), July–Aug. 1978, pp. 88–94.

"Arts: A New York State of Mind." *Washington Post*, Nov. 3, 1981, p. B7.

"Gene Davis Talks about His Exhibit 'Child and Man'." *Washington Review*, Feb.–Mar., 1984, pp. 16–17.

"Gene Davis: Integral Color." *Architecture* (Washington, D.C.), May 1984, p. 233.

Interviews

Baro, Gene. "Preoccupation with Colour: Conversations with Gene Davis and Albert Stadtler." *Studio International* (London), Nov. 1967, pp. 204–11.

Rose, Barbara. "Conversation with Gene Davis." *Artforum* (New York), Mar. 1971, pp. 50–54.

Hopps, Walter. "Gene Davis and the Stripe as Subject Matter." *Art News* (New York), Feb. 1975, pp. 32–36.

Cohen, Jean Lawlor. "Of Stripes on Canvas: A Conversation with Gene Davis." *Washington Star*, Dec. 17, 1978, p. D2.

Swift, Mary. "An Interview with Gene Davis." *Washington Review*, Dec. 1978–Jan. 1979, pp. 7–9.

Cohen, Jean Lawlor. "A Conversation with Gene Davis." *Art International* (Lugano), Summer 1979, pp. 53–61.

On the Artist

Books

Wall, Donald, ed. *Gene Davis*. New York: Praeger Publishers, 1975. Interviews by Walter Hopps, Barbara Rose, and Donald Wall.

Baro, Gene. *Gene Davis Drawings*. New York: Arts Publisher, 1982.

Naifeh, Steven W. *Gene Davis*. New York: Arts Publisher, 1982.

Selected Articles

Ahlander, Leslie Judd. "Art in Washington: An Artist Speaks." *Washington Post*, Aug. 26, 1962, p. G7.

Ahlander, Leslie Judd. "Emerging Art in Washington." *Art International* (Lugano), Nov. 1962, pp. 30–33.

Rose, Barbara. "The Primacy of Color." *Art International* (Lugano), May 1964, pp. 22–26.

Stevens, Elisabeth. "The Washington Color Painters." *Arts Magazine* (New York), Nov. 1965, pp. 30–31.

Nordland, Gerald. "Gene Davis Paints a Picture." *Art News* (New York), Apr. 1966, pp. 46–49, 61–64.

Kainen, Jacob. "Gene Davis and the Art of Color Interval." *Art International* (Lugano), Dec. 1966, pp. 31–33.

Green, Eleanor. "Gene Davis." *Corcoran Gallery of Art Bulletin* (Washington, D.C.), Nov. 1967, pp. 27–30.

Lawlor, Jean G. "Gene Davis and the Art of His Stripe." *Washington Post*, Feb. 25, 1968, Potomac Section, pp. 11–13, 16–17, 19.

Richard, Paul. "Nothing Ordinary about a Davis Stripe." *Washington Post* (Washington D.C.), July 14, 1968, p. E1.

Wall, Donald. "The Micro-Paintings of Gene Davis." *Artforum* (New York), Dec. 1968, pp. 46–50.

Pomeroy, Ralph. "Gene Davis." *Arts Magazine* (New York), Mar. 1970, pp. 32–34.

Richard, Paul. "Gene Davis: His Subject Is the Stripe." *Washington Post*, Nov. 22, 1970, p. E8.

Wall, Donald. "Gene Davis and the Issue of Complexity." *Studio International* (Lugano), Nov. 1970, pp. 188–91.

Loring, John. "Print as Surface." *Arts Magazine* (New York), Sept. 1973, pp. 48–49.

Wall, Donald. "Gene Davis: New Paintings." *Arts Magazine* (New York), June 1975, pp. 69–71.

Baro, Gene. "Gene Davis: The Drawn Image." *Arts Magazine* (New York), May 1976, pp. 106–7.

Wall, Donald. "Striped Paintings of Gene Davis and Morris Louis." *Arts Magazine* (New York), Dec. 1976, pp. 106–15.

Lewis, JoAnn. "Stripes of an Artist's Life." *Washington Post*, Jan. 30, 1977, pp. E1, E3.

Henry, Gerrit. "Gene Davis: Window Paintings." *Arts Magazine* (New York), Apr. 1978, pp. 154–55.

Tannous, David. "Those Who Stay." *Art in America* (New York), July/Aug. 1978, pp. 78–87.

Naifeh, Steven. "Gene Davis: Beyond the Stripe." *Art International* (Lugano), Sept.–Oct. 1980, pp. 107–16.

Baro, Gene. "Gene Davis." *Arts Magazine* (New York), Nov. 1982, pp. 44–45.

Pennington, Buck. "Regional Office Reports: Mid-Atlantic." *Archives of American Art Journal* (Washington, D.C.), no. 1, 1982, p. 32.

Drath, Viola. "Gene Davis: Stripes Forever." *Washington Dossier*, Feb. 1983, pp. 16–20.

Allen, Jane Addams. "Gene Davis: He Aims to Please Himself." *Washington Times*, Mar. 21, 1983, p. B12.

Hynes, Timothy. "Gene Davis: Where Opposites Meet." *Arts Magazine* (New York), June 1983, pp. 88–90.

Selected One-Artist Exhibitions and Reviews

Dupont Theater Gallery, Washington, D.C. *Drawings by Gene Davis*, Sept. 30–Nov. 10, 1952. Cat., introduction by Jacob Kainen; statement by the artist.

Catholic University, Washington, D.C. *Gene Davis*, Nov. 30–Dec. 15, 1953.

Watkins Gallery, American University, Washington, D.C. *Gene Davis*, Feb. 13–Mar. 6, 1955.

Jefferson Place Gallery, Washington, D.C. *Gene Davis*, Mar. 3–21, 1959.

Jefferson Place Gallery, Washington, D.C. Title unknown, June 1960.

Jefferson Place Gallery, Washington, D.C. *Gene Davis*, Jan. 10–28, 1961.

Jefferson Place Gallery, Washington, D.C. *Gene Davis*, Nov. 27–Dec. 15, 1962.

Poindexter Gallery, New York. *Gene Davis*, Sept. 17–Oct. 5, 1963.

 Judd, Donald. "Gene Davis." *Arts Magazine* (New York), Oct. 1963, pp. 59–60.

 Swenson, G. R. "Reviews and Previews." *Art News* (New York), Nov. 1963, p. 18.

Corcoran Gallery of Art, Washington, D.C. *Gene Davis: Washington Artists Exhibition*, Dec. 17, 1963–Jan. 12, 1964.

Poindexter Gallery, New York. *Gene Davis*, Feb. 16–Mar. 6, 1965.

 Barnitz, Jacqueline. "Gene Davis." *Arts Magazine* (New York), Apr. 1965, p. 57.

 Edgar, Natalie. "Gene Davis." *Art News* (New York), Apr. 1965, p. 12.

 Lippard, Lucy R. "New York Letter." *Art International* (Lugano), Apr. 1965, pp. 60–61.

Poindexter Gallery, New York. *Gene Davis*, Jan. 4–22, 1966.

 Baker, Elizabeth C. "Reviews and Previews." *Art News* (New York), Feb. 1966, p. 14.

 Jacobs, Jay. "Gene Davis." *Arts Magazine* (New York), Mar. 1966, p. 55.

Hofstra University, Hempstead, New York. *Gene Davis: Selected Paintings 1963–1966*, Nov. 1–29, 1966. Cat., introduction by Michael Phillips.

Hayden Gallery, Massachusetts Institute of Technology, Cambridge. *Gene Davis: Recent Paintings*, Jan. 10–Feb. 4, 1967. Cat., text by Bitite Vinklers.

Poindexter Gallery, New York. *Gene Davis, New Paintings*, Feb. 7–25, 1967.

 Burton, Scott. "Reviews and Previews." *Art News* (New York), Mar. 1967, p. 12.

Jefferson Place Gallery, Washington, D.C. *Sonata for Three Rooms*, Mar. 27–Apr. 15, 1967.

Fischbach Gallery, New York. *Gene Davis: New Paintings*, Oct. 14–Nov. 2, 1967.

Galerie Ricke, Kassel, West Germany. *Gene Davis: Bilder 1964–1967*, Dec. 1, 1967–Jan. 18, 1968.

The Jewish Museum, New York. *Gene Davis*, Mar. 20–May 12, 1968.

 Feldman, Anita. "Gene Davis, Robert Irwin, Richard Smith." *Arts Magazine* (New York), May 1968, p. 54.

Fischbach Gallery, New York. *Micro-Paintings, 1966*, Apr. 6–27, 1968.

 Simon, Rita. "Gene Davis—Micro-paintings 1966." *Arts Magazine* (New York), May 1968, p. 57.

 Pomeroy, Ralph. "Reviews and Previews." *Art News* (New York), Summer 1968, p. 14.

San Francisco Museum of Modern Art. *Gene Davis*, Apr. 10–May 12, 1968. Cat., introduction by Gerald Nordland. Circulating exhibition.

Henri Gallery, Washington, D.C. *Gene Davis: New Paintings and Sculpture*, June 11–July 1968.

Fischbach Gallery, New York. *Micro-Paintings, Gene Davis*, Feb. 22–Mar. 13, 1969.

 Burton, Scott. "Reviews and Previews." *Art News* (New York), Apr. 1969, p. 13.

Fischbach Gallery, New York. *Gene Davis: New Paintings*, Mar. 7–26, 1970.

 Glueck, Grace. "New York Gallery Notes." *Art in America* (New York), Mar. 1970, pp. 148–52.

 Ratcliff, Carter. "Gene Davis." *Art News* (New York), May 1970, p. 26.

 Vinklers, Bitite. "New York." *Art International* (Lugano), May 1970, p. 85.

Henri Gallery, Washington, D.C. *Gene Davis: Paintings, 1958–1960*, Nov. 1970.

Corcoran Gallery of Art, Washington, D.C. *Gene Davis: The Early Paintings, 1952—1960*, Nov. 14–Dec. 20, 1970.

Fischbach Gallery, New York. *Gene Davis: Early Paintings*, Feb. 20–Mar. 11, 1971.

 Domingo, Willis. "New York Galleries." *Arts Magazine* (New York), Apr. 1971, pp. 83–84.

 Wolmer, Bruce. "Gene Davis." *Art News* (New York), Apr. 1971, p. 10.

Fischbach Gallery, New York. *Gene Davis: Recent Paintings*, Nov. 20–Dec. 20, 1971.

 Rosenstein, Harris. "Reviews and Previews." *Art News* (New York), Jan. 1972, p. 12.

 Masheck, Joseph. "Gene Davis." *Artforum* (New York), Feb. 1972, pp. 84–85.

 Ratcliff, Carter. "New York Letter." *Art International* (Lugano), Feb. 1972, p. 52.

University of Utah Museum of Fine Arts, Salt Lake City. *Gene Davis Paintings; 1960–1972*, Apr. 16–May 14, 1972. Circulating exhibition.

Dunkelman Gallery, Toronto. *Gene Davis*, Sept. 23–Oct. 7, 1972.

 Zemans, Joyce. "Davis: Dunkelman Gallery." *Artscanada* (Toronto), Oct. 1972, p. 68.

 Marshall, W. Neil. "Toronto Letter: Gene Davis." *Art International* (Lugano), Dec. 1972, pp. 54–55.

Fischbach Gallery, New York. *Gene Davis: Drawings and Lithographs*, Mar. 11–Apr. 5, 1973.

 Henry, Gerrit. "Reviews and Previews." *Art News* (New York), May 1973, p. 86.

Quay Gallery, San Francisco. *Gene Davis: Paintings, Drawings*, May 1–26, 1973.

Fischbach Gallery, New York. *Gene Davis: Paintings*, Nov. 10–Dec. 5, 1973.

 Thomsen, Barbara. "Reviews and Previews." *Art News* (New York), Jan. 1974, p. 89.

 von Baron, Judith. "Gene Davis." *Arts Magazine* (New York), Jan. 1974, p. 65.

 Masheck, Joseph. "Gene Davis." *Artforum* (New York), Feb. 1974, p. 73.

The New Gallery, Cleveland. *Gene Davis: Paintings, Drawings, Prints*, Jan. 10–Feb. 9, 1974.

Tibor de Nagy Gallery, Houston. *Gene Davis: Paintings, Drawings, Prints*, Feb. 21–Mar. 16, 1974.

Fischbach Gallery, New York. *Gene Davis*, Apr. 26–May 21, 1975.

 Frackman, Noel. "Gene Davis/Anne Dunn." *Arts Magazine* (New York), Sept. 1975, p. 10.

Harcus Krakow Rosen Sonnabend Gallery, Boston. *Gene Davis: Paintings, Graphics*, May 11–June 12, 1975.

Reed College, Portland, Oregon. *Gene Davis: Paintings, 1960–1974*, Oct. 4–26, 1975.

Fischbach Gallery, New York. *Gene Davis: Drawings*, Mar. 16–27, 1976.

Fischbach Gallery, New York. *Gene Davis: Paintings*, Mar. 29–Apr. 10, 1976.

 Hobhouse, Janet. "Gene Davis at Fischbach." *Art in America* (New York), Sept. 1976, pp. 108–9.

Michael Berger Gallery, Pittsburgh. *Gene Davis*, Oct. 23–Nov. 14, 1976.

Corcoran Gallery of Art, Washington, D.C. *Gene Davis: Rectangle Paintings*, Jan. 11–Feb. 6, 1977. Cat., text by Jane Livingston.

 Forgey, Benjamin. "Yipes! Gene Davis without Stripes." *Washington Star*, Jan. 16, 1977, p. F24.

 Tannous, David. "Gene Davis at the Corcoran and Protetch." *Art in America* (New York), May 1977, pp. 109–10.

Max Protetch Gallery, Washington, D.C. *Gene Davis: 1949–1960*, Jan. 1977.

 Tannous, David. "Gene Davis at the Corcoran and Protetch." *Art in America* (New York), May 1977, pp. 109–10.

Max Protetch Gallery, Washington, D.C. *Gene Davis: 1960–Present*, Feb. 1977.

Fischbach Gallery, New York. *Gene Davis, Rectangle Paintings 1957–1958*, Apr. 23–May 12, 1977.

 Turner, Norman. "Gene Davis." *Arts Magazine* (New York), Sept. 1977, p. 29.

Fischbach Gallery, New York. *Gene Davis: The Elemental Stripe, Early and Late*, Mar. 4–23, 1978.

Walker Art Center, Minneapolis. *Gene Davis: Recent Paintings (1970–78)*, Aug. 13–Oct. 1, 1978. Cat., interview by Lisa Lyons. Circulating exhibition.

Droll/Kolbert Gallery, New York. *Gene Davis: Drawings, A Retrospective Exhibition (1952–1978)*, Mar. 7–31, 1979.

 Kramer, Hilton. "Art: New Drawings by Gene Davis." *The New York Times*, Mar. 9, 1979, p. C19.

 Cavaliere, Barbara. "Gene Davis." *Arts Magazine* (New York), May 1979, p. 30.

Nadelman, Cynthia. "Gene Davis." *Art News* (New York), Summer 1979, pp. 174–75.

Protech-McIntosh Gallery, Washington, D.C. *Gene Davis: Paintings of the Fifties and Recent Work,* Jan. 8–Feb. 2, 1980.

Droll/Kolbert, New York. *Gene Davis,* Mar. 19–Apr. 16, 1980.

Kokin Gallery, Chicago. *Gene Davis: New Works,* Sept. 13–Oct. 18, 1980.

Arts Gallery, Baltimore. *Gene Davis: New Paintings and Drawings,* Oct. 2–Nov. 3, 1980. Cat., text by Tom Haulik.

Frank Kolbert Gallery, New York. *Gene Davis: The 1950's,* Feb. 7–Mar. 7, 1981.
 Baro, Gene. "Gene Davis." *Art International* (Lugano), Mar.–Apr. 1981, pp. 71–72.

I. Irving Feldman Galleries, Sarasota, Florida. *Gene Davis: Drawings, Paintings,* Feb. 24–Mar. 21, 1981.

McIntosh/Drysdale Gallery, Washington, D.C. *Gene Davis, The Stripe: Variations, 1959–1981,* May 2–June 3, 1981.

The Brooklyn Museum, New York. *Gene Davis: Thirty Years of Drawing,* Dec. 3, 1982–Feb. 6, 1983.

Charles Cowles Gallery, New York. *Gene Davis,* Dec. 4–31, 1982.
 Henry, Gerrit. "Gene Davis Show at Charles Cowles." *Art in America* (New York), Mar. 1983, pp. 151–52.
 Silverthorne, Jeanne. "Gene Davis at Charles Cowles." *Artforum* (New York), Mar. 1983, p. 76.
 Nadelman, Cynthia. "Reviews and Previews." *Art News* (New York), Apr. 1983, p. 164.

Middendorf/Lane Gallery, Washington, D.C. *Gene Davis: Recent Paintings,* Feb. 26–Mar. 26, 1983.

Delaware Art Museum, Wilmington. *Gene Davis: Recent Paintings and Drawings,* Oct. 14–Nov. 27, 1983.

Washington Project for the Arts, Washington, D.C. *Child and Man: A Collaboration,* Nov. 19–Dec. 10, 1983.

Charles Cowles Gallery, New York. *Gene Davis, The Stripe: Variations,* Jan. 7–28, 1984.

Gallery of Art (University of Missouri) at Kansas City. *Gene Davis: The Random and the Ordered,* Jan. 27–Feb. 26, 1984. Cat., text by Pinky Kase.

Middendorf Gallery, Washington, D.C. *Gene Davis: Drawings,* May 10–June 15, 1984.

Charles Cowles Gallery, New York. *Gene Davis,* Dec. 1–29, 1984.

Charles Cowles Gallery, New York. *Gene Davis Focus: 1960–1966,* Sept. 20–Oct. 25, 1986. Cat., text by Donald Kuspit.
 Grimes, Nancy. "Reviews and Previews." *Art News* (New York), Dec. 1986, p. 145.
 Raven, Arlene. "Reviews and Previews." *New Art Examiner* (Chicago), Jan. 1987, pp. 56–57.

Pence Gallery, New York. *Gene Davis Selected Works: 1960–1965,* Jan. 17–Feb. 28, 1987.

Pence Gallery, Santa Monica, California. *Gene Davis, Selected Works, 1960–1965,* Jan. 17–Feb. 28, 1987.

National Museum of American Art, Smithsonian Institution, Washington, D.C. *Gene Davis, A Memorial Exhibition,* Feb. 27–May 17, 1987. Cat., texts by Jacquelyn Days Serwer, Douglas Davis, and Donald Kuspit.

Charles Cowles Gallery, New York. *Gene Davis,* Jan. 30–Feb. 27, 1988. Cat., text by Stephen Westfall.

AL HELD

By the Artist

Writings

"Panel." *It Is* (New York), Autumn 1958, p. 78.

Picture Portfolio. *Kulchur* (New York), Winter 1964–65, cover and pp. 33–36.

Statement in Rose, Barbara and Sandler, Irving. "Sensibility of the Sixties." *Art in America* (New York), Jan.–Feb. 1967, p. 53.

"Jackson Pollock: An Artists' Symposium, Part 1." *Art News* (New York), Apr. 1967, p. 32.

"On Art and Architecture." *Perspecta II, The Yale Architectural Journal* (New Haven), no. 11, 1967, p. 169.

Poirier, Maurice and Necol, Jane. "The 60's in Abstract: 13 Statements and an Essay." *Art in America* (New York), Oct. 1983, pp. 124–26.

Interviews

Glaser, Bruce. "The New Abstraction [Discussion with Paul Brach, Al Held and Ray Parker]." *Art International* (Lugano), Feb. 20, 1966, pp. 41–45.

Cummings, Paul. Interview, Nov. 19, Dec. 12, 19, 30, 1975, Jan. 8, 1976. Washington, D.C.: Archives of American Art.

Walker, James Faure. "Al Held, Interview." *Artscribe* (London), July 1977, pp. 5–9.

Cummings, Paul. "Interview: Al Held Talks with Paul Cummings." *Drawing* (New York), July–Aug. 1980, pp. 34–37.

Hughes, G. "Al Held [Interview]." *Arts Review* (London), Feb. 26, 1982, p. 81.

Cooke, C. "Al Held [Interview]." *Arts Review* (London), Feb. 1982, p. 81.

On the Artist

Book

Sandler, Irving. *Al Held.* New York: Hudson Hills Press, 1984.

Selected Articles

Ashton, Dore. "Abstract Expressionists and Imagists." *Arts and Architecture* (Los Angeles), Dec. 1961, pp. 4–5.

Sandler, Irving H. "Al Held Paints a Picture." *Art News* (New York), May 1964, pp. 42–45, 51.

Ashton, Dore. "Al Held: New Spatial Experiences." *Studio International* (London), Nov. 1964, pp. 4–5.

Ashton, Dore. "Art." *Arts and Architecture* (Los Angeles), Aug. 1965, p. 89.

Ashton, Dore. "3 Centuries of American Painting." *Studio International* (London), Aug. 1965, pp. 86–89.

Ashton, Dore. "Art: Exhibit of Systemic Painting at the Guggenheim Museum." *Arts and Architecture* (Los Angeles), Nov. 1966, pp. 6–7.

"An American Largeness." *Time* (New York), July 14, 1967, p. 64.

Burton, Scott. "Big H." *Art News* (New York), Mar. 1968, pp. 50–53, 70–72.

Stiles, Knut. "The Paintings of Al Held." *Artforum* (New York), Mar. 1968, pp. 49–53.

Calas, Nicolas. "The Originality of Al Held." *Art International* (Lugano), May 15, 1968, pp. 38–41. Reprinted in Calas, Nicolas. *Art in the Age of Risk.* New York: E. P. Dutton, 1968.

McCourbrey, John W. "Al Held: Recent Paintings." *Art Journal* (New York), Spring 1969, pp. 322–24.

Rose, Barbara. "Al Held. Long Distance Runner." *New York,* Apr. 17, 1972, p. 89.

Finkelstein, Louis. "Al Held: Structure and the Intuition of Theme." *Art in America* (New York), Nov.–Dec. 1974, pp. 83–88.

Masheck, Joseph and Pincus-Witten, Robert. "Al Held: Two Views." *Artforum* (New York), Jan. 1975, p. 54.

Ashton, Dore. "New York." *Coloquio Artes* (Lisbon), Oct. 1975, pp. 13–18.

Kuhn, Annette. "Culture Shock: Philadelphia Mural Project." *The Village Voice* (New York), June 7, 1976, page unknown.

Sandler, Irving H. "Individual Character and Presence: Al Held's Paintings, 1959–1961." *Arts Magazine* (New York), Apr. 1980, pp. 186–87.

Ashbery, John. "Portraits and Puzzles." *Newsweek* (New York), Apr. 5, 1982, pp. 79–80.

Glaser, David J. "Al Held's Strategy of Structural Conflict." *Arts Magazine* (New York), Jan. 1983, pp. 82–83.

Cohen, Ronny. "New Editions: Al Held's." *Art News* (New York), Oct. 1983, p. 86.

Selected One-Artist Exhibitions and Reviews

Galerie Huit, Paris. *Al Held,* exact dates unknown, 1952.

Poindexter Gallery, New York. *Al Held,* Dec. 15, 1958–Jan. 10, 1959.

Poindexter Gallery, New York. *Al Held,* Jan. 18–Feb. 6, 1960.
 C[rehan], H[ubert]. "Reviews and Previews." *Art News* (New York), Jan. 1960, p. 15.
 D[ennison], G[eorge]. "In the Galleries: Al Held." *Arts Magazine* (New York), Jan. 1960, p. 58.

Bonino Galeria, Buenos Aires. *Al Held,* exact dates unknown, 1961.

Poindexter Gallery, New York. *Al Held,* May 1–20, 1961.
 S[andler], I[rving] H. "Reviews and Previews." *Art News* (New York), May 1961, p. 15.

Poindexter Gallery, New York. *Al Held,* Nov. 13–Dec. 1, 1962.
 Sandler, Irving H. "In the Galleries." *New York Post Magazine,* Nov. 25, 1962.
 S[andler], I[rving] H. "Reviews and Previews." *Art News* (New York), Dec. 1962, p. 14.
 J[udd], D[onald]. "In the Galleries: Al Held." *Arts Magazine* (New York), Jan. 1963, p. 47.
 Sandler, Irving H. "New York Letter." *Quadrum* (Brussels), no. 14, 1963, pp. 121–22.

Galerie Renée Ziegler, Zurich. *Al Held,* Oct. 6, 1964–closing date unknown. Cat., text by Harold Szeemann.

Galerie Gunar, Dusseldorf. *Al Held,* exact dates unknown, 1964. Cat., text by Albert Schulze Vellinhhausen, in German and English, translated by Herbert Kurnitzki; essay by Irving Sandler, reprinted from *Toward a New Abstraction.* New York: The Jewish Museum, 1963.

Galerie Müller, Stuttgart. *Al Held,* Jan. 14–Mar. 2, 1966.

Stedelijk Museum, Amsterdam. *Al Held,* Mar. 25–May 1, 1966. Cat., text by W. A. L. Beeren.

André Emmerich Gallery, New York. *Al Held,* Apr. 15–May 4, 1967.
 Burton, Scott. "Reviews and Previews." *Art News* (New York), Apr. 1967, pp. 9, 12.
 Deutsch, Stanley I. "Al Held." *57th St. in Review* (New York), May 18, 1967, p. 3.
 B[attcock], G[regory]. "In the Galleries: Al Held." *Arts Magazine* (New York), May 1967, pp. 58–59.

Galerie Renée Ziegler, Zurich. *Al Held,* exact dates unknown, 1967.

San Francisco Museum of Art. *Al Held,* Mar. 16–Apr. 21, 1968. Cat., text by Eleanor Green. Circulating exhibition.

André Emmerich Gallery, New York. *Al Held,* Oct. 5–24, 1968.

"Images: Al Held at Emmerich." *Arts Magazine* (New York), Sept.–Oct. 1968, p. 24.

Kramer, Hilton. "Al Held." *The New York Times,* Oct. 12, 1968, page unknown.

Perreault, John. "Art." *The Village Voice* (New York), Oct. 17, 1968, pp. 17, 26.

Wasserman, Emily. "New York: Al Held, André Emmerich Gallery." *Artforum* (New York), Dec. 1968, pp. 56–58.

Institute of Contemporary Art of the University of Pennsylvania, Philadelphia. *Al Held, Recent Paintings,* Nov. 20–Dec. 26, 1968. Cat., text by John W. McCoubrey. Circulating exhibition.

Campbell, Lawrence. "Reviews and Previews." *Art News* (New York), Nov. 1968, p. 12.

André Emmerich Gallery, New York. *Al Held: New Paintings,* Mar. 14–Apr. 1, 1970.

R[atcliff], C[arter]. "Reviews and Previews." *Art News* (New York), Apr. 1970, p. 68.

Galerie Renée Ziegler, Zurich. *Al Held,* May 1–30, 1970.

Donald Morris Gallery, Detroit. *Al Held: Recent Paintings,* Oct. 16–Nov. 13, 1971. Cat.

André Emmerich Gallery, New York. *Al Held: New Paintings,* Apr. 1–19, 1972. Cat.

Shirey, David L. "Al Held's Art in a Significant Change." *The New York Times,* Apr. 8, 1972, page unknown.

Wolmer, Denise. "In the Galleries." *Arts Magazine* (New York), May 1972, p. 66.

Siegel, Jeanne. "Reviews and Previews." *Art News* (New York), May 1972, p. 50.

————. "Editor's Letters," *Art News* (New York), Summer 1972, p. 6.

Smith, Alvin. "New York Letter." *Art International* (Lugano), Summer 1972, p. 81.

André Emmerich Gallery, New York. *Al Held: New Paintings,* Oct 5–24, 1973. Cat.

Campbell, Lawrence. "Reviews and Previews." *Art News* (New York), Nov. 1973, p. 98.

Bell, Jane. "New York Galleries." *Arts Magazine* (New York), Dec. 1973, p. 75.

Masheck, Joseph. "Reviews." *Artforum* (New York), Dec. 1973, pp. 78–81.

Robins, Corinne. "Al Held: New York Black and White." *Art International* (Lugano), Summer 1974, p. 22.

Galerie André Emmerich, Zurich. *Al Held,* Jan 12–Feb. 16, 1974.

Gielhaar, C. "Neue Bilder und Zeichnungen, Zürich; Exhibition." *Pantheon* (Munich), Apr. 1974, p. 202.

Donald Morris Gallery, Detroit. *Al Held: Recent Paintings and Drawings,* June 8–July 6, 1974. Cat.

The Whitney Museum of American Art, New York. *Al Held,* Oct. 10–Dec. 1, 1974. Cat., text by Marcia Tucker.

Kramer, Hilton. "Al Held Leaves us Uneasy and Disturbed." *The New York Times,* Oct. 20, 1974, p. 33.

Derfner, Phyllis. "New York Letter." *Art International* (Lugano), Dec. 15, 1974, p. 38.

Galerie Müller, Cologne. *Al Held,* exact dates unknown, 1974.

André Emmerich Gallery, New York. *Al Held,* Mar. 15–Apr. 3, 1975.

Jared Sable Gallery, Toronto. *Al Held,* Apr. 26–May 17, 1975.

Dault, Gary Michael. "Best Bet in Art Shows, Controversial Al Held." *Toronto Star,* Apr. 25, 1975, page unknown.

————. "Al Held's Aggressive Paintings Grab Attention." *Toronto Star,* May 2, 1975, page unknown.

Kristzwiser, Kay. "Color Superfluous for Painter Held." *Toronto Globe and Mail,* May 9, 1975, page unknown.

Dault, Gary Michael. "Al Held: The Jared Sable Gallery." *Artscanada* (Toronto), June 1975, pp. 98–99.

Adler Castillo Gallery, Caracas. *Al Held,* exact dates unknown, 1975.

André Emmerich Gallery, New York. *Al Held,* Nov. 13–Dec. 1, 1976.

Galerie Renée Ziegler, Zurich. *Al Held: Frühe Werke/Early Works,* Jan. 15–Feb. 19, 1977. Cat.

Lienert, Konrad Rudolph. "Al Held Bezeichnet Sich Als Amerikanischen Cézanne." *Neue Zürcher Zeitung* (Zurich), Jan. 27, 1977, page unknown.

Galerie Roger d'Amécourt, Paris. *Al Held,* March 1977. Cat., introduction by Roger d'Amécourt.

Kenedy, R. C. "Paris." *Art International* (Lugano), July–Aug. 1977, pp. 57–62.

Annely Juda Fine Art, London. *Al Held,* July 28–Sept. 30, 1977.

Donald Morris Gallery, Birmingham, Michigan. *Al Held,* Nov. 5–Dec. 10, 1977.

Galerie André Emmerich, Zurich. *Al Held: Neue Bilder und Zeichnungen/Recent Paintings and Drawings,* 1977. Cat., commentary by the artist.

Institute of Contemporary Art, Boston. *Al Held: Paintings and Drawings 1973–1978,* Feb. 15–Apr. 1, 1978. Cat., texts by Elisabeth Sussman and Leon G. Shiman.

André Emmerich Gallery, New York. *Al Held: New Paintings,* Apr. 29–May 17, 1978. Cat., text by Andrew Forge.

Harnett, Lila. "Art: Al Held." *Cue Magazine* (New York), Apr. 29–May 12, 1978, p. 24.

Raynor, Vivien. "Art: Al Held Puts Op in a Hall of Mirrors." *The New York Times,* May 12, 1978, page unknown.

Frackman, Noël. "Arts Reviews: Al Held." *Arts Magazine* (New York), Sept. 1978, p. 24.

Perrone, Jeff. "Reviews: New York." *Artforum* (New York), Sept. 1978, p. 87.

Gamwell, Lynn. "Al Held." *Arts Magazine* (New York), Dec. 1978, p. 15.

Marianne Friedland Gallery, Toronto. *Al Held,* May 6, 1978.

Janus Gallery, Venice, California. *Al Held,* Oct. 13–Nov. 11, 1978.

André Emmerich Gallery, New York. *Al Held,* Feb. 17–Mar. 7, 1979.

Kramer, Hilton. "Art: Al Held Adds Color to Geometry." *The New York Times,* Feb. 23, 1979, page unknown.

Berlind, Robert. "Review of Exhibitions: Al Held at Emmerich." *Art in America* (New York), May–June 1979, p. 138.

Robert Miller Gallery, New York. *Al Held 1959–1961,* Mar. 29–Apr. 26, 1980. Cat., text by Irving Sandler.

Kramer, Hilton. "Al Held: Bringing Two Esthetic Worlds." *The New York Times,* Apr. 20, 1980, page unknown.

André Emmerich Gallery, New York. *Al Held: New Paintings 1980,* Nov. 22–Dec. 10, 1980. Cat., text by Andrew Forge.

Gimpel-Hanover & André Emmerich Galerien, Zurich. *Al Held: Neue Bilder/Recent Paintings,* exact dates unknown, 1980. Cat., text by Willy Rotzler, in German, and Andrew Forge, in English. Circulating exhibition.

Grand Palais, Paris. F.I.A.C. (Faire Internationale d'Art Contemporain) exhibition with André Emmerich Gallery, New York. *Al Held,* Oct. 23–29, 1981.

Gimpel-Hanover & André Emmerich Galerien, Zurich. *Al Held,* Nov. 14, 1981–Jan. 9, 1982.

Foster, Hal. "Reviews: Al Held, André Emmerich Gallery." *Artforum* (New York), Feb. 1981, p. 75.

Staniszewski, Mary Anne. "Reviews and Previews." *Art News* (New York), Apr. 1981, pp. 191–92.

Juda Rowan Gallery, London. *Al Held: Recent Paintings,* Feb. 2–Mar. 6, 1982.

Leslie, J. "Al Held at the Juda Rowan Gallery." *Arts Review* (London), Feb. 1982, p. 67.

Ayers, R. "Al Held at Juda Rowan." *Artscribe* (London), Mar. 1982, p. 66.

Robert Miller Gallery, New York. *Al Held: 1954–1959,* Mar. 6–Apr. 3, 1982. Cat., text by Irving Sandler.

Kramer, Hilton. "Al Held: 1954–59." *The New York Times,* Mar. 6, 1982, page unknown.

Gallati, Barbara. "Arts Reviews: Al Held 1954–59." *Arts Magazine* (New York), May 1982, p. 27.

Friedman, Jon R. "Arts Reviews: Al Held." *Arts Magazine* (New York), June 1982, p. 21.

Campbell, Lawrence. "Exhibitions New York: Al Held at Robert Miller." *Art in America* (New York), Sept. 1982, pp. 164–65.

Henry, Gerrit. "Reviews and Previews." *Art News* (New York), Sept. 1982, pp. 172, 176.

André Emmerich Gallery, New York. *Al Held,* Nov. 4–27, 1982.

Brach, Paul. "Review of Exhibitions: Al Held at Emmerich." *Art in America* (New York), Jan. 1983, pp. 116–17.

Donald Morris Gallery, Birmingham, Michigan. *Al Held,* May 7–June 4, 1983.

André Emmerich Gallery, New York. *Al Held: Drawings from 1976,* Mar. 22–Apr. 14, 1984. Cat.

Richard Gray Gallery, Chicago. *Al Held,* Mar. 28–Apr. 25, 1984.

Marianne Friedland Gallery, Toronto. *Al Held: Major Paintings and Works on Paper,* Nov. 10–28, 1984.

Gimpel-Hanover & André Emmerich Galerien, Zurich. *Al Held: Zeichnungen von 1976,* exact dates unknown, 1984.

André Emmerich Gallery, New York. *Al Held,* Apr. 25–May 18, 1985.

André Emmerich Gallery, New York. *Al Held, New Paintings,* Oct. 2–26, 1985. Cat.

John Berggruen Gallery, San Francisco. *Al Held: Recent Paintings,* Apr. 16–May 17, 1986.

Juda Rowan Gallery, London. *Al Held: Drawings,* Jan. 22–Feb. 28, 1987.

Robert Miller Gallery, New York. *Al Held: Taxi Cabs,* Mar. 3–28, 1987. Cat., text by Donald Kuspit.

André Emmerich Gallery, New York. *Al Held,* Apr. 2–25, 1987.

Donald Morris Gallery, Birmingham, Michigan. *Al Held: New Paintings,* Apr. 23–May 28, 1988.

RICHARD ANUSZKIEWICZ

By the Artist

Writings
"A Study in the Creation of Space with Life Drawing." M.F.A. thesis, Yale University, 1955.

Interview
Slate, Joseph. "So Hard to Look at: An Interview with Richard Anuszkiewicz." *Contempora* (Atlanta), May/June, 1970.

On the Artist

Book
Lunde, Karl. *Anuszkiewicz.* New York: Harry N. Abrams, 1977.

Selected Articles
"Simple Form, Simple Color." *Time* (New York), July 19, 1963, pp. 56–57, 59.

Morris, Bernardine. "Anuszkiewicz Sets Legs into Motion." *The New York Times*, May 29, 1965, p. 15.

"Recent Acquisitions." *St. Louis Museum Bulletin*, May 1966, pp. 1–2.

"Richard Anuszkiewicz: Primary Contrast." *Currier Gallery of Art Bulletin* (Manchester, N.H.), July/August 1966.

Karshan, Donald H. "Graphics '70: Richard Anuszkiewicz." *Art in America* (New York), Mar./Apr. 1970, pp. 56–59.

Krauss, Rosalind. "Portrait of the Artist—Richard Anuszkiewicz." *TheARTgallery* (Ivoryton, Conn.), Mar. 1971, pp. 21–35.

Gruen, John. "Beautiful Discourse with Space." *Art News* (New York), Sept. 1979, pp. 68–69.

Corbino, Marcia. "Square Roots: Richard Anuszkiewicz Takes a Four-Sided Approach to Art." *Sarasota Herald-Tribune* (Florida), Mar. 23, 1980, pp. 11–13, 20.

Langer, Sandra L. "Cosmic Genesis: A Critical Reappraisal of Richard Anuszkiewicz's Art." *Arts Magazine* (New York), Apr. 1984, pp. 118–20.

Selected One-Artist Exhibitions and Reviews
Butler Art Institute, Youngstown, Ohio. Title and exact dates unknown, 1955.

The Contemporaries, New York. *Richard Anuszkiewicz: First New York Exhibition*, Feb. 29–Mar. 19, 1960.
> Butler, Barbara. "Richard Anuszkiewicz." *Arts Magazine* (New York), Apr. 1960, p. 63.

The Contemporaries, New York. *Richard Anuszkiewicz*, Mar. 27–Apr. 15, 1961.

The Contemporaries, New York. *Anuszkiewicz*, opening date unknown–Mar. 16, 1963.
> Rose, Barbara. "New York Letter." *Art International* (Lugano), Apr. 25, 1963, pp. 57–60.
> Faunce, Sarah C. "Reviews and Previews." *Art News* (New York), Apr. 1963, p. 14.

Sidney Janis Gallery, New York. *New Paintings by Anuszkiewicz*, Nov. 3–27, 1965. Cat.
> Goldin, Amy. "Richard Anuszkiewicz." *Arts Magazine* (New York), Jan. 1966, p. 62.

Pardee Hall, Lafayette College, Easton, Pennsylvania. *Radius 5*, Apr. 16–May 10, 1966. Cat., text by James A. Michener.

The Cleveland Museum of Art. *Richard Anuszkiewicz: Recent Paintings*, Sept. 20–Oct. 16, 1966.

Sidney Janis Gallery, New York. *Richard Anuszkiewicz*, Oct. 3–28, 1967. Cat.
> Glueck, Grace. "Sidney Janis Gallery." *Art in America* (New York), Sept./Oct. 1967, p. 111.

> Perreault, John. "Reviews and Previews." *Art News* (New York), Oct. 1967, p. 12.

Jaffe-Friede Gallery, The Hopkins Center, Dartmouth College, Hanover, New Hampshire. *Anuszkiewicz*, Nov. 10–Dec. 5, 1967.

Galerie der Spiegel, Cologne, West Germany. Title and exact dates unknown.

Van Deusen Gallery, Kent State University, Akron, Ohio. *15 Paintings/Anuszkiewicz*, July 21–Aug. 9, 1968. Cat.

Sidney Janis Gallery, New York. *Anuszkiewicz: New Paintings*, Apr. 2–26, 1969.
> Canaday, John. "Richard Anuszkiewicz: It's Baffling." *The New York Times*, Apr. 5, 1969, p. 23.
> K[urtz], S[tephen] A. "Reviews and Previews." *Art News* (New York), Apr. 1969, p. 8D.
> Frackman, Noel. "Richard Anuszkiewicz." *Arts Magazine* (New York), May 1960, p. 60.
> Schjeldahl, Peter. "New York Letter." *Art International* (Lugano), Summer 1969, p. 69.

Sidney Janis Gallery, New York. *New Paintings by Richard Anuszkiewicz*, Feb. 10–Mar. 6, 1971. Cat.
> B[enedikt], M[ichael]. "Reviews and Previews." *Art News* (New York), Feb. 1971, p. 17.
> Domingo, Willis. "Richard Anuszkiewicz." *Arts Magazine* (New York), Mar. 1971, p. 57.

DeCordova Museum, Lincoln, Massachusetts. *Paintings by Richard Anuszkiewicz*, Jan. 16–Mar. 5, 1972. Cat., text by Carlo M. Lamagna.

Jacksonville Art Museum, Florida. *Richard Anuszkiewicz*, Mar. 2–26, 1972. Cat.

Loch Haven Art Center, Orlando, Florida. Title and exact dates unknown.

Sidney Janis Gallery, New York. *New Paintings by Richard Anuszkiewicz*, Mar. 7–31, 1973.
> Bell, Jane. "Richard Anuszkiewicz." *Arts Magazine* (New York), May 1973, p. 69.
> Henry, Gerrit. "Reviews and Previews." *Art News* (New York), May 1973, p. 86.
> Kingsley, April. "New York Letter." *Art International* (Lugano), Summer 1973, p. 94.

United States Information Agency international traveling exhibition, circulated to American Embassies in ten cities, 1974–76.

Andrew Crispo Gallery, New York. *Richard Anuszkiewicz: Recent Paintings*, Mar. 21–Apr. 12, 1975.
> Lunde, Karl. "Richard Anuszkiewicz: Andrew Crispo Gallery." *Arts Magazine* (New York), Mar. 1975, pp. 56–57.
> Chapin, Louis. "Reviews and Previews." *Art News* (New York), May 1975, p. 98.

Ulrich Museum of Art, Wichita State University, Kansas. *Richard Anuszkiewicz: Paintings*, Oct. 1–26, 1975.

Billy Rose Pavilion, Israel Museum, Jerusalem. *Anuszkiewicz: Acrylic Paintings 1966–1974*, Summer 1976. Brochure, statement by the artist.

La Jolla Museum of Contemporary Art, California. *Richard Anuszkiewicz: Selected Paintings*, Sept. 18–Oct. 31, 1976. Cat., text by Richard Armstrong. Circulating exhibition.

FOB Gallery, Reed College, Portland, Oregon. *Anuszkiewicz: Recent Paintings and Prints*, Jan. 22–Feb. 20, 1977.

Allentown Art Museum, Pennsylvania. *Richard Anuszkiewicz: Op-Art Painting in Retrospect*, Jan. 14–Feb. 26, 1978.

Alex Rosenberg Gallery, New York. *Richard Anuszkiewicz: The Centered Square*, Mar. 7–Apr. 14, 1979. Cat., text by Gene Baro.
> Gibson, Eric. "Richard Anuszkiewicz." *Art International* (Lugano), May 1979, p. 24.

The Sterling and Francine Clark Art Institute, Williamstown, Massachusetts. *Richard Anuszkiewicz: Prints and Multiples*, Oct. 20–Dec. 2, 1979. Cat. Circulating exhibition.

University Fine Arts Galleries, Tallahassee, Florida. *Richard Anuszkiewicz: Prints*, Jan. 24–Feb. 27, 1981. Cat., text by Elayne H. Varian.

Erie Art Center, Pennsylvania. *Richard Anuszkiewicz: Prints and Multiples 1964–79*, Mar. 8–Apr. 8, 1981.

Museum of Fine Arts, St. Petersburg, Florida. *Richard Anuszkiewicz Prints*, May–June 1981. Cat.

Lowe Art Museum, Coral Gables, Florida. *Richard Anuszkiewicz Prints*, May–June 1981.

Hokin Gallery, Bay Harbor Islands, Florida. Title and exact dates unknown, 1981.

Museo Rayo, Roldanillo, Valle, Colombia. *Richard Anuszkiewicz, Grabados*, exact dates unknown, 1982.

Pembroke Gallery, Houston, Texas. *Richard Anuszkiewicz*, Feb. 2–Mar. 10, 1984.

Butler Art Institute, Youngstown, Ohio. *Anuszkiewicz*, Mar. 4–Apr. 1, 1984. Cat.

Graham Modern, New York. *Richard Anuszkiewicz: The Temple Series: 1982–1984*, Apr. 14–May 12, 1984. Cat., text by John Gruen.
> Russell, John. "Art: Critics' Choices." *The New York Times*, Apr. 29, 1984, page unknown.

The Heckscher Museum, Huntington, New York. *Richard Anuszkiewicz*, Apr. 15–May 13, 1984.
> Harrison, Helen A. "A Master Colorist in a 'Disinterested Search for Perfection'." *The New York Times*, May 6, 1984, p. 30.

Canton Art Institute, Ohio. *Richard Anuszkiewicz*, Sept. 16–Nov. 3, 1984.

Hokin/Kaufman Gallery, Chicago. *Richard Anuszkiewicz: Recent Paintings*, June 1985.

Charles Foley Gallery, Columbus, Ohio. *Richard Anuszkiewicz: Current Works*, Oct. 11–Nov. 30, 1985.

Schweyer-Galdo Galleries, Pontiac, Michigan. Title and exact dates unknown, 1985.

Brevard Art Center and Museum, Melbourne, Florida. *Anuszkiewicz: The Last Decade*, Feb. 6–Mar. 23, 1986. Cat., text by the artist. Circulating exhibition.

Richard Green Gallery, New York. *Richard Anuszkiewicz: Constructions 1986–87*, Mar. 24–Apr. 18, 1987.

Stetson University, Deland, Florida. Title and exact dates unknown, 1987.

Richard Green Gallery, New York. *Anuszkiewicz, Four Decades*, Mar. 16–Apr. 16, 1988.
> Heartney, Eleanor. "Richard Anuszkiewicz." *Art News* (New York), Apr. 1988, pp. 135–36.

Riva Yares Gallery, Scottsdale, Arizona. *Richard Anuszkiewicz Painted Constructions*, Apr. 24–May 28, 1988. Cat.

LUDWIG SANDER

On the Artist

Selected Articles

Sandler, Irving. "Sander Paints a Picture." *Art News* (New York), Sept. 1959, p. 40 ff.

Schuyler, J. "Sander at the Mixolydian Edge." *Art News* (New York), Dec. 1965, pp. 26–27.

Hagen, Y. "Ludwig Sander: The First and the Last Poor Artist Whose Address Was To Be Sagoponack." *American Fabrics and Fashions* (U.S.A.), no. 129, 1983, pp. 54–55.

Selected One-Artist Exhibitions and Reviews

Hacker Gallery, New York. *Ludwig Sander,* Nov. 10–Dec. 6, 1952.

Ritter, Chris. "Ludwig Sander," *Art Digest* (New York), Nov. 15, 1952, p. 20.

Goodnough, Robert. "Reviews and Previews." *Art News* (New York), Nov. 1952, p. 56.

Hendler Gallery, Philadelphia. *Ludwig Sander,* opening date unknown–Mar. 1954.

Weller, Allen S. "Ludwig Sander." *Art Digest* (New York), Mar. 1, 1954, p. 28.

Leo Castelli Gallery, New York. *Ludwig Sander,* Nov. 10–28, 1959.

T[illim], S[idney]. "Ludwig Sander." *Arts* (New York), Dec. 1959, p. 57.

S[chuyler], J[ames]. "Reviews and Previews." *Art News* (New York), Dec. 1959, p. 17.

Ashton, Dore. [Review in] *Art & Architecture* (Los Angeles), Jan. 1960, p. 33.

James David Gallery, Miami. Title and exact dates unknown, 1960.

Leo Castelli Gallery, New York. *Ludwig Sander,* May 2–20, 1961.

Judd, Donald. "Ludwig Sander." *Arts* (New York), May 1961, p. 84.

Kroll, Jack. "Reviews and Previews." *Art News* (New York), May 1961, p. 12.

The Kootz Gallery, New York. *Ludwig Sander: New Paintings,* Apr. 17–May 5, 1962.

Campbell, Lawrence. "Reviews and Previews." *Art News* (New York), Apr. 1962, p. 14.

The Kootz Gallery, New York. *Ludwig Sander,* Jan. 7–25, 1964.

E[dgar], N[atalie]. "Reviews and Previews." *Art News* (New York), Jan. 1964, p. 17.

Harrison, J. "Ludwig Sander." *Arts Magazine* (New York), Mar. 1964, p. 65.

The Kootz Gallery, New York. *Ludwig Sander,* Dec. 7–24, 1965.

Goldin, Amy. "Ludwig Sander." *Arts Magazine* (New York), Feb. 1966, p. 57.

A. M. Sachs Gallery, New York. *Ludwig Sander,* opening date unknown–Nov. 11, 1967.

E[dgar], N[atalie]. "Reviews and Previews." *Art News* (New York), Nov. 1967, p. 63.

A. M. Sachs Gallery, New York. *Ludwig Sander,* Jan. 7–30, 1969.

E[dgar], N[atalie]. "Reviews and Previews." *Art News* (New York), Feb. 1969, p. 68.

B[rumer], M[iriam]. "Ludwig Sander." *Arts Magazine* (New York), Mar. 1969, p. 68.

Mellow, James R. "New York Letter." *Art International* (Lugano), Mar. 1969, p. 59.

Pincus-Witten, Robert. "Reviews." *Artforum* (New York), Apr. 1969, p. 71.

Gimpel & Hanover Galerie, Zurich. *Ludwig Sander,* Oct. 11–Nov. 15, 1969.

Lawrence Rubin Gallery, New York. *Ludwig Sander: Recent Paintings,* Apr. 4, 1970–closing date unknown.

Campbell, Lawrence. "Reviews and Previews." *Art News* (New York), May 1970, p. 73.

Ratcliff, Carter. "New York Letter." *Art International* (Lugano), Summer 1970, p. 143.

Lawrence Rubin Gallery, New York. *Ludwig Sander,* Jan. 8–Feb. 2, 1972.

Ratcliff, Carter. "New York Letter." *Art International* (Lugano), Mar. 1972, p. 36.

S[iegel], J[eanne]. "Reviews and Previews." *Art News* (New York), Mar. 1972, p. 54.

Wolmer, Denise. "Ludwig Sander." *Arts Magazine* (New York), Mar. 1972, p. 58.

Borden, Lizzie. "Reviews." *Artforum* (New York), Apr. 1972, p. 86.

Theo Waddington Galleries, London. Title and exact dates unknown, 1972.

Lawrence Rubin Gallery, New York. Title and exact dates unknown, 1973.

Knoedler Contemporary Art, New York. *Ludwig Sander,* Feb. 2–21, 1974.

Olson, Roberta. "Ludwig Sander." *Arts Magazine* (New York), Apr. 1974, p. 62.

Siegel, Jeanne. "Reviews and Previews." *Art News* (New York), Apr. 1974, p. 102.

Knoedler Contemporary Art, New York. *Ludwig Sander,* May 3–30, 1975.

Ellenzweig, Allen. "Ludwig Sander." *Arts Magazine* (New York), Sept. 1975, p. 4.

Herrera, Hayden. "Reviews." *Artforum* (New York), Sept. 1975, pp. 68–69.

Frank, Peter. "Reviews and Previews." *Art News* (New York), Oct. 1975, p. 114.

M. Knoedler & Co., Inc., New York. *Ludwig Sander,* Feb. 26–Mar. 17, 1977.

Frackman, Noel. "Ludwig Sander." *Arts Magazine* (New York), May 1977, p. 30.

Rosa Esman Gallery, New York. *Ludwig Sander, Drawings: 1933–1959,* Dec. 6, 1977–Jan. 5, 1978.

Cavaliere, Barbara. "Ludwig Sander." *Arts Magazine* (New York), Feb. 1978, p. 32.

M. Knoedler & Co., Inc., New York. *Ludwig Sander (1906–1975),* Dec. 1–20, 1979. Cat., text by Andrew Hudson.

Hudson, A. "On Ludwig Sander's Paintings: The Adjustments Where Art Begins." *Art International* (Lugano), Dec. 1979, pp. 73–76.

Tatransky, Valentin. "Ludwig Sander." *Arts Magazine* (New York), Feb. 1980, p. 35.

M. Knoedler & Co., New York. *Ludwig Sander,* Dec. 11, 1982–Jan. 6, 1983.

Henry, Gerrit. "New York Reviews." *Art News* (New York), May 1983, p. 149.

FRANK STELLA

By the Artist

Writings

"Commentaire de *Complexité simple—Ambiguïté.*" In *Kandinsky: Album de l'exposition.* Paris: Musée national d'art moderne, Centre Georges Pompidou, 1984.

"On Caravaggio." *The New York Times,* Feb. 3, 1985, Magazine Section, p. 38 ff.

Working Space (The Charles Eliot Norton Lectures, 1983–84). Cambridge, Mass., and London: Harvard University Press, 1986.

Kramer, Hilton. "The Crisis in Abstract Art" (review of *Working Space,* by Frank Stella). *Atlantic Monthly* (Boston), Oct. 1986, pp. 94, 96–98.

Golding, John. "The Expansive Imagination" (review of *Working Space,* by Frank Stella). *Times Literary Supplement* (London), Mar. 27, 1987, pp. 311–12.

Interviews

Steyn, Juliet. "Frank Stella Talks About His Recent Work." *Art Monthly* (London), May 1977, pp. 14–15.

Rippon, Peter, Terence Maloon, and Ben Jones. "Frank Stella." *Artscribe* (London), July 1977, pp. 13–17.

Gintz, Claude. "Entretien avec Frank Stella." *Artistes* (Paris), Apr.–May 1980, pp. 6–13.

Ronnen, Meir. "Frank Stella on Making Art." *Jerusalem Post Magazine,* May 22, 1981, p. 17.

Antonio, Emile de. "Geo-Conversation: Frank Stella—A Passion for Painting." *GEO* (New York), Mar. 1982, pp. 13–16.

Corbett, Patricia. "Frank Stella." *Art and Auction* (New York), Feb. 1983, pp. 59–61.

Berman, Avis. "Artist's Dialogue: A Conversation with Frank Stella." *Architectural Digest* (Los Angeles), Sept. 1983, pp. 70, 74, 78.

"Frank Stella Talks About. . . ." *Vanity Fair* (New York), Nov. 1983, p. 94.

Goldman, Judith. "An Interview with Frank Stella." *Frank Stella, Fourteen Prints—with Drawings, Collages, and Working Proofs.* Princeton,: The Art Museum, Princeton University, 1983. Reprinted in *Frank Stella: Had Gadya, after El Lissitzky—A Series of Prints, 1982–1984.* Tel Aviv: The Tel Aviv Museum, 1986.

Jones, Caroline. "Spaces and the Enterprise of Painting." *Harvard Magazine* (Cambridge, Mass.), May–June 1984, pp. 44–51.

McGee, Celia. "Art Takes Its Chances, and Its Knocks: The New York Newsday Interview with Frank Stella." *Newsday* (New York), July 9, 1986, page unknown.

McGill, Douglas C. "Stella Elucidates Abstract Art's Link to Realism." *The New York Times,* Dec. 7, 1986, page unknown.

Lectures

Address in honor of William Seitz. The Art Museum, Princeton University, New Jersey, Feb. 19, 1977.

"Painterly Painting Today." College Art Association Annual Convention, New York, Jan. 27, 1978.

"Ordinary Questions." Bezalel Academy of Arts and Design, Jerusalem, May 18, 1981.

Lecture in the series "Artists Talk About Their Work." Museum of Fine Arts, Boston, Feb. 17, 1982.

"Working Space," series of six lectures delivered as Charles Eliot Norton Professor of Poetry, Harvard University, Cambridge, Massachusetts, Oct. 12, Nov. 9, Dec. 6, 1983, Feb. 6, Mar. 5, Apr. 4, 1984. Individual lectures also delivered at Walker Art Center, Minneapolis, Feb. 21, 1982; College Art Association National Convention, New York, Feb. 26, 1982; San

Antonio Art Institute, Mar. 17, 1983; Musée national d'art moderne, Centre Georges Pompidou, Paris, May 11, 1984; Queens College, City University of New York, Oct. 1, 1984; Stedelijk Museum, Amsterdam, Dec. 14, 1984; The Metropolitan Museum of Art, New York, Mar. 3, 1985; The Art Institute of Chicago, Apr. 24, 1985. All six lectures published as *Working Space*, Cambridge, Mass., and London: Harvard University Press, 1986.

"An Artist's View of Prints." The Grolier Club, New York, Apr. 27, 1984.

Talk given at "The Frick Collection: Controversies and Personal Viewpoints" (part of a seminar on the conservation and restoration of paintings). The Frick Collection, New York, Apr. 16, 1985.

Convocation address. Dartmouth College, Hanover, New Hampshire, Sept. 1985.

On the Artist

Books

Rosenblum, Robert. *Frank Stella*. Harmondsworth, England, and Baltimore: Penguin Books, 1971.

Axsom, Richard H. *The Prints of Frank Stella: A Catalogue Raisonné, 1967–1982*. New York: Hudson Hills Press in association with The University of Michigan Museum of Art, Ann Arbor, 1983.

Meier, Richard. *Shards by Frank Stella*. London and New York: Petersburg Press, 1983.

Rubin, Lawrence, with an introduction by Robert Rosenblum. *Frank Stella: Paintings 1958 to 1965—A Catalogue Raisonné*. New York: Stewart, Tabori & Chang, 1986.

Selected Articles

Key, Donald. "Stripe Painting has been Rough Road." *Milwaukee Journal*, June 12, 1960, page unknown.

Rosenblum, Robert. "Frank Stella. Five Years of Variations on an Irreductible Theme." *Artforum* (San Francisco), Mar. 1965, pp. 21–25.

Leider, Philip. "Frank Stella." *Artforum* (San Francisco) June 1965, pp. 24–26.

Creeley, Robert. "Frank Stella: A Way to Go." *Lugano Review*, Summer 1965, pp. 189–97.

Fried, Michael. "Shape as Form: Frank Stella's New Paintings." *Artforum* (Los Angeles), Nov. 1966, pp. 18–27.

Cone, Jane Harrison. "Frank Stella's New Paintings." *Artforum* (New York), Dec. 1967, pp. 34–41.

Bourdon, David. "A New Cut in Art." *Life* (New York), Jan. 19, 1968, pp. 42–49.

"Stella's Art Takes a New Shape." *America Illustrated*, Dec. 1968, pp. 4–9 [Russian text. Published by USIA exclusively for distribution abroad; Russian issue no. 146, Polish issue no. 119].

Rosenblum, Robert. " 'An Exhilarating Adventure,' Frank Stella." *Vogue* (New York), Nov. 15, 1969, pp. 116–17, 160.

Calas, Nicolas. "Frank Stella the Theologian." *Arts Magazine* (New York), Dec. 1969–Jan. 1970, pp. 29–31.

Reeves, Jean. "Stella, An Artist Who Assaults Our Optical Senses." *Buffalo Evening News*, Mar. 7, 1970, p. B9.

Kramer, Hilton. "Art: Two Uses of the Shaped Canvas." *The New York Times*, Oct. 16, 1971, p. 25.

Krauss, Rosalind. "Stella's New Work and the Problem of Series." *Artforum* (New York), Dec. 1971, pp. 40–44.

Lebensztejn, Jean Claude. "57 Steps to 'Hyena Stomp'." *Art News* (New York), Sept. 1972, pp. 60, 67, 70, 75.

Finkelstein, Louis. "Seeing Stella." *Artforum* (New York), June 1973, pp. 67–70.

MacKintosh, Alistair. "Making of the President." *Art and Artists* (London), Sept. 1974, pp. 34–39.

Lebensztejn, Jean-Claude. "Eight Statements." *Art in America* (New York), July/Aug. 1975, pp. 67–75.

Millet, Catherine. "Un Peintre: Frank Stella—Histoire (ou contrehistoire) de l'éspace littéral." *Art Press* (Paris), Nov.–Dec. 1975, pp. 14–15.

Smith, Roberta. "Frank Stella's New Paintings: The Thrill Is Back." *Art in America* (New York), Nov.–Dec. 1975, pp. 86–88.

Frackman, Noel. "Frank Stella's Abstract Expressionist Aerie: A Reading of Stella's New Paintings." *Arts Magazine*, Dec. 1976, pp. 124–26.

Hopkins, Budd. "Frank Stella's New Work: A Personal Note." *Artforum* (New York), Dec. 1976, pp. 58–59.

Richard, Paul. "Stella: High Energy." *Buffalo Evening News*, Feb. 12, 1977, p. C9.

Maloon, Terence. "Frank Stella: From American Geometry to French Curves." *Artscribe* (London), July 1977, pp. 11–14.

Leider, Philip. "Stella Since 1970." *Art in America* (New York), Mar.–Apr. 1978, pp. 120–30.

Stevens, Mark. "Stella: Letting Go." *Newsweek* (New York), May 1, 1978, pp. 94–95.

Siegel, Jeanne. "Recent Colored Reliefs." *Arts Magazine* (New York), Sept. 1978, pp. 152–54.

Rosenblum, Robert. "Frank Stella's New Art: Eye Openers." *Vogue* (New York), Feb. 1979, pp. 247, 296.

Kramer, Hilton. "Frank Stella's Brash and Lyric Flight." *Portfolio* (New York), May 1979, pp. 48–55.

Hughes, Robert. "Ten Years That Buried the Avant-Garde." *Sunday Times Magazine* (London), Dec. 30, 1979, pp. 16–21, 41–47.

Whelan, Richard. "All Dressed Up With No Place To Go." *Art News* (New York), Feb. 1980, pp. 76–79.

Axsom, Richard H. "Frank Stella's Graphics." *The Print Collector's Newsletter* (New York), Mar./Apr. 1980, pp. 1–2.

Frackman, Noel. "Tracking Frank Stella's Circuit Series." *Arts Magazine* (New York), Apr. 1982, pp. 134–37.

Wolff, Theodore F. "Frank Stella: As Important a Printmaker as He is a Painter." *Christian Science Monitor* (Boston), Jan. 25, 1983, p. 19.

Ratcliff, Carter. "Stella: Flirting with Geometry." *Vogue* (New York), Feb. 1983, p. 53.

Silverthorne, Jeanne. "Frank Stella." *Artforum* (New York), Feb. 1983, pp. 81–82.

Feinstein, Roni. "Frank Stella's Prints 1967–1982." *Arts Magazine* (New York), Mar. 1983, pp. 112–15.

Rosenblum, Robert. "Stella's Third Dimension." *Vanity Fair* (New York), Nov. 1983, pp. 86–93.

Faber, Harold. "Painter's Speeding Sentence: Art Lectures for Public." *The New York Times*, Mar. 17, 1984, page unknown.

Faber, Harold. "Artist Delivering Lectures in Lieu of Jail for Speeding." *The New York Times*, Apr. 30, 1984, page unknown.

Solway, Diane. "Frank Stella: Speaking in the Abstract." *M* (New York), July 1984, pp. 154–57.

Hennessy, Richard. "The Man Who Forgot How To Paint." *Art in America* (New York), Summer 1984, pp. 13–25.

Tomkins, Calvin. "Profiles (Frank Stella): The Space Around Real Things." *The New Yorker* (New York), Sept. 10, 1984, pp. 53–97.

Ratcliff, Carter. "Frank Stella: Portrait of the Artist as Image Administrator." *Art in America* (New York), Feb. 1985, pp. 94–107.

Cramer, George W. Letter to the editor. *Art in America*, May 1985, p. 5. (Response to C. Ratcliff, Feb. 1985.)

Richardson, Brenda. Letter to the editor. *Art in America*, May 1985, p. 5. (Response to C. Ratcliff, Feb. 1985.)

Storr, Robert. "Issues and Commentary: Frank Stella's Norton Lectures—A Response." *Art in America* (New York), Feb. 1985, pp. 11–15.

Turner, Norman. "Stella on Caravaggio." *Arts Magazine* (New York), Summer 1985, p. 91.

Fiske, Edward B. "Painters' Strokes Help Him in Squash." *The New York Times*, May 30, 1986, Sports Section, page unknown.

Smith, Roberta. "Oh, the Pity." *Connoisseur* (New York), Aug. 1986, pp. 92–93.

Ceysson, Bernard. " 'Ut pictura pictura': Frank Stella ou l'abstraction accomplié." *Artstudio* (Paris), Summer 1986, pp. 26–37.

McGill, Douglas C. "Stella Elucidates Abstract Art's Link to Realism." *The New York Times*, Dec. 7, 1986, page unknown.

Weschler, Lawrence. "Stella's Flying Ships." *Art News* (New York), Sept. 1987, pp. 92–99.

Stevens, Mark. "Frank Stella's Serious Fun." *Newsweek* (New York), Oct. 19, 1987, pp. 82–83.

Kenner, H. "Frank Stella: America's Genius of Insignificant Form." *Art & Antiques* (Bergenfield, N.J.), Nov. 1987, p. 136.

Selected One-Artist Exhibitions and Reviews

Malden Public Library, Massachusetts. *Frank Stella*, June 15–30, 1959.

Leo Castelli Gallery, New York. *Frank Stella*, Sept. 27–Oct. 16, 1960.

Preston, Stuart. "Housing in Art's Many Mansions." *The New York Times*, Oct. 2, 1960, p. 21.

Mot, Helen De. "Frank Stella." *Arts Magazine* (New York), Oct. 1960, p. 64.

Petersen, Valerie. "Reviews and Previews." *Art News* (New York), Nov. 1960, p. 17.

Sandler, Irving H. "New York Letter." *Art International* (Lugano) Dec. 1, 1960, p. 25.

Galerie Lawrence, Paris. *F. Stella*, Nov. 7, 1961–closing date unknown.

Ashbery, John. "Can Art Be Excellent if Anybody Could Do It?" *International Herald Tribune* (Paris), Nov. 8, 1961, p. 11.

Leo Castelli Gallery, New York. *Frank Stella*, Apr. 28–May 19, 1962.

Campbell, Lawrence. "Reviews and Previews." *Art News* (New York), Summer 1962, p. 17.

Judd, Donald. "Frank Stella." *Arts Magazine* (New York), Sept. 1962, p. 17.

Ferus Gallery, Los Angeles. *Frank Stella*, Feb. 18, 1963–closing date unknown.

Langsner, Jules. "Los Angeles Letter." *Art International* (Lugano), Mar. 25, 1963, pp. 75–76.

Factor, Donald. "Frank Stella, Ferus Gallery." *Artforum* (San Francisco), May 1963, p. 44.

Leo Castelli Gallery, New York. *Frank Stella*, Jan. 4–Feb. 6, 1964.

Genauer, Emily. "Art Tour. The Galleries, A Critical Guide." *New York Herald Tribune*, Jan. 11, 1964, p. 9.

O'Doherty, Brian. "Frank Stella and a Crisis of Nothingness." *The New York Times*, Jan. 19, 1964, p. 21.

Swenson, G. R. "Reviews and Previews." *Art News* (New York), Feb. 1964, p. 11.

Lippard, Lucy R. "New York." *Artforum* (San Francisco), Mar. 1964, p. 18.

Kozloff, Max. "Stella." *Art International* (Lugano), Apr. 1964, p. 64.

Galerie Lawrence, Paris. *Frank Stella*, May 12–June 2, 1964.

Kasmin Limited, London. *Frank Stella: Recent Paintings*, Sept. 29–Oct. 24, 1964.

Lynton, Norbert. "Stella and Feeley." *Art International* (Lugano), Dec. 1964, pp. 44–45.

Ferus Gallery, Los Angeles. *Frank Stella in an Exhibition of New Work*, Jan. 26–Feb. 1965.

Leider, Philip. "Small but Select." *Frontier* (Los Angeles), Mar. 1965, pp. 21–22.

David Mirvish Gallery, Toronto. *Frank Stella*, Apr. 15–May 8, 1966.

Leo Castelli Gallery, New York. *Frank Stella*, May 5–June 2, 1966.

Kramer, Hilton. "Representative of the 1960's." *The New York Times*, Mar. 20, 1966, p. 21.

Bourdon, David. "A New Direction." *Village Voice* (New York), Mar. 24, 1966, p. 17.

Kozloff, Max. "Art." *Nation* (New York), Mar. 28, 1966, pp. 370–72.

Ashton, Dore. "Conditioned Historic Reactions." *Studio International* (London), May 1966, pp. 204–7.

Bochner, Mel. "Frank Stella." *Arts Magazine* (New York), May 1966, p. 61.

Krauss, Rosalind. "Frank Stella, Castelli Gallery." *Artforum* (Los Angeles), May 1966, pp. 47–49.

Lippard, Lucy R. "New York Letter." *Art International* (Lugano), Summer 1966, p. 113.

Pasadena Art Museum, California. *Frank Stella: An Exhibition of Recent Paintings*, Oct. 18–Nov. 20, 1966. Cat. Circulating exhibition.

Kasmin Limited, London. *Frank Stella: A Selection of Paintings and Recent Drawings*, Nov. 11–Dec. 3, 1966.

Russell, John. "Reviews and Previews." *Art News* (New York), Feb. 1967, p. 58.

Galerie Bischofsberger, Zurich. *Frank Stella*, Feb. 17–Mar. 18, 1967.

Curjel, Hans. "Ausstellungen: Zürich." *Werk* (Winterthur, Switzerland), Apr. 1967, p. 256.

Leo Castelli Gallery, New York. *Frank Stella*, Nov. 25–Dec. 23, 1967.

Battcock, Gregory. "Painting Paintings for Corners." *Westside News and Free Press* (New York), Dec. 7, 1967, n.p.

Perreault, John. "Blown Cool." *Village Voice* (New York), Dec. 7, 1967, pp. 18–19.

Kramer, Hilton. "Frank Stella: 'What You See is What You See.'" *The New York Times*, Dec. 10, 1967, p. 39.

Castle, Frederick. "What's That the '68 Stella? Wow!" *Art News* (New York), Jan. 1968, pp. 46–47 and 68–71.

Fischer, John. "Frank Stella." *Arts Magazine* (New York), Feb. 1968, p. 59.

Washington Gallery of Modern Art, Washington, D.C. *Frank Stella: Recent Paintings and Drawings*, Feb. 28–Mar. 31, 1968.

Gold, Barbara. "Stella Exhibits in Washington." *The Sun* (Baltimore), Mar. 3, 1968, p. 6.

Davis, Douglas. "Stella: 'Only What Can Be Seen There is There'." *National Observer* (Washington, D.C.), Mar. 25, 1968, p. 2.

David Mirvish Gallery, Toronto. *Frank Stella: Recent Paintings*, Mar. 7–Apr. 1968.

Russell, Paul. "Frank Stella." *Artscanada* (Toronto), June 1968, p. 45.

Harcus/Krakow Gallery, Boston, Massachusetts. *The First Lithographic Projects of Frank Stella*, Mar. 16–Apr. 20, 1968.

Irving Blum Gallery, Los Angeles. *Frank Stella*, Mar. 1968–closing date unknown.

New Gallery, Bennington College, Vermont. *Frank Stella*, May 13–May 28, 1968.

Kasmin Limited, London. *Frank Stella: Recent Paintings*, Dec. 6, 1968–closing date unknown.

Kenedy, R. C. "London Letter." *Art International* (Lugano), Feb. 20, 1969, pp. 38–39.

Masheck, Joseph. "Frank Stella at Kasmin." *Studio International* (London), Feb. 1969, pp. 90–91.

University of Puerto Rico, Mayaguez. *Frank Stella*, Mar. 1969.

Ruiz de la Mata, Ernesto J. "Frank Stella." *San Juan Star, Sunday Magazine*, Mar. 23, 1969, page unknown.

Rose Art Museum, Brandeis University, Waltham, Massachusetts. *Recent Paintings by Frank Stella*, Apr. 2–May 11, 1969.

Driscoll, Edgar. "Stella Shines at Brandeis." *Boston Morning Globe*, Apr. 15, 1969, p. 25.

Giuliano, Charles. "Mr. Stella d'Oro of the Art World." *Boston After Dark*, Apr. 16, 1969, p. 11.

Irving Blum Gallery, Los Angeles. *Frank Stella*, Nov. 4, 1969–closing date unknown.

Leo Castelli Gallery, New York. *Frank Stella*, Nov. 6–Dec. 6, 1969.

Rosenblum, Robert. "Frank Stella." *Vogue* (New York), Nov. 15, 1969, pp. 116–17, 160.

Pincus-Witten, Robert. "New York." *Artforum* (New York), Jan. 1970, pp. 66–67.

Ratcliff, Carter. "New York Letter." *Art International* (Lugano), Jan. 1970, p. 96.

The Museum of Modern Art, New York. *Frank Stella*, Mar. 26–May 31, 1970. Circulating exhibition.

Kramer, Hilton. "Art: A Retrospective of Frank Stella." *The New York Times*, Mar. 25, 1970, p. 34.

Perreault, John. "Art: Skin Deep." *The Village Voice* (New York), Apr. 2, 1970, p. 14.

Dover, Douglas. "The Art Past." *Newsweek* (New York), Apr. 13, 1970, p. 98.

Leider, Philip. "Literalism and Abstraction: Reflections on Stella Retrospective at the Modern." *Artforum* (New York), Apr. 1970, pp. 44–51. Letter in reply by William Rubin, *Artforum*, June 1970, pp. 10–11.

Domingo, Willis. "Reviews." *Arts Magazine* (New York), Apr. 1970, p. 55.

Alloway, Lawrence. "Art." *The Nation* (New York), May 4, 1970, p. 540.

Rosenberg, Harold. "The Art World." *The New Yorker* (New York), May 9, 1970, pp. 103–16.

Baker, Elizabeth C. "Frank Stella Perspectives." *Art News* (New York), May 1970, pp. 46–49, 62–64.

Marandel, Patrice J. "New York Letter." *Art International* (Lugano), May 1970, p. 73.

Ashton, Dore. "New York Commentary." *Studio International* (London), June 1970, p. 275.

Ratcliff, Carter. "New York." *Art International*, Summer 1970, pp. 134–36.

Lawrence Rubin Gallery, New York. *Frank Stella: Recent Paintings*, Jan. 10–Feb. 7, 1970.

Vinklers, Bitite. "New York." *Art International* (Lugano), Mar. 1970, p. 94.

Galerie Renée Ziegler, Zurich. *Frank Stella*, Jan. 27–Feb. 14, 1970.

Joseph Helman Gallery, St. Louis. *Frank Stella Drawings*, Sept. 12, 1970–closing date unknown.

Hansen-Fuller Gallery, San Francisco. *Frank Stella: Paintings and Prints*, Feb. 9–Mar. 6, 1971.

David Mirvish Gallery, Toronto. *Frank Stella*, Apr. 8–27, 1971.

Lawrence Rubin Gallery, New York. *Frank Stella Recent Work*, Oct. 2–23, 1971.

Baker, Elizabeth C. "Frank Stella, Revival and Relief." *Art News* (New York), Nov. 1971, pp. 34–35, 87–89.

Domingo, Willis. "Reviews." *Arts Magazine* (New York), Nov. 1971, p. 60.

Ratcliff, Carter. "New York Letter." *Art International* (Lugano), Dec. 20, 1971, pp. 59–60.

Sandler, Irving. "Stella at Rubin." *Art in America* (New York), Jan.–Feb. 1972, p. 33.

Kasmin Limited, London. *Frank Stella: New Paintings*, Oct. 27, 1971–closing date unknown.

Denvir, Bernard. "London Letter." *Art International* (Lugano), Jan. 1972, p. 50.

Elderfield, John. "London Commentary." *Studio International* (London), Jan. 1972, pp. 30–31.

John Berggruen Gallery, San Francisco. *Frank Stella: Prints and Drawings*, exact dates unknown, 1971.

Irving Blum Gallery, Los Angeles. *Frank Stella*, Feb. 15, 1972–closing date unknown.

Leo Castelli Gallery, New York. *Frank Stella*, Jan. 6–Jan. 27, 1973.

Schjeldahl, Peter. "Frank Stella: The Best—and the Last—of His Breed?" *The New York Times*, Jan. 21, 1973, p. II-23.

Siegel, Jeanne. "Frank Stella, Castelli Gallery." *Art News* (New York), Feb. 1973, p. 78.

White, Edmund. "Frank Stella Explores a New Dimension." *Saturday Review* (New York), Mar. 3, 1973, pp. 53–54.

Stitelman, Paul. "Frank Stella." *Arts Magazine* (New York), Mar. 1973, p. 69.

Kingsley, April. "New York Letter." *Art International* (Lugano), Apr. 1973, pp. 53–54.

Masheck, Joseph. "Frank Stella, Castelli Gallery Uptown." *Artforum* (New York), Apr. 1973, pp. 80–81.

Phillips Collection, Washington, D.C. *Frank Stella: Recent Work*, Nov. 3–Dec. 2, 1973.

Richard, Paul. "Stella: Not So Simple Anymore." *The Washington Post*, Nov. 10, 1973, p. 1.

Forgey, Benjamin. "Starring Stella." *Washington Star News*, Nov. 23, 1973, p. 1.

Knoedler Contemporary Art, New York. *Frank Stella: Recent Paintings*, Nov. 10–29, 1973.

Kingsley, April. "New York Letter." *Art International* (Lugano), Apr. 1973, pp. 53–54.

Bell, Jane. "Frank Stella: Knoedler Contemporary." *Arts Magazine* (New York), Jan. 1974, p. 67.

Gilbert-Rolfe, Jeremy. "Reviews: Frank Stella, Knoedler Contemporary Art." *Artforum* (New York), Feb. 1974, pp. 67–68.

Janie C. Lee Gallery, Dallas. *Frank Stella: Recent Paintings*, Dec. 1, 1973–closing date unknown.

Portland Center for the Visual Arts, Oregon. *Frank Stella: Recent Works*, Jan. 13–Feb. 10, 1974. Circulating exhibition.

Janie C. Lee Gallery, Houston. *Frank Stella*, Jan. 26, 1974–closing date unknown.

Leo Castelli Gallery, New York. *Frank Stella Metal Relief*, May 3–24, 1975.

Bourdon, David. "Frank Stella." *The Village Voice* (New York), May 19, 1975, page unknown.

Battcock, Gregory. "Da New York Notizie—Assailing Technology." *Domus* (Milan), Sept. 1975, p. 53.

Frank, Peter. "Reviews and Previews." *Art News* (New York), Sept. 1975, p. 113.

Herrera, Hayden. "Reviews: Frank Stella, Leo Castelli Gallery, Downtown." *Artforum* (New York), Sept. 1975, p. 67.

Zimmer, William. "Frank Stella." *Arts Magazine* (New York), Sept. 1975, p. 12.

Janie C. Lee Gallery, Houston. *Frank Stella: Variations on the Square 1960–1974*, Sept. 27, 1975–closing date unknown.

Galerie Daniel Templon, Paris. *Frank Stella: Recent Paintings*, Oct. 21–Nov. 15, 1975.

Ace Gallery, Venice, California. *Frank Stella: High-Relief Aluminum Paintings*, Nov. 1975.

 Welling, James. "New Work by Frank Stella." *Artweek* (Oakland, Calif.), Nov. 29, 1975, pp. 1, 18.

Galerie André Emmerich, Zurich. *Frank Stella: Neue Reliefs*, Jan. 17–Feb. 28, 1976.

Sears Bank and Trust Company, Chicago. *Frank Stella: Paintings and Graphics*, Mar. 1–Apr. 30, 1976.

Kunsthalle Basel, Switzerland. *Frank Stella: Neue Reliefbilder—Bilder und Graphik*, Mar. 17–Apr. 11, 1976. Cat.

M. Knoedler & Co., New York. *Frank Stella: Recent Paintings*, Oct. 2–28, 1976.

 Russell, John. "Art Beyond Good and Bad Taste." *The New York Times*, Oct. 8, 1976, Section C, p. 17.

 Hess, Thomas B. "Stella Means Star." *New York*, Nov. 1, 1976, pp. 62–63.

 Alloway, Lawrence. "Art." *The Nation* (New York), Nov. 20, 1976, pp. 541–42.

 Andre, Michael. "Reviews and Previews." *Art News* (New York), Dec. 1976, p. 115.

 Perrone, Jeff. "Frank Stella: Knoedler Gallery." *Artforum* (New York) Dec. 1976, pp. 74–75.

 Goldin, Amy. "Frank Stella at Knoedler." *Art in America* (New York), Jan.–Feb. 1977, p. 126.

Baltimore Museum of Art. *Frank Stella: The Black Paintings*, Nov. 23, 1976–Jan. 23, 1977. Cat., text by Brenda Richardson.

 Ward, Mary Martha. "Frank Stella." *Arts Magazine* (New York), Dec. 1976, p. 24.

David Mirvish Gallery, Toronto. *Frank Stella: An Historical Selection*, Dec. 4, 1976–Jan. 4, 1977.

Ace Gallery, Venice, California. *Frank Stella: Major Paintings*, exact dates unknown, 1976.

 Richard, Paul. "Frank Stella at Forty: A Fierce and Entertaining Logic." *Washington Post*, Jan. 9, 1977, pp. 141–42.

 Smith, Roberta. "Frank Stella at the Baltimore Museum." *Art in America* (New York), July–Aug. 1977, pp. 101–2.

Galerie M. Bochum, West Germany. *Frank Stella Shaped Canvases*, Feb. 4–Mar. 13, 1977.

Hans Strelow und Rudolf Zwirner, Cologne, West Germany. *Frank Stella: Metal Reliefs from the Year 1976*, Feb. 4–Mar. 13, 1977.

Galerie Rudolf Zwirner, Cologne, West Germany. *Frank Stella: Metallreliefs aus dem Jahre 1976*, Feb. 4–Mar. 12, 1977.

Kunsthalle Bielefeld, West Germany. *Frank Stella: Werke 1958–1976*, Apr. 17–May 29, 1977.

 Winter, Peter. "Frank Stella: Werke 1958–1976, Kunsthalle Bielefeld." *Pantheon* (Munich), July–Aug.–Sept. 1977, pp. 244–45.

Museum of Modern Art, Oxford, England. *Aluminum Reliefs 1976–77*, Apr. 23–May 29, 1977. Cat. Circulating exhibition.

 Feaver, William. "The Stella Collection." *Observer* (London), May 8, 1977.

 McEwen, John. "Star Struck." *The Spectator* (London), May 14, 1977, pp. 27–28.

 Overy, Paul. "Frank Stella's Exhilarating Vitality." *Times* (London), May 17, 1977.

 Domingo, Willis. "Stella, Hofmann." *Art Monthly* (London), May 1977, p. 16.

 [Review in] *Art Monthly* (London), May 1977, p. 16.

John Berggruen Gallery, San Francisco. *Frank Stella: Paintings and Recent Prints*, Nov. 23, 1977–Jan. 7, 1978.

Knoedler Gallery, London. *Frank Stella: Paintings, Drawings, and Prints, 1959–1977*, Dec. 8, 1977–closing date unknown.

 Lucie-Smith, Edward. "Stella—The Defiant Giant." *Evening Standard* (London), Dec. 21, 1977, p. 27.

 McEwen, John. "Pinch-Pots and Skateboards." *The Spectator* (London), Dec. 24, 1977, p. 33.

Linda Farris Gallery, Seattle, Washington. *Singerle Variations*, Dec. 8–30, 1977.

Getler/Pall, New York. *Frank Stella Prints*, Dec. 17, 1977–Jan. 28, 1978.

Sable-Castelli Gallery, Toronto. *Frank Stella*, Jan. 28–Feb. 11, 1978.

Fort Worth Art Museum, Texas. *Stella Since 1970*, Mar. 19–Apr. 30, 1978. Cat. Circulating exhibition.

 Hunter, Janet. "Frank Stella in a New Light." *Dallas Morning News*, Mar. 11, 1978, p. F1.

 Hunter, Janet. "Stella's Captivating Color." *Dallas Morning News*, Mar. 15, 1978, p. F1.

 Marvel, Bill. "Frank Stella: A Rebel Rebels Against His Own Art." *Dallas Times Herald*, Mar. 26, 1978, page unknown.

 Hughes, Robert. "Stella and the Painted Bird." *Time* (New York), Apr. 3, 1978, pp. 66–67.

 Ennis, Michael. "Stella Since 1970." *Artweek* (Oakland, Calif.), Apr. 8, 1978, pp. 1, 16.

 Kramer, Hilton. "Frank Stella's Vigorous Reaffirmation." *The New York Times*, May 14, 1978, p. D-27.

 Marvel, Bill. "Stella at Fort Worth." *Horizon* (New York), May 1978, pp. 40–47.

 Stevens, Mark. "Stella: Letting Go." *Newsweek* (New York), May 1978, pp. 94–95.

 Ashbery, John. "Birds on the Wing Again." *New York*, Sept. 11, 1978, pp. 90–91.

 Toupin, Gilles. "Frank Stella: évolution ou révolution?" *La Presse* (Montreal), Nov. 11, 1978, p. D21.

 Nizon, Virginia. "Stella Shows Abstract Art Isn't Painted into a Corner." *Gazette* (Montreal), Nov. 24, 1978, p. 20.

Galerie Valeur, Nagoya, Japan. *Frank Stella*, Aug. 21–Sept. 2, 1978.

Visual Arts Museum, School of Visual Arts, New York. *Frank Stella: The Series within a Series*, Oct. 10–30, 1978.

 Russell, John. "Stella Shows His Metal in SoHo." *The New York Times*, Jan. 19, 1979, pp. C–1, 16.

Leo Castelli Gallery, New York. *Indian Birds: Painted Metal Reliefs*, Jan. 6–27, 1979.

 Kingsley, April. "Frank Stella: Off the Wall." *The Village Voice* (New York), Jan. 29, 1979, p. 70.

 Nisselson, Jane. "Stella's Indian Birds." *Art World* (New York), Jan.–Feb. 1979, p. 8.

 Gibson, Eric. "Frank Stella." *Art International* (Lugano), Mar. 1979, pp. 50–51.

 Levin, Kim. "Frank Stella." *Arts Magazine* (New York), Mar. 1979, p. 22.

 Perlberg, Deborah. "Frank Stella, Leo Castelli Gallery." *Artforum* (New York), Mar. 1979, pp. 63–64.

 Whelan, Richard. "Reviews and Previews." *Art News* (New York), Mar. 1979, p. 182.

 Lawson, Thomas. "Frank Stella/Leo Castelli." *Flash Art* (Milan), Mar.–Apr. 1979, p. 23.

The Museum of Modern Art, New York. *Frank Stella: The Indian Bird Maquettes*, Mar. 12–May 1, 1979.

 Levin, Kim. "Frank Stella." *Arts Magazine* (New York), Mar. 1979, p. 22.

Rose Art Museum, Brandeis University, Waltham, Massachusetts. *Metallic Reliefs*, May 13–July 1, 1979.

 Baker, Kenneth. "Stella by the Cold Light of Day: New Paintings That Holler." *Boston Phoenix*, May 22, 1979, Section 3, p. 10.

Galerie Valeur, Nagoya, Japan. *Frank Stella: 8 Drawings: 1976 Sketch Singerli Variation/1977 Exotic Bird Series*, Nov. 5–30, 1979.

Galerie Ninety-Nine, Bay Harbor Islands, Florida. *Frank Stella: Paintings and Prints*, Feb. 16–Mar. 8, 1980.

Koh Gallery, Tokyo. *Frank Stella*, Mar. 17–Apr. 30, 1980.

Knoedler Gallery, London. *Frank Stella: Works on Paper*, Apr. 1980.

Galerie Valeur, Nagoya, Japan. *Frank Stella: Recent Works*, May 6–May 24, 1980.

Centre d'Arts Plastiques Contemporains de Bordeaux, France. *Frank Stella: peintures 1970–1979*, May 9–July 26, 1980. Cat.

L. A. Louver Gallery, Venice, California. *Frank Stella: Polar Co-ordinator for Ronnie Peterson*, May 20–June 14, 1980.

Kunstmuseum Basel, Switzerland. *Frank Stella: Working Drawings/Zeichnungen 1956–1970*, May 22–July 27, 1980. Cat.

Akira Ikeda Gallery, Nagoya, Japan. *Frank Stella*, Aug. 4–Aug. 23, 1980.

Getler/Pall Gallery, New York. *Frank Stella*, Oct. 21–Nov. 15, 1980.

Bell Gallery, List Art Center, Brown University, Providence, Rhode Island. *Frank Stella: The Prints*, Apr. 25–May 20, 1981.

Akira Ikeda Gallery, Nagoya, Japan. *Frank Stella Works: Paintings, Drawings and Maquettes*, June 1–27, 1981.

M. Knoedler & Co., New York. *Frank Stella: Metal Reliefs*, Oct. 28–Nov. 18, 1981.

 Kramer, Hilton. "Frank Stella." *The New York Times*, Nov. 6, 1981, page unknown.

 Larson, Kay. "Art: The Odd Couple." *New York*, Nov. 23, 1981, pp. 73–77.

Galerie Hans Strelow, Dusseldorf, West Germany. *Frank Stella: New York*, Dec. 10, 1981–Jan. 16, 1982.

Akira Ikeda Gallery, Nagoya, Japan. *Frank Stella: New Reliefs*, Mar. 8–Mar. 31, 1982.

Akira Ikeda Gallery, Tokyo. *Frank Stella: Recent Work*, Mar. 8–Mar. 31, 1982.

Knoedler Gallery, London. *Frank Stella*, May 25–July 3, 1982.

 Foster, Hal. "Frank Stella at Knoedler." *Art in America* (New York), Feb. 1982, p. 142.

Art Gallery of Hamilton, Canada. *Frank Stella: The Polar Co-ordinator*, June 25–Aug. 1, 1982.

University of Michigan Museum of Art, Ann Arbor. *The Prints of Frank Stella*, Sept. 25–Nov. 21, 1982.

Castelli Graphics, New York. *Frank Stella "Swan Engravings" 1982*, Oct. 7–Nov. 18, 1982.

Martin-Gropius-Bau, Berlin, West Germany. *Zeitgeist*, Oct. 15–Dec. 19, 1982.

Addison Gallery of American Art, Phillips Academy, Andover, Massachusetts. *Frank Stella: From Start to Finish*, Oct. 23–Dec. 17, 1982. Cat.

 Raynor, Vivien. "Frank Stella Exhibits at His Alma Mater." *The New York Times*, Nov. 7, 1982, p. H33.

Leo Castelli Gallery, New York. *Exhibition of South African Mines*, Oct. 30–Nov. 20, 1982.

 Smith, Roberta. "Abstraction: Simple and Complex." *The Village Voice* (New York), Nov. 23, 1982, p. 102.

Kitakyushu Municipal Museum of Art, Japan. *Working Drawings from the Artist's Collection*, Nov. 3–29, 1982. Cat.

Getler/Pall, New York. *Frank Stella: Works on Paper*, Dec. 28, 1982–Jan. 29, 1983.

Whitney Museum of American Art, New York. *Frank Stella: Prints, 1967–1982*, Jan. 13–Mar. 13, 1983.

 Glueck, Grace. "Frank Stella's Prints at the Whitney." *The New York Times*, Jan. 14, 1983, p. C22.

Hughes, Robert. "Expanding What Prints Can Do." *Time* (New York), Feb. 28, 1983, p. 60.

The Jewish Museum, New York. *Frank Stella: Polish Wooden Synagogues—Constructions from the 1970s,* Feb. 9–May 1, 1983. Cat.

 Smith, Roberta. "A Double Dose." *The Village Voice* (New York), Mar. 1983, p. 106.

Marianne Friedland Gallery, Toronto. *Frank Stella: The Circuit Series and the Swan Engravings,* Feb. 26, 1983–closing date unknown.

San Francisco Museum of Modern Art. *Resource/ Response/Reservoir: Stella Survey 1959–1982,* Mar. 10–May 1, 1983. Cat.

Goldman-Kraft Gallery, Ltd., Chicago. *Frank Stella,* June 3, 1983–closing date unknown.

Akira Ikeda Gallery, Tokyo. *Frank Stella: Reliefs,* Aug. 8–31, 1983.

Albright-Knox Art Gallery, Buffalo. *Frank Stella—Works from the Permanent Collection,* July 22–Sept. 5, 1983.

Skirball Museum, Hebrew Union College, Los Angeles. *Focus on Frank Stella: Nasielk II, A Polish Wooden Synagogue Construction,* Oct. 11, 1983–closing date unknown.

The Harcus Gallery, Boston. *Graphics and Mixed Media,* Nov. 12–Dec. 7, 1983.

Fogg Art Museum, Harvard University Art Museum, Cambridge, Mass. *Frank Stella: Selected Works,* Dec. 7, 1983–Jan. 26, 1984.

 Baker, Kenneth. "Art: The Shape of Things to Come—Frank Stella's Past Performances." *Boston Phoenix,* Jan. 17, 1984, pp. 5, 12.

M. Knoedler, Zurich. *Frank Stella: Recent Work,* Dec. 14, 1983–Jan. 21, 1984. Circulating exhibition.

Fort Worth Art Museum. *Frank Stella: The Swan Engravings,* Oct. 14–Dec. 2, 1984. Cat., text by Robert Hughes.

M. Knoedler & Co., New York. *Frank Stella: Relief Paintings,* Jan. 26–Feb. 23, 1985.

 Russell, John. "The Power of Frank Stella." *The New York Times,* Feb. 1, 1985, pp. C1, C22.

 Flam, Jack. "The Gallery: Surprises from Frank Stella." *The Wall Street Journal* (New York), Feb. 12, 1985, p. 28.

 Cohen, Ronny. "Frank Stella." *Art News* (New York), May 1985, p. 115.

 O'Brien, Glenn. "Frank Stella, Knoedler Gallery." *Artforum* (New York), May 1985, pp. 108–9.

L. A. Louver, Venice, California. *Frank Stella: Illustrations After El Lissitsky's Had Gadya,* Feb. 5–Mar. 9, 1985. Circulating exhibition.

Akira Ikeda Gallery, Tokyo. *Frank Stella,* Mar. 15–Apr. 20, 1985.

Knoedler Gallery, London. *Frank Stella: Ceramic Reliefs and Steel Reliefs,* May 15–June 15, 1985.

ICA Gallery, Institute of Contemporary Arts, The Mall, London, England. *Frank Stella: Works 1979–1985 and New Graphics,* May 17–July 17, 1985. Circulating exhibition.

 Fallon, Brian. "Frank Stella Exhibition at Douglas Hyde." *Irish Times* (Dublin), Aug. 15, 1985.

Akira Ikeda Gallery, Nagoya, Japan. *Frank Stella: New Prints,* Aug. 5–31, 1985.

Getler/Saper Gallery, New York. *Frank Stella: Classic Prints,* Dec. 17, 1985–Jan. 11, 1986.

Richard Green Gallery, New York. *Frank Stella: Illustrations after El Lissitsky's Had Gadya,* Mar. 1–Mar. 27, 1986.

Gagosian Gallery, New York. *The Pre-Black Paintings: 1958,* Mar. 28–May 30, 1986.

 Schwabsky, B. "Frank Stella." *Arts Magazine* (New York), Oct. 1987, pp. 110–11.

Akira Ikeda Gallery, Tokyo. *Frank Stella: New Reliefs,* May 6–31, 1986.

Laumeier Sculpture Park, St. Louis, Missouri. *Frank Stella at Laumeier,* June 15–Aug. 31, 1986.

Carnegie Mellon University Art Gallery, Pittsburgh. *Frank Stella: Color and Form on Paper,* Oct. 25–Dec. 13, 1986.

Knoedler Gallery, London. *Frank Stella,* June 19–July 16, 1987.

 Beaumont, M. R. "Frank Stella." *Arts Review* (London), July 3, 1987, pp. 452–53.

The Museum of Modern Art, New York. *Frank Stella: 1970–1987,* Oct. 12, 1987–Jan. 5, 1988. Cat., text by William Rubin. Circulating exhibition.

 Stevens, Mark. "Frank Stella's Serious Fun: Creating New Art with the Flair of an Old Master. *Newsweek* (New York), Oct. 19, 1987, pp. 82–83.

 Kuspit, Donald. "Frank Stella: Museum of Modern Art." *Artforum* (New York), Dec. 1987, pp. 109–10.

Stedelijk Museum, Amsterdam. *Frank Stella: 1970–1987,* Feb. 12–Apr. 10, 1988.

James Corcoran Gallery, Santa Monica, California. *Frank Stella,* Apr. 28–May 28, 1988.

AGNES MARTIN

By the Artist

Writings

"The Untroubled Mind," edited by Ann Wilson. *Studio International* (London), Feb. 1973, pp. 64–65. Also in *Flash Art* (Milan), June 1973, pp. 6–8.

"Reflections," transcribed and edited by Lizzie Borden. *Artforum* (New York), Apr. 1973, p. 38.

Poirier, Maurice, and Necol, Jane. "The '60s in Abstract: 13 Statements and an Essay." *Art in America* (New York), Oct. 1983, pp. 122–37.

On the Artist

Selected Articles

Hess, Thomas B. "You Can Hang It in the Hall." *Art News* (New York), Apr. 1965, p. 43.

Alloway, Lawrence. "Background to Systemic." *Art News* (New York), Oct. 1966, pp. 30–33.

Pincus-Witten, Robert. "Systemic Painting." *Artforum* (New York), Nov. 1966, pp. 42–45.

Ashton, Dore. "Agnes Martin." *Quadrum* (Brussels), no. 20, 1966, pp. 148–49.

Michelson, Annette. "Agnes Martin: Recent Paintings." *Artforum* (New York), Jan. 1967, pp. 46–47.

Mendelbaum, Elaine. "Insoluble Units, Unity and Difficulty." *Art Journal* (New York), Spring 1968, pp. 259–60.

Kolbert, Frank. "Agnes Martin." Unpublished ms., Yale University, 1970.

Linville, Kasha. "Agnes Martin: An Appreciation." *Artforum* (New York), June 1971, pp. 72–73.

Alloway, Lawrence. "Formlessness Breaking Down Form: The Paintings of Agnes Martin." *Studio International* (London), Feb. 1973, pp. 61–63.

Crimp, Douglas. "Agnes Martin: Numero, Misura, Rapporto [Agnes Martin: Number, Measure, Relationship]." *Data* (Milan), Winter 1973, pp. 82–85.

Alloway, Lawrence. "Agnes Martin." *Artforum* (New York), Apr. 1973, pp. 32–37.

Borden, Lizzie. "Early Work." *Artforum* (New York), Apr. 1973, pp. 39–44.

Ratcliff, Carter. "Agnes Martin and the 'Artificial Infinite'." *Art News* (New York), May 1973, pp. 26–27.

Celant, Germano. "Agnes Martin." *Flash Art* (Milan), June 1973, pp. 3–8.

Rose, Barbara. "Pioneer Spirit." *Vogue* (New York), June 1973, pp. 114–15, 157.

Morris, Lynda. "Agnes Martin." *Art Press* (Paris), June–Aug. 1974, p. 33.

Wilson, A. "Agnes Martin, the Essential Form: the Committed Life." *Art International* (Lugano), Dec. 1974, pp. 50–52.

Gruen, John. "Agnes Martin: 'Everything, everything is about feeling . . . feeling and recognition'." *Art News* (New York), Sept. 1976, pp. 91–94.

Sims, Patterson. "Permanent Collection Acquisition: Agnes Martin 'Untitled II'." *Whitney Review* (New York), 1976–77, pp. 30–31.

Ashbery, John. "Art." *New York,* Apr. 17, 1978, pp. 87–88.

McEvilley, Thomas. " 'Gray Geese Descending': The Art of Agnes Martin." *Artforum* (New York), Summer 1987, pp. 94–99.

Selected One-Artist Exhibitions and Reviews

Section II, New York. *Agnes Martin,* Dec. 2–20, 1958.

 Burckhardt, Edith. "Exhibitions at Section II." *Art News* (New York), Dec. 1958, p. 17.

 Ventura, Anita. "Agnes Martin." *Art Digest* (New York), Jan. 1959, p. 59.

Section II, New York. *Agnes Martin*, Dec. 29, 1959–Jan. 16, 1960.

Ashton, Dore. "Art Drawn from Nature." *The New York Times*, Dec. 29, 1959, p. 23.

B. B. "Agnes Martin." *Arts Magazine* (New York), Jan. 1960, pp. 50–51.

Campbell, Lawrence. "Agnes Martin." *Art News* (New York), Jan. 1960, p. 16.

Betty Parsons Gallery, New York. *Agnes Martin*, Sept. 25–Oct. 14, 1961.

Coates, Robert M. "Variations on Themes." *The New Yorker* (New York), Oct. 14, 1961, pp. 202–4, 207.

Edgar, Natalie. "Agnes Martin." *Art News* (New York), Oct. 1961, pp. 11–12.

Robert Elkon Gallery, New York. *Agnes Martin: Recent Paintings*, Nov. 27–Dec. 15, 1962.

Beck, James H. "Agnes Martin." *Art News* (New York), Jan. 1963, p. 13.

Judd, Donald. "Agnes Martin." *Arts Magazine* (New York), Feb. 1963, p. 48.

Robert Elkon Gallery, New York. *Agnes Martin*, Nov. 12–30, 1963.

Lonngren, Lilian. "Agnes Martin." *Art News* (New York), Dec. 1963, p. 52.

Judd, Donald. "Agnes Martin." *Arts Magazine* (New York), Jan. 1964, pp. 33–34.

Rose, Barbara. "New York Letter." *Art International* (Lugano), Jan. 1964, p. 53.

Robert Elkon Gallery, New York. *Agnes Martin*, Apr. 10–30, 1965.

Johnston, Jill. "Agnes Martin." *Art News* (New York), Apr. 1965, p. 10.

Berkson, William. "Agnes Martin." *Arts Magazine* (New York), May/June 1965, p. 66.

Lippard, Lucy R. "New York Letter." *Art International* (Lugano), Sept. 20, 1965, p. 60.

Robert Elkon Gallery, New York. *Agnes Martin*, Oct. 22–Nov. 12, 1966.

Kozloff, Max. "Art." *The Nation* (New York), Nov. 14, 1966, pp. 524–25.

Benedikt, Michael. "New York Letter." *Art International* (Lugano), Dec. 1966, p. 65.

Perreault, John. "Agnes Martin." *Art News* (New York), Dec. 1966, p. 14.

Nicholas Wilder Gallery, Los Angeles. Title and exact dates unknown, 1967.

Livingston, Jane. "Los Angeles: Agnes Martin." *Artforum* (New York), Dec. 1967, p. 62.

Robert Elkon Gallery, New York. *Agnes Martin, John McCrackers*, May 3–31, 1969.

Mellow, James R. "New York Letter." *Art International* (Lugano), Summer 1969, p. 51.

Ratcliff, Carter. "Agnes Martin, John McCrackers." *Art News* (New York), Summer 1969, p. 18.

Robert Elkon Gallery, New York. *Agnes Martin: Drawings 1961–1966*, May 2–28, 1970.

Hobhouse, Janet. "Agnes Martin at Robert Elkon." *Arts Magazine* (New York), May 1970, p. 63.

Henry, Gerrit. "Agnes Martin." *Art News* (New York), Summer 1970, p. 64.

Nicholas Wilder Gallery, Los Angeles. Title and dates unknown, 1970.

Young, Joseph E. "Los Angeles: Agnes Martin." *Art International* (Lugano), Mar. 1970, p. 85.

Plagens, Peter. "Los Angeles: Agnes Martin." *Artforum* (New York), Apr. 1970, p. 86.

School of Visual Arts, New York. Title unknown, Apr. 20–May 25, 1971.

Ratcliff, Carter. "Agnes Martin." *Art News* (New York), Sept. 1971, p. 16.

Robert Elkon Gallery, New York. *Agnes Martin: Eight Paintings 1961–1967*, Mar. 4–29, 1972.

Bishop, James. "Agnes Martin." *Art News* (New York), Apr. 1972, p. 55.

Lubell, Ellen. "Agnes Martin." *Arts Magazine* (New York), Apr. 1972, p. 68.

Smith, Alvin. "New York Letter." *Art International* (Lugano), May 1972, p. 58.

Institute of Contemporary Art, University of Pennsylvania, Philadelphia. *Agnes Martin*, Jan. 22–Mar. 1, 1973. Cat., text by Lawrence Alloway and Agnes Martin. Circulating exhibition.

Crimp, Douglas. "New York Letter." *Art International* (Lugano), Apr. 1973, p. 57.

Ratcliff, Carter. "Agnes Martin and the 'Artificial Infinite'." *Art News* (New York), May 1973, pp. 26–27.

Schjeldahl, Peter. "Agnes Martin." *Art in America* (New York), May 1973, p. 110.

The Museum of Modern Art, New York. *Agnes Martin: On a Clear Day*, May 14–Aug. 26, 1973.

Andre, Michael. "Agnes Martin." *Art News* (New York), Oct. 1973, p. 92.

Galleria LP 220, Turin. *Agnes Martin: Portfolio*, Sept. 25–Oct. 19, 1973.

Kunstraum Munchen, Munich. *Agnes Martin*, Nov. 20–Dec. 22, 1973. Cat., introduction by Hermann Kern; text by the artist.

"Kunstraum, München; Kunsthalle Tübingen; ausstellungen." *Pantheon* (Munich), Apr. 1974, p. 180.

Nicholas Wilder Gallery, Los Angeles. Title and exact dates unknown, 1973.

Thornycroft, Ann. "California Report." *Studio International* (London), Dec. 1973, p. 244.

Robert Elkon Gallery, New York. *Agnes Martin: Drawings 1960–1967*, Mar. 9–Apr. 3, 1974.

Bell, Jane. "Agnes Martin." *Arts Magazine* (New York), May 1974, p. 60.

Heinemann, Susan. "Agnes Martin." *Artforum* (New York), May 1974, p. 76.

Fine Arts Museum, Santa Fe, New Mexico. Title and exact dates unknown, 1974.

Coke, Van Deren. "Perfections of Line." *Art News* (New York), Nov. 1974, p. 42.

The Pace Gallery, New York. *Agnes Martin: New Paintings*, Mar. 1–Apr. 1, 1975.

Hoesterey, Ingeborg. "New York." *Art International* (Lugano), May 1975, p. 57.

Zimmer, William. "Agnes Martin." *Arts Magazine* (New York), May 1975, p. 18.

Zucker, Barbara. "Agnes Martin." *Art News* (New York), May 1975, p. 95.

Gula, Kasha. "New York: Agnes Martin at Pace." *Art in America* (New York), May–June 1975, pp. 85–86.

Smith, Roberta. "Agnes Martin, Pace Gallery." *Artforum* (New York), Summer 1975, pp. 72–73.

The Pace Gallery, New York. *Agnes Martin: Recent Paintings*, May 1–29, 1976.

Weissman, Julian. "Agnes Martin." *Art News* (New York), Sept. 1976, p. 119.

Robert Elkon Gallery, New York. *Agnes Martin: Paintings 1961–67*, May 1–June 2, 1976.

Ellenzweig, Allen. "Agnes Martin." *Arts Magazine* (New York), Sept. 1976, pp. 26–27.

Weissman, Julian. "Agnes Martin." *Art News* (New York), Sept. 1976, p. 119.

Arts Council of Great Britain, Hayward Gallery, London. *Agnes Martin Paintings and Drawings 1957–75*, 1977. Cat., text by Dore Ashton and text of lecture given by

Agnes Martin at Yale University, Apr. 5, 1976.

Rouve, P. "Sam Stephenson, Agnes Martin." *Arts Review* (London), Mar. 18, 1977, p. 173.

Roberts, Keith. "Current and Forthcoming Exhibitions." *Burlington Magazine* (London), Apr. 1977, p. 299.

Crichton, Fenella. "London." *Art International* (Lugano), May–June 1977, p. 70.

Maloon, T. "The Makings of Americans: Agnes Martin and Frank Stella." *Artscribe* (London), July 1977, pp. 10–13.

"Paintings and Drawings 1957–1975: Hayward Gallery, London; exhibit." *Pantheon* (Munich), July 1977, pp. 269–70.

The Pace Gallery, New York. *Agnes Martin: Recent Paintings*, Sept. 17–Oct. 15, 1977.

Henry, Gerrit. "Agnes Martin." *Art News* (New York), Nov. 1977, p. 246.

Perrone, Jeff. "Agnes Martin." *Artforum* (New York), Dec. 1977, pp. 58–59.

The Pace Gallery, New York. *Agnes Martin: New Watercolors*, Mar. 25–Apr. 22, 1978.

Cavaliere, Barbara. "Agnes Martin/Group Show." *Arts Magazine* (New York), June 1978, p. 39.

Schjeldahl, Peter. "Agnes Martin." *Artforum* (New York), Summer 1978, p. 69.

Welish, Marjorie. "Agnes Martin at Pace." *Art in America* (New York), Sept./Oct. 1978, p. 121.

The Mayor Gallery, London. *Agnes Martin: Six New Paintings*, Apr. 4–May 13, 1978.

Burr, James. "Close to Nothing." *Apollo* (London), Apr. 1978, p. 331.

Spalding, F. "Agnes Martin." *Arts Review* (London), Apr. 1978, p. 202–3.

Robert Elkon Gallery, New York. *Agnes Martin: Drawings of the Sixties*, Oct. 7–Nov. 8, 1978.

Larson, Kay. "Agnes Martin." *Art News* (New York), Dec. 1978, pp. 143–44.

Harcus/Krakow Gallery, Boston. *Agnes Martin: Recent Drawings*, Nov. 4–29, 1978.

Margo Leavin Gallery, Los Angeles. *Agnes Martin: Recent Watercolors*, Apr. 7–May 5, 1979.

Rosenthal, Adrienne. "Whispers from Nature." *Artweek* (Oakland, Calif.), Apr. 28, 1979, p. 5.

The Pace Gallery, New York. *Agnes Martin: 1979 Paintings*, Sept. 21–Oct. 13, 1979.

Cavaliere, Barbara. "Agnes Martin." *Arts Magazine* (New York), Dec. 1979, pp. 22–23.

Nadelman, Cynthia. "Agnes Martin." *Art News* (New York), Dec. 1979, p. 155.

Ulrich Museum of Art, Wichita State University, Kansas. Organized by The Pace Gallery, New York, and the artist. *Agnes Martin: Paintings*, Mar. 18–Apr. 6, 1980. Circulating exhibition.

Hoffman, Andrea. "Lines and Colors of Nature." *Artweek* (Oakland, Calif.), Sept. 20, 1980, p. 5.

Kerr, Marcianne. "Agnes Martin: Paintings." *Dialogue* (Munroe Falls, Ohio), Mar./Apr. 1981, p. 34.

Richard Gray Gallery, Chicago. *Agnes Martin: New Paintings-Watercolors*, Sept. 27–Oct. 1980.

The Pace Gallery, New York. *Agnes Martin: Paintings 1981*, Sept. 25–Oct. 31, 1981.

Kuspit, Donald B. "Agnes Martin at Pace." *Art in America* (New York), Jan. 1982, p. 139.

The Pace Gallery, New York. *Agnes Martin: New Paintings*, Dec. 3, 1982–Jan. 8, 1983.

Henry, Gerrit. "Agnes Martin: Pace." *Art News* (New York), Mar. 1983, p. 159.

The Pace Gallery, New York. *Agnes Martin: Recent Paintings*, Jan. 20–Feb. 11, 1984.

The Mayor Gallery, London. *Agnes Martin: Recent Paintings*, Feb. 1–Mar. 16, 1984.

LARRY POONS

The Pace Gallery, New York. *Agnes Martin: New Paintings*, Jan. 16–Feb. 18, 1985.
 Silverthorne, Jeanne. "Agnes Martin." *Artforum* (New York), Apr. 1985, pp. 89–90.
 Cotter, H. [Review in] *Flash Art* (Milan), Apr./May 1985, p. 38.
 Birmelin, Blair T. "Agnes Martin at Pace." *Art in America* (New York), May 1985, p. 177.
The Pace Gallery, New York. *Agnes Martin: New Paintings*, Sept. 19–Oct. 25, 1985.
Waddington Galleries, London. *Agnes Martin: Recent Paintings*, Feb. 5–Mar. 1, 1986. Cat.
The Pace Gallery, New York. *Agnes Martin: New Paintings*, Sept. 19–Oct. 25, 1986.
 Grimes, Nancy. "Agnes Martin: Pace." *Art News* (New York), Dec. 1986, p. 140.
Gallerie Yvon Lambert, Paris. *Agnes Martin*, Apr. 25–May 20, 1987.
 Piguet, P. "Agnes Martin." *L'Oeil* (Paris), May 1987, p. 88.
 Bouisset, Maïten. "Agnes Martin: le temps d'une réspiration." *Art Press* (Paris), June 1987, p. 64.
 Prodhon, F. C. [Review in] *Flash Art* (Milan), Summer 1987, p. 121.
Barbara Krakow Gallery, Boston. *Agnes Martin*, Mar. 5–Mar. 30, 1988.

By the Artist

Interview

Tuchman, Phyllis. "An Interview with Larry Poons." *Artforum* (New York), Dec. 1970, pp. 45–50.

On the Artist

Selected Articles

Johnson, Charlotte B. "Trends and Traditions: Recent Acquisitions." *Gallery Notes* (Albright-Knox Art Gallery, Buffalo), no. 2, Spring 1964, p. 5.
Tillim, Sidney. "Larry Poons: The Dotted Line." *Arts Magazine* (New York), Feb. 1965, pp. 16–21.
Kozloff, Max. "Larry Poons." *Artforum* (San Francisco), Apr. 1965, pp. 26–29.
Coplans, John. "Larry Poons." *Artforum* (San Francisco), June 1965, pp. 33–35.
"Portrait." *Kunstwerk* (Baden-Baden), Apr. 1966, p. 106.
Fry, Edward F. "Poons: A Clean and Balanced World?" *Art News* (New York), Feb. 1967, pp. 34–35, 69–71.
Lippard, Lucy. "Larry Poons: The Illusion of Disorder." *Art International* (Lugano), Apr. 1967, pp. 22–26.
Champa, Kermit S. "New Paintings by Larry Poons." *Artforum* (New York), Summer 1968, pp. 39–42.
Henning, Edward. "Larry Poons: Untitled." *Cleveland Museum Bulletin*, Apr. 1970, pp. 118–22.
Moffett, Kenworth. "Railroad Horse." *Boston Museum Bulletin*, nos. 361–62, 1972, p. 109.
Fenton, Terry. "Larry Poons: Recent Paintings." *Art Spectrum* (Lugano), Jan. 1975, pp. 30–31, 37–40.
Tatransky, Valentin. "Unities and Antipodes: Larry Poons and Robert Smithson." *Arts Magazine* (New York), Sept. 1982, pp. 116–20.

Selected One-Artist Exhibitions and Reviews

Green Gallery, New York. *Larry Poons*, Nov. 4–23, 1963.
 O'Doherty, Brian. [Review in] *The New York Times*, Nov. 17, 1963, page unknown.
 Swenson, G. R. "Reviews and Previews." *Art News* (New York), Nov. 1963, p. 19.
 Fried, Michael. "New York Letter." *Art International* (Lugano), Jan. 1964, p. 55.
 H[arrison], J[ane.] "Larry Poons." *Arts Magazine* (New York), Jan. 1964, p. 31.
Green Gallery, New York. *Larry Poons*, Apr. 7–May 2, 1964.
Green Gallery, New York. *Poons*, Feb. 10–Mar. 6, 1965.
 Baker, Elizabeth C. "Reviews and Previews." *Art News* (New York), Mar. 1965, p. 12.
 Judd, Donald. "New York Letter." *Art International* (Lugano), Apr. 1965, p. 74.
Leo Castelli Gallery, New York. *Larry Poons*, Jan. 7–28, 1967.
 S[iegel], J[eanne]. "Larry Poons." *Arts Magazine* (New York), Feb. 1967, p. 56.
Kasmin Limited, London. *Larry Poons: Recent Paintings*, Apr. 5–27, 1968.
Leo Castelli Gallery, New York. *Larry Poons*, Nov. 2–23, 1968.
 Perreault, John. "Reviews and Previews." *Art News* (New York), Dec. 1968, p. 52.
 N[emser], C[indy]. "Larry Poons." *Arts Magazine* (New York), Dec. 1968–Jan. 1969, p. 58.
 Krauss, Rosalind. "New York." *Artforum* (New York), Jan. 1969, pp. 54–55.
Lawrence Rubin Gallery, New York. *Larry Poons: New Paintings*, Oct. 4–29, 1969.
 Ratcliff, Carter. "Reviews and Previews." *Art News* (New York), Oct. 1969, pp. 64–66.

[M. W.]. "Larry Poons." *Arts Magazine* (New York), Nov. 1969, p. 60.
 Bourgeois, Jean-Louis. "Larry Poons." *Artforum* (New York), Dec. 1969, p. 72.
 Ratcliff, Carter. "New York Letter." *Art International* (Lugano), Dec. 1969, p. 72.
Lawrence Rubin Gallery, New York. *Larry Poons*, Oct. 3–27, 1970.
 Glueck, Grace. "New York Gallery Notes: Peace Plus." *Art in America* (New York), Sept. 1970, pp. 41–42.
 Ratcliff, Carter. "Reviews and Previews." *Art News* (New York), Nov. 1970, p. 66.
 Domingo, Willis. "Larry Poons: Lawrence Rubin Gallery." *Arts Magazine* (New York), Nov. 1970, p. 61.
 Marandel, J. Patrice. "Lettre de New York." *Art International* (Lugano), Dec. 1970, p. 72.
 Ratcliff, Carter. "New York Letter." *Art International* (Lugano), Dec. 1970, p. 68.
Kasmin Limited, London. *Larry Poons: New Paintings*, Jan. 20–Feb. 6, 1971.
 Denvir, Bernard. "London Letter." *Art International* (Lugano), Mar. 1971, p. 46.
Lawrence Rubin Gallery, New York. *Larry Poons: Recent Paintings*, Nov. 13–Dec. 1, 1971.
 Ashbery, John. "Reviews and Previews." *Art News* (New York), Jan. 1972, p. 22.
 Ratcliff, Carter. "New York Letter." *Art International* (Lugano), Jan. 1972, p. 68.
 Fried, Michael. "Larry Poons' New Paintings." *Artforum* (New York), Mar. 1972, pp. 50–52.
Lawrence Rubin Gallery, New York. *Larry Poons*, Sept. 30–Oct. 17, 1972.
 Schjeldahl, Peter. "Larry Poons—'A Sort of Soap Opera Career.'" *The New York Times*, Oct. 15, 1972, Sec. 2, p. 23.
 Anderson, Laurie. "Larry Poons: Rubin." *Arts Magazine* (New York), Nov. 1972, p. 71.
 Siegel, Jeanne. "Reviews and Previews." *Art News* (New York), Nov. 1972, p. 79.
 Baker, Kenneth. "A New Concept of Painting." *The Christian Science Monitor* (Boston), Dec. 16, 1972, p. HF1.
 Ratcliff, Carter. "Larry Poons." *Artforum* (New York), Jan. 1973, p. 82.
 Ratcliff, Carter. "New York." *Art International* (Lugano), Jan. 1973, p. 68.
David Mirvish Gallery, Toronto. *Larry Poons*, Apr. 28–May 19, 1973.
 Marshall, W. Neil. "Toronto Letter." *Art International* (Lugano), Summer 1973, p. 43.
Knoedler Contemporary Art, New York. *Larry Poons*, Sept. 29–Oct. 18, 1973.
Edmonton Art Gallery, Canada. *Larry Poons: Recent Paintings*, May 2–30, 1974. Cat., introduction by Terry Fenton.
Knoedler Contemporary Art, New York. *Larry Poons*, Nov. 2–20, 1974.
 Russell, John. "New Paintings by Larry Poons: Knoedler." *The New York Times*, Nov. 9, 1974, p. 25.
 Ellenzweig, Allen. "Larry Poons: Knoedler Contemporary Art." *Arts Magazine* (New York), Jan. 1975, p. 6.
 Henry, Gerrit. "Reviews and Previews." *Art News* (New York), Jan. 1975, pp. 110, 112.
 Smith, Roberta. "Larry Poons: Knoedler Contemporary Art." *Artforum* (New York), Feb. 1975, pp. 64–65.
Ace Gallery, Venice, California. *Larry Poons: Recent Paintings*, Jan.–Feb. 5, 1975.

Galerie André Emmerich, Zurich. *Larry Poons*, Sept. 6–Oct. 11, 1975.

Knoedler Contemporary Art, New York. *Larry Poons*, Nov. 8–Dec. 3, 1975.

Zucker, Barbara. "Reviews and Previews." *Art News* (New York), Jan. 1976, pp. 121–22.

Stimson, Paul. "Larry Poons at Knoedler." *Art in America* (New York), Mar.–Apr. 1976, pp. 107–8.

Hoesterey, Ingeborg. "New York." *Art International* (Lugano), Apr.–May 1976, p. 49.

Daniel Templon, Paris. *Larry Poons*, Feb. 10–Mar. 6, 1976.

David Mirvish Gallery, Toronto. *Larry Poons: Recent Paintings*, May 8–June 2, 1976.

M. Knoedler & Co., New York. *Larry Poons: Recent Paintings*, Oct. 30–Nov. 18, 1976.

Betz, Margaret. "Reviews and Previews." *Art News* (New York), Jan. 1977, pp. 125–26.

Frackman, Noel. "Larry Poons: Knoedler." *Arts Magazine* (New York), Jan. 1977, p. 27.

Watson/de Nagy, Houston. *Larry Poons: Recent Paintings*, Feb. 5–Mar. 2, 1977.

Ace Gallery, Venice, California. *Larry Poons: Major Works*, Feb. 1977.

M. Knoedler & Co., New York. *Larry Poons*, Oct. 29–Nov. 19, 1977.

Russell, John. "Larry Poons: Knoedler Gallery." *The New York Times*, Nov. 11, 1977, p. C17.

Frackman, Noel. "Larry Poons." *Arts Magazine* (New York), Jan. 1978, p. 21.

Galerie Ninety-Nine, Bay Harbor Islands, Florida. *Larry Poons: New Paintings*, Jan. 13–Feb. 3, 1978.

Galerie Wentzel, Hamburg, West Germany. *Larry Poons*, May 9–July 8, 1978.

M. Knoedler & Co., New York. *Larry Poons*, Nov. 4–18, 1978.

Tatransky, Valentin. "Larry Poons, Knoedler." *Flash Art* (Milan), Jan.–Feb. 1979, p. 42.

André Emmerich Gallery, New York. *Larry Poons*, Oct. 6–31, 1979.

Cavaliere, Barbara. "Larry Poons." *Arts Magazine* (New York), Dec. 1979, p. 23.

Monte, James. "Poons: A Brief Review." *Arts Magazine* (New York), Dec. 1979, pp. 150–51.

Perrone, Jeff. "Larry Poons: André Emmerich Gallery." *Artforum* (New York), Dec. 1979, pp. 76–77.

Bremer, N. "André Emmerich Gallery, New York; Exhibit." *Pantheon* (Munich), Jan. 1980, p. 40.

Theo Waddington Galleries, Toronto. *Larry Poons: Paintings 1971–1975*, June 14–July 12, 1980.

Mays, John Bentley. "Poons Gets Physical on Canvas." *Globe & Mail* (Toronto), June 13, 1980, page unknown.

Galerie Ninety-Nine, Bay Harbor Islands, Florida. *Larry Poons: Recent Works*, Jan. 16–31, 1981.

André Emmerich Gallery, New York. *Larry Poons*, Mar. 5–21, 1981.

Baro, Gene. "New York Letter." *Art International* (Lugano), Aug.–Sept. 1981, p. 118.

Gallery One, Toronto. *Larry Poons*, Mar. 7–26, 1981.

Museum of Fine Arts, Boston. *Larry Poons: Paintings 1971–1981*, Nov. 11, 1981–Mar. 21, 1982. Cat., text by Kenworth Moffett.

Allara, Pamela. "Larry Poons, Museum of Fine Arts; Sandi Slone, Wheaton College." *Art News* (New York), Apr. 1982, p. 178.

André Emmerich Gallery, New York. *Lawrence Poons*, Apr. 1–24, 1982.

Yau, John. "Lawrence Poons at André Emmerich." *Art in America* (New York), Oct. 1982, p. 134.

Meredith Long & Company, Houston. *Lawrence Poons: Recent Works on Canvas*, May 11–June 11, 1982.

Gallery One, Toronto. *Lawrence Poons: New Paintings*, Dec. 4, 1982–Jan. 6, 1983.

André Emmerich Gallery, New York. *Lawrence Poons*, Feb. 5–26, 1983.

Kuspit, Donald. "Larry Poons." *Artforum* (New York), May 1983, pp. 98–99.

Gallery One, Toronto. *Lawrence Poons: New Paintings*, Oct. 4–25, 1984.

André Emmerich Gallery, New York. *Lawrence Poons*, Feb. 28–Mar. 23, 1985.

Tatransky, Valentin. "Lawrence Poons." *Arts Magazine* (New York), May 1985, p. 10.

O'Brien, Glenn. "Lawrence Poons." *Artforum* (New York), Summer 1985, pp. 102–3.

André Emmerich Gallery, New York. *Lawrence Poons: New Paintings*, June 5–July 3, 1986.

Tillim, Sidney. "Lawrence Poons." *Art in America* (New York), Sept. 1986, pp. 139–40.

ROBERT MANGOLD

By the Artist

Writings

"Work Comments/1965–1966." *Systemic Painting*. New York: The Solomon R. Guggenheim Museum, 1966, p. 25.

"Robert Mangold." *Flash Art* (Milan), Dec. 1973–Jan. 1974, p. 17.

Robert Mangold: Six Arcs. New York: Lapp Princess Press, 1978.

Interviews

Krauss, Rosalind. "Interview with Robert Mangold." *Artforum* (New York), Mar. 1974, pp. 36–38.

White, Robin. "Interview with Robert Mangold." *View* (Oakland, Calif.), Dec. 1978, pp. 1–24.

Poirier, Maurice, and Necol, Jane. "The 60s in Abstract: 13 Statements and an Essay." *Art in America* (New York), Oct. 1983, p. 130.

On the Artist

Selected Articles

Lippard, Lucy R. "Robert Mangold and the Implications of Monochrome." *Art and Literature* (Lausanne), 1966, pp. 116–30.

Lippard, Lucy R. "The Silent Art." *Art in America* (New York), Jan.–Feb. 1967, pp. 58–63. Reprinted in *Changing/Essays in Art Criticism*. New York: E. P. Dutton, 1971, pp. 130–40.

Bochner, Mel. "Compilation for Robert Mangold." *Art International* (Lugano), Apr. 20, 1968, pp. 29–30.

Rosenstein, Harris. "To Be Continued." *Art News* (New York), Oct. 1970, pp. 63–65, 82–83.

Masheck, Joseph. "Humanist Geometry." *Artforum* (New York), Mar. 1974, pp. 39–43.

Stevens, Mark. "Beautiful Deceptions." *Newsweek* (New York), Mar. 24, 1980, pp. 93–95.

Berlind, R. "Robert Mangold: Nuanced Deviance." *Art in America* (New York), May 1985, pp. 160–67.

Gruen, John. "Robert Mangold: A Maker of Images—Nothing More and Nothing Less." *Art News* (New York), Summer 1987, pp. 132–38.

Selected One-Artist Exhibitions and Reviews

Thibaut Gallery, New York. *Robert Mangold*, Jan. 4–25, 1964.

Campbell, Lawrence. "Reviews and Previews." *Art News* (New York), Jan. 1964, p. 19.

Harrison, Jane. "Robert Mangold." *Arts Digest* (New York), Mar. 1964, p. 67.

Lippard, Lucy R. "Reviews." *Artforum* (San Francisco), Mar. 1964, p. 19.

Fried, Michael. "New York Letter." *Art International* (Lugano), Apr. 25, 1964, p. 58.

Fischbach Gallery, New York. *Robert Mangold*, Oct. 12–30, 1965.

Canaday, John. "Reviews." *The New York Times*, Oct. 16, 1965, page unknown.

Gruen, John. *New York Herald Tribune*, Oct. 16, 1965, page unknown.

Bourdon, David. "Cool Obdurate Art." *The Village Voice* (New York), Oct. 21, 1965, page unknown.

Lippard, Lucy R. "Robert Mangold/Walls and Areas." *Art News* (New York), Oct. 1965, p. 10.

Benedikt, Michael. "New York Letter." *Art International* (Lugano), Dec. 20, 1965, p. 41.

B[erkson], W[illiam]. "Robert Mangold." *Arts Magazine* (New York), Dec. 1965, pp. 65–66.

Fischbach Gallery, New York. *Robert Mangold/Recent Paintings*, Nov. 4–30, 1967.

B[enedikt], M[ichael]. "Robert Mangold." *Art News* (New York), Nov. 1967, p. 60.

Glueck, Grace. "New York Gallery Notes." *Art in America* (New York), Nov.–Dec. 1967, p. 124.

Mellow, James R. "On Art, The Means Become the Subject." *The New Leader* (New York), Jan. 15, 1968, pp. 29–30.

Mellow, James R. "New York Letter." *Art International* (Lugano), Jan. 20, 1968, p. 62.

Ashton, Dore. "New York Commentary." *Studio International* (London), Jan. 1968, p. 41.

Pincus-Witten, Robert. "Robert Mangold: Fischbach." *Artforum* (New York), Jan. 1968, p. 59.

Galerie Müller, Stuttgart. *Robert Mangold*, Mar. 23–May 3, 1968.

Fischbach Gallery, New York. *Robert Mangold*, Feb. 22–Mar. 13, 1969.

Mellow, James R. "New York Letter." *Art International* (Lugano), Apr. 20, 1969, p. 38.

Wasserman, Emily. "Robert Mangold." *Artforum* (New York), May 1969, p. 67.

Fischbach Gallery, New York. *Robert Mangold: X Series Drawings*, Apr. 25–May 14, 1970.

R[osenstein], H[arris]. "Reviews and Previews." *Art News* (New York), Summer 1970, p. 64.

Fischbach Gallery, New York. *Robert Mangold: Recent Work*, Oct. 24–Nov. 19, 1970.

Glueck, Grace. "New York Gallery Notes." *Art in America* (New York), Nov. 1970, p. 168.

Domingo, Willis. "Robert Mangold: Fischbach." *Arts Magazine* (New York), Dec. 1970, p. 58.

Linville, Kasha. "Robert Mangold: Fischbach." *Artforum* (New York), Dec. 1970, p. 81.

Ratcliff, Carter. "New York Letter." *Art International* (Lugano), Jan. 1971, p. 27.

The Solomon R. Guggenheim Museum, New York. *Robert Mangold*, Nov. 9, 1971–Jan. 2, 1972. Cat., text by Diane Waldman.

Rosenstein, Harris. "Reviews and Previews." *Art News* (New York), Jan. 1972, p. 18.

Baker, Kenneth. "Robert Mangold: Guggenheim Museum/Fischbach Gallery." *Artforum* (New York), Feb. 1972, p. 80.

Fischbach Gallery, New York. *Robert Mangold: New Work*, Nov. 20–Dec. 20, 1971.

Rosenstein, Harris. "Reviews and Previews." *Art News* (New York), Jan. 1972, p. 18.

Baker, Kenneth. "Robert Mangold: Guggenheim Museum/Fischbach Gallery." *Artforum* (New York), Feb. 1972, p. 80.

Fischbach Gallery, New York. *Robert Mangold: Paintings*, Jan. 13, 1973–closing date unknown.

Henry, Gerrit. "Reviews and Previews." *Art News* (New York), Feb. 1973, p. 79.

Boice, Bruce. "Robert Mangold: Fischbach Gallery Uptown." *Artforum* (New York), Apr. 1973, pp. 78–79.

Crimp, Douglas. "New York Letter." *Art International* (Lugano), Apr. 1973, pp. 57–58.

Da Marilena Bonomo, Bari, Italy. *Robert Mangold: 27 Disegni*, Feb. 1, 1973–closing date unknown.

Lisson Gallery, London. *Robert Mangold*, Feb. 27–Mar. 31, 1973.

Fuller, Peter. "Robert Mangold: Lisson Gallery." *Arts Review* (London), Mar. 1973, p. 184.

Annemarie Verna, Zurich. *Robert Mangold*, Mar. 30–May 3, 1973.

Max Protetch, Washington, D.C. *Robert Mangold*, Oct. 21–31, 1973.

Galerie Yvon Lambert, Paris. *Robert Mangold*, exact dates unknown, 1973.

Peppiatt, Michael. "Paris: Robert Mangold." *Art International* (Lugano), Apr. 1973, p. 70.

John Weber Gallery, New York. *Robert Mangold: New Paintings*, Jan. 12–Feb. 6, 1974.

Lubell, Ellen. "Robert Mangold." *Arts Magazine* (New York), Mar. 1974, p. 67.

La Jolla Museum of Contemporary Art, California. *Robert Mangold*, Mar. 23–May 12, 1974. Cat., text by Naomi Spector.

Galerie de Gestlo, Hamburg, West Germany. *Robert Mangold—Aquatintae*, Oct. 26–Nov. 28, 1974.

The Jared Sable Gallery, Toronto. *Robert Mangold*, Nov. 16–30, 1974.

John Weber Gallery, New York. Title unknown. Nov. 23–Dec. 18, 1974.

Battcock, Gregory. "New York Developments." *Art & Artists* (New York), Feb. 1975, p. 4.

Lubell, Ellen. "Robert Mangold." *Arts Magazine* (New York), Feb. 1975, pp. 10–11.

Heinemann, Susan. "Robert Mangold: John Weber." *Artforum* (New York), Feb. 1975, p. 67.

Wasserman, Emily. "Robert Mangold at Weber." *Art in America* (New York), May–June 1975, pp. 101–2.

Cusack Gallery, Houston. *Robert Mangold: Recent Paintings*, Feb. 8, 1975–closing date unknown.

ACE L.A., Los Angeles. *Robert Mangold: Recent Paintings*, Sept. 20–Oct. 18, 1975.

Daniel Weinberg Gallery, San Francisco. *Robert Mangold: Paintings*, Jan. 13–Feb. 7, 1976.

John Weber Gallery, New York. *Robert Mangold: New Paintings*, Mar. 27–Apr. 21, 1976.

Lubell, Ellen. "Robert Mangold: John Weber." *Arts Magazine* (New York), June 1976, p. 30.

Wooster, Ann Sargent. "Reviews and Previews." *Art News* (New York), Summer 1976, p. 179.

Museum Haus Lange, Krefeld, West Germany. *Robert Mangold: Four Large Works*, Jan. 30–Mar. 6, 1977. Cat., text by Gerhard Storck.

John Weber Gallery, New York. *Robert Mangold*, Oct. 1–25, 1977.

Bell, Tiffany. "Robert Mangold: John Weber." *Arts Magazine* (New York), Dec. 1977, p. 36.

Betz, Margaret. "Reviews and Previews." *Art News* (New York), Dec. 1977, pp. 137–38.

Foster, Hal. "Robert Mangold: John Weber." *Artforum* (New York), Dec. 1977, pp. 63–64.

Galleria la Polena, Genoa, Italy. *Mangold*, Oct. 13–Nov. 13, 1977. Cat.

Young/Hoffman Gallery, Chicago. *Robert Mangold: Paintings on Canvas, Masonite & Paper*, Oct. 14–Nov. 15, 1977.

Jean & Karen Bernier, Athens, Greece. *Robert Mangold: New Paintings*, Mar. 28–Apr. 15, 1978.

Protetch-McIntoch Gallery, Washington, D.C. *Robert Mangold: Recent Paintings and Drawings*, Nov. 11–Dec. 2, 1978.

Galerie Schellman & Klüser, Munich. *Robert Mangold: Paintings, Drawings and Prints*, exact dates unknown, 1978.

Stockerbrand, Janni. "Robert Mangold." *Heute Kunst/Flash Art* (Milan), Jan. 1979, p. 10.

John Weber Gallery, New York. *Robert Mangold*, Jan. 6–30, 1979.

Bell, Tiffany. "Robert Mangold." *Arts Magazine* (New York), Mar. 1979, p. 32.

Perlberg, Deborah. "Robert Mangold." *Artforum* (New York), Mar. 1979, p. 63.

John Weber Gallery, New York. *Robert Mangold: Painting for 3 Walls*, Mar. 1–29, 1980.

Bell, Tiffany. "Robert Mangold." *Arts Magazine* (New York), Mar. 1980, p. 3.

Foster, Hal. "Robert Mangold: John Weber Gallery." *Artforum* (New York), May 1980, pp. 74–75.

Frank, Elysbeth. "Robert Mangold at John Weber." *Art in America* (New York), May 1980, pp. 150–51.

Lawson, Thomas. "Robert Mangold." *Flash Art* (Milan), Summer 1980, p. 21.

Texas Gallery, Houston. [*Robert Mangold: New Paintings*], Apr. 7–May 10, 1980.

Kalil, Susie. "Mangold goes Diagonal." *Artweek* (Oakland, Calif.), Apr. 26, 1980, pp. 1, 18.

Richard Hines Gallery, Seattle. *Robert Mangold: Recent Paintings*, Nov. 5–Dec. 20, 1980.

Hoshour Gallery, Albuquerque. *Robert Mangold: Recent Work*, Jan. 16, 1981–closing date unknown.

Lisson Gallery, London. *Robert Mangold: Paintings*, Apr. 29–May 30, 1981.

Sidney Janis Gallery, New York. *Robert Mangold*, Mar. 4–27, 1982.

Westphall, Stephan. "Robert Mangold." *Arts Magazine* (New York), June 1982, p. 20.

Cohen, Ronny. "Reviews and Previews." *Art News* (New York), Sept. 1982, p. 176.

Stedelijk Museum, Amsterdam. *Robert Mangold: Paintings 1970–1982*, Oct. 21–Dec. 6, 1982. Cat., text by Suzanna Singer.

Groot, Paul. "Robert Mangold: Stedelijk Museum." *Artforum* (New York), Mar. 1983, p. 82.

Daniel Weinberg Gallery, Los Angeles. *Robert Mangold: Recent Paintings*, Oct. 15–Nov. 19, 1983.

Galerie Nordenhake, Malmö, Sweden. *Robert Mangold: Malringar*, Jan. 14, 1984–closing date unknown.

Paula Cooper Gallery, New York. *Frame Paintings 1983–84*, Apr. 19–May 19, 1984.

Akron Art Museum, Ohio. *Robert Mangold: Recent Paintings*, Nov. 18, 1984–Jan. 6, 1985. Cat. Circulating exhibition.

Kelley, J. "American Art Since 1970: A Shaky Transition." *Artweek* (Oakland, Calif.), Apr. 7, 1984, p. 1.

McDonald, R. "Seeking the Essential." *Artweek* (Oakland, Calif.), July 13, 1985, p. 5.

Berkson, Bill. "Robert Mangold." *Artforum* (New York), Jan. 1986, p. 98.

Institute of Contemporary Art, Boston. *Currents, Number 10*, Nov. 1984.

Lisson Gallery, London. *Robert Mangold: Recent Paintings*, Mar. 7–Apr. 5, 1986.

Paula Cooper Gallery, New York. *Robert Mangold: Recent Paintings and Drawings*, May 3–31, 1986.

Paula Cooper Gallery, New York. *Robert Mangold: Six New Large-Scale Paintings and New Works on Paper*, May 3–24, 1986.

Donald Young Gallery, Chicago. *Robert Mangold: New Paintings*, Nov. 21, 1986–closing date unknown.

Paula Cooper Gallery, New York. *Robert Mangold: Works on Paper*, Mar. 25–Apr. 18, 1987.

Hallen für Neue Kunst, Schaffhausen, Switzerland. *Robert Mangold*, May 2–Oct. 31, 1987.

Wechsler, M. "Reviews." *Artforum* (New York), Oct. 1987, p. 141.

Kageneck, Christian von. "Robert Mangold." *Kunstwerk* (Baden-Baden), Dec. 1987, pp. 47–48.

Paula Cooper Gallery, New York. *Robert Mangold: Recent Paintings*, Nov. 7–26, 1987.

Schwendenwien, Jude. "Reviews and Previews." *Art News* (New York), Feb. 1988, pp. 137–38.

Kuspit, Donald. "Robert Mangold: Paula Cooper." *Artforum* (New York), Mar. 1988, pp. 133–34.

Fabian Carlsson Gallery, London. *Robert Mangold: Paintings*, Jan. 13–Feb. 6, 1988.

DOROTHEA ROCKBURNE

By the Artist

Writings

"Works and Statements." *Artforum* (New York), Mar. 1972, pp. 29–33.

Rosenberg, J. E. Reply with rejoinder. *Artforum* (New York), June 1972, p. 9.

"Rockburne: Considerations of Procedure on the Series 'Carta Carbone.'" *Flash Art* (Milan), Sept.–Oct. 1972, p. 6.

"Notes to Myself on Drawing." *Flash Art* (Milan), Apr. 1974, p. 66.

"A Project by Dorothea Rockburne." *Artforum* (New York), Oct. 1984, pp. 74–75.

"Putting Together Thoughts on the New Painting." *Artforum* (New York), Oct. 1984, pp. 72–75.

"Special Issue: Drawing in the '80's." *WhiteWalls, A Magazine of Writing by Artists* (Chicago), Spring 1986, p. 51.

Interviews

Licht, Jennifer. "Interview with Dorothea Rockburne." *Artforum* (New York), Mar. 1972, pp. 34–36.

Olson, Roberta. "Interview with Dorothea Rockburne." *Art in America* (New York), Nov.–Dec. 1978, pp. 141–45.

Gruen, John. "Artist's Dialogue: Dorothea Rockburne." *Architectural Digest* (Los Angeles), Feb. 1987, pp. 4–47.

On the Artist

Selected Articles

Bochner, Mel. "A Note on Dorothea Rockburne." *Artforum* (New York), Mar. 1972, p. 28.

Licht, Jennifer. "Work and Method." *Art & Artists* (London), Mar. 1972, pp. 32–35.

Ratcliff, Carter. "Dorothea Rockburne: New Prints." *The Print Collector's Newsletter* (New York), May–June 1974, pp. 3–32.

Murray, Nancy. "Dorothea Rockburne." *Parachute* (Montreal), Spring 1977, pp. 35–37.

Perrone, Jeff. "Working Through, Fold by Fold." *Artforum* (New York), Jan. 1979, pp. 44–50.

Pincus-Witten, Robert. "Mel and Dorothea: Rehearsing One's Coolness." *Arts Magazine* (New York), Nov. 1979, pp. 121–29.

"Prints & Photographs Published: Dorothea Rockburne." *Print Collector's Newsletter* (New York), July/Aug. 1983, p. 105.

Storr, Robert. "Painterly Operations." *Art in America* (New York), Feb. 1986, pp. 84–89.

Gruen, John. "Dorothea Rockburne's Unanswered Questions." *Art News* (New York), Mar. 1986, pp. 97–101.

Brenson, Michael. "A New World Painter Views the Masterpieces of Old World Innovators." *The New York Times*, Apr. 29, 1988, pp. C1, C36.

Selected One-Artist Exhibitions and Reviews

Bykert Gallery, New York. *Dorothea Rockburne*, Dec. 5, 1970–Jan. 6, 1971.

 Perreault, John. "Art." *The Village Voice* (New York), Dec. 17, 1970, p. 25.

 Siegel, Jeanne. "Dorothea Rockburne." *Art News* (New York), Jan. 1971, p. 57.

 Pincus-Witten, Robert. "New York: Dorothea Rockburne." *Artforum* (New York), Feb. 1971, pp. 75–76.

 Ratcliff, Carter. "New York Letter." *Art International* (Lugano), Feb. 1971, p. 69.

Galerie Sonnabend, Paris. Title and exact dates unknown, 1971.

 Pleynet, Marcelin. "Paris Letter." *Art International* (Lugano), Summer 1971, p. 78.

Bykert Gallery, New York. *Dorothea Rockburne*, Jan. 8–Feb. 3, 1972.

 Glueck, Grace. "Previews." *Art in America* (New York), Jan. 1972, p. 41.

 Rosenstein, Harris. "Reviews and Previews." *Art News* (New York), Mar. 1972, pp. 53–54.

 Wolmer, Denise. "Dorothea Rockburne." *Arts Magazine* (New York), Mar. 1972, p. 58.

The New Gallery, Cleveland. *Dorothea Rockburne: Fuchsian Drawings 1–6*, Mar. 11–Apr. 4, 1972.

Galleria Toselli, Milan. *Dorothea Rockburne*, June 1972.

Galleria Marilena Bonomo, Bari, Italy. *Dorothea Rockburne*, Oct. 22–Nov. 11, 1972.

University of Rochester Art Gallery, New York. *Dorothea Rockburne: Ipanema Suite: Drawings*, Dec. 1–19, 1972.

Bykert Gallery, New York. *Drawing Which Makes Itself*, Jan. 27–Feb. 22, 1973.

 Boice, Bruce. "Dorothea Rockburne, Bykert." *Artforum* (New York), Apr. 1973, pp. 77–78.

 Crimp, Douglas. "New York Letter." *Art International* (Lugano), Apr. 1973, pp. 58–59.

 Mayer, Rosemary. "Dorothea Rockburne." *Arts Magazine* (New York), Apr. 1973, p. 74.

 Thomsen, Barbara. "Dorothea Rockburne at Bykert." *Art in America* (New York), May–June 1973, p. 99.

 Boice, Bruce. "Il Nuovo Lavoro di Dorothea Rockburne." *Data* (Milan), Summer 1973, pp. 36–41 (English translation, pp. 101–3).

Lisson Gallery, London. *Dorothea Rockburne*, Mar. 30–Apr. 23, 1973.

 Rees, R. J. "Dorothea Rockburne at the Lisson Gallery." *Studio International* (London), June 1973, p. 295.

Hartford College of Art, Connecticut. *Dorothea Rockburne*, Apr. 23–May 5, 1973. Cat., text by Bruce Boice.

Daniel Weinberg Gallery, San Francisco. *Dorothea Rockburne*, May 7–June 2, 1973.

 Montgomery, Cara. "Dorothea Rockburne." *Arts Magazine* (New York), Sept. 1973, p. 56.

Galleria Toselli, Milan. *Dorothea Rockburne*, May 1974.

Galerie Charles Kirwin, Brussels. *Dorothea Rockburne*, Oct. 1975. Cat., text by Naomi Spector.

John Weber Gallery, New York. *Dorothea Rockburne: Working with the Golden Section, Structure and Color*, Oct. 30–Nov. 27, 1976.

 Ellenzweig, Allen. "Dorothea Rockburne." *Arts Magazine* (New York), Jan. 1977, p. 35.

 Shapiro, Lindsay Stamm. "Dorothea Rockburne at John Weber." *Art in America* (New York), Mar. 1977, p. 112.

Galleria la Polena, Genoa, Italy. *Rockburne*, Mar. 15–Apr. 5, 1977.

John Weber Gallery, New York. *Dorothea Rockburne/Drawing: Structure and Curve*, Oct. 21–Nov. 21, 1978. Cat., text by Michael Marlais.

 Russell, John. "Gallery View." *The New York Times*, Nov. 19, 1978, p. D31.

 Bell, Tiffany. "Dorothea Rockburne." *Arts Magazine* (New York), Jan. 1979, p. 22.

 Saltzman, Cynthia. "Reviews and Previews." *Art News* (New York), Jan. 1979, pp. 156–57.

 Tatransky, Valentin. "Dorothea Rockburne: John Weber." *Flash Art* (Milan), Jan.–Feb. 1979, p. 39.

Texas Gallery, Houston. *Dorothea Rockburne: A Decade of Drawings*, Feb. 13–Mar. 10, 1979.

Texas Gallery, Houston. *Dorothea Rockburne: Works from the Egyptian Series*, Jan. 31–Feb. 28, 1981.

 Kalil, Susie. "Geometric Order and Subversion." *Artweek* (Oakland, Calif.), Feb. 28, 1981, p. 24.

 Baker, Kenneth. "Dorothea Rockburne's Egyptian Paintings." *Artforum* (New York), Apr. 1981, pp. 24–25.

The Museum of Modern Art, New York. *Dorothea Rockburne: Locus Series*, May 9–July 7, 1981.

Xavier Fourcade, Inc., New York. *Dorothea Rockburne: Egyptian Paintings and White Angels 1979–1981*, Sept. 22–Oct. 24, 1981.

 Larson, Kay. "Dorothea Rockburne." *New York*, Oct. 26, 1981, p. 95.

 Phillips, Deborah C. "Reviews and Previews." *Art News* (New York), Dec. 1981, p. 173.

 Frank, Elizabeth. "Dorothea Rockburne at Xavier Fourcade." *Art in America* (New York), Jan. 1982, p. 138.

David Bellman Gallery, Toronto. *Dorothea Rockburne: Angels*, Oct. 17–Nov. 14, 1981.

Margo Leavin Gallery, Los Angeles. *Dorothea Rockburne Recent Watercolors and Drawings*, Feb. 27–Mar. 27, 1982.

Xavier Fourcade, New York. *Dorothea Rockburne: The Way of Angels, 1981–1982*, Oct. 22–Nov. 27, 1982.

 Henry, Gerrit. "Reviews and Previews." *Art News* (New York), Jan. 1983, p. 141.

 Herrera, Hayden. "Dorothea Rockburne at Fourcade." *Art in America* (New York), Feb. 1983, pp. 129–30.

 Kuspit, Donald. "Dorothea Rockburne." *Artforum* (New York), Mar. 1983, p. 77.

Galleriet Lund, Sweden. *Dorothea Rockburne: The Way of Angels*, Mar. 5–30, 1983.

Xavier Fourcade, Inc., New York. *Dorothea Rockburne: Painting and Drawing 1982–1985*, Feb. 23–Mar. 30, 1985.

 Brenson, Michael. "Dorothea Rockburne." *The New York Times*, Mar. 1, 1985, page unknown.

 Bell, Jane. "Reviews and Previews." *Art News* (New York), May 1985, p. 115.

 Cohen, Ronny. "Dorothea Rockburne." *Artforum* (New York), Summer 1985, p. 111.

Xavier Fourcade, Inc., New York. *Dorothea Rockburne: A Personal Selection, Paintings 1968–1986*, Feb. 15–Mar. 28, 1986.

 Russell, John. "Dorothea Rockburne." *The New York Times*, Feb. 21, 1986, page unknown.

 Brenson, Michael. "Art." *The New York Times*, Mar. 9, 1986, p. 21.

 Stavitsky, Gail. "Dorothea Rockburne." *Arts Magazine* (New York), May 1986, p. 104.

 Boettger, Suzaan. "Dorothea Rockburne: Xavier Fourcade." *Artforum* (New York), Summer 1986, pp. 129–30.

Arts Club of Chicago. *Dorothea Rockburne: Recent Paintings and Drawings*, Jan. 12–Feb. 25, 1987. Cat., text by Robert Storr.

André Emmerich Gallery, New York. *Dorothea Rockburne: New Paintings: Pascal and Other Concerns*, Mar. 5–Apr. 2, 1988. Cat. introduction by Robert Storr.

 Loughery, J. "Dorothea Rockburne." *Arts Magazine* (New York), May 1988, p. 92.

 Haus, Mary Ellen. "Reviews and Previews." *Art News* (New York), Summer 1988, p. 171.

JO BAER

By the Artist

Writings

"Letters." *Artforum* (New York), Sept. 1967, pp. 5–6.

"Edward Kienholz: A Sentimental Journeyman." *Art International* (Lugano), Apr. 1968, pp. 45–49.

"Letters." *Artforum* (New York), Apr. 1969, pp. 4–5.

"The Artist and Politics: A Symposium." *Artforum* (New York), Sept. 1970, pp. 35–36.

"Mach Bands: Art Vision" and "Xerography & Mach Bands: Instrumental Model." *Aspen Magazine* (New York), Fall–Winter 1970.

"Fluorescent Light Culture." *American Orchid Society Bulletin* (West Palm Beach, Fla.), Sept.–Oct. 1971.

"Art and Politics" and "On Painting." *Flash Art* (Milan), Nov. 1972, pp. 6–7. ("Art and Politics" reprinted from "The Artist and Politics: A Symposium." *Artforum* [New York], Sept. 1970).

Interviews

Guilbaut, Serge, and Sgan-Cohen, Michael. "Jo Baer: peintre traditionnel et 'radical'." *Art Press* (Paris), May 1974, pp. 16–18.

"To and Fro and Back and Forth. A Conversation between Jo Baer and Seamus Coleman." *Art Monthly* (London), Mar. 1977, pp. 6–10.

Poirier, Maurice, and Necol, Jane. "The 60's in Abstract: 13 Statements and an Essay." *Art in America* (New York), Oct. 1983, pp. 136–37.

On the Artist

Selected Articles

Insley, Will. "Jo Baer (A Poem)." *Art International* (Lugano), Feb. 1969, pp. 26–28.

Lippard, Lucy R. "Color at the Edge." *Art News* (New York), May 1972, pp. 24–25, 64–66. Reprinted in *From the Centre, Feminist Essays on Women's Art.* New York: E. P. Dutton, 1976, pp. 172–80.

Loring, J. "Jo Baer." *Arts Magazine* (New York), Apr. 1975, p. 70.

Smith, Roberta. "Letters: Reply with Rejoinder." *Artforum* (New York), Nov. 1975, p. 9.

Paternosto, César. "Letters: Criticism of Smith's Review on Baer at Whitney." *Artforum* (New York), Nov. 1975, p. 9.

Kuspit, Donald B. "Jo Baer: Intimations of Variety." *Art in America* (New York), Nov./Dec. 1975, pp. 76–77.

Selected One-Artist Exhibitions and Reviews

Fischbach Gallery, New York. *Jo Baer,* Feb. 12–Mar. 4, 1966.

Ashbery, John. "Reviews and Previews." *Art News* (New York), Feb. 1966, p. 13.

Goldin, Amy. "Jo Baer." *Arts Magazine* (New York), Apr. 1966, p. 69.

Lippard, Lucy. "New York Letter." *Art International* (Lugano), Apr. 1966, p. 73.

Noah Goldowsky Gallery, New York. *Jo Baer: Paintings,* Jan. 3–31, 1970.

Atirnomis. "Jo Baer." *Arts Magazine* (New York), Feb. 1970, p. 57.

Kline, Katherine. "Reviews and Previews." *Art News* (New York), Feb. 1970, p. 10.

Ratcliff, Carter. "New York." *Art International* (Lugano), Mar. 1970, p. 70.

Wasserman, Emily. "Jo Baer: Goldowsky Gallery." *Artforum* (New York), Mar. 1970, p. 77.

Locksley-Shea Gallery, Minneapolis. *Jo Baer—Brice Marden Major Works,* Mar. 25–Apr. 11, 1970.

Galerie Ricke, Cologne, West Germany. *James Rosenquist, Jo Baer,* Nov. 17–Dec. 15, 1970.

Pfeiffer, G. "Galerie Ricke, Köln Ausstellung." *Kunstwerk* (Baden-Baden), Jan. 1971, p. 79.

School of Visual Arts, New York. *Jo Baer: Paintings from 1962–1963,* Mar. 9–Apr. 14, 1971.

Mellow, J. R. "Jo Baer: Serial Paintings, Visual Art Gallery." *The New York Times,* Apr. 11, 1971, Section 2, p. 27.

Linville, Kasha. "Jo Baer: School of Visual Arts." *Artforum* (New York), May 1971, p. 77.

Ratcliff, Carter. "Reviews and Previews." *Art News* (New York), May 1971, p. 10.

Lo Giudice Gallery, New York. *Jo Baer: New Paintings,* Apr. 29–May 24, 1972.

Schjeldahl, Peter. "Jo Baer: Playing on the Senses." *The New York Times,* May 14, 1972, Section 2, p. 23.

Ratcliff, Carter. "Jo Baer: Notes on 5 Recent Paintings." *Artforum* (New York), May 1972, pp. 28–32.

Matthias, Rosemary. "Jo Baer: Lo Giudice." *Arts Magazine* (New York), Summer 1972, pp. 57–58.

Flavin, Dan. "Letters." *Artforum* (New York), Oct. 1972, p. 9.

Galerie Rolf Ricke, Cologne, West Germany. *Jo Baer,* Jan. 13–Feb. 8, 1973.

Kerber, Bernhard. "Szene Rhein-Ruhr." *Art International* (Lugano), May 1973, p. 55.

Nicholas Wilder Gallery, Los Angeles. *Jo Baer—Recent Works,* Apr. 10–May 9, 1973.

Canavier, Elena Karina. "Baer's Painterly Elegance." *Artweek* (Oakland, Calif.), Apr. 28, 1973, p. 5.

Daniel Weinberg Gallery, San Francisco. *Jo Baer: Paintings 1962–1972,* Feb. 7–Mar. 2, 1974.

Whitney Museum of American Art, New York. *Jo Baer,* May 1–July 13, 1975. Cat., introduction by Barbara Haskell.

Hess, Thomas B. "They Don't Pussyfoot." *New York,* June 2, 1975, p. 65.

Russell, John. "Paintings by Jo Baer at Whitney Museum." *The New York Times,* June 21, 1975, p. 23.

Smith, Roberta. "Jo Baer: Whitney Museum of American Art." *Artforum* (New York), Sept. 1975, pp. 73–77.

Texas Gallery, Houston. *Jo Baer,* Jan. 3–24, 1976.

Lisson Gallery Ltd., London. *Jo Baer,* Jan. 13–Feb. 17, 1976.

Tagg, John. "Jo Baer: Lisson Gallery." *Studio International* (London), Mar. 1976, p. 208.

Museum of Modern Art, Oxford, England. *Jo Baer: Paintings 1962–1974,* Oct. 16–Nov. 20, 1977. Cat., introduction by David Elliott; text by Rudi Fuchs, statements by the artist. Circulating exhibition.

Stedelijk van Abbemuseum, Eindhoven, The Netherlands. *Jo Baer: Schilderijen 1962–1975,* Apr. 12–May 7, 1978.

Stedelijk van Abbemuseum, Eindhoven, The Netherlands. *Jo Baer,* Jan. 10–Feb. 9, 1986.

Art Galaxy, New York. *Paintings and Drawings by Jo Baer,* opening date unknown–Mar. 7, 1987.

McEvilley, Thomas. "Jo Baer: Art Galaxy; Oil & Steel Gallery." *Artforum* (New York), May 1987, p. 141.

Oil & Steel Gallery, New York. *Jo Baer,* opening date unknown–Mar. 7, 1987.

McEvilley, Thomas. "Jo Baer: Art Galaxy; Oil & Steel Gallery." *Artforum* (New York), May 1987, p. 141.

BRICE MARDEN

By the Artist

Writings

with Mogensen, Paul and Novros, David. Carl Andre, ed. "New in New York: Line Work." *Arts Magazine* (New York), May 1967, pp. 49–50.

"Three Deliberate Greys for Jasper Johns." *Art Now: New York,* Mar. 1971, n.p.

Kurtz, Bruce, ed. [Statement] "Documenta 5: A Critical Preview." *Arts Magazine* (New York), Summer 1972, p. 43.

Suicide Notes. Lausanne: Editions des Massons, 1974.

Lebensztejn, Jean-Claude. "Eight Statements." *Art in America* (New York), July–Aug. 1975, pp. 67–75.

Poirier, Maurice and Necol, Jane. "The 60's in Abstract: 13 Statements and an Essay." *Art in America* (New York), Oct. 1983, pp. 122–37.

Wei, Lilly. "Talking Abstract, Part One." *Art in America* (New York), July 1987, pp. 80–97.

Interviews

Sharp, Willoughby, ed. "Points of View: A Taped Conversation with 4 Painters." *Arts Magazine* (New York), Jan. 1971, pp. 41–42.

deAk, Edit; Moore, Alan; and Robinson, Mike. "Conversation with Brice Marden." *Art-Rite* (New York), Spring 1975, pp. 39–42.

McCann, Cecile N. "An Interview with Brice Marden." *Artweek* (Oakland, Calif.), Dec. 4, 1976, pp. 15–16.

White, Robin. "Brice Marden." *View* (Oakland, Calif.), June 1980, pp. 1–24.

Price, Aimée Brown. "Artist's Dialogue: A Conversation with Brice Marden." *Architectural Digest* (Los Angeles), May 1983, pp. 54–60.

"Brice Marden in Conversation with William Furlong." *Art Monthly* (London), June 1988, pp. 3–5.

On the Artist

Selected Articles

Ashbery, John. "Grey Eminence." *Art News* (New York), Mar. 1972, pp. 26–27, 64–66.

Smith, Roberta Pancoast. "Brice Marden's Painting." *Arts Magazine* (New York), May–June 1973, pp. 36–41.

Gilbert-Rolfe, Jeremy. "Brice Marden's Painting." *Artforum* (New York), Oct. 1974, pp. 3–38.

Bann, Stephan. "Adriatics à propos of Brice Marden." *20th Century Studies* (Canterbury, Eng.), no. 15/16, 1976, pp. 116–29.

Betz, Margaret. "New Editions: Brice Marden." *Art News* (New York), Sept. 1977, p. 104.

"Prints & Photographs Published: Brice Marden." *Print Collector's Newsletter* (New York), Nov. 1979, p. 162.

"Prints & Photographs Published: Brice Marden." *Print Collector's Newsletter* (New York), Mar./Apr. 1980, p. 17.

"Prints & Photographs Published: Brice Marden." *Print Collector's Newsletter* (New York), Sept. 10, 1983, p. 144.

Poirier, Maurice. "Color-Coded Mysteries." *Art News* (New York), Jan. 1985, pp. 52–61.

Storr, Robert. "Brice Marden: Double Vision." *Art in America* (New York), Mar. 1985, pp. 118–25.

Selected One-Artist Exhibitions and Reviews

The Wilcox Gallery, Swarthmore College, Pennsylvania. Title unknown, Dec. 6, 1963–Jan. 6, 1964.

Bykert Gallery, New York. *Brice Marden,* Nov. 15–Dec. 8, 1966.

Andre, Carl. "Two Part Review." *57th Street Review* (New York), Nov. 15, 1966, insert after p. 6.

Goldin, Amy. "Brice Marden." *57th Street Review* (New York), Nov. 15, 1966, p. 7.

G[ollin], J[ane]. "Reviews and Previews." *Art News* (New York), Nov. 1966, p. 15.

Glueck, Grace. "Brice Marden." *The New York Times*, Dec. 3, 1966, p. 37.

G[oldin], A[my]. "Reviews and Previews." *Art News* (New York), Dec. 1966, p. 14.

Bykert Gallery, New York. *Brice Marden/Back Series*, Jan. 6–31, 1968.

Perreault, John. "Art." *The Village Voice* (New York), Jan. 18, 1968, p. 36.

Battcock, Gregory. "The Moral Integrity of Smudges." *The New York Free Press*, Jan. 25, 1968, p. 10.

"Brice Marden Art in New York." *Time* (New York), Jan. 26, 1968, page unknown.

Battcock, Gregory. "Brice Marden." *Arts Magazine* (New York), Feb. 1968, p. 66.

B[urton], S[cott]. "Reviews and Previews." *Art News* (New York), Feb. 1968, pp. 14–15.

Picard, Lil. "Brief aus New York." *Das Kunstwerk* (Stuttgart), Feb.–Mar. 1968, p. 77.

Wasserman, Emily. "Brice Marden." *Artforum* (New York), Mar. 1968, pp. 57–58.

Bykert Gallery, New York. *Drawings by Brice Marden*, Nov. 30, 1968–Jan. 2, 1969.

B[runelle], A[l]. "Brice Marden." *Art News* (New York), Jan. 1969, p. 24.

Ashton, Dore. "New York Commentary." *Studio International* (London), Feb. 1969, p. 95.

Bykert Gallery, New York. *New Paintings*, Apr. 26–May 17, 1969.

R[osenstein], H[arris]. "Brice Marden." *Art News* (New York), May 1969, p. 69.

Ashton, Dore. "New York Commentary." *Studio International* (London), July 1969, p. 29.

Galerie Yvon Lambert, Paris. *Brice Marden*, Sept. 25–Oct. 25, 1969.

Peppiatt, Michael. "Paris." *Art International* (Lugano), Nov. 1969, p. 56.

Galerie Françoise Lambert, Milan. *Brice Marden*, Jan. 30–Feb. 15, 1970.

Bykert Gallery, New York. *Brice Marden, Robert Duran*, Feb. 3–26, 1970.

Calas, Nicolas. "Marden and Duran at Bykert." *Arts Magazine* (New York), Mar. 1970, p. 62.

Ratcliff, Carter. "Reviews and Previews." *Art News* (New York), Mar. 1970, p. 63.

Wasserman, Emily. "Brice Marden." *Artforum* (New York), Apr. 1970, p. 79.

Ratcliff, Carter. "New York Letter." *Art International* (Lugano), May 1970, p. 76.

Bykert Gallery, New York. *Brice Marden*, Oct. 31–Nov. 26, 1970.

Gruen, John. "Brice Marden." *New York*, Nov. 30, 1970, p. 57.

Glueck, Grace. "From Master to Modular: New York Gallery Notes." *Art in America* (New York), Nov.–Dec. 1970, pp. 167–68.

Ratcliff, Carter. "Reviews and Previews." *Art News* (New York), Dec. 1970, p. 58.

Domingo, Willis. "Brice Marden: Bykert Gallery." *Arts Magazine* (New York), Dec. 1970–Jan. 1971, p. 58.

Masheck, Joseph. "Brice Marden." *Artforum* (New York), Jan. 1971, p. 72.

Ratcliff, Carter. "New York Letter." *Art International* (New York), Feb. 20, 1971, p. 69.

Konrad Fischer, Dusseldorf. *Brice Marden, Bilder und Zeichnungen*, May 18–June 7, 1971.

Galleria Gian Enzo Sperone, Turin. June 11, 1971–closing date unknown.

Bykert Gallery, New York. *Brice Marden*, Feb. 5–Mar. 1, 1972.

Ratcliff, Carter. "New York Letter." *Art International* (Lugano), Apr. 20, 1972, p. 31.

Wolmer, Denise. "Brice Marden: Bykert Gallery." *Arts Magazine* (New York), Apr. 1972, p. 65.

Locksley Shea Gallery, Minneapolis. *Brice Marden: New Paintings*, Apr. 21–May 12, 1972.

Jack Glenn Gallery, Corona del Mar, California. *Brice Marden*, Feb. 3–Mar. 2, 1973.

Bykert Gallery, New York. *Brice Marden, New Paintings: Grove Group*, Feb. 24–Mar. 22, 1973.

Hess, Thomas B. "Exhibitions Noted." *New York*, Mar. 19, 1973, p. 75.

Siegel, Jeanne. "Reviews and Previews." *Art News* (New York), Apr. 1973, p. 79.

Borden, Lizzie. "Brice Marden: Bykert Gallery." *Artforum* (New York), May 1973, pp. 76–77.

Anderson, Alexandra C. "Brice Marden at Bykert." *Art in America* (New York), May–June 1973, pp. 99–100.

Mayer, Rosemary. "Attitudes Toward Materials, Content and the Personal." *Arts Magazine* (New York), May–June 1973, pp. 63–66.

Crimp, Douglas. "New York Letter." *Art International* (Lugano), Summer 1973, pp. 89–90.

Konrad Fischer, Dusseldorf. *Brice Marden*, July 1973.

G[ruterich], M[arlis]. "Brice Marden." *Heute Kunst* (Milan), Oct. 1973, p. 29.

Galerie Yvon Lambert, Paris. *Brice Marden*, Sept. 18–Oct. 18, 1973.

Cane, Louis. "Brice Marden." *Peinture, Cahiers Théoriques* (Paris), no. 819, 1973, pp. 46–49.

Galerie Françoise Lambert, Milan. *Brice Marden: Disegni*, Oct. 19–Nov. 19, 1973.

Contemporary Arts Museum, Houston. *Brice Marden Drawings, 1964–1974*, Jan. 24–Mar. 10, 1974. Circulating exhibition. Cat., text by Dore Ashton.

Bykert/Downtown, New York. *Etchings and Drawings, Brice Marden: Paintings, David Novros*, Feb. 9–Mar. 2, 1974.

Hess, Thomas B. "On the Sunny Side of the Street." *New York*, Mar. 11, 1974, p. 76.

Herrera, Hayden. "Reviews and Previews." *Art News* (New York), Apr. 1974, pp. 97–98.

Gilbert-Rolfe, Jeremy. "Brice Marden, David Novros, Bykert Gallery Downtown." *Artforum* (New York), May 1974, p. 68.

Bykert Gallery, New York. *New Paintings, Brice Marden*, Mar. 23–Apr. 17, 1974.

Hess, Thomas B. "Hello, Old Paint." *New York*, Apr. 22, 1974, pp. 73–74.

Shorr, Harriet. "Brice Marden at Bykert." *Art in America* (New York), May–June 1974, pp. 104–5.

Dreiss, Joseph. "Brice Marden: Bykert." *Arts Magazine* (New York), June 1974, pp. 58–59.

Gilbert-Rolfe, Jeremy. "Brice Marden." *Artforum* (New York), June 1974, pp. 68–69.

Herrera, Hayden. "Reviews and Previews." *Art News* (New York), Summer 1974, pp. 110–11.

Cirrus Gallery, Los Angeles. *Brice Marden: 12 New Etchings*, May 7–31, 1974.

The Jared Sable Gallery, Toronto. *Brice Marden*, Sept. 14–28, 1974.

Bykert Gallery, New York. *Brice Marden, Drawings 1964–1974*, Oct. 19–Nov. 1, 1974.

Smith, Roberta. "Brice Marden." *Artforum* (New York), Jan. 1975, pp. 63–64.

Locksley Shea Gallery, Minneapolis. Title unknown, Oct. 25–Nov. 15, 1974.

Larson, Philip. "Minneapolis: Brice Marden." *Arts Magazine* (New York), Jan. 1975, p. 23.

The Solomon R. Guggenheim Museum, New York. *Brice Marden*, Mar. 7–Apr. 27, 1975. Cat., text by Linda Shearer.

Hess, Thomas. "Brice Marden." *New York*, Apr. 7, 1975, p. 70.

Hoesterey, Ingeborg. "Brice Marden: Guggenheim Museum." *Art International* (Lugano), June 1975, p. 77.

Bremer, Nina. "Brice Marden: Solomon R. Guggenheim Museum." *Pantheon* (Munich), July–Sept. 1975, p. 276.

Hester Royen Gallery, London. Title and exact dates unknown, 1975.

McCorquodale, Charles. "London." *Art International* (Lugano), Apr. 1975, pp. 39–40.

Sperone Westwater Fischer, Inc., New York. *Brice Marden*, Apr. 3–21, 1976.

Bourdon, David. "Brice Marden: Sperone Westwater Fischer." *The Village Voice* (New York), Apr. 19, 1976, p. 104.

Perrone, Jeff. "Brice Marden: Sperone Westwater Fischer." *Artforum* (New York), June 1976, pp. 65–66.

Sargent-Wooster, Ann. "Reviews and Previews." *Art News* (New York), Summer 1976, p. 177.

Bell Gallery, List Art Building, Brown University, Providence, Rhode Island. *Brice Marden: Works on Paper*, Nov. 19–Dec. 11, 1977.

Jean & Karen Bernier, Athens, Greece. *Brice Marden: Etchings and Recent Drawings*, Nov. 22–Dec. 3, 1977.

The Pace Gallery, New York. *Brice Marden: Recent Paintings and Drawings*, Sept. 23–Oct. 21, 1978. Cat., text by Jean-Claude Lebensztejn.

Ashbery, John. "Brice Marden: Pace." *New York* (New York), Oct. 2, 1978, p. 130.

Zimmer, William. "Vehicles for Rare Color." *The Soho Weekly News* (New York), Oct. 5, 1978, p. 96.

Bell, Jane. "Reviews and Previews." *Art News* (New York), Nov. 1978, pp. 183–84.

Gibson, Eric. "New York Letter." *Art International* (Lugano), Nov.–Dec. 1978, pp. 69–70.

Cavaliere, Barbara. "Brice Marden." *Arts Magazine* (New York), Dec. 1978, p. 22.

Buonagurio, Edgar. "Brice Marden." *Arts Magazine* (New York), Feb. 1979, p. 32.

Kunstraum, Munich. *Brice Marden Drawings 1964–1978*, exact dates unknown, 1979. Cat., text by Hermann Kern and Klaus Kertess. Circulating exhibition.

The Pace Gallery, New York. *Brice Marden*, Sept. 26–Oct. 25, 1980.

Hale, Niki. "Of a Classic Order: Brice Marden's Thira." *Arts Magazine* (New York), Oct. 1980, pp. 152–53.

Cavaliere, Barbara. "Brice Marden." *Arts Magazine* (New York), Dec. 1980, pp. 54–55.

Foster, Hal. "Brice Marden, Pace Gallery." *Artforum* (New York), Dec. 1980, p. 72.

Staniszewski, Mary Anne. "Reviews and Previews." *Art News* (New York), Dec. 1980, p. 190.

Frank, Elizabeth. "Brice Marden at Pace." *Art in America* (New York), Jan. 1981, pp. 123–24.

French-Frazier, Nina. "Brice Marden." *Art International* (Lugano), Jan.–Feb. 1981, pp. 140–42.

Whitechapel Art Gallery, London. *Brice Marden: Paintings, Drawings and Prints 1975–80*, May 8–June 21, 1981. Cat., texts by Nicholas Serota, Stephan Bann, Roberta Smith. Statements by the artist. Circulating exhibition.

Gilmour, P. "Brice Marden." *Arts Review* (London), May 22, 1981, p. 215.

DAVID NOVROS

Bumpus, Judith. "Brice Marden: Paintings, Drawings and Prints 1975–80." *The Connoisseur* (London), May 1981, p. 14.

Petzal, Monica. "Brice Marden, Robert Mangold." *Art Monthly* (London), June 1981, pp. 10–11.

Lucie-Smith, Edward. "Brice Marden." *Art International* (Lugano), Aug.–Sept. 1981, pp. 70, 72.

The Pace Gallery, New York. *Brice Marden: Marbles, Paintings and Drawings,* Oct. 29–Nov. 27, 1982. Cat., text by William Zimmer.

 Russell, John. "Art: Marden on Marble, On Canvas and on Paper." *The New York Times,* Nov. 12, 1982, page unknown.

 Henry, Gerrit. "Brice Marden." *Art News* (New York), Jan. 1983, p. 141.

 Storr, Robert. "Brice Marden at Pace." *Art in America* (New York), Jan. 1983, pp. 120–21.

The Pace Gallery, New York. *Brice Marden,* Sept. 28–Oct. 27, 1984. Cat.

 Harris, Susan A. "Brice Marden." *Arts Magazine* (New York), Jan. 1985, p. 40.

Daniel Weinberg Gallery, Los Angeles. *Brice Marden: Paintings and Drawings,* Dec. 8, 1984–Jan. 12, 1985.

Mary Boone/Michael Werner, New York. *Brice Marden: New Paintings,* Mar. 7–28, 1987. Cat., text by Peter Schjeldahl.

 Caley, Shäun. "Spotlight: Brice Marden." *Art* (Milan), Summer 1987, p. 92.

 Poirier, Maurice. "Brice Marden: Mary Boone." *Art News* (New York), Summer 1987, pp. 201–2.

 Yau, John. "Brice Marden." *Artforum* (New York), Summer 1987, p. 118.

Butler Gallery, Houston. *Brice Marden: Etchings to Rexroth,* Apr. 1–30, 1987.

Cirrus Gallery, Los Angeles. *Brice Marden Prints,* Dec. 8, 1987–Jan. 9, 1988.

Mary Boone/Michael Werner, New York. *Brice Marden,* Apr. 9–May 7, 1988.

 Ellis, Stephen. "Brice Marden at Mary Boone." *Art in America* (New York), June 1988, pp. 157–58.

Anthony d'Offay Gallery, London. *Brice Marden: Recent Paintings & Drawings,* Apr. 22–May 24, 1988.

By the Artist

Writings

"Jackson Pollock: An Artists' Symposium, Part 2." *Art News* (New York), May 1967, pp. 27–29.

David Novros: Fresco Drawings. [Preparatory study for a fresco executed at the University of Texas Health Science Center at Dallas, Summer 1977]. Dallas: University of Texas, 1978.

Nodelman, Sheldon. *Marden, Novros, Rothko.* Houston and Seattle, Washington: Texas Institute of the Arts, Rice University and University of Washington Press, 1978.

Poirier, Maurice, and Necol, Jane. "The '60s in Abstract: 13 Statements and an Essay." *Art in America* (New York), Oct. 1983, p. 135.

On the Artist

Selected Articles

Rosenstein, Harris. "Total and Complex." *Art News* (New York), May 1967, pp. 52–54, 67–68.

Ratcliff, Carter. "Abstract Painting, Specific Space: Novros and Marden in Houston." *Art in America* (New York), Sept./Oct. 1975, pp. 84–88.

Kutner, Janet. "Recent Frescoes." *Arts Magazine* (New York), Sept. 1976, p. 4.

Kutner, Janet. "Novros (Fresco at the University of Texas Health Science Center in Dallas)." *Arts Magazine* (New York), Sept. 1978, p. 18.

Murdoch, Robert. "Public Passages: David Novros." *Art in America* (New York), Jan. 1985, pp. 104–11.

Cohen, Edie Lee. "Miami Murals." *Interior Design* (New York), Jan. 1986, pp. 220–23.

Nesmith, Lynn. "Courthouse Walls Become a Canvas." *Architecture* (New York), June 1986, pp. 20–21.

Selected One-Artist Exhibitions and Reviews

Park Place Gallery, New York. *David Novros,* Jan. 25–Feb. 24, 1966.

 Ashbery, John. "David Novros." *Art News* (New York), Mar. 1966, p. 13.

 Adrian, Dennis. "David Novros: Park Place Gallery." *Artforum* (Los Angeles), Apr. 1966, p. 48.

 Ashton, Dore. "Artist as Dissenter: New York Commentary." *Studio International* (London), Apr. 1966, p. 167.

 Hofne, Ann. "David Novros." *Arts Magazine* (New York), May 1966, p. 62.

Dwan Gallery, Los Angeles. *David Novros,* Nov. 1–26, 1966.

 Coplans, John. "David Novros in L. A." *Artforum* (New York), Jan. 1967, p. 27.

Park Place Gallery, New York, and Dwan Gallery, New York. *David Novros,* Apr. 2–26 and Apr. 1–26, 1967.

 Sloane, Pat. "David Novros." *Arts Magazine* (New York), May 1967, p. 57.

 Johnston, J. "David Novros." *Artscanada* (Toronto), June/July 1967, Supplement 8, page unknown.

Galerie Grunert Muller, Stuttgart. *David Novros,* Mar. 4–Apr. 21, 1967.

Bykert Gallery, New York. *David Novros,* Apr. 27–May 25, 1968.

 Burton, Scott. "David Novros." *Art News* (New York), May 1968, p. 56.

 N[emser], C[indy]. "David Novros." *Arts Magazine* (New York), May 1968, p. 65.

Bykert Gallery, New York. *David Novros,* Mar. 29–Apr. 24, 1969.

 Rosenstein, Harris. "David Novros." *Art News* (New York), Apr. 1969, p. 22.

Glueck, Grace. "Reviews." *Art in America* (New York), May 1969, pp. 117–18.

Pincus-Witten, Robert. "David Novros: Bykert Gallery." *Artforum* (New York), Summer 1969, p. 62.

Mizuno Gallery, Los Angeles. *David Novros,* exact dates unknown, 1969.

 Plagens, Peter. "David Novros: Mizuno Gallery." *Artforum* (New York), Jan. 1970, pp. 74–75.

Bykert Gallery, New York. *David Novros: New Paintings,* Apr. 27–May 16, 1970, p. 70.

 Rosenstein, Harris. "Reviews and Previews." *Art News* (New York), May 1970, p. 70.

Mizuno Gallery, Los Angeles. *David Novros,* exact dates unknown, 1970.

 Terbell, Melinda. "California: Los Angeles." *Arts Magazine* (New York), Dec. 1970–Jan. 1971, p. 49.

Bykert Gallery, New York. *David Novros: New Paintings,* Mar. 2–25, 1971.

 Pincus-Witten, Robert. "David Novros." *Artforum* (New York), May 1971, p. 76.

Bykert Gallery, New York. *David Novros: New Paintings,* Apr. 2–29, 1972.

 Ratcliff, Carter. "New York Letter." *Art International* (Lugano), Summer 1972, p. 56.

 Rosenstein, Harris. "David Novros." *Art News* (New York), Summer 1972, p. 56.

Rosa Esman Gallery, New York. *David Novros: Fresco Studies,* Mar. 3–28, 1973.

 Brunelle, Al. "Rosa Esman Gallery." *Art News* (New York), May 1973, p. 85.

 Mayer, Rosemary. "Rosa Esman Gallery." *Arts Magazine* (New York), May 1973, p. 66.

 Smith, Roberta. "David Novros: Rosa Esman and Bykert Galleries." *Artforum* (New York), June 1973, p. 87.

Bykert Gallery, New York. *David Novros: New Paintings,* Apr. 14–May 3, 1973.

 Anderson, A. C. "Bykert and Rosa Esman Galleries." *Art in America* (New York), May 1973, pp. 99–101.

Texas Gallery, Houston. *David Novros,* Mar. 17–Apr. 16, 1973.

Bykert Gallery, New York. *David Novros,* Nov. 5–23, 1974.

 Preiss, Joseph. "David Novros." *Arts Magazine* (New York), Jan. 1975, p. 14.

 Heinemann, Susan. "David Novros: Bykert Uptown and Downtown Galleries." *Artforum* (New York), Feb. 1975, p. 67.

Felicity Samuels Gallery, London. Title and exact dates unknown, 1974.

 Crichton, Fenella. "London Letter." *Art International* (Lugano), Summer 1974, p. 62.

Locksley-Shea Gallery, Minneapolis. *David Novros: Paintings,* May 17–July 1975.

 Larson, Philip. "David Novros." *Arts Magazine* (New York), Sept. 1975, p. 29.

Texas Gallery, Houston. *David Novros,* Oct. 11–Nov. 7, 1975.

Sperone Westwater Fischer, New York. *David Novros,* May 15, 1976–closing date unknown.

 Smith, Roberta. "David Novros at Sperone Westwater Fischer." *Art in America* (New York), Sept.–Oct. 1976, pp. 106–7.

 Ratcliff, Carter. "David Novros." *Artforum* (New York), Oct. 1976, pp. 63–64.

Sperone Westwater Fischer, New York. *David Novros: Paintings and Drawings,* Apr. 29, 1978–closing date unknown.

Perrone, Jeff. "David Novros." *Artforum* (New York), Sept. 1978, pp. 86–87.

Ratcliff, Carter. "New York Letter." *Art International* (Lugano), Oct. 1978, pp. 54–55.

James Corcoran Gallery, Los Angeles. *David Novros Paintings*, Apr. 1–May 1, 1979.

Thread Building, 260 W. Broadway, New York. *David Novros: Paintings*, Nov. 3, 1979–closing date unknown.

Jon Leon Gallery, New York. *David Novros*, Jan. 12, 1983–closing date unknown.

Mary Boone Gallery, New York. *David Novros*, Jan. 15, 1983–closing date unknown.

City Gallery of Contemporary Art, Raleigh, North Carolina. *The Pavilion: A Public Art Proposal*, May 15–June 20, 1987.

JOHN M. MILLER

On the Artist

Selected Articles

Baker, Kenneth. "S. F. Galleries Revive Interest in Minimalism." *San Francisco Chronicle*, Feb. 26, 1988, p. E12.

Selected One-Artist Exhibitions and Reviews

Broxton Gallery, Los Angeles.

Watts Tower Art Center, Los Angeles.

Mizuno Gallery, Los Angeles. *Painting: John Miller*, Jan. 28–Feb. 21, 1980.

Armstrong, Richard. "John M. Miller, Riko Mizuno Gallery." *Artforum* (New York), Apr. 1980, pp. 85–86.

Walker Art Center, Minneapolis. *John Miller: Painting*, Feb. 13–Apr. 3, 1983. Cat.

Modernism, San Francisco. *John M. Miller, Painting*, Apr. 12–May 25, 1985.

New City, Venice, California. *John M. Miller: Recent Paintings*, Nov. 8–Dec. 20, 1986.

Knight, Christopher. "John M. Miller Moves Above Ground." *Los Angeles Herald Examiner*, Dec. 14, 1986, Section E, page unknown.

Colpitt, Frances. "John M. Miller at New City." *Art in America* (New York), Jan. 1987, p. 141.

PETER HALLEY

By the Artist

Writings

"Against Post-Modernism: Reconsidering Ortega." *Arts Magazine* (New York), Nov. 1981, pp. 112–15.

"Note on the New Expressionism Phenomenon." *Arts Magazine* (New York), Mar. 1983, pp. 88–89.

"Nature and Culture." *Arts Magazine* (New York), Sept. 1983, pp. 64–65.

"Notes on Abstraction." *Arts Magazine* (New York), June 1987, pp. 35–39.

Peter Halley: Collected Essays 1981–87. Zurich: Bruno Bischofberger Gallery, 1988.

Interviews

Siegel, Jeanne. "The Artist/Critic of the Eighties, Part One: Peter Halley and Stephen Westfall." *Arts Magazine* (New York), Sept. 1985, pp. 72–79.

Cone, Michèle. "Peter Halley." *Flash Art* (Milan), Feb.–Mar. 1986, pp. 36–38.

On the Artist

Selected Articles

Cameron, D. "In the Path of Peter Halley." *Arts Magazine* (New York), Dec. 1987, pp. 70–73.

Selected One-Artist Exhibitions and Reviews

International with Monument, New York. Title and exact dates unknown. 1986.

Decter, J. "Peter Halley." *Arts Magazine* (New York), June 1986, p. 110.

Cotter, H. [Review in] *Flash Art* (Milan), Summer 1986, pp. 68–69.

Margo Leavin Gallery, Los Angeles. *Peter Halley: New Paintings*, Feb. 28–Apr. 4, 1987.

Fehlair, F. [Review in] *Flash Art* (Milan), Summer 1987, p. 93.

Sonnabend Gallery, New York. *Peter Halley*, Oct. 10–Nov. 8, 1987.

Kuspit, Donald. "Reviews." *Artforum* (New York), Jan. 1988, pp. 112–13.

All references are to page numbers; text references are in roman type, illustrations in *italic*.

PHOTOGRAPH CREDITS

The publishers wish to thank the following photographers, institutions, collectors, and all others who have graciously consented to the reproduction of their photographs. All references are to page numbers.

Albright-Knox Art Gallery, Buffalo: 64, 99, 138, 140, 141, 164, 182.
Allen Memorial Art Museum, Oberlin, Ohio: 118.
Courtesy Richard Anuszkiewicz: 67.
Rudolph Burckhardt: 33, 77.
The Carnegie Museum of Art, Pittsburgh: 133.
Henri Cartier-Bresson, © Smithsonian Institution, Washington, D.C.: 111.
Geoffrey Clements, Staten Island, New York: 21.
Ralph Coburn: 55.
Fred R. Conrad, *The New York Times*: 176.
George Cserna: 66.
Courtesy Mrs. Gene Davis: 148.
Courtesy André Emmerich Gallery, New York: 130.
Hollis Frampton, courtesy Marion Faller, Buffalo: 69, 75.
Jim Frank: 174.
Maria Gilissen: 178.
Gianfranco Gorgoni: 134.
Carmelo Guadagno and David Heald: 173.

Courtesy Peter Halley: 191.
Michael Halsband: 172.
Courtesy Pat Hearn Gallery, New York: 87.
Biff Henrich, Buffalo: 103, 107, 109, 114, 120, 131, 145, 146, 149, 152, 153, 156, 157, 159, 162, 168, 171, 179.
High Museum of Art, Atlanta: 177.
Frank Kaino: 155.
Ellsworth Kelly: 58, 136, 137.
Brigitte Lacombe: 160.
Marvin P. Lazarus: 158.
Alexander Liberman: 41.
Joe Maloney: 180.
Courtesy Anne and Martin Z. Margulies: 183.
Fred W. McDarrah: 125, 143, 170, 184.
T. Meisel: 108.
John M. Miller: 186.
Milwaukee Art Museum: 123.
Mipaas, © Smithsonian Institution, Washington, D.C.: 29, 100.
Regina Monfort: 101, 102, 112, 122, 163.
Museum of Fine Arts, Boston: 87.
The Museum of Modern Art, New York: 15, 17, 22, 35, 63, 70.

Hans Namuth, New York: 57, 149, 189.
Courtesy David Novros: 83.
Rollyn Puterbaugh: 46.
Walter Rosenblum: 117.
Richard Saunders: 82.
John D. Schiff, © Smithsonian Institution, Washington, D.C.: 104.
© Smithsonian Institution, Washington, D.C.: 128.
Courtesy Sonnabend Gallery, New York: 88, 89.
Squidds & Nunns, Tujunga, California: 169, 187.
Joseph Szaszfai: 43, 139.
Courtesy Texas Gallery, Houston: 175.
Mildred Tolbert: 167.
University of North Carolina: 33.
Malcolm Varon, New York: 115, 165.
Cora Kelley Ward: 61.
Burton Wasserman, © Smithsonian Institution, Washington, D.C.: 96.
Sarah Wells, New York: 126, 127, 185.
Courtesy Mike and Penny Winton: 144.
Bill Witt, © Smithsonian Institution, Washington, D.C.: 132.
Courtesy Wolff Gallery, New York: 86.
Yale University Art Gallery, New Haven: 98, 106, 121.